Documenting the World

Documenting the World

Film, Photography, and the Scientific Record

EDITED BY GREGG MITMAN AND
KELLEY WILDER

The University of Chicago Press
Chicago and London

Gregg Mitman is the Vilas Research and William Coleman Professor of History of Science, Medical History, and Environmental Studies at the University of Wisconsin–Madison. He is the author of *Breathing Space: How Allergies Shape Our Lives and Landscapes, Reel Nature: America's Romance with Wildlife on Film*, and *The State of Nature: Ecology, Community, and American Social Thought*. **Kelley Wilder** is a reader in photographic history at the Photographic History Research Centre, De Montfort University, Leicester. She is the author of *Photography and Science*.

The University of Chicago Press, Chicago 60637
The University of Chicago Press, Ltd., London
© 2016 by The University of Chicago
All rights reserved. Published 2016.
Printed in China

25 24 23 22 21 20 19 18 17 16 1 2 3 4 5

ISBN-13: 978-0-226-12911-2 (cloth)
ISBN-13: 978-0-226-12925-9 (e-book)
DOI: 10.7208/chicago/9780226129259.001.0001

Library of Congress Cataloging-in-Publication Data

Names: Mitman, Gregg, editor. | Wilder, Kelley E. (Kelley Elizabeth), 1971– editor.
Title: Documenting the world : film, photography, and the scientific record /
 Gregg Mitman and Kelley Wilder, editors.
Description: Chicago ; London : The University of Chicago Press, 2016. |
 Includes bibliographical references and index.
Identifiers: LCCN 2016008502 | ISBN 9780226129112 (cloth : alk. paper) |
 ISBN 9780226129259 (e-book)
Subjects: LCSH: Photography—Scientific applications. | Photography—Scientific
 applications—History. | Photography—History.
Classification: LCC TR692 .D63 2016 | DDC 770—dc23 LC record
 available at http://lccn.loc.gov/2016008502

♾ This paper meets the requirements of ANSI/NISO Z39.48-1992
(Permanence of Paper).

Contents

Introduction

GREGG MITMAN AND KELLEY WILDER

Imagine the twentieth century without photography and film. Absent in its history would be images that defined historical moments and generations: the Battle of the Somme, the death camps of Auschwitz, the assassination of John F. Kennedy, the Apollo lunar landing. There would be no photos of migrant farm workers during the Great Depression, no family album of suitably posed great aunts. It would be a history constituted from, dare we say it, *just* artist renderings and the written and spoken word. To inhabitants of the twenty-first century, deeply immersed in visual culture, such a history feels insubstantial, imprecise, and perhaps even unscientific. And yet photographic technology was not always a necessary condition for the accurate documentation of history. History's "protocols of evidence and argument" long consisted of writing rather than picturing.[1] But the introduction first of photography and subsequently of film in documenting the present created new types of records that altered notions of historical, legal, and scientific evidence; changed interactions among scientists and their subjects; and challenged the very construction and meaning of the archive.

The documentary impulse that emerged in the late nineteenth century combined the power of science and industry with a particularly utopian (and often imperialistic) belief in the capacity of photography and film to visually capture the world, order it, and render it useful for future generations. The "unifying sense of purpose," evident in early manifestos like *The Camera as Historian*, which encouraged the scientific use of photography and film in documenting projects of truly enormous scope, is perhaps now less visible, buried amid the staggering quantity of photographs and films that such projects generated.[2] In fact, the vestiges of the documentary impulse are still found everywhere: in storage freezers of scientific laboratories and natural

history museums, in the attics and basements of private homes, in the archives of libraries and universities, and on websites, ranging from Archive .org to Youtube.com.

In the virtual world of images summoned by every scholarly query, we tend to forget the material dimensions of the visual. But the sheer mass of photograph and film documents that take up space in archives and consume vast resources in their virtual state on the web is a reminder that the materiality of photographs and films extends far beyond the chemistry, size, and format of a particular document. At 100 million images and counting, Corbis, for example, one of the largest sites for one-stop shopping for digital still and moving images, is dependent upon a gigantic physical infrastructure of fiber optic cables, routers, hubs, and servers that greatly expand the material footprint of the archival image. It is merely the tip of an iceberg, amassed over a century of collecting via photography and film. Whether we measure in quantities of acid-free solander boxes and meters of rolling stack shelving or by the electricity powering countless servers delivering the public interface of museums and galleries, online databases and image banks, it is clear that acquisition and storage far outstrip chemistry, size, and format as material aspects of the documentary impulse.[3] Stopping at acquisition and storage would also only give an incomplete picture of the effect of this impulse. Each step of documentation—from the initial recording of images, to their acquisition and storage, to their circulation—has physically transformed natural and built environments, altered the lives of human subjects, reconstituted disciplines of knowledge, and changed economic and social relationships.

This book is about the material and social life of photographs and films made in the scientific quest to document the world. We find their material and social traces in the impulse that drove their creation; the historical and disciplinary dynamics that surrounded their production; the collecting practices of librarians, archivists, and corporations; and the archives they inhabit. Together, the essays in this volume call into question the canonical qualities of the authored, the singular, and the valuable image, and transgress the divides separating the still photograph and the moving image, as well as the analogue and the digital. They also overturn the traditional role of photographs and films in historical studies as passive illustrations in contrast to active textual scholarship.

In the last decade, photographic and film scholars like Gillian Rose, Joan Schwartz, Paula Amad, Elizabeth Edwards, and others have taken seriously the notion that questions of materiality and agency lie at the heart of photographic documentation.[4] Shifting the focus away, as Rose writes, from "scientific description [or] artistic sensibilities" and toward the work that photo-

graphs and films as documents do in the world requires a close look at the urge to document the world in still and moving images. Influenced by structuralist philosophy, in particular Michel Foucault, scholars like John Tagg and Allan Sekula, to name perhaps the best known, delved into the social and political structures of photographic archives as early as the late 1970s, opening up a field of research in which the evidential and recording power of photographs was largely socially constructed and politically motivated.[5] In this volume, we see the documentary impulse as part of a set of practices with epistemic intent, deeply influenced by the ideals and practices of late nineteenth-century scientific communities. The sheer excess of documentary material, coupled with the diversity of scientific disciplines that have produced and utilized it, far outstrips the ability of any single methodology or discipline to comprehend an impulse that has at times been gargantuan in its ambitions. Because photographs and films as objects move so readily across different cultural spheres—for example, from the family, to the courtroom, to the tabloid press, as Jennifer Tucker reveals in her analysis of the Tichborne claimant affair (chapter 2)—shifting their meanings accordingly, a mixture of methods and crossing of boundaries across the fields of photographic and film history, visual anthropology, and science and technology studies is in order. In attending to the mobility, materiality, and mutability of photographs, for instance, Elizabeth Edwards is able to interrogate a photograph of Pasi, a Torres Strait inhabitant, taken by anthropologist A. C. Haddon, as both an anthropological object indicative of a sea change in anthropological methodology and a family portrait (chapter 5). "Meaning" and "fact" lie not simply inside the photographic material but in a set of relationships formed between the maker, the user, the object, and the archive.

Drawing upon scholars from across the fields of art history, visual anthropology, and science and technology studies, *Documenting the World* interrogates questions of materiality and agency in the work that photographs and films do as evidentiary documents, narrative objects, and the stuff of archives. Despite the authors' different disciplinary backgrounds, the essays share a commitment to make tangible the different material manifestations of photographs and films: in the making of the document as evidence (Tucker, Edwards, Geimer, Vertesi); in the narratives accompanying the circulation and recirculation of still and moving images (Edwards, Mitman, Ginsburg); and in the life of photographs and films within the archive (Klamm, Wilder, Blaschke).

These themes—documents and evidence, circulation and recirculation, and archival lives—offer a general structure to the volume. We open with acts of becoming, as photographs and films acquire evidentiary force in the world. The essays span more than a century, from the place of photographs and films

as evidence in the Victorian courtroom and anthropology to the making of scientific documents out of manipulated digital images beamed back from the Mars Rover. Documentary images matter in the way that people imagine the past, make sense of the present, and envision the future. In his essay "The Colors of Evidence" (chapter 3), for example, Peter Geimer asks the provocative question, "How could it be that throughout the nineteenth century photographs were treated as documents, visual evidence, and traces of the real even though such a fundamental dimension of reality—color—was missing?" Photography and film have mattered literally, as Geimer shows, in imaginings of the past as a monochromatic world of black and white.

But what happens when the material and social relations of the documentary object are reconstituted, resulting in quite different stories and political ends from those initially intended in their making? In Gregg Mitman's investigative journey into the many lives of a 1926 Harvard expedition film shot in Liberia (chapter 6) and Faye Ginsburg's exploration of the repurposing of Nazi medical films by disability activists (chapter 7), we find the kind of productive work that can happen when documentary images take on second lives. The debris left by colonial and totalitarian regimes in their impulse to collect, classify, and control the world are being taken up by individuals whose ancestors were the objects of an imperial gaze.[6] In these liberating acts, photographs and films are literally reborn through new social relations.

If photographs and films can be so easily repurposed, so too is the visual archive subject to being cast adrift from its moorings in particular institutional practices. With deep ties to the visual regimes of nineteenth-century bureaucratic management and colonial rule, and increasingly influenced by twenty-first-century commerce, the visual record is anything but neutral. Even in repurposing, the photograph, film, or archive carries with it traces of its origins and of its original institutional place. Stefanie Klamm details the complicated path taken by photographs to get into archaeological and art historical institutions (chapter 8), which then immediately begin to efface disciplinary presumptions and individual social biographies in order to envision the timelessness of the archive over highly individual times and places of production.

Why should these particular media be accorded the kind of attention we have outlined?

Over the last two decades it has become increasingly apparent that photographic technology, with its scientific overtones, has often been invoked to legitimize visual methods for investigating the world, as well as for recording and archiving it.[7] At the same time a "pictorial turn" has informed scholarship in science studies.[8] As historians, anthropologists, and sociologists of science became more attentive to the relationships between "making and knowing," sci-

entific images—whether illustrations, graphs, photographs, or films—became a site for investigating the practices at work through which knowledge claims became stabilized and an entry into realist-constructivist debates that animated much scholarship in science studies during the 1980s.[9] In recent years, the scientific image has also offered a portal into the changing culture of science—a means for discerning shifting epistemic virtues, norms, and codes of behavior embodied in the scientific persona, as well as the permeability of boundaries between the cultures of science and other sites of cultural production, from craft guilds in the early modern period to the Hollywood studio system of the twentieth century.[10] Since Lisa Cartwright's groundbreaking work two decades ago on the cinema as a social apparatus through which Western science and medicine have analyzed, configured, and regulated the human body, scholars in film studies and visual culture have likewise been drawn to scientific images in discerning the cultures and experiences of looking across different forms of knowledge and spectatorship.[11]

Until recently, image content has been at the core of much scholarship on the visual culture of science. But new approaches, driven by an attentiveness to the medium itself and to the ecologies—material, social, and perceptual—through which new objects come into being are taking hold across the fields of art history, visual anthropology, and science studies.[12] It is an approach motivated by what Jennifer Tucker has described as "the need for greater critical awareness of visual images as physical, material artifacts mediated by past and present forces."[13] Deeply attentive to the material culture of making, collecting, and storing photographs and films, the authors in this volume believe the medium matters, literally, in both its analog and digital forms. *Medium* refers, after all, to a "thing which acts as an intermediary." According to the *Oxford English Dictionary*, it also refers to an "intervening substance through which a force acts." As objects, photographs and films are constituted through a set of relations that give them agency in the world.[14] They, along with the archives that contain them, are, as Faye Ginsburg notes in this volume (chapter 7), "grounded in powerful cultural narratives and counternarratives that have histories and consequences."[15] Organizing structures that house photographs and films also work on the researcher in various ways.[16] Corbis' image bank, for example, and its structure of a search engine based on market-driven demands, invisibly channels researchers in the direction of certain types of images over others, as Estelle Blaschke's essay (chapter 10) reveals. To imbue photographic and film documents with agency is to look upon them through the dynamic social interaction between people and things.[17]

Physically, photography and film create different taking, viewing, storage, and circulation experiences. We pass a still photograph from hand to hand

or post it to a colleague, family member, or friend. The tactile nature of photographic exchange, as well as a photograph's ability to become lost in text archives, are avenues closed to film. But time-lapse techniques not available to photography can focus an observer's attention on processes of long duration. The size, shape, and chemistry of film reels and photograph albums necessitate different cataloguing, archives, and research rooms. In turn, these research rooms demand our attention as scholars for how they shape research practice and the historical narratives emerging from it.[18] Both in and out of the archive, photographs and films are also constantly acquiring new meanings, becoming part of a social fabric as we use them to relate to each other, to the past, and to the future.[19]

In recent years, historians of science have drawn attention to the life of scientific objects. Such objects may, like photographable spirits, have faded away in existence. Or they may, like MRI pictures of mirror neurons, be in a state of becoming. Of critical importance is that such objects have action on the world. We do not intend here a sort of simple animism, but to recognize that photographic material and the archives that they make up are "heavy with consequences for everyday experience."[20] We interact with photographs in complicated ways, and the impulses that led to their creation imbue them and their archives with a particular sense of purpose. In these essays, photographs compose human biographies, stake out disciplinary boundaries, and endow planets with physical properties. Not all material objects are imbued with epistemic attributes, of course. But the distinctive materiality of the photographic medium, lending itself at times to a magical illusion of objectivity rendered by the receptive properties of a chemically treated surface, has often given photographs and films important epistemic status across a range of scientific fields. Even while each individual film and photograph can be an epistemic object, the objects they in turn construct can become epistemic things. Sometimes their existence as objects appears ephemeral, like Percival Lowell's photographs of canals on Mars, only to be reborn in a different time and place as decorrelation stretches proving different colored soil on the Mars Rover mission.[21] Photographic biographies of people, things, disciplines, species, events, and countries change over time not only with the changing nature of the audiences, but also with the changing understanding, heightened awareness, and shifting technologies that comprise photography and film documents. What makes their biographies most compelling is the polysemy of their accumulated histories, created for one purpose, archived for another, and reinterpreted for yet another.[22] And what sets the lives of these objects in motion is an initial impulse to document the world.

The Rise of an Impulse

When Alexander Graham Bell took over the presidency of the National Geographic Society in 1898, he envisioned a new life for the society's failing magazine, announcing that it would cover "the world and all that is in it." The magazine was the first popular scientific periodical in the United States to make extensive use of photographs. It was a decision rooted in the experiences of the magazine's editor, Gilbert Grosvenor, whose father, Edwin Grosvenor, an Amherst College history professor and friend of Bell, had published in 1895 a scholarly history of Istanbul richly documented with photoengravings.[23] By the late nineteenth century, the ontological faith in photography (soon followed by a similar belief in the authenticity of film) became a compelling reason for its incorporation into the methods and exposition of emerging human sciences (history, anthropology, archaeology, geography, art history) seeking scientific authority and legitimacy. As Costanza Caraffa notes, documentary photography's appeal in the historical disciplines rested in a belief that at long last one would be "able to reconstruct the past as it really was (Ranke's *wie es eigentlich gewesen war*)" through the camera's ability to record "hard ('authenticated') facts."[24] And the archive became, by the late nineteenth century, the widely agreed repository where such documents in the scientific pursuit of history would be stored.[25]

Photography and film enabled Bell's grandiose ambitions to capture "the world and all that is in it." But those ambitions were also rooted in a particular Judeo-Christian perspective that Donna Haraway has described as a God's eye view.[26] Indeed, Bell's popular slogan was but a variation of Psalm 24, "the Earth is the Lord's and the fullness thereof." Collecting, classifying, and ordering the world were part and parcel of imperial ambitions. The documentary impulse and the remains of it found among the countless photographs and films located in colonial archives suggest how rooted "the dream of a totalizing taxonomy" and an accompanying totalizing vision of the world were in the practices of empire.[27] We recognize the Eurocentric focus of documentary practices and image-making discussed in this volume. It is a limitation shaped by the questions asked in this volume that revolve around the material and social lives of photography and film in science and in the archive. It is also an invitation to consider how documentary practices have been understood outside the particularly Western ways of seeing and knowing the world explored in this collection of essays.

While photography and film helped realize the utopian and imperial ambitions of Western nations and institutions to visually seize and contain the

world, the perspectives and projects that followed were unified neither in their goals nor in their ideologies. Yet the impulse is undeniable.[28] How else can we explain the immense quantities of film footage and photographs dating to the late nineteenth and early twentieth centuries that fill the spaces of national, museum, university, industrial, and private archives throughout Europe and North America, and whose holdings are now the source of contention by peoples who never wished for themselves, or their stories and rituals, to be contained?[29] We discover these impulses everywhere. They find expression in the ambitious plans of Ernest Mouchez, director of the Paris Observatory, who organized an international conference in 1887 to engage the participation of eighteen observatories from twelve countries to create a photographic map, a grand *carte du ciel* or astrographic catalogue, of stars to the fifteenth magnitude. The project came to an official end in 1970, but not before over 22,000 photographic plates of the skies had been taken.[30]

Closer to the earth, across English counties, cities, and towns, over a thousand photographers, from local camera club participants to members of natural history, archaeological, and antiquarian societies, took part in Britain's photographic survey movement between 1885 and 1918. The result, as Elizabeth Edwards writes, "was a historical topography manifested through antiquities, built environments, folk customs, current events of historical interest, and, in the more ambitious, geology and natural history" and an archive of over 55,000 images.[31] This photographic impulse extended far into the British Empire's reach. The Archaeological Survey of India, established in 1861 by the British Raj to survey and document the historical sites of India, gathered up over 30,000 images now contained in the British Library. Their production depended on the labor of British officers and Indian photographers; the latter, unlike their British counterparts, never received credit on the photographs or official publications. The presence and absence of such traces are telling reminders of the colonial power relationships inscribed in the visual record.[32]

But the nature and extent of these impulses were not confined to national and colonial patrimonies on display. They could also be put in the service of those without power, whose lives were often hidden. In the 1930s, the Farm Security Administration made visible the plight of the downtrodden and displaced—from sharecroppers, to migrant workers, to the urban poor—to the American public. Amidst "the piles of this, stacks of that, yards of this, miles of that, boxes, bales, and timber" gathered by FSA photographers, Edward Steichen found the "most remarkable human documents ever rendered in pictures."[33]

Single iconic images, such as Dorothea Lange's "Migrant Mother," that so

captured Steichen and became etched into historical memory, have been the subject of countless works in photographic and art history. Less attention has been paid to the copiousness of material gathered by the FSA staff under the lead of economist Roy Stryker. The 77,000 black-and-white photographs and 1,600 kodachromes taken by staff photographers in the field between 1935 and 1942, which Steichen in 1938 referred to as "the tweedle dum and tweedle dee," suggests that something propelled FSA photographers beyond a logic of singularity. The sheer number of photographic records taken is a clue to the documentary practice that turned FSA photographer Dorothea Lange into a "discoverer, a real social observer."[34] When we consider the weight of documentary evidence gathered up by FSA photographers, the place of photography in a long tradition of the social science survey dating back to Lewis Hine's early twentieth-century photographs of workplace conditions in the industrial mills of Pittsburgh comes into view. And it shifts our attention to the hybrid properties of photography and film as media of art, of science, and of their interrelationship.

Sciences of the Everyday

Within the predilection and fascination to document the world lie a passion and nostalgia for the everyday that gathered particular momentum at the turn of the twentieth century. The advent of cinema and its early fascination with capturing the actuality of ordinary events solidified what Mary Ann Doane describes as the "drive to fix and make repeatable the ephemeral."[35] Before film became entrenched in narrative form, the "collection and storage of information about daily life," as Paula Amad writes, was a part of the "early application of film's positivist and utilitarian tendencies."[36] Such uses are evident, like their photographic counterparts, across countries and institutions. In 1920, the *Journal de Cine-Club* commented on a remarkable "cinema museum" in Boulogne-sur-Seine that housed kilometers of film documenting intimate and seemingly mundane elements of social life throughout the world: migrants looking into the camera, huddled together, on a transatlantic voyage; passersby on a New York City street. From 1908 to 1931, the wealthy French banker Albert Kahn built an Archives de la Planète, sending travelers throughout the world who helped to amass an almost unfathomable visual inventory of life that comprised 72,000 color autochromes, 4,000 stereographic images, and 183,000 meters of largely unedited film.[37] Not to be outdone, the American industrialist Henry Ford sponsored one of the largest film production units in the world. The motion picture department of the Ford Motor Company shot

and collected over 1.5 million feet of film from 1914 to the 1940s, documenting scenes of social life, industrial processes and products, and urban and rural landscapes across the United States and throughout the globe.[38]

Industrialists like Kahn and Ford were hardly alone in their enthusiasm for the promise of photography and film in amassing a record of "the world and all that is in it." Already a part of the 1898 Cambridge Torres Strait Expedition, still and moving pictures had become thoroughly ingrained into the practices of expeditionary science by the 1920s. Indeed, almost every expedition undertaken on behalf of the American Museum of Natural History after the First World War, from William Douglas Burden's 1926 expedition to the Dutch East Indies in search of the Komodo dragon to Roy Chapman Andrews' hunt for fossil dinosaurs in the Gobi, included a film and photographic record of landscapes, wildlife, and the customs and daily life of people encountered along the way. Sometimes the aspirations of industrialists and scientists combined. Citroën sponsored three expeditions across the Sahara, central Africa, and Asia in motorcars, accompanied by geographers, archaeologists, and cameramen documenting on film the physical and economic geography, ancient monuments, and ethnic groups in remote regions of the world. The films were advertisements for and testimony to the combined power of science and industry, remarked president of the Royal Geographic Society Major-General Sir Percy Cox, in "bringing various remote and uncivilized portions of the world within the purview and reach of civilization, not only in the interests of Citroën, but in the interests of science generally."[39] Citroën's expeditions, like the Harvard African Expedition undertaken on behalf of Firestone, the subject of Mitman's essay (chapter 6), are indicative of the extent to which film became an instrumental part of expanding the global economic reach of science and industry in the wake of the First World War.

In his efforts to establish a new genre of film "documentary" dedicated to the "creative treatment of actuality," the British filmmaker John Grierson condescendingly referred to this accumulating body of travelogues, newsreels, industrial and scientific film as "plain descriptions of natural material."[40] But Grierson's beginnings as a filmmaker in Britain's Empire Marketing Board were beholden to the "laborious accumulation of facts" in the service of promoting scientific research and economic development in the British colonies.[41] The history of nonfiction film did not move along a predetermined course from the raw, unedited slices of everyday life in early actuality films to the artistic form of narrative documentary. The camera's devotion to what Paula Amad describes as the "servile accumulation of facts" in early actuality film was itself part of film and photography's scientific force and attraction. But the very presence of the camera had a material affect on the relationship between

the scientist and his or her subject that at times needed to be disciplined. Elizabeth Edwards notes how A. C. Haddon expressed frustration with photographs from the Torres Strait Expedition ruined because the subject was "looking at the photographer, not at his work" in the "common actions of daily life."

This obsessive impulse to capture the seemingly mundane, ephemeral moments of life in all its "multiplicity, diversity, and contingency" can, in part, be seen as a reaction to the dizzying speed with which time came to be registered as a function of modernity.[42] Industrial technologies and processes that revolutionized travel, communication, mass production, and energy also made possible technologies of representation capable of recording the excess of things and accelerated temporality that at times seemed too difficult for the human mind and body to absorb and comprehend. In the relentless pulse and pace of industrial mechanization, life could be too easily lost. And it was life, in all its spontaneity and contingency, that both became a subject of early cinema and shaped cinematic practices. Indeed, as Hannah Landecker has argued, early cinema emerged out of a "dense set of interconnected works dealing with life, time, and film."[43] Science and cinema converged in the early twentieth century around the problem of seeing life and representing time. Across numerous scientific disciplines, the potentiality of cinema lay in its power to examine and exhibit the unseen hidden dimensions of life and movement: to see life through time.

"Contingency," Doane notes, "introduces the element of life and the concrete." But the "conceptualization of life in terms of chances" is a distinctly modern notion, as Lorraine Daston observes.[44] The rise of statistics in the nineteenth century offered one means to assure contingency did not become chaos. Statistical regularities allowed for individual caprice and uncertainty, but guaranteed that order in the world still prevailed. Charles Darwin built the whole edifice of the animal and plant kingdom on chance, yet his theory of evolution by natural selection enabled him to see "grandeur in this view of life." The contingent found expression in early cinema (and photography too). But like probabilistic or evolutionary theory, cinema provided a structuring element in which to control and contain the ephemeral and uncertain. The cataloguing system of Albert Kahn's archive or Henry Ford's motor company was one attempt at bringing order to this cinema of the everyday. The emergence of narrative form was another. Scientific disciplines too—anthropology, human geography, and natural history, among others—whose subject matter relied upon life, gravitated to this new technology. Through disciplinary practices of observation, themselves shaped by the camera, these sciences brought meaning and purpose to the visuality of the local, contingent, and movements of ordinary life. Whether documenting men on the

lookout for dugong in the Torres Strait, the collection of biological and medical specimens in the interior of Liberia, or cinerary urns dating to the Bronze Age found near St. Andrews, the camera elevated the everyday to the status of scientific object across the disciplines of the human and life sciences.

Becoming Documents

Key to these projects and to the promise they held forth was the photographic medium and its now canonized promise of scientific accuracy and everyday intimacy.[45] Announced to the public in 1839 via the two largest and most powerful scientific bodies in Europe, photography promised to churn out numbers of observers of very high quality, making it instantly attractive to the professionalizing human and life sciences. In one of his working notebooks of 1839, William Henry Fox Talbot described looking at his photogenic drawings as looking "thro' nature up to Nature's God," invoking the same Judeo-Christian language utilized by so many documenting projects.[46] A scientist himself, Talbot wrote eloquently about the inclusion of individuals outside the specialized training of scientists into the fraternity of observers, heretofore attainable only through half a lifetime of self-sacrifice. Modern science, and especially the cult of observation, requiring tireless, mechanical, accurate attention, gave verbal expression to the visual potential of photography.[47] The invention of photography put science into visual practice, validating some of its most cherished methods.[48] Photography became so quickly synonymous with science that Edgar Allan Poe could describe it in 1840, a scant year after its public announcement, as "the most extraordinary triumph of modern science."[49]

But it would be decades before the photographic record, the early version of the photographic document, truly came into its own by embracing the recording of everyday life. Recording seems so much a part of photography's legitimate path now that it is surprising to find that the title "record" is seldom found in the literature before the last three decades of the century, appearing with increasing frequency as more and more photographic surveys began in the late 1880s and early 1890s.[50] Perhaps it is because the idea of photographic evidence was not a foregone conclusion but a matter, as Jennifer Tucker writes, of debate about skills, aesthetics, and judgment.[51] It might also be that the timely confluence of photography in the hard sciences, the human sciences, and "modern" archival and document sciences in Western societies achieved an elevated status for the photographic "record" as a document invested with appropriately scientific levels of neutrality, objectivity, and reliability.[52] These three apparently essential scientific qualities have cast the

photographic archive as a passive resource, "to be mined when useful, ignored at whim."[53] And yet the essays in this volume bear out the curious power of the photographic medium to produce what Talbot called "evidence of a novel kind."[54] That novelty rests not only in the "unobserved and unsuspected" detail found in photographic images, and in the manner of their recording, as Talbot claimed, but also, as is crucially addressed in this volume, in the practices of making, archiving, circulating, and remaking quantities of these photographic documents.[55] Photographs and films, infused as they are with the interests of makers, collectors, and users, are documents that tell us a great deal about evidence in the legal system, the formation of the historical imagination, and the way planetary scientists generate research topics. They also tell us about the changing values placed on photographic and film material.

Over the years, there have been many attempts to identify where exactly photographic and film documents acquire their evidentiary power. Many of them can be organized under the two titles of indexicality (the causal relationship) and mimesis (the resemblance relationship), although these terms are still contested.[56] These two theories, along with later interventions by Tagg and Sekula asserting the role of society and institutional regimes, have historically paid attention to the process of making photographs and films.[57] How photographic and filmic documents come into being and acquire trust remains a crucial question—one addressed by the authors in this volume as well. As a result of the digital revolution, the chemistry and format of photographs and films have recently dominated discussions of making and medium specificity.[58] Taking archives as an aspect of medium specificity as we do in this volume leads, however, to a broadening of the debates originating in and responding to indexicality and mimesis. Previously, there has not been much question about who "makes" a photographic or film document. In this volume, court judges, collectors, scientists, librarians, archivists, students, and businessmen are added to cinematographers and photographers as "makers" of photographic documents. The invention of photography, after all, was not just a technological achievement, but "the cultural invention of a new medium of seeing."[59]

Like many theories about photography that have been influenced subtly by addressing only the single image, indexicality requires a one-to-one causality, the "this" of language. But much more is at play in the evidentiary status of photography that goes beyond the indexical nature of the single image. What happens when we consider the abundance produced through photography and film, which has led to an "ineradicable surfeit" of detail that characterizes photography and film as objects and the archives that contain them?[60]

The individual image is submerged under the sheer weight of numbers: the 400,000 prints, negatives, and digital images of the United States Geological Survey,[61] the 100 million images of Corbis, the complete map of the Earth every three years achieved with LANDSAT. These archives generate evidence from photographs in ways that build on one person's trust in an individual photograph; discipline that trust through scientific constraints that reflect, for instance, anthropological, art historical, or archaeological agendas; and, finally, appeal to the mass of documentary materials gathered.

In the late nineteenth century, photographs became a part of documentary sources that historians debated when considering the nature of their craft. The belief that photography, properly disciplined, could be harnessed in the production of historical facts was premised on the control of the production of visual images.[62] The conditions of making were regarded as critical to a photograph's authority as a documentary source. But the value of photographs and films as historical objects might not be "because photographs accurately record what places looked like in the past." Nor is it because the photograph was, in Nesbit's words, "a detailed blank," whose only shape was imposed by external forces.[63] Their value might lie instead, as authors in this volume posit, in the "production, circulation and consumption of photographs that produce and reproduce the imagined geographies of the social group or institution for which they were made."[64] The material properties of photographs, and the physical affect of masses of photographs goes beyond an examination of the effect of image production or content. Indeed, "that the formal qualities of images themselves may be in large part irrelevant is suggested by their historical trajectories and the radical revaluations that they undergo."[65] The size, the shape, the mounting, the presentation, and the mass of photographic materials—their physicality—are all equally valid sources of historical information.[66] This presents an argument not about what photographs *represent* but about what they *do* and particularly what they do in large groups, as cultural documents. Singularity, in any sense of the word or deed, does not enter into documenting projects, nor does it, as Blaschke points out, follow Benjamin's model of endless reproduction. There is always a physical limit on photographic and in particular digital reproduction. Documenting projects do not produce single (although they do create iconic) representations, but massed representation. And it is here, in the copiousness of material captured by the camera, and in the photographic and film records produced (themselves material objects), where the evidentiary weight of these documenting impulses can be found.[67] This volume intends to broaden the debate about photographic documents beyond the concepts of mimesis and indexicality, whose presence is undeniable. We focus on a series of

practices in which photography and film, in particular documenting projects, engage in order to tease out some new ways of negotiating this difficult material in groups, not in one photograph or frame of film at a time. The authors take very seriously the abundance of photographic material, rather than its individuality.

A surfeit (of details or numbers) can be seen as excessive, "a luxury" in Geimer's words, or it can be seen as abundance, potential or latent creative power. When the photographic surfeit is treated as excessive, it lives a limited life, constrained by its original intentions. To turn from seeing surfeit as excess to seeing it as abundance is a precondition for its recirculation. When excess becomes abundance, for instance at the point of disciplinary division between cultural and physical anthropology, as in Edwards' essay (chapter 5), or institutional reorganization under an increasingly present notion of "photographic," the subject of Wilder's article (chapter 9), the stage is set for a relational transformation that sets the object in motion once again: from structure to process, from singularity to mass, from disappearance to becoming (dead to living), and from periodicity to totality. As Edwards notes, often the shift in attitude from one of excess toward one of abundance accompanies a radical shift in the sorts of photographs that are made and in the way that the everyday in photography and in human life is engaged. This engagement, or interaction between photography and film and people and places, is where "the full meaning of the content of a photographic document resides."[68]

Contemplating "the action in which [photographs and films] participate,"[69] we find that photographic materials change the way courtrooms work, the way archives are constructed, and the way humans tell history. Photography and film are used to "see new things" (Vertesi, chapter 4) from a new perspective (Geimer, chapter 3) and with particular sets of disciplinary eyes (Edwards, chapter 5). These records, and the archives in which they are located, live and gain evidentiary force through their circulation and recirculation across both space and time.[70]

Circulation

Writing about scientific objects as if they have biographies implies that they have lives that stretch into the past and project into the future. We not only recognize photographs, we rearticulate them and refigure them into historical accounts matching our own experience.[71] Originally, the photographic documents we investigate were made with a specific purpose in mind: portraying Arthur Orton, or Olympia or the collection catalogue. Although photographs and films can be exchanged and repurposed, they can never entirely shed the

conditions of their making. Even in the endless copies of some photographs, the material traces of their making are apparent. Although the division into making, exchanging, and repurposing seems very close to Tagg's model of making, circulating, and consumption,[72] what we are actually talking about is not the economy of consumption but the economy of documents and their evidential currency. In the consumption model, there is an assumed passivity on the part of photographic and film documents. In the economy of documents, the photographs and films play an active part.

While the traces of the past live on in the visual document, the future is a precondition for their circulation and rebirth. The expectation of the future invested the photographic and film record with an even greater degree of veracity. "To trust that a thing we know is real," observed the philosopher Michael Polanyi, "is to feel that it has independence and power for manifesting itself in yet unthought of ways in the future."[73] Here rested the power of the photograph and film as scientific documents. They were themselves capable of becoming, of acting upon the world both in the present and in some unimagined future. Sometimes their resurrection, as in the case of Nazi-produced films and photographs reclaimed by disability activists, may "have a redemptive second life," as Ginsburg notes (chapter 7), "documenting the world in an entirely different way than was originally intended."

Photographs and films have, in short, the potential of vitality. Perhaps this is why Bergson's vitalist philosophy had a particularly strong influence on French film criticism of the 1920s and upon later realist film theorists such as Siegfried Kracauer. Among film critics like Louis Delluc, film's affinity for "life itself" became a focus of attraction and contemplation. We should not forget that Bergson's vitalism, which so informed Kracauer's association of film with the "flow of life's rendition of the everyday," was itself beholden to turn-of-the-century life sciences and to a philosophy not of machines but of living beings.[74] Bergson rejected a mechanical notion of time as a series of discrete, divisible moments—captured in the still plates of Étienne-Jules Marey's chronophotograph. Time was instead an endless flow. "Duration," Bergson wrote, "is the continuous progress of the past which gnaws into the future and which swells as it advances."[75]

In the period between the two world wars, the attraction of holism across the human and life sciences drew attention to the relationality of being in place and time. "Wherever anything lives, there is, open somewhere, a register in which time is being inscribed," Bergson wrote. Such a perspective put the past in a different relation to the present and future. It suggests, as the anthropologist Tim Ingold writes, that the "life of every being, as it unfolds, contributes

at once to the progeneration of the future and the regeneration of the past. "[76] This is the action of films and photographs as living documents. C. C. Fagg, an active participant in Britain's regional survey movement, where the camera served as the observational and recording instrument of choice, argued in 1930 that "the roots of the future are in the past." The life of the region was always in a state of becoming. It "presents," Fagg suggested, "a mosaic of survivals and developments from the past together with incipient tendencies foreshadowing the future. "[77]

The documentary impulse was as much about the future as it was about a past, absent, but never extinguished. Unlike the projects they discuss, this volume does not have any claim to coverage of the subject. It is instead a beginning, a series of histories about a certain impulse that can no doubt be found in many more projects, many more decades, and many more archives to come.

Notes

1. John Tagg, *The Disciplinary Frame: Photographic Truths and the Capture of Meaning* (Minneapolis: University of Minnesota Press, 2009), xvi.

2. H. D. Gower et al., *The Camera as Historian: A Handbook to Photographic Record Work for Those Who Use a Camera and for Survey or Record Societies* (London, 1916). For more on this title see Elizabeth Edwards, *Camera as Historian* (Durham: Duke University Press, 2012).

3. Blaschke, this volume, chapter 10.

4. Gillian Rose, "Practising Photography: An Archive, a Study, Some Photographs, and a Researcher," *Journal of Historical Geography*, 26:4 (2000): 555–71; Joan Schwartz, "'The Geography Lesson': Photographs and the Construction of Imaginative Geographies," *Journal of Historical Geography* 22 (1996): 16–45; Schwartz, "'We Make Our Tools and Our Tools Make Us': Lessons from Photographs for the Practice, Politics, and Poetics of Diplomatics," *Archivaria* 40 (1995): 40–74; Paula Amad, *Counter-Archive: Film, the Everyday and Albert Kahn's Archives de la Planète* (New York: Columbia University Press, 2010); Elizabeth Edwards, *Raw Histories: Photographs, Anthropology, and Museums* (Oxford: Berg, 2001).

5. John Tagg, *The Burden of Representation: Essays on Photographies and Histories* (London: Macmillan, 1988), was a series of essays that had been published and given as lectures since at least 1979. Allan Sekula, "The Body and the Archive," in *The Contest of Meaning: Critical Histories of Photography*, ed. Richard Bolton (Cambridge: MIT Press, 1989), 343–88.

6. On ruins, objects, and imperial formations, see Anne Laura Stoler, ed., *Imperial Debris: On Ruins and Ruination* (Durham: Duke University Press, 2013).

7. See, among many others, W. J. T. Mitchell, *What Do Pictures Want? The Loves and Lives of Images* (Chicago: University of Chicago Press, 2005); Schwartz, "We Make Our Tools"; Elizabeth Edwards, "Unblushing Realism and the Threat of the Pictorial: Photographic Survey and the Production of Evidence 1885–1918," *History of Photography* 33, no. 1 (February 2009): 3–17.

8. W. J. T. Mitchell coined this term in the 1990s, while Martin Jay used a similar term, the "visual turn," applied to visual studies. For an overview of the history of these movements see

Margaret Dikovitskaya, *Visual Culture: The Study of the Visual after the Cultural Turn* (Cambridge: MIT Press, 2005), 47–64.

9. Pamela Smith, "Art, Science, and Visual Culture in Early Modern Europe," *Isis* 97 (2006): 85. For an early focus on representation in science and its importance to the realist-constructivist debates within STS in the 1980s, see Ian Hacking, *Representing and Intervening: Introductory Topics in the Philosophy of Natural Science* (Cambridge: Cambridge University Press, 1983), and Michael Lynch and Steve Woolgar, eds., *Representation in Scientific Practice* (Cambridge: MIT Press, 1990). Bruno Latour's essay, "Drawing Things Together," in *Representation in Scientific Practice*, Lynch and Woolgar, was an explicit intervention in this debate.

10. On the importance of the visual in different epistemic cultures, see Peter Galison, *Image and Logic: A Material Culture of Microphysics* (Chicago: University of Chicago Press, 1997). On scientific persona, see Lorraine Daston and Peter Galison, *Objectivity* (London: Zone Books, 2007). For an entry into scholarship on the permeability of scientific images across different cultural domains, see David Kirby, *Lab Coats in Hollywood: Science, Scientists, and Cinema* (Cambridge: MIT Press, 2011); Hannah Landecker, "Microcinematography and the History of Science and Film," *Isis* 97 (2006): 121–32; Gregg Mitman, *Reel Nature: America's Romance with Wildlife on Film*, 2nd ed. (Seattle: University of Washington Press, 2009); David Serlin, ed., *Imagining Illness: Public Health and Visual Culture* (Minneapolis: University of Minnesota Press, 2010); Pamela Smith, *The Body of the Artisan: Art and Experience in the Scientific Revolution* (Chicago: University of Chicago Press, 2006); Jennifer Tucker, *Nature Exposed: Photography as Eyewitness in Victorian Science* (Baltimore: Johns Hopkins University Press, 2005).

11. Lisa Cartwright, *Screening the Body: Tracing Medicine's Visual Culture* (Minnesota: University of Minnesota Press, 1995). See also Fatimah Tobing Rony, *The Third Eye: Race, Cinema, and Ethnographic Spectacle* (Durham: Duke University Press, 1996); Alison Griffiths, *Wondrous Difference: Cinema, Anthropology, and Turn-of-the-Century Visual Culture* (New York: Columbia University Press, 2002).

12. Adrian J. Ivahkiv, *Ecologies of the Moving Image: Cinema, Affect, Nature* (Waterloo: Wilfred Laurier University Press, 2013).

13. Jennifer Tucker, "The Historian, the Picture and the Archive," *Isis* 97 (2006): 112.

14. This is a concept that has spread from art history to anthropology and material culture studies and beyond. See for instance Alfred Gell, *Art and Agency* (Oxford: Oxford University Press, 1998), or Mitchell, *What Do Pictures Want?*

15. Edwards, *Raw Histories*; Chris Pinney, *Camera Indica: The Social Life of Indian Photographs* (Chicago: University of Chicago Press, 1998).

16. Rose, "Practising Photography," 555–71.

17. There are many scholars working on similar ideas of sociomateriality in anthropology, social geography, art history, and STS. The most recent use of these ideas pertaining to photographic and film histories specifically are those of Edwards, *Raw Histories*, and Edwards, "Photography and the Material Performance of the Past," *History and Theory* 48 (2009): 130–50; Schwartz, "We Make Our Tools"; Amad, *Counter-Archive*; James Hevia, "The Photography Complex, Exposing Boxer Era China (1900–1901), Making Civilization," in *Photographies East: The Camera and Its Histories in East and Southeast Asia*, ed. Rosalind C. Morris (Durham: Duke University Press, 2009), 79–119; Pinney, *Camera Indica*; Costanza Caraffa, ed., *Photo Archives and the Photographic Memory of Art History* (Berlin: Deutscher Kunstverlag, 2012).

18. Klamm, chapter 8, this volume; Rose, "Practising Photography"; and Amad, *Counter-Archive*.

19. Edwards, *Raw Histories*, 13.

20. Lorraine Daston, "The Coming Into Being of Scientific Objects," in *Biographies of Scientific Objects*, ed. Lorraine Daston (Chicago: University of Chicago Press, 2000), 3.

21. See Tucker, *Nature Exposed*, and Janet Vertesi, chapter 4, this volume.

22. Edwards, *Raw Histories*, 13–14.

23. Edwin A. Grosvenor, *Constantinople* (Boston: Roberts Brothers, 1895), as discussed in Tamar Y. Rothenberg, *Presenting America's World: Strategies of Innocence in National Geographic Magazine, 1888–1945* (London: Ashgate, 2007). See also Philip Pauly, "The World and All That Is in It: The National Geographic Society, 1888–1918," *American Quarterly* 31 (1979): 517–32.

24. Costanza Caraffa, "From 'Photo Libraries' to 'Photo Archives': On the Epistemological Potential of Art-Historical Photo Collections," in *Photo Archives*, ed. C. Caraffa, 19.

25. Carolyn Steedman, *Dust: The Archive and Cultural History* (New Brunswick, NJ: Rutgers University Press, 2002).

26. Donna Haraway, "The Persistence of Vision," in *The Visual Culture Reader*, ed. Nicholas Mirzoeff (London: Routledge, 2001), 191–98.

27. Michel de Certeau, "L'Espace de l'Archive ou la Perversion du Temps," *Traverses* 36 (1986): 5.

28. Elizabeth Edwards notes that one of the unifying factors in the many English photographic surveys is their "cohesive sense of purpose," in Edwards, "Unblushing Realism and the Threat of the Pictorial Photographic Survey and the Production of Evidence, 1885–1918," *History of Photography* 33 (2009): 3–17. It is this sense of purpose that we wish to address.

29. Faye Ginsburg, "Screen Memories: Resignifying the Traditional in Indigenous Media," in *Media Worlds: Anthropology on New Terrain*, ed. Faye D. Ginsburg, Lila Abu-Lughod, and Brian Larkin (Los Angeles: University of California Press, 2002), 39–57.

30. Jérôme Lemy, *La carte du ciel* (Paris: EDP Sciences, 2008).

31. Edwards, "Photography and the Material Performance of the Past," 131.

32. Sudeshna Guha, "The Visual in Archaeology: Photographic Representation of Archaeological Practice in British India," *Antiquity* 76 (2002): 93–100; Edwards, *Raw Histories*.

33. William Stott, *Documentary Expression and Thirties America* (Chicago: University of Chicago Press, 1986), 11.

34. Anne Whiston Spirn, *Daring to Look: Dorothea Lange's Photographs and Reports from the Field* (Chicago: University of Chicago Press, 2008), 4.

35. Mary Ann Doane, *The Emergence of Cinematic Time: Modernity, Contingency, the Archive* (Cambridge: Harvard University Press, 2002), 22.

36. Amad, *Counter-Archive*, 134.

37. Amad, *Counter-Archive*.

38. See Phillip W. Stewart, *Henry Ford's Moving Picture Show: An Investigator's Guide to the Films Produced by the Ford Motor Company, Volume One: 1914–1920* (Crestview, FL: PMS Press, 2011).

39. Joseph Hackin, "In Persia and Afghanistan with the Citroën Trans-Asiatic Expedition," *Geographical Journal* 83 (1934): 361. On film and the Torres Strait Expedition, see Griffiths, *Wondrous Difference*. On the Citroën expeditions, see Peter J. Bloom, *French Colonial Documentary: Mythologies of Humanitarianism* (Minneapolis: University of Minnesota Press, 2008), 65–94.

40. John Grierson, in *Grierson on Documentary*, edited and compiled by Forsyth Hardy (London: Faber and Faber, 1966), 13, 146.

41. Commonwealth Institute, Tallents Papers, file 25.

42. Doane, *Emergence of Cinematic Time*, 22.

43. Hannah Landecker, "Cellular Features: Microcinematography and Film Theory," *Critical Inquiry* 31 (2005): 907.

44. Doane, *Emergence of Cinematic Time*, 12; Lorraine Daston, "Life, Chance, and Life Chances," *Daedalus* 137, no. 1 (2008): 7.

45. Ginsburg, chapter 7, this volume.

46. Larry J. Schaaf, *Records of the Dawn of Photography: Talbot's Notebooks P&Q* (Cambridge: Cambridge University Press, 1996), P55, May/June 1839.

47. This has been addressed in many places like Tucker, *Nature Exposed*, 20, and in essays by Charlotte Bigg, Jimena Canales, and Kelley Wilder in Lorraine Daston and Elizabeth Lunbeck, eds., *Histories of Observation* (Chicago: University of Chicago Press, 2011).

48. Talbot even presented the discovery of his process to the Royal Society on 31 January 1839, as a validation of the inductive method "put into practice," upholding Jean Baptiste Biot's assertion to the Academie des Sciences in Paris only weeks earlier, that the daguerreotype was a "retina placed at the disposal of physicists." Talbot's statement about induction, published as "Some Account of the Art of Photogenic Drawing" in the *Philosophical Magazine*, 3rd ser., 14, no. 88 (1839): 196–211 and in the *Athenaeum, Mechanic's Magazine*, and the *Literary Gazette*, has recently been remarked on by authors like Tucker, *Nature Exposed*, 20–21, and Douglas R. Nickel, "Talbot's Natural Magic," *History of Photography* 26, no. 2 (Summer 2002): 32–140.

49. Edgar Allan Poe, "The Daguerreotype," *Alexander's Weekly Messenger* no. 15 (January 1840), reproduced in Alan Trachtenberg, *Classic Essays on Photography* (New Haven: Leete's Island Books, 1980), 37–38.

50. In the database Photographs Exhibited in Britain 1839–1860 (http://peib.dmu.ac.uk/ accessed 20 June 2010), the term "record" does not occur as a part of a single exhibit, while the Royal Photographic Society Exhibitions between 1870–1915 (http://erps.dmu.ac.uk/, accessed 20 June 2010) shows only 115 exhibits titled with the word "record" from a selection of many thousand exhibits. Although this is hardly a rigorous study, it is indicative of the vocabulary deployed at the time.

51. Tucker, *Nature Exposed*, 194; and Tucker, chapter 2, this volume.

52. Since Sekula's influential "The Body and the Archive" was published in 1986, there have been many assertions that the evidential power of photographs in archives relies as much on the institutional practices of archives as it does on the representational powers of photographs. Specifically, Edwards suggests that archiving was an integral part of the establishment of photographic "truth values" in Edwards, "Photography and the Material Performance," 138. Joan Schwartz likewise suggests the confluence of the rise of photographic meaning and the notion of modern archiving in "'Records of Simple Truth and Precision': Photography, Archives, and the Illusion of Control," *Archivaria* 50 (2002): 1–40.

53. Elizabeth Edwards, "Photographs: Material Form and the Dynamic Archive," in *Photo Archives and the Photographic Memory of Art History*, ed. Costanza Caraffa (Berlin: Deutscher Kunstverlag, 2011), 47.

54. William Henry Fox Talbot, *The Pencil of Nature* (London: Longman, Brown, Green & Longmans, 1844–46), plate 3.

55. Talbot, *The Pencil of Nature*, plate 13.

56. The original use of C. S. Pierce's "index" in the art world comes from a two-part article by Rosalind Krauss, "Notes on the Index: Seventies Art in America," *Source* vols. 3 and 4 (Spring and Autumn 1977). Two of the most influential works on photography and film as philosophical objects are Roland Barthes, *Camera Lucida: Reflections on Photography*, trans. Richard Howard (New York: Hill and Wang, 1981), and Andrè Bazin and Hugh Gray, "The Ontology of the Photographic Image," *Film Quarterly* 13, no. 4 (Summer 1960): 4–9. For recent arguments adding to the debate see James Elkins, *Photography Theory*, The Art Seminar (New York: Routledge, 2006), and especially François Brunet's contribution in that volume and Douglas R. Nickel, "History of Photography: The State of Research," *Art Bulletin* 83, no. 3 (September 2001): 548–58.

57. For instance Joel Snyder and Neil Walsh Allen, "Photography, Vision and Representation," *Critical Inquiry* 2:1 (Autumn 1975): 143–69.

58. Mary Ann Doane, "Indexicality and the Concept of Medium Specificity," in *The Meaning of Photography*, ed. Robin Kelsey and Blake Stimson (New Haven: Yale University Press, 2008), 3–14.

59. Tucker, *Nature Exposed*, 239.

60. Chris Pinney and Nicolas Peterson, eds., *Photography's Other Histories* (Durham: Duke University Press, 2003), 6. It is a testament to the power of the canonical image, and the modernist histories of photography and film, that indexicality continues so strongly in photographic writings without addressing the multiple image or even multiple details.

61. United States Geological Survey Photo library at http://library.usgs.gov/photo/#/ (accessed 25 October 2010).

62. Edwards, *Camera as Historian*, 55–56.

63. Molly Nesbit, *Atget's Seven Albums* (New Haven: Yale University Press, 1992), 16.

64. Rose, "Practising Photography," 555.

65. Pinney and Peterson, *Photography's Other Histories*, 3.

66. Elizabeth Edwards and Janice Hart, eds., *Photographs Objects Histories: On the Materiality of Images* (London: Routledge, 2004), 2; Rose, "Practising Photography"; Edwards, "Photography and the Material Performance"; Schwartz, "We Make Our Tools," 56. Also see Klamm, chapter 8 in this volume.

67. Schwartz, "We Make Our Tools," 56.

68. Schwartz, "We Make Our Tools."

69. Schwartz, "We Make Our Tools," 52.

70. For more on this see Pinney, *Camera Indica*; Edwards, *Raw Histories*; and Deborah Poole, *Vision, Race, and Modernity: A Visual Economy of the Andean Image World* (Princeton: Princeton University Press, 1997).

71. Edwards, *Raw Histories*, 22.

72. "The history of photography is, above all, the history of an industry catering to such a demand: a history of needs alternatively manufactured and satisfied by an unlimited flow of commodities; a model of capitalist growth in the nineteenth century." Tagg, *Burden of Representation*, 37.

73. Polanyi, quoted in Hans-Jörg Rheinberger, "Cytoplasmic Particles: The Trajectory of a Scientific Object," in *Biographies of Scientific Objects*, ed. Lorraine Daston (Chicago: University of Chicago Press, 2000), 294.

74. Amad, *Counter-Archive*, 302.

75. Henri Bergson, *Creative Evolution*, trans. Arthur Mitchell (New York: H. Holt and Co., 1911), 7.

76. Tim Ingold, *The Perception of the Environment: Essays on Livelihood, Dwelling, and Skill* (London: Routledge, 2000), 143.

77. David Matless, "Regional Surveys and Local Knowledges: The Geographical Imagination in Britain 1918–1939," *Transactions of the Institute of British Geographers*, n.s. 17, no. 4 (1992): 468.

Moving Pictures: Photographs on Trial
in the Sir Roger Tichborne Affair

JENNIFER TUCKER

In 1873, the London Stereoscopic and Photographic Company released into mass circulation a photograph bearing the caption "Briefs of Counsel" (figure 2.1). Depicting a stack of legal briefs across which is draped a leather photo wallet, it might at first be unclear why a photograph like this merited mass circulation; however, most Victorian viewers would have required little more by way of explanation than the portrait in the wallet and the image's caption. Weeks of intense national media coverage of the trial of the Tichborne "Claimant" ensured its status as an iconic image. The trial, which contemporaries often referred to as "the trial of the century" because of its extraordinary length and spectacle, centered on the identity of a man, known as the Claimant, who some said was an aristocrat's son, but who others (including most of that aristocratic family) thought was an impostor. Throughout the Tichborne courtroom drama, which spanned seven years, from the start of Chancery proceedings in 1867 until the criminal trial ended in 1874, exhausted legal personnel and jury members sorted through mountains of textual and visual evidence. Indeed, the collection of volumes of documents and processing of visual evidence were widely seen at the time as the chief factor in the extraordinary length of time it took for the case to move through the courts.[1]

Though mainly remembered today for the enduring issues that it raised about identity and imposture, the protracted legal affair of the Tichborne Claimant attracted notice in its time for the unprecedented volume of documents and items of evidence that lawyers presented and debated. Familiar to students of Victorian society and culture as a case that mobilized the working classes and led to fundamental changes in the Court of Chancery, the Tichborne Affair was also, I argue, a crucial and hitherto overlooked touchstone for public discussion and critical debate over wider changes with respect to

—— THE TICHBORNE CASE. ——

BRIEFS OF COUNSEL

FOR DEFENDANTS

The Hon^ble Lady T.M.J.Doughty Tichborne and The Hon^ble W^m Stourton

"BREVIA GRANDIOSA SED BREVISSIMA"

FIGURE 2.1. "Briefs of Counsel." The caption reads, "The Tichborne Case. Briefs of Counsel for Defendants The Hon^ble Lady T. M. J. Doughty Tichborne and The Hon^ble W^m Stourton. 'Brevia Grandiosa sed Brevissima.'" 72A04/E1/12 (Hampshire Record Office, Winchester).

the place of photography in law and Victorian society during a transitional moment in the 19th century during the 1860s and early 1870s, before the era of the Bertillon method and the introduction of other visual forensic techniques. As the case wound its way through the British judicial system and attracted international media coverage, it highlighted for thousands in Britain and around the world changes in how photographs were being interpreted and constituted as documents; because of the wide editorial and other written commentary given to the case, it also provides a rare historical record of social attitudes toward those changes. In the cultural history of documentary evidence, the case stands out for several reasons, including its intensive use of portrait photography as an index of character and test of personal identity, the role of a much expanded illustrated press in reproducing the visual evidence for mass viewing audiences, the courtroom use of expert and visual evidence, and the uses of pictorial Tichborniana (cartoons, engravings, and *cartes-de-visite*) in constituting a political movement and creating a collective historical memory. A cause célèbre that interested members of a wide and diverse public, the case is important for the way that it generated extensive commentary about the nature of photography and photographic documentation from individuals and groups whose views and opinions are not generally well-represented in the standard histories of photography, such as working-class people, women, and studio photographers. "Briefs of the Trial" viewed in this context is less a Victorian eccentricity than an icon of its age, a figure that captured public notice at a time and place during the nineteenth century when photography was becoming important simultaneously for the mechanical production of material forms of evidence in court and as an important means for representing, in a popular format for mass audience, the significance of documents as records that furnished visual evidence or information.

This essay uses the Tichborne affair to explore some of the wider social meanings of photographic evidence in Victorian society by studying the dispatch and circulation of photographs through what I term the "document economy" of nineteenth-century visual culture. While acknowledging photography's importance as an evidential record (for example, the use of mug shots by prison wardens and detectives to track down miscreants) histories of photography often offer few specifics about photography's uses in legal proceedings themselves (for example, in civil and criminal cases). I argue that the physical circulation and material reproduction of photographs through the documentary economy of Victorian society is vital for a fuller understanding not only of the historical meanings of photography but also of the transformation of nineteenth-century society—including the way in which traditional

practices of law and construction of evidence were being challenged and rede-
fined in an era of imperial expansion.[2] After giving some brief background to
the case and the trial itself, I look at several instances in which photographic
portraits were transformed into investigative and legal documents. A closer
look at the public's fascination with this case reveals its inseparability from
the greater appropriation and assimilation of photography in Victorian soci-
ety and new techniques making possible forms of mechanical reproduction.
It also demonstrates that the constitution of Victorian photography as docu-
mentary evidence depended on more than simply advances in technology: it
also required new social conditions of knowledge.

Photographic Dispatches

Visual documentation and the furnishing of pictorial evidence were central
to the evolution of the Tichborne story even before the relevant photographs
were presented at the Court of Chancery. In 1853, a twenty-three-year-old
aristocrat named Roger Charles Tichborne, heir to the Tichborne fortune, de-
parted England in a ship bound for South America. The young man's family,
after receiving correspondence from him for several months, stopped hearing
from him and later learned that he had died at sea on a ship from Rio de Ja-
neiro bound for New York City. The scant surviving material evidence of his
travels in South America included the letters that he had sent them and two
framed daguerreotype portrait photographs, mailed to his family from Santi-
ago weeks before he disappeared. Sir Roger's grieving mother, Lady Henrietta
Tichborne, whose hope that he had survived the shipwreck endured for years,
placed advertisements for Roger in a "Missing Persons" notice in the *Times*
in 1863, requesting any news about him. To the consternation of other family
members—but to the Dowager Lady Tichborne's delight—a man working as
a butcher in the small town of Wagga Wagga, Australia, eventually answered
the advert, claiming that he was the missing Sir Roger. After an exchange of
letters and eventually a photographic portrait of the butcher, Lady Tichborne
was sufficiently persuaded of his genuineness to pay for him, his wife, and
their infant daughter to sail to France to meet her in person. After they met in
Paris and she recognized him as her long-lost son, she died and, emboldened
by her support, the Claimant, as he became known, then pursued a property
inheritance claim against the Tichborne family in British courts, despite the
fact that his physical appearance, lack of education, and other factors caused
many to question his authenticity.

One of only two surviving portraits of the young Sir Roger, figure 2.2
shows the young Roger C. Tichborne as a young, thin, fashionably dressed

FIGURE 2.2. Daguerreotype of Sir Roger Tichborne from a sitting in Santiago, 1853. National Records Archive CN 28-195.

man wearing a rather bored expression, his hat pulled low on his brow. Taken in a commercial photography studio in Santiago, Chile, in 1853, shortly before he went missing, it later provided a significant clue for comparison with photos of the man who later claimed his identity.

Historian Geoffrey Batchen remarks on the function of family portraits as mementos and signifiers of the presence of those absent.[3] In the particular case of the 1853 Chilean daguerreotype, its significance rests also in the larger story of expanded transportation, commercial, and communication

networks: developments that were broadening the form and function of so-
cial relationships and also attenuating them, such that this eventually became
a case both of remembering and of forgetting. In the young Tichborne's case,
the photograph served both as a memento and as a method of proof to his
family that he had landed in South America. As he makes clear in his letter
that accompanied the daguerreotype, he also intended for it to give his fam-
ily visual proof of his health and vigor: positive effects, he suggested, of his
South American travels. Depressed over a love affair with his cousin that had
been interrupted by his uncle and aunt and fearing that their disapproval was
partly due to his poor health, he wrote his aunt in a letter that described to
her what, to him, was the important feature of the photograph, namely his
suntan, acquired in vigorous mountain walks.

Just as the young Tichborne turned to portrait photography as a means for
showing a new aspect of himself to his family back in England, the Claimant
and his agents in Australia also used photography to communicate with the
same family, in support of his claim of a direct familial tie. Figure 2.3 shows a
large, middle-aged man in rumpled clothes, leaning against a rude fence. Made
in a photographic studio in Wagga Wagga, Australia, the photograph shows
the Claimant around the time that he answered the London advertisement. A
little over ten years after she had received her son's daguerreotype from South
America, Lady Tichborne opened another letter, with this print in the mail,
furnishing evidence of the Claimant's appearance.

Was this act an exchange of a family portrait, or an attempt at fraud? After
the Claimant and his family moved to Europe, speculation spread that he was
not the Tichborne heir but rather a working-class man named Arthur Orton
from a family of ship victuallers who had grown up in Wapping around the
London docks and later emigrated to Australia. Friends and lawyers for the
Claimant seized on the photographic evidence almost immediately to defend
his petition. Dispatching copies of his portrait by mail to friends and family,
the Claimant's lawyers hoped to establish both that a photo of his was not a
portrait of Orton and (even better) that the more recent photograph was a
plausible likeness of Tichborne (only older and stockier). They also mailed re-
productions of his photo to people who were known to have met Roger in
South America during his time there in 1853, such as tavern keepers and fellow
travelers. The Wagga Wagga and Sydney photographs and other photographs
that the Claimant later sat for in Paris and London not only served to press
his claim with the Tichborne family; they also served as protection for him
against others who, hearing of the discovery, might come forward to the fam-
ily and impersonate him.[4] They also, however, opened his identity to wider
public scrutiny in a new age of mechanical reproduction.

FIGURE 2.3. Close up of the Wagga Wagga photograph. 72A04/E1/1 (Hampshire Record Office, Winchester).

Photographic communication in the age before jet travel and the Internet entailed numerous disappointments and challenges, yet as the Tichborne affair shows, people went to the trouble of mailing photographs around the world because they thought photographs particularly valuable for awakening individual memories.[5] As the highly publicized case went on to illustrate for thousands of observers, photography was not only used by the state to discipline its citizens, as it certainly was in these early days of police uses of photography; it also could be used by members of the working poor, as in this case, to seek new destinies. Photographic proof and its assessment were

context-specific and, as John Tagg states, understanding photographs in historical terms requires a sense of "the time their meaning takes."[6] Over time, the photographs of the young Roger and the man who claimed to be him were circulated and reproduced for thousands to view and collect at home, in stark contrast to the majority of portrait photographs that never entered the public's eye or historical imagination.

Photography in the Witness Box

From the start, the two Tichborne trials tested the judicial system's processes for deciding disputed cases of personal identity using the still relatively new medium of photography.[7] The photo wallet shown in figure 2.4 was prepared especially for the court's use by lawyers and court-appointed special agents to gather testimony from eyewitnesses in Australia and South America. Each red leather photograph wallet held six cabinet-size photos of Tichborne and the Claimant. When folded out, the leather case measured 30.5″ × 7.5″; each portrait itself measured approximately 4″ × 5.5″.[8] Daguerreotypy not being a reproductive process, the original daguerreotype of young Tichborne was a unique specimen object; however, because it was possible by this time to make duplicates of it by making a photograph of the daguerreotype using new processes, prints were made and reproduced widely, as in the wallet (figure 2.5).

FIGURE 2.4. Red leather photo wallet used for gathering witness testimonies during the prosecution of the Chile and Australia commissions and in *Tichborne v. Lushington*. 72A04/E1/2 (Hampshire Record Office, Winchester).

The testimony gathered by the commissions using the photo wallet provides a rare historical window into the wide range of opinions on photographic and expert evidence being expressed around the time when photographs began, for the first time, to be regularly admitted as legal evidence.[9] In September 1868, the court ordered the appointment of a special commission to gather information from witnesses who either had known the young Roger in his youth, or who had encountered the man who claimed to be him in South America and Australia. This did not come cheaply: an estimated £4,000 (out of trial expenditures totaling at least £55,315) was expended for the Australia and Chile commissions alone, an amount that included £1,500 for the solicitation of "other witnesses, agents, printing, etc."[10] The commission agents met first in Chile, holding a series of cross-examinations in Melipilla, Santiago, and Valparaiso from early December 1868 through early January 1869 before moving on to Australia in order to examine witnesses in Melbourne, Wagga Wagga, and Hobart Town.[11]

The construction of the photo wallet containing Tichborne photographs as a legal exhibit demonstrates how a portable photographic archive became integral to the legal process of gathering evidence and testimony outside the physical space of the courtroom. The commission agents and lawyers for both sides asked each witness who came before them a series of questions. People from all walks of life possessing knowledge about Tichborne and the Claimant provided testimony to the commission agents before the first

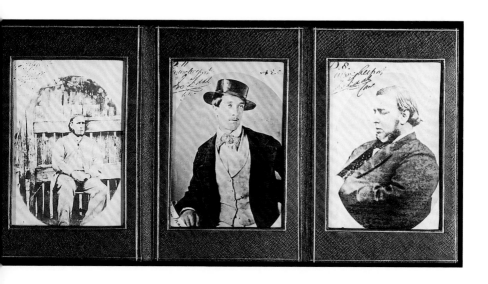

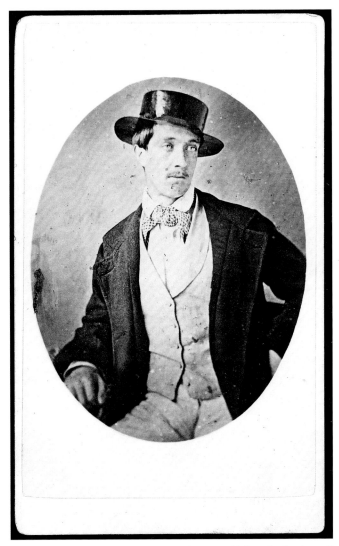

FIGURE 2.5. Paper copy of the Chile daguerreotype of 1853, very likely made after the trial had begun, c. 1871. 72A04/E1/4/2/1 (Hampshire Record Office, Winchester).

trial: from young gentleman aristocrats who had served in the Sixth Dragoons in Ireland with the young Tichborne when he was twenty years old, to sailors, bricklayers, domestic servants, publicans, printers, architects, agricultural laborers, gardeners, police, and Australian shepherds. All potentially had clues that would crack the case and establish the Claimant either as the genuine heir or unveil him as an opportunistic impostor.[12] Collectively, this body of testimony provides evidence of the "affecting presence" of pho-

tography; that is, how the same photograph (for example, the Santiago daguerreotype of Tichborne or the Parisian studio portrait of the Claimant)
moved people in different ways: from expressions of loss and bereavement, to
laughter and declarations of skepticism, of technical skill, and of memories
of the past.[13] Many of the individuals who testified before the Australia and
Chile commissions left few if any other material traces about their lives and
work. Their recorded narratives thus provide a unique documentary record
of the life and working conditions of ordinary people, mostly English emigrants, in Australia and Chile. It also provides rare Victorian documentation
of the attitudes of people from an extremely wide cross-section to the new
technology of photography, what they considered trustworthy and what they
did not.

Among the people the commission agents and lawyers interviewed in
Chile was one group that I want to especially highlight for our project in this
book: photographic artists. Photographers became leading witnesses for both
sides due to their expertise in how photographs were made and materially
reproduced by the use of different techniques. One such witness was Thomas C.
Helsby, an English photographer from Liverpool who had immigrated to Chile
and established a commercial studio in Santiago sometime during the 1840s,
and who took the portrait of Roger that later became famous. Years later, called
as a witness to the trial of his former sitter, Helsby verified making both the
original daguerreotype and a duplicate of it by means of a separate photographic process: Helsby replied that he could verify the daguerreotype he had
made by the "class of frame."[14]

Around the same time, the commissioners also interviewed the Sydney-
based commercial studio photographer Barcroft Capel Boake who, after being
shown the photograph labeled "D17," responded, "This is a photograph copy
of that profile likeness; it is printed from the negative taken at the time, and
which I preserved; it was printed by me last week from the negative; I gave
him some copies of D17; I still have the negative." When photo number D16
was shown him, he testified, "I know this likeness; it is my doing, it is a print
of the negative from which the prints were made that were given by me to Sir
Roger; the print was made last week; it is a likeness of the person who called
himself Sir Roger."[15] Reflecting concerns already being raised about possible
opportunities to tamper with the evidence before the photos were returned
safely to the court, each photograph used during the execution of the depositions was signed individually by the commission agents and the lawyers, as
well as by the photographer who made the photographic reproductions for the
wallets, John Edwin Mayall. We can think here of Michael Lynch's point about
the salience to legal processes of how evidence samples are collected at the

scene: containers signed by agents who handled them; paper trails designed to establish a "chain of custody."[16] Over time, the portrait photographs—so typical of those produced in this age—became identifiable as documents through processes of archiving (in the wallet) and markings (e.g., labels and signatures) that created an aura of authenticity in documents that could be mechanically reproduced. Elizabeth Edwards' idea of photographic "entropy"—that is, the desire to manage the losses associated with photography resulting, among other things, from material degradations or failure to classify properly—is particularly useful for thinking of how those circulating the photographs pretrial worked to secure their meanings as evidence.[17]

In the Tichborne trial, the display and reading of the case archive became intrinsic to the logic of interrogation through which the case was produced. Moreover, because so many witnesses and experts were called to testify, the Tichborne trial highlighted for all to see how photographs were used as evidence, including the variety of different factors, including agency and skill, that operated in the constitution of the photograph as a document. In fact, in 1871 and 1872, the years of the first trial, *Tichborne v. Lushington*, the handling of expert and visual evidence at the civil case before the Court of Common Pleas became a drama witnessed by thousands by virtue of the publication of court transcript verbatim in the *Times* and updates that appeared in newspapers around the world.

In this way, the sensational trial of the Tichborne Claimant also became a public trial of photographic documentation. Among hundreds of items of evidence presented and interpreted at the trial, photographs differed in being the only form of evidence on which everyone remotely involved with the case (and many who were not) both looked upon and rendered an opinion. In light of the multiple conceptions of photographs as both truth and artifice that circulated in the wider society, it was perhaps inevitable that opinions over the meaning and value of the Tichborne photographs would clash in the context of a courtroom trial, particularly one in which so many hundreds of witnesses participated and gave their opinions publicly. Unlike in many other trials of evidence, however, these issues had to somehow be resolved in the courtroom, where a judgment of guilt or innocence—and the fate of individuals and families—hung in the balance. Later in the century, judges gained more power and control over the processes by which circumstantial evidence was gathered and weighed before juries, in part as a direct result of this case. But particularly in the first trial, in which documents poured into Westminster from all directions, and where processes for handling them often seemed poised to undermine the judicial process entirely, the probity and

value of photographic evidence and the expertise of those most familiar with it was to be strenuously tested.

Photographic editors and readers felt they had a stake in how photographs (and by extension, photographers) were represented in the Tichborne trial and the commentary surrounding it.[18] The two leading national photographic journals, *The Photographic News* and the *British Journal of Photography*, addressed some of the most contested issues about the photographic evidence at the trial in their extensive, detailed coverage of the first Tichborne trial. The editor of *The Photographic News* suggested "calling in photographic experts in such cases" particularly when, as in this trial, both older and newer photographic technologies were being so closely scrutinized.[19] The court did, eventually, turn to photographic chemists as scientific expert witnesses to answer technical questions about the photos. The well-respected photographer Colonel Archibald Henry Stuart-Wortley's testimony was valued by both sides, for example, because he was knowledgeable both about the older daguerreotype process used for the original photograph of the young Roger as well as about the newer processes used for making prints and duplicates of the Claimant. Stuart-Wortley, a seasoned photographer, first took up photography in Africa in 1853 while serving in the army. He began exhibiting portraits and instantaneous seascape photographs in 1862, the same year he was elected as a member of the Photographic Society of London. About forty years of age at the time of the trial, he had received numerous prizes and awards for his landscapes and seascapes. He was a regular contributor of short articles to *The Photographic News* and *The Photographic Journal*, recognized by his scientific peers as the author of one of a number of innovative dry collodion processes in the 1860s.[20]

Reported widely in the national and photographic press, the colonel's testimony sheds light on perceptions of the social status of the photographer at this time and place as well as on what technical matters the court was unsure.[21] Stuart-Wortley was asked to provide testimony on subjects ranging from different exposure times to whether or not daguerreotypes could be manipulated, to whether or not daguerreotypes suffered from injury from exposure to air once that process had begun. He also answered questions about whether an experienced photographer could make corrections or copies based on the corrected photographs, whether this specimen had been taken from a corrected copy, and what made for a good photographic product.

For photographers such as Colonel Stuart-Wortley, the trial of the Tichborne Claimant was especially important, not because the Claimant's inheritance claim preyed on his mind, but because the highly visible public

controversy exposed divisions between skilled photographers and, more potentially damaging, put the faults of photography on public display. Much of the legal interest in the handling of photographic evidence presented during the trials was due to the fact that the Tichborne Trial took place before judicial strategies for handling the photographs had emerged in the courts later in the century. As Jennifer Mnookin explains in her important account of nineteenth-century legal attitudes toward demonstrative forms of evidence, two general sorts of attitudes governed late nineteenth-century legal discourses about photography. The first took photographs to be an especially privileged form of evidence, typically stressing one of two things: either the unmediated nature of photography (its ability to mechanically transcribe nature as if it were a process in which nature reproduced itself directly), or the unprecedented lifelike fidelity of the photograph. "If a difference exists between a photograph and an eye-witness testimony," asked one nineteenth-century legal expert, "should we not give the greater credence to the photograph, whose testimony, we know, is perfectly truthful and generally commensurate with the fact, while that of a vouching witness, and also of the witness to speak to the question of identity, may be mistaken or perjure"?[22] Understood in this way to be the outcome of a mechanical process, photography was constructed as the highest form of evidence, capable of offering uniquely objective knowledge of the world.[23] Yet a second legal attitude toward photography viewed the photographic image not as a mechanical and unmediated replication of nature but as an artificial and constructed representation of it. Here, too, people tended to arrive at this view from one of two positions: either that photography had certain inherent distortions, or human intervention played a significant role in the construction of the photographic image. As Mnookin explains, most nineteenth-century judges responded to the challenges presented by photography by declaring the new technology to be analogous to other forms of representation, such as diagrams, drawings and maps. This analogy in turn ushered in a "culture of construction" in the courtroom, in which the use of visual evidence (both mechanically made images and other kinds of visual depictions) grew in frequency and significance. Rather than diminishing the value of photographic evidence however, conceptualizing the photograph in terms of illustrative evidence invigorated the whole category of what is now known as "demonstrative evidence": a fact that perhaps helps to explain why, even today, demonstrative evidence still hovers awkwardly on the boundary between illustration and proof.[24]

Both perspectives on photography, and many others, were on display during the Tichborne Trial, a fact that doubtless contributed to the vehement

controversy over the significance and meaning of the photographic portraits. A contributor to a leading national photographic journal somewhat wearily explained it this way: "In the great Tichborne trial photography has played an unusually prominent part, and the value of photography as a means of identification has been the subject of amusingly varied, and for the most part, uncomplimentary opinions. Some witnesses confess themselves unable to see likenesses in photographs at all, and others hold their value for such purposes as very trifling indeed. Notwithstanding this professed low estimate on the part of witnesses and counsel, much is made at times to depend upon the evidence of camera pictures, and upon such occasions a lamentably imperfect acquaintance with their characteristics is frequently manifest."[25] While photographers never tired of emphasizing that the photographs must be seen in the context of the documenting skills of the photographic artist, for others this argument only served as a further reminder of the photograph's fallibility, its capacity for manipulation.

Popular Archives

Both before and after the Claimant's conviction, Victorian trial watchers stimulated demand for commercial photographs and engravings of this wildly popular hero, a man who remained one of the most celebrated and despised celebrities of his age. After the court found him guilty of imposture in the second trial, he was ordered to serve ten years of a fourteen-year sentence in a London prison: a reversal of the typical pattern where prisoners in London served time in Australia. From jail, he eventually published, in 1895, a famous "Confession," which he later recanted. Many of his supporters, meanwhile, continued to search for evidence, including photographs, that would give him his freedom.

This high level of popular interest in the man, and not just the trial, ensured that the conclusion of the trial did not mean the end of the wide dispersal of Tichborne documents. From the mid-1860s through the mid-1870s and beyond, through acts of physical markings and archiving (labels, captions, and incorporation into legal exhibits, such as the photo wallet) as well as through acts of looking at expert commentary and popular speech, individual portrait photos had been transformed from relatively private visual statements into public documentary evidence. Hundreds of photographs, engravings, and cartoons portraying the central figures and scenes from the sensational courtroom drama circulated in Victorian illustrated newspapers, periodicals, *cartes*, cabinets, and handbills.[26] One commentator described the scene that greeted passersby as they walked London streets:

Alongside Cheapside the busiest merchant intent on business and scheming to win thousands in the commercial world, would pause amid his industrious speculations, to gaze on the portraits of individuals prominently connected with the great trail. There in shop windows was exhibited the skill of the photographer in the production of countenances the world was anxious to behold. If you wandered to Madame Tussaud's and there gazed your fill on the life-like figures peopling the rooms of the old French lady, you beheld the Claimant modelled with artistic fidelity and commanding general notice and eager inspection.

At every street corner you could purchase half-a-dozen portraits and views connected with the case, warranted genuine, as the talkative purveyor eloquently informed you, and exhibiting his artistic treasures would give a description of each to his listeners, and obtain patronage from those inclined to encourage the efforts of the vendor to turn a penny by the case.[27]

Such was the dense reproduction of Tichborne-associated images in mass culture even before the trial began that, when the lawyers made their first appearance in court, a contemporary noted that "each was eagerly regarded and easily recognized through their familiar portraits, from shilling photographs down to the correct engravings in that artistic journal the *Police News*."[28] Some indication of the enduring interest in the case can still be seen today in the private collections of material and visual evidence of people who continued to collect Tichborne materials and to compile scrapbooks and albums containing *cartes* of the trial's central figures well into the early decades of the twentieth century.

People collected Tichborniana, among other reasons, because they believed that it would persist in British culture's collective memory: that it was a case for the future. As one astute commentator noted, "The first trial of the Claimant will remain permanently impressed on the common memory," for it would "be discussed in the remote future" and "remembered when centuries have elapsed."[29] As historian Raphael Samuel noted in his notable essay, "The Eye of History," history was recognized during the nineteenth century as something not belonging solely to experts but rather made by and belonging to ordinary people.[30] Indeed, the material survives today in large part because contemporaries thought it should be preserved for posterity.

What animated public interest in visual reproductions of the trial's central figures? Lynda Nead and Judith Walkowitz both have discussed how the Victorian taste for moral narratives extended to contests over popular, mass-produced pictorial representations.[31] The case may have also appealed to observers' appetite for solving mysteries themselves, by analyzing clues as to whether the Tichborne Claimant himself was genuine.[32] For photographers

𝔗𝔥𝔢 𝔣𝔬𝔩𝔩𝔬𝔴𝔦𝔫𝔤

PHOTOGRAPHS BY W. SAVAGE

Will be sent on receipt of Stamps or P. O. Order to W. SAVAGE,

Wykeham Studio, **WINCHESTER.**

No.			Post
1	A fine cabinet portrait of Sir Roger, the Claimant	2/- ...	2/1
2	Eleven Carte de visite portraits of Sir Roger, the Claimant—all different ...	1/- ...	1/1
	[These portraits were all taken from life, at Alresford, near Tichborne, by W. Savage.]		
3	A Carte de visite portrait of Mr. Roger Charles Tichborne, from a daguerreotype taken in South America	1/- ...	1/1
4	A Carte de visite portrait of the late Sir Alfred Tichborne, taken by W. Savage	1/- ...	1/1
5	A cabinet portrait of the late Dowager Lady Tichborne	2/- ...	2/1
6	A Carte de visite of ditto	1/- ...	1/1

FIGURE 2.6. Registry of Tichborne photographs for commercial sale by William Savage. 72A04/E6/1 (Hampshire Record Office, Winchester).

like the small tradesman William Savage, based in Winchester, near the Tichborne Estate, the trial presented an opportunity to boost his economic profits. Savage, who himself took one of the best-known studio photographs of the Tichborne Claimant at a sitting that probably took place at the Claimant's lodgings in Arlesford, reproduced several Tichborne photographs for commercial sale and mass circulation. These included the Paris photo,[33] the Wagga Wagga photo,[34] and other photos that, like many of his peers, he dutifully registered at the Stationers Hall (figure 2.6). Among the items for sale were "Eleven Carte de visite portraits of Sir Roger, the Claimant—all different" (£1); "A carte de visite portrait of Mr. Roger Charles Tichborne, from a daguerreotype taken in South America" (£1); "A Carte de visite portrait of the late Sir Alfred Tichborne, taken by W. Savage" (£1); and "A cabinet portrait of the late Dowager Lady Tichborne" (£2)."[35]

Various social interests were in play for participants in Tichborne visual culture. For the Claimant's many supporters, the trial was not settled to their satisfaction. They used photographs to help rally support for the disgraced Claimant after the end of the trial. One particularly notable example of this type of repurposing can be seen, for example, in the so-called "Tichborne Blended Photographs," created and circulated via an illustrated pamphlet. The "Tichborne Blended Photographs," a triptych of the Santiago and Claimant portraits overlaid with a metrical grid, is an early example of photo-anthropometric methods before the introduction of Bertillon techniques (figure 2.7). Its creator, William Mathews, a photographer, became convinced from reading about the trial in the papers that it would be possible to prove the Claimant's identity with Tichborne by measuring the diameter of the eyes and discovering whether any physical similarity persisted, despite other physical changes associated with

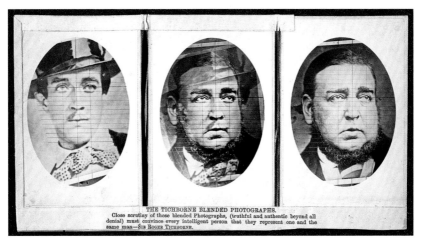

FIGURE 2.7. William S. Mathews, "Tichborne Blended Photograph," reproduced in William S. Mathews, *Admeasurement of Photographs, as Applied to the Case of Sir Roger Tichborne: Identity Verified by Geometry* (London, 1873). Courtesy of University College London (Galton Archives).

aging and overeating.[36] This image serves here as a reminder both of how the Tichborne visual evidence circulated far beyond the physical confines of the courtroom itself and of how wider social debates about heredity and environment informed contemporary understandings. (A copy exists today in the papers of Sir Francis Galton, pioneer of composite photographic portraiture and a leading founder of British eugenics and social statistics.) Among a host of other images, it attests to the existence of a popular archive of documentary visual materials and memorabilia that continued to be constituted as evidence long after the trial in which they were constituted as demonstrative evidence had itself ended.

By reading and vigorously debating the circumstantial evidence in the case, the trial's spectators were "speaking the law" in that, as in another famous "trial of the century" over a century later, the O. J. Simpson murder trial, "evidentiary documents and testimonial evidence were made available to the media audience, so that the progressive revelation of the open corpus of documents that made up 'the case' was a major part of the daily drama witnessed by millions of viewers."[37] Thus, although "photography in an age of movement" has come to refer to photographs that capture motion, an alternative meaning of that expression took hold in England and elsewhere during the mid-nineteenth century, ascribing significance to something that requires further historical investigation: how people from various walks of life recognize and respond to a changing world in which photographic documents and

other forms of visual evidence play an ever-expanding role. While the central archive therefore remains fruitful as a core paradigm for thinking about the stability, values, and cultural functions of documents, including photographs, new issues are being raised by recent studies of the traffic in the material forms of photographic communication. As Annette Kuhn and Kirsten Emiko McAllister explain in their introduction to *Locating Memory: Photographic Acts*, understanding how photographs resonate in cultures requires the study of photograph both in situ—where they are found in archives, private collections, and art galleries—and also as they "circulate intertextually and internationally across time and across multiple media."[38] Elizabeth Edwards has also noted in her pathbreaking work that the making, collection, and display of amateur and professional photographs throughout Britain and the British Empire were among the complex of practices through which photographs "both become meaningful and produce meaning themselves."[39]

The visual culture of the Tichborne trials also points us toward some too little studied aspects of documentary practice. It shows, for example, that documentary practices did not always reside in acts of making and archiving photographs alone. As photographs moved across various sites, they generated stories, from mass media narratives about criminality and the production of imaginative family genealogies to debates about social progress, biology, and adaptation.[40] While the Tichborne case is rather unique in that a single studio portrait entered the mass society and the public eye via courtroom procedures and illustrated press, it suggests more general conclusions, such as how domains of nineteenth-century photography often treated separately (such as the law, family life, and the popular culture of celebrity) intersected and interacted.

Conclusion

The use of photographs as visual evidence in the nineteenth century and beyond prompts us as historians and critics to think in new ways both about how photographic archives are themselves historically constituted and about the methods that we use to trace the passages, or movements, of photographs as they changed hands through time and space, particularly in the age before digital transmission.[41] In this essay I have suggested that in studying the history of photography's role as documentary evidence, we pay attention not only to the collection of photographs, but also to the mechanisms for their dispersal. As the Tichborne case suggests, the mid- to late-Victorian document economy consisted not only of an immense collection of documents circulating through

society; it also consisted of a chain of documentaries. Thus photographs in the era of the Tichborne trial were more than simply court documents; they provided what historian Raphael Samuel in another context called a "social form of knowledge." As key to understanding the time their meanings take, we need to grasp how those meanings are not constituted solely in the pictures themselves, but also in the acts of thoughtful looking.

Notes

1. For historical treatments of the trial see especially Rohan McWilliam, *The Tichborne Claimant: A Victorian Sensation* (London: Hambledon Continuum, 2007); Michael Roe, *Kenealy and the Tichborne Cause: A Study in Mid-Victorian Populism* (Melbourne: Melbourne University Press, 1974); and Douglas Woodruff, *The Tichborne Claimant: A Victorian Mystery* (London: Farrar and Straus, 1957).

2. The phrase "documentary evidence" was invoked repeatedly at the trial. See, for example, 72A04/A1/1/1 (Hampshire Record Office). "Document" refers here to items furnishing proof, evidence, information, while "economy" denotes those activities related to the production and distribution of goods and services in a particular geographic region. My understanding of documentary culture owes much to anthropologist Deborah Poole's book, *Vision, Race, and Modernity: A Visual Economy of the Andean Image World* (Princeton: Princeton University Press, 1997). On the history of criminal photography, see esp. Richard Ireland, "The Felon and the Angel Copier: Criminal Identity and the Promise of Photography in Victorian England and Wales," in Louis A. Knafla, ed., *Policing and War in Europe, Criminal Justice History* (Westport, CT: Greenwood Press, 2002), 53–86; Allan Sekula, "The Body and the Archive," *October* 39 (Winter 1986): 3–64; and John Tagg, *The Burden of Representation: Essays on Photographies and Histories* (Minneapolis: University of Minnesota Press, 1993).

3. Geoffrey Batchen, *Forget Me Not: Photography and Remembrance* (Princeton: Princeton Architectural Press, 2004).

4. Letter from William Gibbes to Arthur Cubitt, 21 April 1866: "In order to provide against anything happening to him we are going to have several Photographs taken of him in different positions so that his relations may recognise him." Hampshire Record Office, 72A04/A1/1/2, p. 1511.

5. John Holmes to Pedro Castro, 1 September 1868: "By the mail of the first of May last I sent you a large photograph of Sir Roger Tichborne, and I cannot understand how it is you did not receive it. I now forward you by this mail another copy, which I hope will reach you safely." Hampshire Record Office, 72A04/A1/2/4, p. 139.

6. John Tagg, "Neither Fish Nor Flesh," *History and Theory* 48, no. 2 (December 2009): 77–81.

7. The two trials were *Tichborne v. Lushington*, a civil trial on the inheritance claim, followed closely by *Regina v. Castro*, a criminal trial alleging imposture.

8. Today, they are in the archives of the Hampshire Record Office, where they were deposited by one of the solicitors in the case.

9. For the wider context see Tal Golan, *Laws of Man and Laws of Nature: The History of Scientific Expert Testimony in England and America* (Cambridge: Harvard University Press, 2004); Golan, "History of Scientific Expert Testimony in the English Courtroom," *Science in Context* 12 (1999): 5–34; Jennifer Mnookin, "The Image of Truth: Photographic Evidence and the Power of Analogy," *Yale Journal of Law and the Humanities* (1998); and David Tait, "Rethinking the Role

of the Image in Justice: Visual Evidence and Science in the Trial Process," *Law, Probability, and Risk* 6, no. 1–4 (2007): 311–18.

10. Some expenses were unpaid, even as of 1874. See Hampshire Record Office, 72A04/B3.

11. See Hampshire Record Office, 72A04/A1/2/3, volume of printed papers, c. 1872, esp. pp. 1–7.

12. Hampshire Record Office, 72A04/A1/2/4.

13. For historiography of "affecting presence" of photographs see esp. Elspeth H. Brown and Thy Phu, eds., *Feeling Photography* (Durham: Duke University Press, 2014). On photographs as aids to memory, see especially Geoffrey Batchen, *Forget Me Not: Photography and Remembrance* (Princeton: Princeton Architectural Press, 2004).

14. Hampshire Record Office, 72A04/A1/2/4, p. 112.

15. Hampshire Record Office, 72A04/A1/2/3, p. 51.

16. Michael Lynch, "Archives in Formation: Privileged Spaces, Popular Archives, and Paper Trails," *History of the Human Sciences* 12:2 (May 1999): 65–87, quoted on 80.

17. Elizabeth Edwards, "Photography and the Material Performance of the Past," *History and Theory* 48 (December 2009): 130–50.

18. For more examples, see Jennifer G. Tucker, *Nature Exposed: Photography as Eyewitness in Victorian Science* (Baltimore: Johns Hopkins University Press, 2005).

19. "Photography in the Tichborne Case," *The Photographic News* (17 November 1871): 542.

20. For background see Katherine di Giulio, *Natural Variations: Photographs by Colonel Stuart-Wortley* (San Marino, CA: Huntington Library Press, 1994), and John Hannavy, *Encyclopedia of Nineteenth-Century Photography*, vol. 1, p. 13. See also Stuart-Wortley, "On Photography in Connection with Art," *The Photographic Journal* (15 October 1863): 365–68.

21. For more on Stuart-Wortley's cross-examination, see Hampshire Record Office, 72A04/A1/1/4 (4 December 1871–21 December 1871), pp. 3194–3215.

22. Mnookin, "The Image of Truth," 17.

23. For the longer cultural history of this ideal of "mechanical objectivity," see especially Lorraine Daston and Peter Galison, *Objectivity* (London: Zone, 2007).

24. Mnookin, "The Image of Truth," 58–62.

25. "Photography in the Tichborne Case," *The Photographic News* (17 November 1871): 542.

26. Interest in the case continues to the present day. The Australian novelist Marcus Clarke used elements of the Tichborne case in his *His Natural Life* (1874). The novelist Anthony Trollope wrote a lightly fictionalized account of the case, *Is He Popinjoy?* (1878). Mark Twain's *Following the Equator* (1897) contains a chapter about the Tichborne case. A 1924 play by Margaret Watts about the case was performed in London. The 1995 album *The Green Bicycle Case* by the Australian band the Lucksmiths contains a track titled "The Tichborne Claimant." The 1998 movie *The Tichborne Claimant* is loosely based on the case.

27. Edwin Drew, "The Tichborne Trial in London," pamphlet, inserted into scrapbook. Hampshire Record Office, 72A04/B3, pp. 4–7.

28. Hampshire Record Office, 72A04/B3, p. 4.

29. Drew, "The Tichborne Trial in London," pp. 4–5.

30. Raphael Samuel, "The Eye of History," in *Theatres of Memory: Past and Present in Contemporary Culture*, vol. 1 (London: Verso, 1996), 315–36.

31. Lynda Nead, *The Haunted Gallery: Painting, Photography, Film, c. 1900* (New Haven: Yale University Press, 2007); Judith Walkowitz, *City of Dreadful Delight: Narratives of Sexual Danger in Late-Victorian London* (Chicago: University of Chicago Press, 1992).

32. Carlo Ginzburg, *Clues, Myths, and the Historical Method* (Baltimore: Johns Hopkins University Press, 1992); Neal Harris, *Humbug: The Art of P. T. Barnum* (New York: Little, Brown, 1973).

33. The Paris portrait was reproduced (see back) by William Savage, Photographer, Winchester, price 1 shilling. See also handbill: "Copy of Portrait of Sir Roger Tichborne sent to George Orton at Singapore by his Sister with his Reply and Memorandum written on Carte de Visite" (price, 1 shilling), Hampshire Record Office, 72A04/C4/5.

34. Hampshire Record Office, 72A04/E6/1.

35. Hampshire Record Office, 72A04/E6/1.

36. William S. Mathews, *Admeasurement of Photographs, as Applied to the Case of Sir Roger Tichborne: Identity Verified by Geometry* (London, 1873).

37. Lynch, "Archives in Formation," 76.

38. Annette Kuhn and Kirsten Emiko McAllister, "Introduction," in Kuhn and McAllister, eds., *Locating Memory: Photographic Acts* (New York: Berghahn Books, 2006), 1.

39. Edwards, "Photography and the Material Performance of the Past," 136.

40. We might begin by expanding Bruno Latour's concept of the "chain of translation" to account for the nonlinear and often unpredictable movements of photographs that moved across several evidentiary domains at once. See Bruno Latour, *We Have Never Been Modern*, trans. Catherine Porter (New York, London: Harvester Wheatsheaf, 1993).

41. Bruno Latour, "Drawing Things Together," in Michael Lynch and Steve Woolgar, eds., *Representation in Scientific Practice* (Cambridge: MIT Press, 1990), 19–68; Elizabeth Edwards and Janice Hart, eds., *Photographs Objects Histories: On the Materiality of Images* (New York: Routledge, 2004); Poole, *Vision, Race, and Modernity*; Lorraine Daston, ed., *Biographies of Scientific Objects* (Chicago: University of Chicago Press, 2000).

The Colors of Evidence: Picturing the Past in Photography and Film

PETER GEIMER

> When I had seen my first colour film and left the cinema, I had a terrible experience—I saw the world as a coloured film.
>
> RUDOLF ARNHEIM

The practice of documenting the world through photography and film in the nineteenth and early twentieth centuries presents a curious dilemma. Photographic media rendered the world largely in black and white. In contrast to the colorful phenomena of nature or culture (and in contrast to the way we perceive them) photography produced a tonality of its own, a specific spectrum of black, white, and grey, or sometimes brown or violet, but never in immediate accordance with the natural appearance of things. At the same time photographs, and later films, were treated as documents, traces of the real, visual evidence or proof. How could it be that throughout the nineteenth century photographs were treated as documents, visual evidence, and traces of the real even though such a fundamental dimension of reality—color—was missing? And what happened when color detached itself from this monochromatic regime and promised to show things of the past as they really look?

History in Monochrome

In 1877 the French photographer Louis Ducos du Hauron presented a colored view of the city of Agen, a tricolor transparency mounted on paper and the first surviving color photograph of an outdoor scene. Twenty years later the American Frederic Eugene Ives produced colored stereo pictures by projecting black-and-white photographs through blue-violet, green, and red filters and superimposed the resulting glass positives in his "Chromoscope," a stereoscopic viewing device. Further experiments were made and the inauguration of color photography finally took place in 1907 when Auguste and Louis Lumière presented the autochrome, the first commercially available process for color photography.[1] These early color pictures differed fundamentally from

two other ways of bringing color to photography. In his *Some Account of the Art of Photogenic Drawing*, read before the Royal Society in January 1839, William Henry Fox Talbot described the remarkable range of color he had produced in his first photographic attempts, basically photograms of flowers and leaves:

> The images obtained in this manner are themselves white, but the ground upon which they display themselves is variously and pleasingly coloured. Such is the variety of which the process is capable, that by merely varying the proportions and some trifling details of manipulation, any of the following colours are readily attainable: Sky-blue, Yellow, Rose-colour, Brown, of various shades, Black. *Green* alone is absent from the list, with the exception of a dark shade of it, approaching to black. The blue-coloured variety has a very pleasing effect, somewhat like that produced by the Wedgwood-ware, which has white figures on a blue ground.[2]

Thus, the history of photography started in color. But Talbot's colorful depictions had no mimetic function since these "different shades of colour" did not correspond to things in the world but were abstract inscriptions of "different chemical compounds, or mixtures."[3] So although color was an integral part of photography right from the beginning, it was not part of its documentary status and the different applications of the new medium Talbot wanted to present: "portraits," "application to the microscope," representations of "architecture, landscape, and external Nature," "delineations of sculpture," or "copying of engravings."[4] One might even say that in these early specimens color undermined the mimetic function of photography since, instead of presenting a "picture of external nature," it referred to the nature and construction of the medium itself. If we consider Talbot's experiments as one practice of creating color in photography, albeit one that was not mimetic, then it would be possible to identify several other practices that brought color and photography together. Another way of adding color to black-and-white photographs was manual, consisting of painted additions to photography, often performed by artists. In contrast, Ducos de Hauron's view of Agen, Ives' stereographs of flowers, and the autochromes of Auguste and Louis Lumière offered colors that were produced within the technical process itself. Thus, color became an integral part of the photographic process whereas in the case of manual coloring it was a supplement, a kind of cosmetic overlay that could barely conceal the genuine character of black-and-white photography.

But these early color photographs of nineteenth- and twentieth-century emperors, landscapes, and events reveal a puzzling fact. Even though color photographs were supposed to give a broader and more detailed picture of

reality, to be "more natural," to more closely approach truth, the opposite
seems to be the case. Color photographs are strangers amidst the historical
archive of black-and-white photographs. They do not fit into our historical
imagination. Imagine the German Emperor Wilhelm II, with his large mous-
tache, in his highly decorated uniform and wearing his spiked helmet. Pre-
sumably, your inner eye presents the emperor in black and white, wearing
a black-and-white uniform and posing in a world without vivid colors. For
this is how we know Wilhelm II and his contemporaries from historic pho-
tographs—a black-and-white civilization in a black-and-white century. But
when Wilhelm entered the studio of the Neue Photographische Gesellschaft
(New Photographic Society) in Berlin in 1908, he was a colorful personality.
He wore a green jacket with black lapels, golden buttons, an orange sash, and
a pink flower. A photograph that shows him in this colorful dress was taken
in order to present a new patent for color photography to the public. A few
minutes later a second photograph was taken, this time with the emperor in
a red jacket.

In comparison with the usual black-and-white pictures, the two color pho-
tographs from 1908 have a surprising air of artificiality. Instead of discrediting
their black-and-white companions, the early color photographs seem them-
selves ambivalent and unnatural. They seem "too early," somehow "false," sur-
real, even anachronistic as if color did not really belong to the familiar subject
in the picture and was an afterthought or some sort of foreign matter. The ear-
lier we encounter color in historic photographs the more obvious this strange-
ness becomes. Of course, nobody would deny that people in the nineteenth
and early twentieth centuries actually lived their lives in color. But our collec-
tive imagination of these past centuries is based on a visual archive in black
and white: Abraham Lincoln and General John A. McClernand posing before
a tent after the Civil War's first battle on northern soil in Antietam, Maryland
in October 1862; the executed Parisian communards in their cramped coffins
as André Rodolphe Disdéri captured them in 1871; the bleak trenches of World
War I; the exploding airship *Hindenburg* in Lakehurst, New Jersey, in 1937. The
visual evidence we have of these historic people and events is lodged in black-
and-white photography.

In 2004 the American journalist Paul Hendrickson described the same ex-
perience with regard to the famous Farm Security Administration (FSA) that
took up its activity in 1935 as part of the Resettlement Administration and
the New Deal policies of President Roosevelt. The idea of this large photo
campaign was to record American life and the ravages of the Depression on
the rural population. Photographers such as Dorothea Lange, Walker Evans,
Ben Shahn, and Russell Lee were invited to document the condition of the

land, the daily life of tenant farmers and migratory workers, their houses and belongings, their schools, churches, and stores. Hendrickson noted, "There is a powerful inclination for many Americans of a certain age, myself included, to believe that the Great Depression somehow existed in monochrome. [. . .] Those old gelatin-silver prints, made by a corps of sublimely gifted government photographers working for the New Deal, have become part of our national identity. It's as if they're stored, burned there, behind our collective retina."[5] Hendrickon's inclination to believe "that the Great Depression somehow existed in monochrome" obviously has to do with the testimonial character of photography. American life during the '30s is supposed to have happened in black and white *because* cameras fixed it in that way. Without presupposing that, as Roland Barthes put it, a photograph "always carries its referent with itself" and that they are "glued together," this belief would make no sense.[6] If photographs somehow "adhere" to the world they document and if they present this world in monochrome, then it follows that in former times reality must have been in black and white. Even though this conclusion contradicts any reasonable thinking or experience, it has an imaginative power of its own. Historic black-and-white photographs seem to "stain" our mental image of the past.

When Hendrickson referred to the photographs of the Farm Security Administration in 2004, color photography had become the dominant and undisputed standard of photographic representation. So he studied these monochromatic depictions of American history *in contrast* to the world of colored representations that dominated visual culture in his own time. Before I dwell on these different regimes of color in photographic and also filmic documentation I will take a look back at the nineteenth century when color photography did not exist—apart from some marginal exceptions that had little influence on the understanding of photography. How could it be that throughout the nineteenth century photographs were treated as documents, visual evidence, and traces of the real even though such a fundamental dimension of reality—color—was missing?

Where Have All the Colors Gone?

For almost a hundred years photography did well without reproducing color. Historians of photography have often ignored this peculiar fact in the dominant teleological success story. Photography, they claimed, progressed from long exposure times in early days to shutter speeds below 1/1000 second. It shrank from the clumsy camera obscura to an enormous variety of hand-

held, specialized cameras. In short, the histories progressed from deficiency to perfection, from limitation to exploration. The persistent absence of color does not fit into this picture of permanent progress. Some authors excused this deplorable lack—as if color photography had always been the final aim of nineteenth-century photographers, as if they had worked very hard to obtain colored pictures but had tragically failed. According to Brian Coe, curator of the Kodak Museum, nineteenth-century photography was driven by a "search for colour. From the introduction of the first photographic processes in 1839, the sense of wonder of many of those who saw the new 'light drawings' was tempered with disappointment that the colours of Nature, as well as its forms, were not recorded. In an attempt to remedy this deficiency, it soon became the practice to add colour to the monochrome photographs."[7] Coe rightly reminds us that coloring photographs by hand was a common practice even in the early days of photography. But this specific use should not be generalized and adapted to photography as such, to all the different uses and functions of nineteenth-century photography. This teleological perspective reduces nineteenth- and early twentieth-century photography to an *imperfect* enterprise, a space of mere deficiency. The same tendency is obvious in Pamela Roberts' monograph on the first hundred years of color photography. The author observes "a desire to photograph in color" throughout the nineteenth century and the first hundred years of photography are presented as an international "race" for color.[8] This teleological narration resembles the way art historians used to describe the invention and success of linear perspective—as if Alberti and Brunelleschi finally ended a long sad era of deficient pictures, freeing painting from its deplorable ignorance of linear perspective. It is obviously true that color—at least as humans experienced it in the visible spectrum—was *absent* in photography for almost one hundred years. But this absence does not necessarily mean that it *lacked*. This holds true both for the documentary status of black-and-white photographs and for their aesthetic quality.

In 1854 the French designer and photographer Adolphe Braun published his *Fleurs photographiées*, an album of carbon prints. For these prints Braun used fine coal or lampblack in order to produce a specific and quite unusual tonality. Although he intended his photographs to be models for industrial design studios, art critics soon validated them as autonomous works of art.[9] The use of coal and lampblack in the context of his *Fleurs photographiées* might seem unusual. For what could be associated more with a brilliant spectrum of colors than flowers? And where have all these colors gone on Braun's arrangements in black, white, grey, and brown? Braun's decision clearly shows

that he was not primarily interested in imitating nature. Instead of copying the natural appearance of flowers he *transferred* them into the specific visuality and tonality of photographs. This becomes very clear when compared to his Italian colleague Pietro Guidi, who colored a black-and-white photograph in order to imitate the natural appearance of grapes. Guidi's piece can be read as an allusion to Pliny and the famous anecdote according to which Zeuxis painted grapes in such a realistic manner that birds came along to pluck them. Guidi introduces color in order to compensate for a failure of photography, and in this respect he actually supports Coe's or Roberts' perspective. Photography failed to reproduce color, therefore photographers needed to look for supplementary techniques. Braun, on the other hand, insisted on a specific photographic tonality. In his photographs of flowers the absence of color is obvious—one might even say we perceive the absence of red, blue, yellow, violet, and green—but this absence marks no deficiency since the photograph offers a tonality of its own, a specific photographic regime of visuality. Thus, artistic photography made clear that the tonality of "black-and-white" photographs could be an intentional and positive quality instead of marking a deplorable lacuna.

For obvious reasons things change with regard to documentary or scientific photography. If a photograph is supposed to "document the world" it is puzzling that the world is colored whereas its early photographic depictions were monochrome. It is even more puzzling that this striking difference did not discredit photography from the outset. Some authors complained about the loss of color in photography but their objections did not dominate the field. On the contrary, it is quite remarkable how seldom these complaints were made and to what extent the first commentators tended to ignore the lack of color. In his famous *Pencil of Nature* (1844–46) Talbot gave a vivid description of the new medium that amounted to a programmatic report on its aesthetic and documentary power as well as instructions for its use. Talbot insisted on the natural origin of the pictures that "have been formed or depicted by optical and chemical means alone, and without the aid of any one acquainted with the art."[10] He stressed their "impartiality" and their richness of detail. He praised "the testimony of the imprinted paper" and its potential to be "evidence of a novel kind" in a court of law. He emphasized their revelatory power in preserving details that the operator himself did not recognize when taking the photograph. He imagined portrait galleries of "ancestors who lived a century ago," and he even speculated about photographing in the dark thanks to the ultraviolet part of the spectrum. This emphasis on the "the truth and reality of representation" is not at all diminished by the obvious elimination of color.

It is true that Talbot discussed the characteristic alterations that photography produced due to the irregular effect that different parts of the solar spectrum produced on sensitive paper. "Blue objects affect the sensitive paper almost as rapidly as white ones do. On the contrary, green rays act very feeble—an inconvenient circumstance, whenever green trees are to be represented in the same picture with buildings of a light hue, or with any other light coloured objects."[11] But these irregularities did not affect Talbot's insistence on the truthfulness and exactitude of photography.

Twenty years later the American physician and writer Oliver Wendell Holmes drew a similar picture. Holmes praised the art of "making a sheet of paper reflect images like a mirror and hold them as a picture" and, like Talbot, he highlighted the revelatory power of photography. "Theoretically, a perfect photograph is absolutely inexhaustible. In a picture you can find nothing which the artist has not seen before you; but in a perfect photograph there will be as many beauties lurking, unobserved, as there are flowers that blush unseen in forests and meadows."[12] Seen through a stereoscope and thus adding the illusion of three dimensions, these recordings seemed to be perfect equivalents of nature. In a utopian perspective, as it is characteristic for these early descriptions of new media and technologies, Holmes envisioned a future archive of sterescopic representations that would finally substitute for the material world.

> *Form is henceforth divorced from matter.* In fact, matter as a visible object is of no great use any longer, except as the mould on which form is shaped. Give us a few negatives of a thing worth seeing, taken from different points of view, and that is all we want of it. [...] Every conceivable object of Nature and Art will soon scale off its surface for us. [....] The consequence of this will soon be such an enormous collection of forms that they will have to be classified and arranged in vast libraries, as books are now. The time will come when a man who wishes to see any object, natural or artificial, will go to the Imperial, National, or City Stereographic Library and call for its skin or form, as he would for a book at any common library.[13]

Holmes' prospect is based on a remarkable belief in the truthfulness of photography that obviously overshot the mark. But again, it is striking that the evident loss of color in photography did not affect his utopia of duplicating the world in the future. When Holmes mentioned the monochrome appearance of photographs it counted as a negligible loss that could not harm the project. "We must, perhaps, sacrifice some luxury in the loss of color; but form and light are the great things."[14] So why did the eye-catching absence of

natural color not undermine the trust in photographic truth? Why did the insight in the troubling alterations of photographic color not prevent photographers and scientists from using them as documents?

One reason for this astonishing circumstance is the fact that photographs do not necessarily have to resemble their models in order to function as visual documents. Photography, more than any other visual medium, has often been described as a trace, impression, or index of the real. Like Talbot and other early nineteenth-century pioneers of photography, authors as different as Charles Sanders Peirce, Susan Sontag, Rudolf Arnheim, Roland Barthes, and Rosalind Krauss have considered how the photographic image differs from other traditional forms of visualization. Its special status seems to derive less from the photographic end product—the isolated, fixed picture—than from the technical process of its production.[15] Indeed, if we look at the end product, photography might be similar to painting (the same iconographic topics, similar composition, etc.). But if we look at the procedures and techniques that constitute them, they differ fundamentally. The aforementioned authors have sought, each in his or her own way, to identify the unique material link between object and image as the essence of photography. This understanding could do *without color*. Color photography never has been a necessary condition for the concept of the photographic trace nor did its absence in the nineteenth and early twentieth centuries discredit this concept. The paradigm of the trace, the imprint, the index was established on the basis of black-and-white photographs. This simple fact disproves a widespread misunderstanding in photographic theory, namely that the notion of indexicality necessarily presupposes that photographic pictures resemble the objects they represent. But photographs do not necessarily have to look like their models in order to count as a trace of something preexisting. The lack of color is no lack of reference. The patron of this argument is Roland Barthes. In his *Camera Lucida* Barthes insists on the testimonial character of photography and, at the same time, expresses his dislike for color photography.

> Perhaps it is because I am delighted (or depressed) to know that the thing of the past, by its immediate radiations (its luminances), has really touched the surface which in its turn my gaze will touch, that I am not very fond of Color. [. . .] I always feel (unimportant what actually occurs) that in the same way, color is a coating applied *later on* the original truth of the black-and-white-photograph. For me color is an artifice, a cosmetic (like the kind used to paint corpses). What matters to me is not the photograph's "life" (a purely ideological notion) but the certainty that the photographed body touches me with its own rays and not with a superadded light.[16]

There is no contradiction between his insistence on the testimonial character of photography and the lack of color.

Empathy

Against this background Hendrickson's inclination "to believe that the Great Depression somehow existed in monochrome" and became "stored, burned there, behind our collective retina" is nothing unusual. Hendrickson took the photographs of the FSA as historical documents and stressed their testimonial function. The documenting, he writes, "turned into a pictorial encyclopedia of America herself—a portrait not just of rural life, where so much erosion of land and spirit had taken place, but a portrait of millions of Americans going about their day-to-day living—sometimes joyfully, sometimes desperately—in mill towns and missing towns and mountain towns and huge urban centers."[17]

But when Hendrickson looked at this "pictorial encyclopedia," things had become much more complicated. Not only had color photography replaced the former black-and-white standard, but as it turned out color had entered the FSA photographs on their own territory and right from the beginning. In 1978 art historian Sally Stein discovered over 1,600 pictures of the Farm Security Administration that were taken in Kodachrome. In 1935, Kodak introduced the first continuous-tone color transparency film for motion picture cameras, following it one year later with slide film for still cameras. According to Hendrickson these early color photographs remained hidden because they were lost for years in the bureaucratic labyrinths of the Library of Congress and nobody seemed to have missed them. They did not turn up in the various publications of the FSA photographs in newspapers and magazines in the '30s. Interestingly enough, after Stein's discovery, they disappeared for a second time since no great public attention was paid to their resurrection, so that Hendrickson presents his book (and the corresponding exhibition) in 2004 as "a hopeful corrective."[18] But what kind of corrective could the unexpected occurrence of color offer when the collective memory worked in monochrome?

According to Hendrickson color photography allows for a deeper and much more detailed access to the past. He picks out one of the photographs.

It was taken in September 1941, by an FSA photographer named Jack Delano. The color is a little washed and faded with time, but *because* it exists in color, I think it can be argued that we are permitted to enter the image more fully, participate more immediately in its emotions and proffered pleasures. I am not trying to make any kind of blanket aesthetic statement here about the

efficacy of color vs. black-and-white-work. (If I had to choose, I'd probably still always go with black and white.) I am just talking about this photograph, one particular moment, some sixty-three-years ago, when time got stopped in a box, when we were given, in perpetuity, so to speak, five slightly dazed and charming and nameless children on their gay New England midway.[19]

Hendrickson once more expresses an old fascination for photography and its capacity to "stop time in a box," the "art of fixing a shadow," as Talbot put it.[20] In this respect color photography seems to mark an increase of immediacy and emotive participation in the past. "Because the image is in color, I think I am able to feel something in a deeper way about the very cotton of her dress, of all the dresses here, which I take to be homemade, sewn, each of them, by the same hand. [. . .] Color, too, in this instance, permits me—or so I believe—to get back in touch with the carnival freak-show glories of those state-fair midways."[21]

Hendrickson's "conversion" from black-and-white to color photography makes clear that perceiving these photographs is also a question of habit. For years Hendrickson was familiar with black-and-white photographs of the Depression but as soon as he became accustomed to the existence of the color photographs he accepted them as historical documents as well. Moreover, Hendrickson's case makes clear that the perception of black and white also depends on biographical coordinates. The inclination "to believe that the Great Depression somehow existed in monochrome" concerns, as he says, "many Americans of a certain age." Looking at black-and-white photographs might be another experience for people who actually lived at that time and kept a personal memory of it. In the end Hendrickson's statement remains quite undecided. "If I had to choose," he concludes, "I'd probably still always go with black and white." He figures, however, that in color photographs the past comes alive, allowing a greater proximity to the people and things represented in the photographs in a way that it does not in black and white. Color, says Hendrickson, allows us "to enter the image more fully, participate more immediately in its emotions and proffered pleasures." Even if Hendrickson himself fails to justify his notion of the different effect/affect and function of black-and-white and color photography systematically, there appear to be several underlying differences. Black and white stands for the testimonial character of photography, its relevance as a historical document and as a medium of collective memory. Color, in contrast, stands for the possibility of empathy with things past, and their emphatic ability to be rekindled. Thus black-and-white photography preserves the historical distance of the past, while color enables its appropriation and reanimation.

While Hendrickson attributes to color photography a greater approach-ability to past events, Barthes sees in it only the desperate attempt to bridge this irrevocable distance of the past. This is why in the previously quoted passage from *Camera Lucida*, color in photography is described as a "coating applied *later on* the original truth of the black-and-white-photograph," an "artifice, a cosmetic (like the kind used to paint corpses)."[22] For Barthes every photograph is a witness to death, because whatever it expresses is, in the isolated moment of exposure, stilled and archived. It is therefore a misunderstanding to assume, as is often done, that Barthes implies a cult of photographic immediacy and presence. For Barthes, photography is an emanation of reality, but an "emanation of *past reality*."[23] "The important thing is that the photograph possesses an evidential force, and that its testimony bears not on the object but on time."[24] It follows that a photograph sets no presence before our eyes, it neither preserves nor recalls. "What I see is not a memory, an imagination, a reconstitution, a piece of Maya, such as art lavishes upon us, but reality in a past state: at once the past and the real."[25] Barthes' insistence on the photographic characteristic of validation is then provided with a critical amendment, that the validation does not concern the presence of the depicted, but rather its qualities of being in the past. A photograph therefore does not keep the objects of its depiction alive for all time, but instead confirms its isolation and its death: it is an "image which produces death while trying to preserve life." In Barthes' view, this relationship would be mendaciously and synthetically painted over by the color of photography. While black-and-white photography reduces the depicted to the pure fact of its having been, color attempts to give a false sense of life to the deceased. "What matters to me is not the photographs' 'life' (a purely ideological notion) but the certainty that the photographed body touches me with its own rays and not with a superadded light."

Remarkably, Barthes, in his reflections on photography, not only wishes to assign photography an ontological purpose, but his book also begins with an acknowledgment of his own emotional involvement. "I have determined to be guided by the consciousness of my feelings."[26] It is well known that shortly after the death of his mother, it was a photograph of her as a five-year-old child that first compelled Barthes to write a treatise on photography. Thus is the dual meaning of "touch" that his text affirmed present—the bodily touch that in the moment of exposure leaves behind a photochemical "emanation" in the photochemical emulsion, and the emotion of the viewer, whose gaze at a later moment meets this emanation.[27] Despite the different meanings these two forms of touch have—in one case physical contact and in the other a form of empathy—Barthes runs these together in his text. As

previously quoted, he writes, "I am delighted (or depressed) to know that the thing of the past, by its immediate radiations (its luminances), has really touched the surface which in its turn my gaze will touch." Like Hendrickson, Barthes also emphasizes particular details like the clothing of those pictured in the description of his consternation. "I think I am able to feel something in a deeper way about the very cotton of her dress," wrote Hendrickson about the girl in the color photograph by Jack Delano. In Barthes' description of the photograph of his mother as a five-year-old, he similarly mentions "her hair, her skin, her dress, her gaze, *on that day*."[28] While Hendrickson links his empathy to the presence of the color, for Barthes the emotional impact of photography relies precisely on the "truth of black and white." Clearly this is not about which of the two authors is correct. The affect of photography will not be determined by argument, and each viewer has to decide whether he or she finds an empathetic entrance to photography easier in color or in black and white. What can be secured is that here two different regimes of representation are at work. One is reanimation, which color, based on its ability to approach the past, favors. The other is a historical witnessing of the truth that insists on the photographic confirmation of having been, and this confirmation relies on the "unadorned" tonality of the black-and-white image.

An opposition of black and white to color can also be made with a view of diverging conceptions of fidelity to reality. Here two ideal and typical positions may also be contrasted. According to Jeremy Adamson, chief of the Prints and Photographs Division of the Library of Congress, the color photographs of the FSA participate in a decisive shift in history: "a historic divide in visual representation—between the monochrome world of the premodern age and the brilliant hues of the present day." For Adamson, with Kodachrome "an unexpected advance in photographic technology" took place: "the ability to capture on film precisely what the eye saw through the viewfinder."[29] Adamson divides the teleological perspective described above, whereby the incidence of color marks a break that distinguishes modern and up-to-date color photographs from their still imperfect "premodern" ancestors. Moreover, Adamson's remark leads to a widespread metaphor that was at work throughout the nineteenth and early twentieth centuries: the concept of the photographic camera as an "artificial eye."[30] It corresponds to a theoretical understanding of optical media that treats them as extensions of the human body or as a substitution for it.[31] In this understanding the visual output of technical media is something familiar to us. We understand these media, for they are externalized doubles of ourselves. Thus, the photographic camera reveals what our eyes would have seen at the spot and if it "sees" and photographs the world in color, it comes closer to our own perception.

In his *Towards a Philosophy of Photography*, Vilém Flusser applied an opposing argument. According to Flusser, color photography is a great deal more foreign and artificial than photography in black and white because its photochemical underpinnings are more complex and abstract.

> Early photographs were black and white, unmistakably attesting to their origins as being abstracted from some theory of optics. With the progress of another theory, chemistry, color photographs became feasible. It appears as if early photographs had extracted color from the world, and that subsequent photographs were able to re-introduce color to the world. In fact, however, color photographs are at least as theoretical as black/white photographs. For example, the "green" of a photographed lawn is an image of the concept "green" as it occurs in some theory of chemistry (say, additive as opposed to subtractive color). The camera (or the film fed into it) is programmed to translate the concept 'green' into an image of 'green'. There is, however a very complex series of successive coding processes between the photographic green and the green "out there," a series which is more complex than the one linking the photographic gray of a black/white photograph with the green of the real lawn. The lawn photographed in color is a more abstract image than the lawn photographed in black-and-white. Color photographs are on a higher level of abstraction than black/white photographs.[32]

Like Barthes, Flusser also acknowledged that black-and-white photography had a greater verisimilitude than color. The rationale he gave, however, is quite the contrary; black and white is "truer" than color because it reveals in its material qualities the artificiality and origins from the theory of photochemistry more authentically than the apparently more natural and verisimilar color photograph. While Barthes grants a photographic image an actual testimonial character, Flusser sees in this relationship to the world just an effect of photochemistry. The more clearly the artificiality of these effects emerges, the "truer" the photograph.

> Black/white photographs are more concrete, and in this sense, are 'truer' than color photographs. Or the other way around: the "truer" the colors of a photograph become, the more mendacious they become. They hide their origins as theory more effectively.[33]

Flusser argues from the point of view of the camera. His striking conclusion, in which color photography is even further from the appearance of things than the black-and-white exposure, is as it were pronounced from the camera's point of view. However part of the conclusion is that the camera in fact has no "sight"—it neither sees nor perceives—but only acts physically and chemically. Where Adamson grants color photography "the ability to

capture on film precisely what the eye saw through the viewfinder," Flusser sees "a very complex series of successive coding processes" that does not correspond to human perception, but substitutes it with a technical artifact. If a greater proximity to pictured objects is seen in the colorfulness of this artifact than in black-and-white photography, according to Flusser it concerns only an apparent immediacy and verisimilitude that is overlaid by the technical nature of the transmission.

"Soldiers Bled Red"—Rhetorics of Immediacy

In the history of film a similar antagonism between color and black and white can be observed, which until now I have described only for the genealogy of photography. With the release of the first color film it was suddenly apparent how little color had been missed in the viewing of black-and-white films. In *Film as Art* Rudolf Arnheim notes:

> It is particularly remarkable that the absence of colors, which one would suppose to be a fundamental divergence from nature, should have been noticed so little before the color film called attention to it. The reduction of all colors to black and white, which does not leave even their brightness values untouched (the reds, for instance, may come too dark or too light, depending on the emulsion), very considerably modifies the picture of the actual world.[34]

Like Barthes had done for photography, in 1937 Siegfried Kracauer also described the entrance of color as an addition that did not bring film closer to reality, but quite the opposite, only gave rise to a disconcerting impression of artifice.

> The blue of the distant mountain range that appears on the screen arouses the fatal notion that nature is a brushed-on/painted-on blue, and the Sahara with the red sun over it is an oil print, it might be an imitation of Africa a hundred times poorer. Nothing but a play of colors, bearing the character of the villainous addition.[35]

According to Kracauer black-and-white film is already enough, the later "play of colors" do not add any substance to its capacity. "Why? Not from the testimony, that the black and white film—known via the many years of trusted acquaintance with it—without the benefit of color. It [black and white] had more tenderly conjured up the blue distance than is now possible through the interjection of Blue." So the color of things is not missing at all in black-and-white film. Rather, instead of being observably optical these colors "testified," which presumably means that the filmic black-and-white was

already inserted in the audience's imagination. At the moment it appeared on screen, the sudden "interference of Blue" could only appear to be a disturbing and unnecessary supplement.

During the period that Kracauer noted these thoughts down, Cavell reached back to a memory from his youth, one that he recounted in *The World Viewed*:

> In my early adolescence, about 1940, I was told by a man whose responses I cared about that he did not like movies to be in color because that made them unrealistic. Already a philosopher, I denied what I felt to be the validity of this remark and refuted it by pointing out that the real world is not in black and white, explaining further that this idea was only the result of having grown accustomed to the look of black and white films; I went on to prophesy that all films would eventually be made in color.[36]

The young Cavell claims that the degree of a film's realism can be assessed according to its visual similarity with the "real world." Now, because this world is undeniably colored, black-and-white film does not equal the verisimilitude of color film. The fact that it is nonetheless realistic is the mere effect of a long-term habituation that with the introduction of color film will gradually dissipate. But Cavell goes on:

> I now have an explanation of the truth of his idea, of my sense then of its truth. It is not merely that film colors were not accurate transcriptions of natural colors, nor that the stories shot in color were explicitly unrealistic. It was that film color masked the black and white axis of brilliance, and the drama of characters and contexts supported by it, along with our comprehensibility of personality and event were secured. Movies in color seemed unrealistic because they were undramatic.[37]

In this revision of his youthful essay, Cavell removes the emphasis of the argument. The realism of film in this essay relies then not only on the most perfect visual correspondence with the "real world." Dramatic composition belongs just as much to realistic representation.

Cavell reflects first on feature films that require a dramatic distribution of light and dark contrast in order to be effective; according to him, these apparently worked less well. It goes without saying that the question of the relationship of color and the "real world" changes when film (aside from its artificial and formal design) avows a documentary function. The question of whether a film shows events that have actually taken place arises in the case of the documentary and that of the movie with very different urgencies. Recent film studies point out that every film issued as a documentary had moments of fictionalizing, in active editing and montage. But many fictionalized history

films have moments of documentary, as noted by the French historian Marc Ferro: "The image of reality can be just as true in a document."[38] Ferro has in mind here Soviet feature films of the 1930s, which had historical information slipped in (for example, about the way shoes were manufactured in the Soviet Union in the 1930s), for the most part against the will of the filmmakers. "Documentary and fictional film," as Gertrud Koch described this polysemy of documentation and fiction, "are not in binary opposition, but lie on a scale that runs from the recording character of the camera to a complex montage of settings."[39] In conclusion I would like to discuss this relationship in an example of film documentation about the Second World War that shows how present the question of color is in precisely this context.

Since the beginning of the 1990s, aided by the dissolution of the Eastern Bloc countries, more and more color films from the First and Second World Wars have appeared in archives and private estates. Through the publication of these films, color entered the imaginary of the historical, which had until this point been primarily black and white. *Apocalypse—La 2ᵉ Guerre Mondiale*, a six-part television documentary by Daniel Costelle and Isabelle Clarke, perhaps set a new standard. It was aired in France in September 2009, and since then has received worldwide distribution. One first notices how the authors of the film explicitly avoid certain telegenic methods of animating the historical: They eschew reenactments, in which actors reconstruct historical incidents, as is now common in comparable documentaries. Nothing is shown that was not from the time of the Second World War. Secondly, they decline to use interviews with witnesses—first and foremost the pictures should speak for themselves. Thirdly, they forgo interviews with experts that are supposed to lend scientific credence to the material shown—the truth should come above all from the pictures. This directorial intervention, for which the series became known, was achieved through the dramatic staging of color. Nearly a quarter of the footage of the series is historical color footage; that is, film images that were shot in the '40s in Agfacolor or Technicolor. The vast majority of the footage is historical black-and-white material, which was digitally colored for the purpose of montage. French film specialist François Montpellier was entrusted with this task. "I give," said Montpellier, "the images their color back as realistically as possible. People didn't live in black and white."[40] David Royle, Smithsonian Channel's executive vice president for programming and production, shares this point of view. "World war was experienced in color. It wasn't fought in black and white. Soldiers bled red."[41]

This view is based on a peculiar logic. Montpellier's formulation, that he "gives the pictures their color back," suggests a false origin. Color is allegedly not added to the black-and-white images, it was simply *given back*, so the

claim goes, in a discrete act of restoration to the images' normal state. "During the Battle of Dunkirk in June 1940, the sky was an overwhelming Spring blue," claimed Montpellier, implying that the color of the world sixty years ago and the recolored black-and-white film of that world achieve perfect congruence. The two authors themselves argue similarly. "The decision to use color," says Isabelle Clarke, "opens up an additional historical dimension. But that also means that the colors must be accurate, so historians have helped. The uniforms of the Armed Forces are not the same in winter as in summer. They have changed over the course of the war. You have to show the wear and tear. For days we looked for green tint of the color Fieldgray. The color allows nuances, you discover new details. The color brought the war from the past into the present."[42] This logic of historical reconstruction is obvious. Like the young Cavell, the filmmakers assume that the world of the past was a world in color, and that a recolored version therefore re-creates the events more realistically than austere and more incomplete black-and-white film despite its historical transmission. And like Adamson in his consideration of the color photographs of the FSA, they assume that the color is able to reproduce the authentic original experience of the sitter. They opted for recoloring, "in order to show better how people experienced the war."[43]

Recalling Flusser's comment on the technologically mediated nature of color and its status as a recollection of a photochemical artifact, the questionable nature of this rhetoric of immediacy becomes clear. In contrast to the self-representation of the filmmakers, the colored sequences were aligned not to the original colors of the past (how would such an approximation with colors long since lost in the depths of history be possible?) but to the gamut of traditional color film stock. What is reconstituted in *Apocolypse* is not the color of events past, but the pale and restricted color palette of historical film. The problem with *Apocalypse* is not the intervention and manipulation. Without montage there would be no entry into the past. The problem is much more that this intervention is concealed insofar as the digital recoloring of the blue on the screen masquerades as the authentic blue of an April day in June 1943.

This example shows how much the function and practice of documentarians have changed since the days of the Farm Security Administration. The photographers of the Great Depression used color and black and white as two different possibilities of visual documentation. This also applies to the photography and film of the Second World War, which are handed down to us partly in color, partly in black and white. The authors of *Apocalypse*, on the other hand, set a new standard. Next to the possibilities of digital manufacture, the black and white of the historical documents appears deficient

and obsolete. The documents need to be "improved." Their black/white no longer counts as a signature of history, but as a technical failure that denies immediate access to past reality but that, thanks to today's technology, can be successfully corrected. What is also erased with the coloring of history is the realization that photography and film are not a restoration of the past, but evidence of its historicity. Documenting the past—in the *Apocalypse* sense—means configuring history in a new way, and claiming that only via this technical postproduction can history become what it actually once was.

Notes

1. For technical and historical details see Pamela Roberts, *A Century of Colour Photography from the Autochrome to the Digital Age* (London: Andre Deutsch, 2007), and Brian Coe, *Colour Photography: The First Hundred Years 1840–1940* (London: Ash and Grant, 1978).

2. William Henry Fox Talbot, *Some Account of the Art of Photogenic Drawing* (London: R. and J. E. Taylor, 1839), 5.

3. Talbot, "Some Account," 5.

4. Talbot, "Some Account."

5. Paul Hendrickson, "The Color of Memory," in *Bound for Glory: America in Color 1939–43*, ed. Deborah Aaronson (New York: Harry Abrams, 2002), 7.

6. Roland Barthes, *Camera Lucida: Reflections on Photography*, trans. Richard Howard (New York: Hill and Wang, 1981), 5–6.

7. Coe, *Colour Photography*, 8.

8. Roberts, *A Century of Colour Photography*, 12.

9. See Adolphe Braun, *Photographies de fleurs, à l'usage des fabriques de toiles peintes, papiers peints, soieries, porcelaines, etc.* (Paris: Mulhouse, 1855). See also Maureen C. O'Brian and Mary Bergstein, *Image and Enterprise: The Photographs of Adolphe Braun* (London: Thames and Hudson, 2000).

10. William Henry Fox Talbot, *Pencil of Nature* (1844–46), introduction by Beaumont Newhall (New York: Da Capo Press, 1968), no pagination.

11. Talbot, *Pencil of Nature*.

12. Oliver Wendell Holmes, "The Stereoscope and the Stereograph," *Atlantic Monthly* 3 (June 1859): 735, 744.

13. Holmes, "The Stereoscope," 748.

14. Holmes, "The Stereoscope," 748.

15. Charles Sanders Peirce: "A photograph [. . .] not only excites an image, has an appearance, but, owing to its optical connexion with the object, is evidence that that appearance corresponds to a reality"; Charles Sanders Peirce, *Collected Papers of Charles Sanders Peirce*, ed. Charles Hartshorne and Paul Weiss (Cambridge: Harvard University Press, 1931–58), vol. 4, paragraph 447, 359. Susan Sontag: A photograph "is also a trace, something directly stenciled off the real, like a footprint or a death mask," "a material vestige of its subject in a way that no painting can be," "the registering of an emanation"; in Susan Sontag, "The Image-World," *On Photography* (New York: Doubleday, 1990), 153–180, 154. Rudolf Arnheim: "The physical objects themselves imprint their image by means of the optical and chemical action of light"; in Rudolf Arnheim, "On the Nature of Photography," *New Essays on the Psychology of Art* (Berkeley:

University of California Press, 1986), 108. Roland Barthes: "The photograph is literally an emana-
tion of the referent. From a real body, which was there, proceed radiations which ultimately touch
me, who am here"; in Roland Barthes, *Camera Lucida*, 80–81. Rosalind Krauss claims that "pho-
tographs stand in a different procedural relationship to their referent than paintings, drawings
or other forms of representation"; they are "the ghostly traces of departed objects; they look like
footprints in sand, or marks that have been left in dust." And she adds, "Every photograph is the
result of a physical imprint transferred by light reflections onto a sensitive surface." Rosalind E.
Krauss, "Notes on the Index: Part I," *The Originality of the Avant-Garde and Other Modernist
Myths* (Cambridge: MIT Press, 1985), 203.

16. Barthes, *Camera Lucida*, 81.

17. Hendrickson, "The Color of Memory," 7.

18. Hendrickson, "The Color of Memory," 14.

19. Hendrickson, "The Color of Memory," 10.

20. Talbot, "Some Account," 201.

21. Hendrickson, "The Color of Memory," 10.

22. Barthes, *Camera Lucida*, 81.

23. Barthes, *Camera Lucida*, 88.

24. Barthes, *Camera Lucida*, 88–89.

25. Barthes, *Camera Lucida*, 82.

26. Barthes, *Camera Lucida*, 10.

27. The physical and chemical details of this transfer are not of interest to Barthes. Like
Talbot and other pioneers of photography in the nineteenth century, Barthes considered pho-
tography to be a magical process: "an emanation of *past reality*: a *magic*, not an art." Barthes,
Camera Lucida, 88.

28. Barthes, *Camera Lucida*, 82.

29. Jeremy Adamson, "Kodachrome: The New Age of Color," in *Bound for Glory*, 190.

30. This concept has been at work since the early days of the medium. In a letter to his
brother, Nicéphore Niépce refered to his early photographic specimen as "retinas," a few years
later Jean Baptiste Biot called Daguerre's invention an "artificial retina," and Talbot in his *Pencil
of Nature* says, "The Camera [. . .] may be said to make a picture of whatever it sees. The object
glass is the eye of the instrument—the sensitive paper may be compared to the retina."

31. In the Anglo-American context this tradition found its most prominent voice in Mar-
shall McLuhan's *Understanding Media: The Extensions of Man* (New York: McGraw-Hill, 1964):
"All media are extensions of our own bodies and senses," 116.

32. Vilém Flusser, *Towards a Philosophy of Photography* (London: Reaktion, 2000), 43–44.

33. Flusser, *Philosophy*, 44.

34. Rudolph Arnheim, *Film as Art* (Berkeley: University of California Press, 1957), 14–15.

35. Siegfried Kracauer, "Zur Ästhetik des Farbenfilms," in *Kino*, ed. Siegfried Kracauer
(Frankfurt am Main: Suhrkamp, 1974), 48.

36. Stanley Cavell, *The World Viewed: Reflections on the Ontology of Film* (Cambridge: Har-
vard University Press, 1979), 90–91.

37. Cavell, *World Viewed*, 91.

38. Marc Ferro, *Cinéma et Histoire* (Paris: Folio, 1993), 75.

39. Gertrud Koch, "Nachstellungen—Film und historisches Moment," in *Die Gegenwart
der Vergangenheit: Dokumentarfilm, Fernsehen und Geschichte*, ed. Eva Hohenberger and Judith
Keilbach (Berlin: Vorwerk 8: 2003), 229.

40. See http://www.lexpress.fr/culture/tele/comment-apocalypse-a-redonne-des-couleurs -a-la-guerre_784414.html.

41. As quoted in Ralph Blumenthal, "Film From the Frontlines: New Glimpses of a War," *New York Times*, Tuesday, 9 November 2009, p. C1; see http://www.nytimes.com/2009/11/10/arts /television/10war.html?_r=0.

42. Isabelle Clarke and Daniel Costelle, "Macht Farbe den Krieg verständlicher?," in *Frankfurter Allgemeine Zeitung*, 13 March 2010, 6.

43. Clarke and Costelle, "Macht Farbe den Krieg verständlicher?," 6.

Mars in the Making: Digital Documentary Practices in Contemporary Planetary Science

JANET VERTESI

Planetary scientist Sam Barton vividly recalls the day in 1985 when he received his subscription copy of the *Whole Earth Review* with a picture of San Francisco swarmed by flying saucers on the front cover. "The headline read, The end of photography as evidence of anything," he laughs. "It was all about of course this new application that a company called Adobe was developing called Photoshop, and they illustrated how fast and trivially easy it was to make pictures of anything . . . [such that] unless someone handed you really a negative of something you shouldn't trust it [photography] any longer."[1] Sam found *Whole Earth*'s headline ironic because he believed that digital photography, with its ease of image manipulation, had transformed his own field from one of speculation into "science." In his account, planetary scientists before digital photographs had relied upon photographs taken by spacecraft equipped with vidicon tube cameras, in combination with the experiential techniques of photogeological interpretation, to develop their hypotheses about planetary surfaces, processes, and formation. But once spacecraft were equipped with CCD cameras and other digital recording devices, former practices appeared not only out of date, but simply untrustworthy in comparison: Sam retrospectively called them "looking at pictures and making up stories." In contrast, the acts of composing, combining, and manipulating digital image files became the new standard of visual evidence in the exploration of the planets. What made these digital documents trustworthy was precisely their manipulation.

This essay examines the practices of making an image into a scientific document, especially as these practices are intimately associated with the trustworthiness of instruments, observers, and visual techniques. The contemporary case demonstrates parallels with and departures from historical studies in

scientific photography. For Sam's field at least, computational manipulation eases some anxieties in producing and documenting our knowledge of alien worlds, but at the same time causes others to arise. Which practices imbue images with documentary status and which do not? And what traces of these documentary practices remain embedded in the image in its final form? I will explore these questions through a case study of digital image processing in contemporary planetary science.

Going Digital

Digital modes of work provide an outstanding site for exploring such questions. First, the work of digital image processing is the work of image manipulation. Practitioners' techniques and software suites transform images in a variety of ways so as to see otherwise invisible details and features in the depicted object in the field. But the very fact of their malleability leaves such images open to suspicion. If images can be manipulated at will, what is to stop them from being "evidence of anything"? Haunted by the ghosts of nineteenth-century photography,[2] the status of the photographic image as document is once again at stake.

Previous eras resolved the questions of photographic status through appeals to the inert mechanical eye of the camera, sometimes tamed through its operator's disciplined hand or experienced eye.[3] Digital images too possess a dual appeal to objectivity in their mechanical acquisition by distant robotic explorers and their trained scientific handlers on Earth. But this mixed mode of operations could give rise to contradictory accounts of intervention. Do digital photos of the planets record a mechanical vision or a human one? And what moralities of observation ought to govern them?[4] Such questions speak to the continuing trajectory of the photograph as document within digital cultures of scientific production.

Turning our attention to a contemporary case study does not only suggest we revisit old questions in a new setting. It also enables us to bring new tools to bear on old questions in the history of science and visual culture. The value of examining contemporary practices is in foregrounding the very activities that are often invisible from the point of view of the archive. Witnessing what scientists do with visual materials—even digital ones—can enhance our understanding of how images become documents: now, and in other times and places. It can reveal the mundane and everyday activities that make images meaningful such that they exert indexical relationships with objects in the world, crafting those objects in the process: what Coulter and Parsons call "the praxiology of perception."[5] It can bring materiality very much to the fore

in a study of such awkwardly material documents as digital images: doubly ephemeral due to their status as images and to the apparent tracelessness of their computational interactions.

Tracing "the document" in its nascent stages—before it becomes archival—reveals the rich practices required to compose these artifacts. Document making with digital materials enrolls both the manipulations necessary to disambiguate the image and highlight and see new things; and the work of constraining those manipulations and manipulators such that the scientific community considers them trustworthy. As I will show, the resulting digital document always carries with it traces of the documentary: of its moment as a document-in-the-making. This contemporary focus, then, offers novel opportunities for the historiography of the image as document.

Contemporary studies, however, demand different methods. My methods and materials are drawn from a laboratory ethnography: a classic practice in science and technology studies involving qualitative sociological fieldwork among a community of scientific practitioners.[6] My immersive ethnography took place in 2006–8 with the planetary science community, with particular focus on an active NASA mission that placed two robotic Rovers on Mars. My primary sources are laboratory observations: observing scientists at work with digital materials alone at their desks in institutions across the United States and Europe, and observing meetings and conferences in which the mission scientists presented the results of their work and outlined the next steps for the robots' exploration. I also conducted interviews with members of the team, and with others on orbital missions around Mars and other planets. I supplement my sociological work with archival research on cameras and image work in missions in the 1960s and 1970s, especially the Viking orbiters and landers launched in 1975. In each of these cases, my interest is in the practices of making digital photographs, taken by robotic observers on other planets, into images that acquire the trustworthy status of the document. To observe this process in action, we will follow "where the action is," first taking a seat at the scientist's desk.[7]

Making It "Pop Out"

Planetary scientist Ben Quinn sits at his desk at the US Geological Survey[8] offices in Flagstaff, Arizona, in front of two large screens. He peers closely at the display of a greyscale image of a rock photographed by a Rover at the edge of a sizeable Martian crater (figure 4.1). Ben suspects that the rock might be a piece of ejecta: a rock thrown outwards from the deep innards during the impact event that formed the crater. If this were the case, scientists could learn

FIGURE 4.1. Ejecta rock in single filter view, at edge of crater. Ethnographic photo.

about the oldest and deepest rocks exposed by the crater's formation without having to send the Rover over dangerous terrain down to the crater floor. The rock also appears to be encrusted with small concretions of the mineral hematite, usually formed with water. But are these embedded in the rock, part of its original material, or are they sitting on top of it, simply windblown into place from across the plain? If the rock is indeed ejecta, then such possibilities present different geological histories for the region. Ben has decided to use images from the Rover's stereo color cameras, the Panoramic Cameras (Pancams),[9] to explore these questions.

It is commonly noted that digital images are both pictorial and numerical, composed of pixel values that count the number of photons that hit the recording CCD plate.[10] But to what end are these visual and numerical features of the digital image put? In MRI brain scans, numerical values are statistically tabulated into visual forms, leading to a different status for both number and picture.[11] But for Ben, a planetary scientist, these two different aspects of the digital image present different ways of interacting with the image, to show otherwise invisible characteristics and features. To effect these visualizations, Ben uses color to distinguish between different elements in the scene.

While Martian minerals commonly appear red to the human eye, they reflect and absorb light differently in other wavelengths. So the Pancams were

built to include thirteen color filters that rotate in front of the camera lens; each can capture photons in various ranges of visible and near infrared light. As photons from the sun reflect off objects on Mars, they pass through the Rover's camera filters en route to the digital recording plate. The photographic plate tabulates the number of photons collected and compiles this into a pixel value, corresponding to the object's ability to reflect light in that wavelength range. Pixels can be viewed as individual numerical values, but it is also common to view them assembled in an image, with the values translating to display on a gradient from white (lots of photons) to black (none).

The Pancams frequently take three or more photographs of the same frame through multiple filters. This presents different filtered perspectives of the same objects. To produce color images, the image processing software acts much like older techniques of photographic composition. When three black-and-white images of the same object taken through different filters are combined in the software, their gradient changes to shades of red, green, and blue, producing a picture in vibrant color. The goal here is not, however, to see Mars as it would be seen by human eyes, with our particular and limited sensitivity to light. The scientific community considers such "true color" images better suited for public engagement than scientific investigation. Instead, scientists like Ben are interested in patterns of light absorption across different filter ranges, as these are considered to be diagnostic of mineralogical composition. Thus the goal is to align filters that display and even heighten that discrepancy between pixel values across frames. That discrepancy, or ratio between numerical values, is "expressed" as a variety of rainbow colors, and is the principle behind "false color" images.

Ben puts this to use in practice by asking the computer to show him aspects of Mars that the human eye cannot see but that the Rover's "eyes" can: the near infrared region spectrum of light. He loads the Pancam image processing software,[12] selects several different filtered frames from among the thirteen-filter set, and combines them until the image of the rock on his screen brightens. As Ben explains it, putting an image into false color allows the scientist to bring out new features in the image that are otherwise invisible in black and white or true color (figure 4.2). Comparing this second image with the prior view of the same rock, one notices instantly the contrast between the turquoise and orange hues corresponding to different parts of the image. When seen in false color, he exclaims, "a lot of these . . . rocks suddenly 'pop out' that weren't there before."[13]

In principle, false color images are composed through relatively simple photographic techniques that have been available since the nineteenth century. But some techniques are unique to digital processing. For example, when Ben

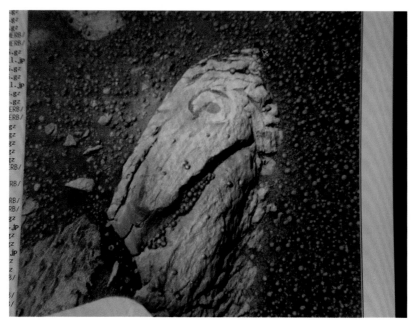

FIGURE 4.2. False color image of ejecta rock. Ethnographic photo.

heightens the contrast between the different filters in the component images, he creates a decorrelation stretch. "Stretching" here is a technical term that refers to increasing the level of contrast between pixels, roughly analogous to using the "contrast" tool on Photoshop. In a decorrelation stretch, the scientist increases the contrast in at least one of the combined filtered images by a particular factor, but does not necessarily apply the same factor to the other images in the combination, thus changing the "correlation" between the pixels across the image frames (figure 4.3). The third iteration of the image of this piece of ejecta is displayed in the garish colors typical of decorrelation stretches, which frequently elicit comparisons to the work of pop artist Andy Warhol.[14]

The purpose of using color, however, is to notice mineralogical distinctions in the Martian terrain. As Ben looks at his decorrelation stretch image of the rock, he exclaims, "If you look at it like this [stretched], wow! That's really a different color. Suddenly there's differences in what I thought were really the same [thing]." Indeed, the ground that was displayed in a single shade of turquoise in the false color view is now separated into pink and blue zones, speckled with yellow, indicating three different mineralogical compositions. Scientists across the mission frequently echoed this sentiment, repeatedly explaining to me that they used false color, decorrelation stretches, and other techniques "to see new things" or to make a hidden feature "pop out." That is,

while a rock might appear to be composed of homogeneous material in one image, combining different filters to produce different colored images of the same rock may help to discriminate between different units with different spectral characteristics. Once Ben can see this difference on his screen, he selects a small region of those pixels that "lit up" in a different color, sampling from the areas that once appeared orange, blue, pink, and yellow. His software then plots the spectral value of the selected pixels across each of the component frames of his digital composite, generating a graph that Ben uses to determine the rock's mineralogical composition (figure 4.4).

Ben credits his ability to see distinctions on the Martian surface to his digital work with the Pancam images. As he puts it:

> If you were walking around with your rock on Mars without Pancam you might not even know that these were different! . . . The ability to discriminate between these units is the real power of Pancam.

The observer here is far from passive, despite the mechanical camera on a robot and the inert computer display. Nor is the observer's ability to see or discern anything on Mars due simply to his "professional vision."[15] Instead, the techniques of remote observation are representational, interactive, iterative, and interventional. From a distance of millions of miles, Ben and his

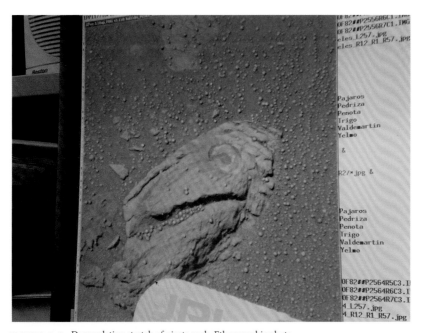

FIGURE 4.3. Decorrelation stretch of ejecta rock. Ethnographic photo.

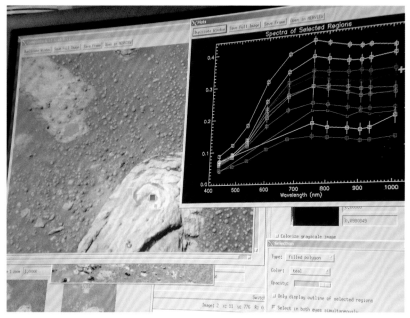

FIGURE 4.4. Diagnostic spectral graph of ejecta rock. Ethnographic photo.

colleagues use their image processing software to actively compose photo-graphs of Mars into something meaningful. As one of Ben's colleagues de-scribed her work, "We have all become what they call 'pixel-pushers' instead of field geologists."[16]

Ben's example displays a few examples of typical digital image manipula-tions. But it also reveals a source of anxiety about digital images. Ben jokingly refers to his work as "just simple data mining" or "goofing around to find stuff," but when does the "goofing around" end and the "science" begin? Mal-leability and combineability can be too-powerful affordances, leaving digital images open to suspicion as to which characteristics are "real" and which are due to a little too much processing. To limit the possibilities for interpreta-tion, then, planetary scientists deploy two additional strategies in their digi-tal image practice which they associate with the production of trustworthy documents: an appeal to mathematics, and an appeal to laboratory practice.

Visual Mathematics

Ross Glover's decorrelation stretches are legendary among the Rover scien-tists. They make even the slightest differences between geological units visible, and with their vivid Technicolor palette they are unmistakable when displayed

in mission science team meetings. When they heard I was studying images, many scientists helpfully suggested that I meet with Ross to learn how he produced such fascinating pictures. But when I arrived at his office and asked him to demonstrate his technique, Ross was perplexed. He opened a standard image processing program on his computer, loaded a set of images taken by the Pancams and said, "I just push this button." Upon clicking a built-in function, the Pancam images turned into a brilliant decorrelation stretch with the familiar colors that marked it as one of his own.

While I was at first disappointed that this unique production could be ascribed to a built-in software function, I quickly learned that for Ross, what was important was that the button initiated a coded script that applied a precise mathematical formula to the images he had selected. Thus, these images were not transformed or interpreted willy-nilly due to his artistic or aesthetic interventions. Instead they were precisely disciplined and maintained a persistent underlying mathematical integrity with respect to the original dataset. This emphasis on the mathematical recalls Michael Lynch's foundational work on the "externalized retina" with concomitant practices of selection and mathematization in scientific image making.[17] However, mathematics is not a value in and of itself: rather, because Ross' image composition was governed by a mathematical formula, it was replicable. His images' very status "as evidence of anything" depended on their ability to be precisely re-created at will by any other interested scientist.

Scientists across the mission repeatedly expressed to me that the virtue of replication made possible by adherence to underlying mathematics was one of the primary ways in which digital work accorded scientific status to their work. This is perhaps unsurprising given the professed importance of replication in the experimental sciences.[18] Just as in experimental practice, however, this appeal to replication does not mean that planetary scientists routinely replicate each other's image work as a way of fact-checking or confirming an experiment.[19] Actors instead invoke it as a "constraint" upon their visual interpretation, a nod to the discipline that binds both the object and the scientist through image-making techniques. Manipulated images can be replicated, planetary scientists explain, because they were created in the first place by a mathematical function applied to a range of numerical pixel values. If they cannot be replicated, then that is because the underlying mathematics has been tampered with in an unpredictable way—and the interpretative leap from the raw data observation to the manipulated image cannot be trusted as documentary.

Consistent with the commitment to mathematical reasoning, many digital image processing practices invoke mathematical expressions related to geometry, functions, integers, and operations. Pixels are added and subtracted,

FIGURE 4.5. Ross maps pixels in three-dimensional space to compute eigenvalues. Ethnographic photo.

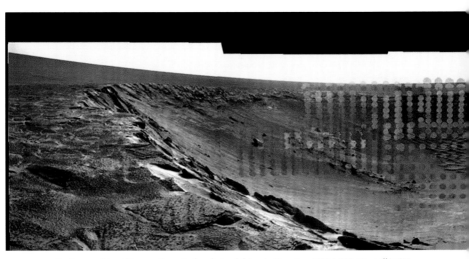

FIGURE 4.6. A co-registered image of spectral and visual datasets. Courtesy NASA/JPL/Cornell/ASU.

multiplied or divided, and may also be subject to complex equations or derivations. Ross frequently plots pixel values in three-dimensional graphic histograms, looking for clusters of dots on the graph that might identify mineralogical commonalities between parts of the visible image. These graphs may even be subject to further functions. Ross demonstrated to me how he used features of matrix algebra, eigenvalues, to compute vector relationships between pixel values, plotting and manipulating them in multidimensional space with his fingertips on his laptop touchpad (figure 4.5).

Ross and others also engaged in practices of "co-registration": overlaying a dataset from one instrument on top of another to glean relationships between, for example, spectral information and imagery (figure 4.6). Practically speaking, overlaying temperature data gleaned from thermal infrared spectrometers on top of visual data in black and white reveals how different areas retain heat, indicating that they might be morphologically or compositionally different. The commitment behind this practice is a belief that the datasets would not align were there no naturally existing mathematical correspondence between them; they would also not align neatly if this natural correspondence were to be irrevocably altered in the course of data manipulation. As one scientist explained, "You can't make a mosaic unless all your pieces are from the same puzzle." This practice thus reflects and supports a correspondence theory of representation.

These software techniques did not appear out of nowhere, but rather build upon longstanding practices in geological photographic interpretation

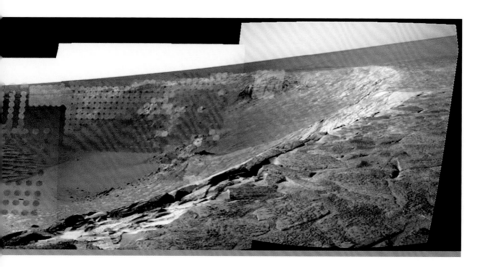

related to photogrammetry. As the name suggests, these practices aimed to quantify the qualitative aspects of photographic interpretation through application of measurement strategies. Tools like protractors and compasses, and techniques such as triangulation using stereoscopic aerial photographs, were once deployed to determine the heights, depths, and ultimately typologies of terrain features visible from flight or from orbit. The American Society of Photogrammetry continues to provide certification in these techniques as well as in those new digital counterparts. The professionalization of these practices speaks to the tension between qualitative visual experience, however well-informed, and reliable quantitative data.[20]

Other analog techniques deployed contour mapping to derive quantities from their visual data. For example, conducting a study of cloud cover on Mars in 1969, one telescopic observer at the Lowell Observatory in Flagstaff, Dr. William McKinney, began his observational work by placing successive sheets of clear plastic on top of Percival Lowell's albedo map of Mars, at the time the standard cartographic base map of the planet. The first layer of plastic superimposed a semitransparent grid over the map; on successive layers he noted, with tally marks at first and then with a final number, the number of days he observed cloudiness in that section of Mars over a period of several months. He then tallied these marks into numbers in the next layer of plastic, then laid a layer on top on which he drew contour lines around areas with similar numbers. These contour lines were eventually abstracted from the numerical data that was, quite literally, underneath them and published as the results of his observations (figure 4.7). While a laborious process, this technique ensured the ability to (quite literally) traceably derive quantitative data from qualitative observations and from there to synthesize that data into a schematized representational form.

These analog methods with visual materials present a rich heritage for digital practices. The tension between the experience, training, and visual acumen of the individual observer on the one hand and the fears of overinterpretation on the other are longstanding anxieties in this field. Building these quantitative techniques into software suites therefore crafts the image into a trustworthy document through the very process of its mathematical manipulation. This certainly illuminates Sam's statement at the outset of this chapter, revealing how the numerical aspect of digital images eclipsed former ways of mathematizing visual interpretation, making them appear untrustworthy by comparison.

But even as these image processing practices craft the image and imaged object into trustworthy photographic records, they also craft the scientist, restraining them only in those types of manipulations that can be mathemati-

FIGURE 4.7. William McKinney's plastic layover technique for computing visual values. Source: Mars Albedo Map, Lowell Observatory Archives. Author's photo.

cally described and therefore replicated. This is a familiar theme in the history and sociology of science. Work by Michael Lynch has deployed Foucault's language of discipline to describe how unruly objects are tamed into a visual field,[21] while Lorraine Daston and Peter Galison have described how this very work of disciplining objects into particular representational modes also disciplines scientist observers as well.[22] This practice continues in the digital era.

The imperative of individual discipline was especially evident in a conversation with Katie, a graduate student whose dissertation work involved computationally aligning orbital and Rover images of Mars across varied scales and visual modes. When I asked if she couldn't just combine the two datasets visually, "eyeballing" the result, she resisted:

> You really have to [do the comparison] mathematically, and it's much more scientifically rigorous to do it that way, anyway . . . Because if you look at two images and you say, oh these two look the same . . . it's hard to get that published . . . Scientists are like, "That's subjective! They might look the same to you but they might look completely different to somebody else!" Science has to be backed up by . . . statistically significant results in order to make sure that you're making the right interpretations.[23]

Note how Katie first associates the mathematical approach to her problem with being "scientifically rigorous." Despite extensive visual manipulation, an appeal to underlying mathematics can support her analysis as "the right interpretation." Further, not to take a mathematical approach is to risk failure in peer review and be held up to accusations of subjectivity. Katie's discussion of publication, peer evaluation, and rigor together invoke the practices of the responsible scientist, whose interpretations can be trusted and whom she hopes someday to become. Thus, the mathematical imperative enforced upon digital manipulation shapes the image processor's identity as a responsible scientist as well.

Analog Practices

So far in these examples, a particular picture of digital practice emerges that enrolls the creativity of visual manipulation to see new things on the one hand tempered with the restraints of mathematical reproducibility on the other. Yet, as in earlier examples of Martian imaging described by Peter Galison,[24] experience and judgment are also called into play to shape interpretation. This judgment is not necessarily honed through computational work, but through embodied copresent experience in environments like the ones under visual investigation. As one team member put it, "Bright kids can make computers sing and dance, now they have much better technical skills, but what they don't have is twenty-five years of being in the field."[25]

Given that at this writing no human being has yet set foot on Mars, "the field" has an intriguing status in planetary science. Maria Lane's study of late nineteenth- and early twentieth-century Martian observations notes the importance of "going into the field"; this largely consisted of parties of

astronomers traveling to remote sites from which to better view Mars through their telescopes due to the variations of atmospheric depth and opacity and light contamination from cities.[26] Later, in the mid-twentieth century, planetary scientists practiced geological field techniques such as geological mapping on Earth before they could apply their skills to extraterrestrial sites. Even today, a planetary scientist's training involves working with orbital images of Earth, drawing on them to identify particular types of terrain, stratigraphic layers, or mineral deposits, and then taking these orbital images into the field, walking carefully around the area on Earth to better understand how what is on the ground is seen from space. In a curious linguistic juxtaposition to digital image work, these terrestrial sites are called "Mars analogs."[27]

Analog sites on Earth are not meant to fully replicate or provide a simulated Martian environment. Instead, the language of analogy invokes another restriction upon the interpretation of digital image data, through an appeal to judgment honed in the field. For example, when one of the two Rovers returned images on a group of oddly textured cobbles, the science team referred constantly to Earth analogs in order to, as they put it, "constrain" their hypotheses about the cobbles' identity and mechanism of formation. One scientist, Nick, using the Rovers' onboard spectrometers, had identified high silica content in the cobbles. But it was unclear whether this silica was a coating or an internal component of the cobble. If it were internal, one could say that the cobble had been built up by silica deposited within a hot spring environment; if it were a coating, it might be a remnant of some transformation to the cobble's surface effected by steam or some other kind of hydrothermic system. The Rover was commanded to take Pancam filtered images as well as Microscopic Imager photographs of the cobbles to make their textures visible to the scientists.

Opening the discussion about these cobble images, Nick suggested that the silica had been deposited in the region and produced two possible hypotheses for the rocks' formation as "distinguishable from one another as a function of silica content as a function of depth." But his colleague interjected that the depth hypothesis was not necessarily "unique," claiming, "You can see in Hawaii for example, there are coatings of opal and silica that are sitting on top of [the grains that make up the rock]." That is, the grains that compose the rock could themselves be coated with silica, not just the exterior of the rock itself, and this would be indicative of yet another geological process. Another scientist agreed. "I have exactly that from Hawaii . . . where I scooped up sand and [examined it] under a microscope," to which another assented, "The Hawaiian silicon coating is a classic."[28] This talk about Hawaii is actually talk about Mars, providing the constraints for what the silica readings could

FIGURE 4.8. Susan's decorrelation stretches of Martian soil. Ethnographic photo.

mean. As the scientists followed up on this conversation, more Mars analogs were invoked. One scientist began making presentations about silica deposits she had examined in Yellowstone hot springs; yet another sent Nick several boxes of silica cobbles that he had personally collected in Hawaii and Nevada for laboratory analysis.

In this example, visual interpretation of the rock through Pancam and microscopic images is tempered with reference to terrestrial sites that might indicate under what conditions a silica-rich rock could be produced. Experiments and laboratory apparatus on Earth are also called upon to produce the right kind of experiential judgment to constrain visual interpretation.[29] Many Mars scientists maintain active analog laboratories alongside their digital laboratories that sport equipment from spectrometers to wet labs, pressure chambers to sandboxes to simulate Martian soil, even vats of cyanobacteria in rooftop greenhouses that simulate early planetary evolutionary environments. These are again used to "constrain" interpretations that rest upon Rover-acquired data alone. For example, one scientist, Susan, made several important discoveries about Martian soil by using Pancam image processing techniques. Like Ben's work with the ejecta rock, Susan's decorrelation stretches showed a distinction in the Martian soil; by transforming follow-up images in the same way, she noticed that the soil's chemistry was changing (figure 4.8). When

presenting her results to her colleagues, she balanced the display of her "pretty pictures"[30] and colorful decorrelation stretches with an appeal to mathematics, using histograms like Ross' to show clusters of pixel values, and graphs like Ben's to show mineralogical features. She then turned to laboratory work to, as she put it, "to be sure this change is real":

> We need to be sure this change is real, so I checked several factors . . . One possible change could be the dehydration of hydrous salts . . . I did an experiment starting with seven water ferric sulphate.[31]

The experimental results suggested that ferric sulphate could change, and determined under which conditions the results she saw in the Pancam spectra might be produced. Describing the experiment to me in a later interview, Susan called it "observation and laboratory experiment put together, and some common knowledge."[32]

In these cases, experiences with terrestrial materials can temper, suggest, support, or challenge hypotheses about Mars. Laboratory data and examples from the field are both invoked to discipline interpretation based on image manipulations. This was especially clear when Susan made a follow-up presentation a few months later, this time only presenting results from Pancam decorrelation stretches and spectral analysis. In the question period following her talk, her colleagues expressed skepticism about her results. Ross accused Susan of "overinterpreting," saying, "I know some of the spectra you're showing in the visible near-infrared had that pretty steep slope so those were obviously dust-affected." His challenge was rooted in his sense of the field environment. As he saw it, Susan was interpreting the Pancam filtered pixels without considering the practical field context in which the soils they depicted were embedded, such as which minerals would commonly be seen together and how much dust contamination the field site could imply. Fresh out of his own laboratory, where he had been analyzing box-loads of silica cobbles, Nick asked Susan, "Are there any lab data . . . that support or sort of suggest what that feature is attributable to?"[33] Such questions revealed a discomfort with appealing to the visible and the mathematical side of the image alone, without equal consideration given to the experience of Earth-based fieldwork.

Digital Documents-in-the-Making

So far, I have described a variety of practices related to the production of visual knowledge about Mars. Some of these practices are visual; others are mathematical. Some are produced through software suites, trained hands and eyes;

others require embodied, physical work in field sites far removed from digital sites. What do these practices suggest to those of us interested in documents-in-the-making, in the digital era and historically?

It is first worth noting that the digital image's very malleability is not only the source of its documentary anxiety, but also the source of its documentary potential. As in Ben's work with the ejecta rock, seeing with digital images is effected through representational intervention. Digital manipulation is a tool for seeing new things and making distinctions apparent in each transformation. As Mars is composed into false color, decorrelation stretches, and pixel graphs, new elements "pop out" or are subdued under the image processor's cursor, producing visual insight. This is not simply a question of a mechanical eye or the authority of judgment exerted upon photographic images. It is a question of composing images that in their very composition make previously invisible aspects visible. Such a consideration is especially obvious in the case of digital image processing, where photographic manipulation in order to see is a constant, iterative activity producing multiple simultaneous visions of the same features in the Martian terrain.[34] But given the strong heritage of digital work in preceding material practices, we are likely to find such purposeful compositional work at play in other times and places as well.

At the same time, the malleability of the image does produce anxieties as to its documentary status. In this contemporary case, we continue to see echoes of previous eras at play in the imposition of digital objectivity. A critical notion here, and likely the source of Sam Barton's faith in digital photographic evidence, is the actor's category: "constraints."[35] Signaling the "thou shalt nots" of digital image processing, "constraint" is the term that planetary scientists wield to identify those disciplinary and disciplining restrictions upon their interpretative work that compose both subjects and objects through visual practice. It therefore calls attention to their field's epistemological commitments in their knowledge-making practices: the precise "how" by which a manipulated image becomes a document.

I have so far discussed several kinds of actors' constraints that contribute to documents-in-the-making. On the one hand, actors appeal to disciplining the digital form of images into mathematical artifacts, subject to mathematical expressions, formulae, and transformations that can be digitally reproduced. This makes a claim to trustworthiness not through a passive mechanism, but through active adherence to statistical rigor that guarantees reproducibility of results. Another set of constraints that actors invoke are generated from field environments, used to eliminate impossible interpretations of pixels and spectra alone through an appeal to field experience on Earth. But as I have noted, the constraints that scientists associate with visual manipulation and

interpretation also constrain their own behavior. Here, recall Katie's commingling of digital image practice, constraints, subjectivity, rigor, and peer review. Sam, Katie, Nick, Ben, Susan, and Ross may work constantly with digital images, shaping them into meaningful representations of Mars, but they restrict themselves from making just any analytical, digital, or analogical move. Their self-restrictions are bound up in the implications of presenting claims to their community that could be considered methodologically suspect. Invoking constraints upon visual manipulation constrains the scientist as well.

Still, mathematics, fieldwork, and self-restraint do not a digital document make. Documenting in practice requires something more than the adequate disciplining of objects and subjects. The work of Bruno Latour on chains of inscriptions is suggestive in this regard. Latour's work on scientists in the Amazon describes how scientists make meaning out of their interactions with images and texts not in isolation, but as embedded within chains of association. Bringing inscriptions together into these chains not only builds associations between representations, or between a representation and "reality," but constructs the very frames of reference that give individual inscriptions meaning. Latour describes the importance of "traceability" in the composition and recomposition of this chain: as samples and observations move from object to inscription in a logbook, they allow others to "go back to each data point in order to reconstitute its history."[36] As documents change in their relation to each other over time, their meaning in the montage changes too.

This is historiographically suggestive, in the sense that opening up the process of document making for analysis—examining the practices of image craft—can reveal the missing links in the chain, otherwise subsumed into the final document. But perhaps unique to the digital era is that each step in the process is subsumed into the digital form of the final image. Images of Mars are quite literally drawn together: from composite filters, strings of software code that mathematically combine and transform pixels, human interventions, and interpretative moves informed by Earth-bound examples such as Yellowstone or laboratory-produced ferric sulphate. The resulting image contains all these elements within it, composed as it is through digital and analog techniques, but also through layering of successive transformations into a final whole.[37] The result may be a single image of ejecta rock, cobbles, or soil on Mars that is eventually circulated in scientific publications or stored in digital archives. But that digital image is itself composed through manipulation practices, incorporating their concomitant constraints, and assembling the entire inscriptional chain into a single meaningful viewing frame. The document contains elements of the documentary.

Conclusions

Although digital images are vulnerable to being cast as "evidence of anything," planetary scientists adopt a series of practices in both the analog and the digital domains to make sense of their robotic visions of Mars. Constraining the limitless domain of image manipulation delimits interpretative leaps and produces rigorous scientists in document production. But these practices also build meaning into the eventual document itself, such that the digital image contains the very chains of reference—the laboratory results, digital manipulations, mathematical transformations, and other practices—that give it meaning.[38] Ben's "goofing around to find stuff" through the manipulation of filters and ratios, Ross' decorrelation stretches, Nick's Hawaiian rocks, and Susan's experimental apparatus are all elements of the praxiology of perception, chained together in their visual production. Taken together, they construct visual knowledge about Mars and ensure the documentary status of the scientists' visual reports.

This digital case presents historiographical implications for documents-in-the-making. One is that attention to document-making practices can reveal the rich associative relationships that give images indexicality and mobility, meaning and status. If we were only to examine the outcome of the documentary process, those images archived on computers or released to the press, a wide range of practices would be invisible to the analyst. Examining images as documents-in-the-making, where their interpretation is far from stabilized, we may witness the blend of digital and analog practices in the manufacture of even single representations. In the midst of all this fluidity, malleability, and hybridity, we also witness the local anxieties about the nature of knowledge production that plague practitioners. Those particular factors that planetary scientists invoke as limitations upon or resources for their image interpretation say something important about how the community makes knowledge through visual work. Thus the production of knowledge by visual media continues to be fraught, regardless of whether it is digital or analog, still or moving, historical or contemporary.

Finally, document making requires examining more than just what image workers do and say about their visual production. Such practices do not exist in isolation. The analyst must move, with the scientist, away from the image maker's desk and out into the world. This can mean moving out into the associated sites of knowledge production that inform visual interpretation, such as the wet lab or the hot spring. Such work-in-the-world shapes the document as well, even as it puts documents to work in the field. But it also means a movement out into the wider community that equally shapes visual

production. For it is not only chemical analysis and mathematical formulae that suitably "constrained" Susan's digital manipulations and interpretations of Martian soil: interactions with Nick and Ross played a role as well. Placing images—digital or otherwise—into the rich context of their collective construction can reveal the widest variety of practices that transform a photograph from a record of a local site of knowledge production, into a document of this or any other world.

Acknowledgments

Many thanks to Lorraine Daston, Michael Gordin, Michael Lynch, Gregg Mitman, Trevor Pinch, Phoebe Sengers, Kelley Wilder, and the Documenting the World group for their invaluable comments on earlier drafts. Sincere thanks also to Antoinette Beiser at the Lowell Observatory Archives, to April Gage in the History Office at NASA Ames Research Center, and to the Mars Rover team for permitting my observations. This work was funded by an NSF Doctoral Dissertation Research Improvement Grant, and the NASA History Office—History of Science Society Fellowship in the History of Space Science, 2009–2010.

Notes

1. The quotes in this paragraph are taken from my interview with Sam, May 24, 2007. Consistent with sociological convention, all names herein are pseudonyms and all interview dates are cited. The article in question is Stewart Brand et al., "Digital Retouching: The End of Photography as Evidence of Anything," *Whole Earth Review* 47 (July 1998): 42–49.

2. Historians of photography will recognize the suspicious character of digital photographs as eerily reminiscent of nineteenth-century debates about photographic verisimilitude and trustworthiness; see especially Jennifer Tucker, "Photography as Witness, Detective, and Impostor: Visual Representation in Victorian Science," in *Victorian Science in Context*, ed. Bernard Lightman (Chicago: University of Chicago Press, 1997), 387–408.

3. Tucker, "Photography as Witness"; on mechanical objectivity versus an appeal to human judgment, see Lorraine Daston and Peter Galison, "The Image of Objectivity," *Representations* 40 (1992): 82–128; Lorraine Daston and Peter Galison, *Objectivity* (New York: Zone Books, 2007); Peter Galison, "Judgment against Objectivity," in *Picturing Science, Producing Art*, ed. Caroline Jones and Peter Galison (New York: Routledge, 1998), 327–59.

4. Lorraine Daston, "The Moral Economy of Science," *Osiris* 10 (1995): 3–24; Daston and Galison, *Objectivity*.

5. Defined as an "appreciation of the modes of perceptual orientation *as forms of practical, social actions, capacities and achievements*." Jeff Coulter and E. D. Parsons, "The Praxiology of Perception: Visual Orientations and Practical Action," *Inquiry* 3 (1990): 251–72, 252, italics in original.

6. Early laboratory ethnographies also focused on images in scientific practice. See Bruno

Latour and Steve Woolgar, *Laboratory Life: The Social Construction of Scientific Facts* (Princeton: Princeton University Press, 1979); Michael Lynch, "The Externalized Retina: Selection and Mathematization in the Visual Documentation of Objects in the Life Sciences," in *Representation in Scientific Practice*, ed. Michael Lynch and Steve Woolgar (Cambridge: MIT Press, 1990), 153–86; Klaus Amann and Karen Knorr-Cetina, "The Fixation of (Visual) Evidence," in *Representation in Scientific Practice*, ed. Michael Lynch and Steve Woolgar (Cambridge: MIT Press, 1990), 85–122.

7. On "where the action is" in digital work, see Michael Lynch, "Laboratory Space and the Technological Complex: An Investigation of Topical Contextures," *Science in Context* 4.1 (1991): 81–109.

8. The US Geological Survey is extensively involved in mapping other planets in the solar system. Once an important institution for the production of American geography and colonial vision on Earth, the USGS now also coordinates peer review and publication of geological maps of Mars and other planets and moons, maintaining records of visual materials from all NASA missions.

9. For a description of the Pancams, see James F. Bell et al., "Mars Exploration Rover Athena Panoramic Camera (Pancam) Investigation," *Journal of Geophysical Research*, 108, E1 (2003), doi 10.1029/2003JE002070.

10. For more on how the planetary science community understands the CCD and digital images, see S. Howell, *Handbook of CCD Astronomy*, Cambridge Observing Handbooks for Research Astronomers series, 2nd ed. (Cambridge: Cambridge University Press, 2006).

11. On the different epistemic status associated with numbers versus pictures, see Anne Beaulieu, "Images Are Not the (Only) Truth: Brain Mapping, Visual Knowledge, and Iconoclasm," *Science, Technology & Human Values*, 27 (2002): 53–86.

12. To produce their pictures, scientists work with a suite of tools in their image processing software of choice, ranging from hand programming in a specialized processing language, to the Pancam software suite, to open-license or commercial tools like Adobe Photoshop. While slightly different in terms of their focus, each program allows a scientist to select several frames they wish to combine, assign frames to color channels, and tweak the resulting color image.

13. Ben's quotes in this section are taken from our observational interview, June 11, 2007.

14. On connections between astronomical image making and twentieth-century art, see Michael Lynch and Samuel Edgerton, "Abstract Painting and Astronomical Image Processing," in *The Elusive Synthesis: Aesthetics and Science*, ed. A. I. Tauber (Dordrecht: Kluwer Academic Publishers, 1996), 103–24.

15. Charles Goodwin, "Professional Vision," *American Anthropologist* 96, no. 3. (1994): 606–33.

16. Ben, however, resisted this as a "derogatory term," saying, "It's sometimes applied to the drone-like process of running canned computer routines to generate standard images." Personal correspondence, Ben Quinn, June 22, 2009.

17. Lynch, "Externalized Retina."

18. Studies of the early Royal Society have noted the epistemic value placed on repeatable experiments as tests or demonstrations of natural phenomena, often contrasted with "monstrous" or one-time cases that tested the limits of nature. See Lorraine Daston and Katherine Park, *Wonders and the Order of Nature, 1150–1750* (New York: Zone Books, 1998), and Steven Shapin and Simon Schaffer, *Leviathan and the Air-Pump: Hobbes, Boyle, and the Experimental Life* (Princeton: Princeton University Press, 1985).

19. On the limits of replication in scientific practice and in historiography, see Harry Collins, *Changing Order: Replication and Induction in Scientific Practice* (London: Sage Publications, 1985), and Otto Sibum, "Reworking the Mechanical Value of Heat: Instruments of Precision and Gestures of Accuracy in Early Victorian England," *Studies in History and Philosophy of Science* 26 (1995): 73–106.

20. This tension is also visible in computer modeling and simulation in terrestrial geology. See Naomi Oreskes, "From Scaling to Simulation: Changing Meanings and Ambitions of Models in Geology," in *Science Without Laws: Model Systems, Cases, Exemplary Narratives,* ed. Angela Creager, Elizabeth Lunbeck, and M. Norton Wise (Durham: Duke University Press, 2007).

21. On image-making practices that discipline objects into visible form, see Michael Lynch, "Discipline and the Material Form of Images: An Analysis of Scientific Visibility," *Social Studies of Science* 15 (1985): 37–66.

22. Daston, "Moral Economy"; Daston and Galison, *Objectivity.*

23. Observational Interview, Katie, June 21, 2007.

24. See Peter Galison's discussion of Mars observer Percival Lowell's visual interpretative practices in "Judgment against Objectivity."

25. Interview, team member, June 7, 2007.

26. Maria Lane, "Geographers of Mars: Cartographic Inscription and Exploration Narrative in Late Victorian Representations of the Red Planet," *Isis* 96 (2005): 477–506.

27. Note that in this case, "analog" refers to the use of *analogy*: establishing the site of study as analogous to another planet. As Stefan Helmreich has claimed in his analysis of astrobiology, through these practices the Earth becomes something more than itself, a representative of "planets" more generally as a category, and a laboratory through which scientists explore what planetary environments might be like. See Stefan Helmreich, *Alien Ocean* (Berkeley: University of California Press, 2009); see also Lisa Messeri, "Placing Outer Space: An Earthly Ethnography of Other Worlds," Ph.D. dissertation, MIT Program in History, Anthropology and Science, Technology and Society, 2011.

28. "End of Sol" team science meeting, May 23, 2007.

29. Lab and field on Earth are equally called into play to manage or otherwise check visual interpretations of Mars. But both the Earth-bound laboratory and the Earth-bound field sites act as "laboratories" for simulating Mars, which is considered "the field." Hence, like the contrasting epistemic status of lab versus field in the early natural sciences, the Earth-based "lab" work provides a check on visual experience in the Martian "field," but not vice versa. On the lab-field dichotomy and epistemic status distinctions in the nineteenth century, see Robert Kohler, *Landscapes and Labscapes* (Chicago: University of Chicago Press, 2002).

30. On aesthetic considerations as boundary work in planetary image processing, see Michael Lynch and Samuel Y. Edgerton, "Aesthetics and Digital Image Processing: Representational Craft in Contemporary Astronomy," in *Picturing Power: Visual Depiction and Social Relations*, ed. Gordon Fyfe and John Law (London: Routledge and Kegan Paul, 1988), 184–220.

31. Team Meeting, February 14, 2007.

32. Interview, Susan, June 18, 2007. For more on this visual discovery, see Janet Vertesi, "*Drawing As*: Distinctions and Disambiguations in Digital Images of Mars," in Catelijne Coopmans, Janet Vertesi, Michael Lynch, and Steve Woolgar, eds., *Representation in Scientific Practice Revisited* (Cambridge: MIT Press, 2014), 15–35.

33. Team Meeting, July 7, 2007.

34. On the purposeful computation of "seeing as" experiences in these varieties of contexts

see Janet Vertesi, *Seeing like a Rover: How Robots, Teams, and Images Craft Knowledge of Mars* (Chicago: University of Chicago Press, 2015).

35. The concept of "constraint" is a belabored one in science studies, related to a debate about the limits of a constructivist approach to the analysis of scientific practice. See Peter Galison, "Contexts and Constraints," in J. Z. Buchwald, ed., *Scientific Practice: Theories and Stories of Doing Physics* (Chicago: University of Chicago Press, 1995), 13–41, 22; Andrew Pickering, *The Mangle of Practice: Time, Agency, and Science* (Chicago: University of Chicago Press, 1995), 207.

36. Bruno Latour, "The 'Pedofil' of Boa Vista: A Photo-Philosophical Montage," *Common Knowledge* 4.1 (1995): 145–87, 161. Recall here McKinney's laborious sheets of plastic, superimposed on an image to literally trace different layers of interpretation.

37. This conflates the moral and epistemic status associated with lab/field, as well as the diagram/photograph, into a single, apparently seamless, viewing experience. See Michael Lynch, "Science in the Age of Mechanical Reproduction: Moral and Epistemic Relations between Diagrams and Photographs," *Biology and Philosophy* 6 (1991): 205–26.

38. In this way, the digital image functions as an inscription of disciplinary practice just as much as the anthropological photographs discussed by Edwards (chapter 5, this volume).

Uncertain Knowledge: Photography and the Turn-of-the-Century Anthropological Document

ELIZABETH EDWARDS

The Discourse of Document

Anthropology can arguably be "seen" as a project of visual imagination, rather than "read" as a particular kind of literature. How anthropology made itself "seen" at the moment when it, like other sciences, had "a new vision of itself" is the subject of this essay.[1] The production and perceived role of photographic documents in the 1890s and early 1900s responded to the epistemological shifts taking place in the emerging modern discipline of anthropology, and the late nineteenth century saw a succession of "methodological propositions for the systematic collection of field data" in anthropology.[2] Attitudes towards anthropological data and thus the anthropological document shifted markedly at this period, demanding both quantitative and qualitative changes in the concept of the evidential. As Engelke has argued, "we can read the history of anthropological thought as a series of debates over questions of evidence."[3] While there has been a plethora of discussion on, for instance, the place of methodology and theory in the positioning of anthropology, there has been little engagement with the nature of the anthropological document itself or even of "evidence" despite frequent calls to its authority.[4] This chapter seeks to explore the place of photography in the making of scientific documents at a transformative moment in anthropology and its visualizing practices.

My focus is on four brief but key statements on the production of photographic documents in British anthropology at the turn of the twentieth century: those from Everard im Thurn and Maurice V. Portman in 1893 and 1896, and two from Alfred Cort Haddon in 1899 (written with J. G. Garson) and 1912 (edited by J. Myers). All are entangled with ideas of the inscription of productive and communicative evidence—that is, with the photograph as document. These statements emerge from shifting and competing concepts

of appropriateness, validity, and effectiveness of the visual document in a period of emerging field tradition.

I shall argue that these debates articulate a shift from a mechanical objectivity of photography itself to an emerging complex objectivity which was constituted through a disciplined subjectivity embodied in the fieldworker's observing eye, immersed in the site of anthropological activity and desire. This is perhaps particularly marked in the British tradition because of the early emergence of the field tradition of anthropology.[5] This did not happen, of course, in isolation. Through the period under discussion a wide range of scientific, and indeed humanistic, disciplines, from ecology to art history, were forging distinctive identities and institutional structures for themselves. Anthropology, tensioned between the sciences and the humanities, was self-consciously formulating itself as a modern discipline with its own distinctive objectives and methodologies in the consolidation and movement away from its eclectic scientific base in the nineteenth century. Anthropology was as open as other disciplines to emergent intellectual trends in, for instance, sociology, psychology, psychoanalysis, and philosophy, and to work as distinct as that of Emile Durkheim, Sigmund Freud, and Henri Bergson, resonating through intellectual and scientific circles.

This epistemological shift demanded new forms of evidence and new forms of documents. The increasing challenge for photography in anthropology, and its eventual nemesis, was the shift from the privileging of surface of both the physical body and of material culture, which could be read through the disciplined eye,[6] to the intangibles of culture such as social and political processes, economic exchange, or kinship. The increasing stress on fieldwork, itself a term borrowed from the biological sciences, and in the British school of anthropology on individual fieldwork as the central anthropological methodology, brought about a radical change in perception of "the anthropological document." Instead the anthropologist's body becomes, effectively, the camera, absorbing and then reproducing information grounded in observation. The statements that are the focus of this chapter are interesting precisely because they catch that cusp of shifting episteme and shifting methods.

The photographic statements on which I am focusing in the four "moments" are in a sense reactive, restatements of a validity of photographic evidence that had been established in nineteenth-century documents. In particular, the statements are temporally inflected with the apprehension of loss: how to make records for the future in the face of racial and cultural hybridity and disappearance.[7] All the writers of photographic instructions suggest, implicitly or explicitly, this sense of disappearance as the fundamental reason

for making photographic documents; to quote im Thurn, "Primitive phases of life are fast fading from the world in this age of restless travel and exploration, and it should be recognized as almost the duty of educated travellers in less known parts of the world to put on permanent record . . . such phases as they may observe."[8] Haddon's thoughts on photography and its documenting powers were likewise developed within the contexts of salvage ethnography, cultural excavation, and their related temporal discourses: "The natives are fast dying out, and . . . so modified by contact . . . that it is our bounden duty to record the physical characteristics, the handicrafts, the psychology, the ceremonial observances and religious beliefs of vanishing peoples."[9] Such ideas underlie these statements on the creation, role, and efficacy of visual documents in anthropology through the last decade of the nineteenth century. But, as I shall suggest, it is also one that changes radically as anthropology's objects shift from human pasts to human presents.

Being on the cusp of an epistemic shift, the statements do not, however, form a neat or satisfying chronological and methodological progression. Rather, they overlap in both time and subject matter in ways that suggest a struggle to create adequate scientific documents during a period of methodological development and uncertainty. The authors themselves occupy a newly figured space in the intellectual movement from a set of scientific approaches to human origins and culture across a range of interests to an emerging professional scientific class, the first generation of whom, like Haddon, were trained in the natural sciences but increasingly saw themselves as "Anthropologists."[10] Haddon himself contemplated this shift in a small book entitled *History of Anthropology* (1910) in which the nature of disciplinary evidence and the role of photography are implied; "whereas the structural characters of man have been studied by trained scientific men, the history of man from a cultural point of view has mainly been investigated by literary men . . . from lack of experience in the field or by virtue of their natural reliance upon documentary evidence not having been sufficiently critical regarding their authorities . . . [they are] liable to lead the unwary into mistakes."[11]

This shift from the specifically biological, premised on the visible specimen, to attempts at a scientific apprehension of the wider environments of tangible and intangible culture, can be understood as part of a much broader realignment in scientific interest. It is especially marked in the emergence of new methodological strands in field sciences like ecology with their stress on wholeness and systemic interconnectivity, ideas that were echoed in anthropology's concern with the explanation of whole cultural systems.[12] What characterized all these expansive visualizations was a shift from the control of

excess in the visualization of the object of study to an engagement with the scientific potential of the messiness of everyday human existence, which I shall term "abundance."[13] I shall argue that the kinds of photographic document produced were central to the emergence of these new scientific identities.

While photographs had flowed round the networks of anthropology throughout the second half of the nineteenth century, especially in relation to delineations of race and material culture, concern about the quality and quantity of visual data is indicative of increasingly shifting claims to disciplinary and observational authority.[14] Images had been absorbed as documents into the emerging discipline of anthropology from a wide range of sources, from the commercial to the scientific. The very subject matter of these photographs and their patterns of consumption, rather than intention or formal style, rendered them documents of anthropology, as is demonstrated by the wide range of forms and styles that were deemed "of anthropological interest."[15] The most systematic attempts to harness photography in the production of the anthropological document was in anthropometrics, which developed a somatic mapping of the physical, and thus racial, body. Such visual practices focused exclusively on the production of mathematically legible documents, in which excess was carefully regulated and the image ontologically "purified" as an anthropological document.[16] The most widely disseminated method was John Lamprey's system of the figure placed in front of a grid of two-inch squares (figure 5.1). The procedure, "On a Method of Measuring the Human Form," demonstrated with specimen photographs by Henry Evans, was published in the pages of the *Journal of the Ethnological Society* in 1869.

The following year, possibly as a critical response to Lamprey's method, T. H. Huxley produced an even more rigorous system of anthropometric photography that was circulated through the British Colonies.[17] If such studies always had a cultural implication, in the sense that culture was believed to be biologically determined in a broad evolutionary hierarchy of races, by the late nineteenth century, both anthropological and photographic practices were increasingly extended to the growing concern with the production of visual documents about cultural practices themselves, not in a sense of the mere collection of facts as general statements, but constituted through extended accounts of observed cultures.[18]

Much analytical attention has been focused on the acts of collecting and observation in the emerging modern paradigm but little on the way in which this translates into "document" as the raw material of disciplinary intention and the construction of "facts" as epistemological units.[19] My concern here is therefore not primarily an analysis of the content of the photographs, although this is itself complex and ambiguous.[20] Rather it is an analysis of the

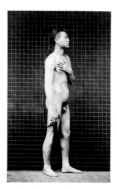

FIGURE 5.1. Henry Evans. Lamprey system of anthropometric photography. 1869, albumen print. Courtesy of Pitt Rivers Museum, University of Oxford, 1945.5.97.3.

constitutive discourses and methodologies of photography in producing the scientific document as "paradigmatic artefacts of ethnographic research." Through these procedures, anthropologists, collectively and individually, could "render the world real for themselves" by positioning the photograph as organized information that could form a knowledge base. It is a process through which photographs themselves might "come to constitute the facts of anthropology."[21]

While these gradual paradigm shifts had, of course, a major impact on anthropological method more broadly, photography is perhaps a key prism through which to consider this. For it is premised on certain forms of observation which, because of the nature of the medium, produced a material document that was specifically intended to translate and transmit data across time and space, a classic case of what Latour has famously described as "immutable mobiles."[22] For the man, and occasionally woman, making the photographs, this was the prima facie case for photography, where particularly in relation to material culture, "pictures . . . are more valuable than tedious verbal descriptions."[23] Of course, written texts in our archival imagination are also documents, but for anthropology, with its privileging of immediate, firsthand observation as the root of knowledge production, photographs had particular force.

Visualizing practices were thus at the conceptual center of the production of anthropological knowledge.[24] As Portman put it, introducing his program for photography at the Anthropological Institute in 1895, "As regards the importance of photography to the anthropologist, particularly when the work is carefully done, there cannot be two opinions."[25] Indeed, the mechanical reassurance of photographic inscription rendered "facts about which there can be no question,"[26] which could be privileged over other forms of transmission

and translation, notably the indigenous voice. They imparted information for documentation, while at the same time constituting replicable scientific data and evidence through the immutable mobile of the photograph: "the record thus obtained may be elucidated by subsequent inquirers on the same spot, while the timid answers of natives to questions propounded through the medium of a native interpreter can be but rarely relied upon, and are more apt to produce confusion than to be of benefit to comparative anthropology."

The emergence of a newly figured self-perception as "anthropologists" and the professionalization of anthropological knowledge, especially in relation to other bodies of scientific knowledge, notably anatomy, geography, and folklore studies,[27] was integrally connected with the emergence of certain forms of document. Nineteenth-century anthropological knowledge was premised on the eighteenth- and earlier nineteenth-century center/periphery model of data collection in which amateur observers and collectors contributed material to the interpreting centers—a process commonly now described, somewhat pejoratively, as "armchair anthropology."[28] The encouragement of the production of anthropological documents, through the collection of ethnographic and anthropological data, was seen as a key function of the Anthropological Institute, which formed the locus of interchange between amateurs and the emerging professionals.[29] It is significant that all the statements about photographic documents that I am considering fall, in one way or another, under its auspices in the last decade of the nineteenth century. From 1874, the Anthropological Institute published a small book, in association with the British Association for the Advancement of Science, entitled *Notes and Queries on Anthropology* [hereafter *N&Q*]. Intended for amateur enthusiasts in the field, such as missionaries and colonial officers as well as for scholars with anthropological interests, knowledge production was expressed in terms of a questionnaire arranged by categories of information, such as religious beliefs, dances, weapons, or modes of greeting, to be collected.[30] It thus offered advice on specific types of information deemed documentable but also, suggested through the structures of the book itself, how this was to be achieved in a discourse of objectivity.[31] It was the influence of *N&Q* that created the direct or indirect contexts for statements about the photographic document, either as a vehicle for the statements themselves or as a focus through which to frame visual documents within an emergent British anthropological method.

However, while at one level the documenting efficacy of photography was assumed, its practice in the production of legible documents remained ambiguous. The potential for the mechanical objectivity of the camera and photography as a recording device was not in question. But the statements that

are my focus did concern themselves, like other emerging disciplinary sciences discussed in the volume, with important "procedural correctness" that would perform data in certain ways in order to create documents of empirical reliability, legibility, and evidential validity.[32] Thus the document depended not only on the camera alone, but on ways in which the disciplinary object, in both senses, was presented to the camera. This became a pressing need as, with the simultaneous expansion of both colonial administration and photographic technologies, the range and quantity of material capable of being absorbed into anthropology expanded. This can perhaps explain the clustering of statements about photography in anthropology at the very particular historical moment in the 1890s when the nature of the document was on the cusp of radical change, poised not only between photography and film (a point to which I shall return) but also, as I have suggested, between earlier nineteenth-century modes of collection, assessment, and archiving and those of a pro-tomodern anthropology. For this represented an equal entanglement with the massive potential expansion of the uncontrolled "excessive" and flawed "document" that might threaten the integrity of the document of an emergent science.

This growing need, at least from the perspective of the disciplinary core, can be traced by the attention given to photography, and thus visual documents, in successive editions of N&Q. Only with the third edition (1899) did an extended discussion of photography appear, although earlier editions had listed photography under methodological tools without expanding upon it. The first edition (1874) simply carries a heading "Photography," with no further text. The absence of text has always been explained through that well-known editorial hassle, the contributor who fails to deliver. But I would argue that it also reflects the photographic possibilities of the image entangled with the anthropological, for even this enforced omission was explained in terms of document quality: "rather than place them [missing sections] in *less skilful hands*, they have been for the present omitted and the headings only inserted."[33] The second edition (1892), under the same editorial team, carried only two half pages of technical advice on photography. While the third edition (1899) overall was almost identical with the second, the photography section was one of the major expansions, from just over one page in total in the second edition to some eleven in the third.

Consequently, the third edition carried the first extensive discussion of photography, both technical and intellectual, to appear in N&Q despite its by then thirty-year history. What is significant, however, is that it still rooted photography firmly in the anthropology of the nineteenth century, with its

emphasis on surface description and the somatic mappings of anthropometry serving a racialist physical anthropology. However, alongside physical anthropologist J. G. Garson's technical detail and anthropometric instruction is Haddon's text, in which the stirrings of other forms of anthropology, with its contingent demands for adequate "documents," might be recognized. It placed the potential of abundance in sharp juxtaposition with the dangers of excess. Haddon's own text changed little between the third (1899) and fourth (1912) editions of N&Q, but the intellectual and methodological framings in which its document-producing capacities were situated were, I shall argue, radically different: as Stocking puts it, one begins to feel that "one has stepped into the ethnographic world of the next [twentieth] century."[34]

Photography for Anthropologists

I am now going to consider the distinctive features and contexts of the small statements by im Thurn, Portman, and Haddon and the way in which they position the making of the anthropological document. What links them is their attention to the efficacy of the carefully managed mechanical process of photography in producing anthropological documents and thus anthropological knowledge. What must be stressed is that, with the exception of the final statement I am considering in the 1912 edition of N&Q, which is clearly characterized by the theoretical and methodological shifts in anthropology over this period, these statements do not constitute a linear progression of methodology but point to the conflicting and even confused sense of where anthropological interest and significance lay, an ambiguity in the *kind* of anthropological knowledge to be produced and its efficacy.

The first statement, in terms of publication history, is that of Everard im Thurn, who worked in British Guiana through the 1880s and 1890s as a colonial officer and museum curator, although significantly he was also trained as a botanist.[35] In 1893 he published a paper entitled "Anthropological Uses of the Camera" in the *Journal of the Anthropological Institute*, which was based on a lantern slide lecture he had given to the institute the same year and which drew on some fifteen years' experience in the colony.[36]

His concern was, as he put it, "the use of the camera for the accurate record, not of the mere bodies of primitive folk—which might indeed be more accurately measured and photographed for such purposes dead than alive, could they be conveniently obtained when in that state—but of these folk regarded as living beings."[37] Im Thurn's remarks have been interpreted as marking the emergence of a more humanistic approach to both anthropology and the production of scientific documents, and as part of a shift to an

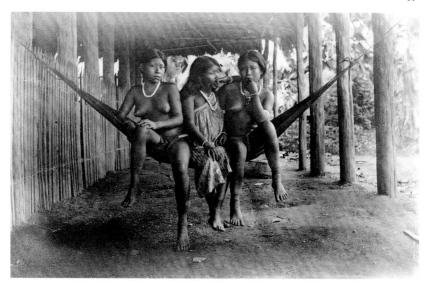

FIGURE 5.2. Everard im Thurn. Young Warrau women on a hammock. British Guiana, c. 1883–84, albumen print. ©RAI 636.

anthropological concern with the "quick and the living" as opposed to the "still and silent."[38] However, it also represents the cusp of an engagement that begins to make the transition that I have noted: from an excess of information to be controlled and focused to an abundance of scientific possibility. For within im Thurn's largely anecdotal account, he marks the emergence of a visualization of the cultural, not simply in terms of cultural assumption read off the biological, but in terms of the daily experience of families, friends, homes, gestures, body language, and the other components of social behaviors (figure 5.2).

He goes on: "Just as the purely physiological photographs of the anthropometrists are merely pictures of lifeless bodies, so the ordinary photographs of uncharacteristically miserable natives . . . seem comparable to the photographs which one occasionally sees of badly stuffed and distorted animals."[39] However, despite his emphasis on the naturalistic as opposed to the anthropometric as document, his premise for the document was at the same time constructed around racialist discourses of purity and miscegenation. It is here that we see tensions between the older styles of anthropometric recording and biologically defined paradigms of anthropology and the nascent field tradition of cultural anthropology emerging from and refiguring a Tylorian tradition of comparative evolutionary cultural anthropology.

Im Thurn's photographic examples, which illustrated his paper, not only

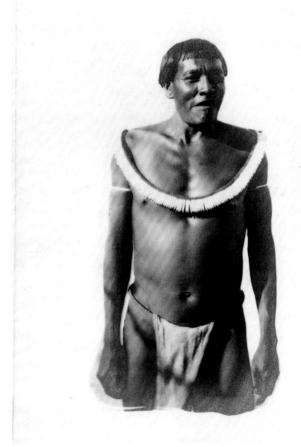

FIGURE 5.3. Everard im Thurn. Lonk wearing featherwork neck and breast ornament. British Guiana, c. 1883–84, albumen print. ©RAI 618.

showed relaxed groups, arms draped around each other, lounging around, playing games, and so forth—the capture of abundance—but also hark back to the practices of photographic document production of an earlier period in which backgrounds in the photographs are often blanked out to focus attention of the body of the subject. For instance, in his photograph of Lonk, the focus is on a particular neck ornament (figure 5.3).

This can be directly related to the blanking out of backgrounds in, for

example, Carl Dammann's photographic atlas *Anthropologisch-ethnologisches Album in Photographien* some twenty years earlier, in which carte de visite photographs of largely commercial production, gathered by the Berliner Gesellschaft für Anthropologie, Ethnologie und Urgeschichte, were rendered "anthropological" documents by the removal of contextualizing backgrounds and the suppression of the cultural in favor of the biological.[40] This raises the question of where the "naturalism" advocated by im Thurn was located, in the image or in the bodily relations of the fieldworker? The naturalism of gesture and bodily deportment so stressed by im Thurn is rendered static, not only by the action of the camera, but by the rendering of that photograph as an anthropological document. For while it stressed the legibility of certain cultural forms, it simultaneously slipped into the traditions of a biological understanding of cultural authenticity.

Im Thurn's statement on photography can be interpreted as a response to what photography can do and the kind of documents it can produce at a given historical moment. But at the same time, as Grimshaw has noted, anthropological strategies are premised on specific observational stances, which presuppose specific relations with the world, which in their turn frame the nature of the document.[41] What is significant is the way in which im Thurn is mindful of the slippage between the objective and the subjective in the creation of documents of an emergent cultural anthropology based in the messiness of experience. Photographs as "living beings" rather than static specimens (figure 5.4) "is indeed a far more difficult proceeding," noted im Thurn, "one much more seldom practised by anthropologists, and one the utility of which for anthropology . . . as an exact science, some anthropologists will, I fancy, be at first sight inclined to question."[42] This comment points again to the tensions and slippages between the control of excess and the valorization of abundance as the site of both cultural and disciplinary significance.

Im Thurn's paper was followed three years later by another statement on the creation of photographic documents for anthropology by Maurice V. Portman, colonial officer in charge of the Andaman Homes in the Andaman Islands in the Bay of Bengal. The Andaman Islands, which had been developed colonially as a prison island after the Indian Rebellion of 1857, had long attracted anthropological interest because its indigenous "negrito" inhabitants were perceived as having remained in a state of isolated primitiveness.[43] As such it was well established in the visual practices and documents of anthropology, largely owing to the efforts of the first officer in charge of the Andaman Homes, E. H. Man, whose almost obsessive collecting and photographing of Andamanese culture had provided a flow of scientific documents to institutions across Europe.[44]

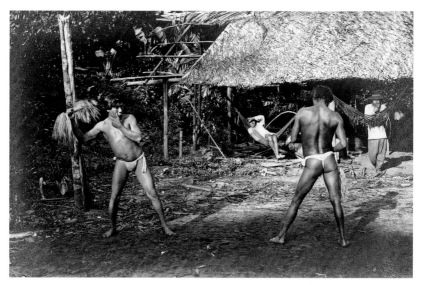

FIGURE 5.4. Everard im Thurn. Young Warrau men playing a game. British Guiana, c. 1883–84, albumen print. ©RAI 641.

Portman's statement, presented to the Anthropological Institute in 1895 and published in its journal the following year, emerged from his experience as a colonial ethnographer making a very substantial series of photographs that surveyed Andamanese culture for the British Museum. In 1889 Portman had offered to make photographs for the museum showing the stages of manufacture of various Andamanese artifacts. Completed in 1893, the project was sent to both the museum and the Government of India (figure 5.5).[45] The project also included an extensive series of full-face and profile anthropometric studies of Andamanese people, with associated measurements, taken in response to part I, of *N&Q* on physical anthropology.[46] The studies resulted in over twenty volumes of photographs, printed in cold-bath platinum to ensure the longevity of the document.[47]

Here the document operates at an individual, series, and collective level, responding to different anticipated forms of attention and desired narratives on the anthropological object. However, for Portman, the production was rigorously circumscribed as he aimed to deliver the controlled scientific specimen and thus valid document "answering questions *accurately*."[48] For him, the excessive inscription of the naturalistic photograph obscured the scientific. With the exception of a few necessary field photographs, such as obtaining wood from a specific tree, the photographs are taken against a plain background—

reminiscent of the blanked-out backgrounds of earlier photographs. They are taken under careful lighting, in a way that focuses the attention of the viewer, controls excess, and isolates the practice as a moment for scientific examination—they resonate with a sense of laboratory practice: "For ethnology, accuracy is what is required. Delicate lighting and picturesque photography are

A similar cut is then made, above, and at some little distance from the handle.

FIGURE 5.5. M. V. Portman. Mangrove tree showing section marked for use in the manufacture of adze. The cuts are overwritten in red crayon. C. 1893–94, platinum print. ©RAI 811.

not wanted; all you have to see to is, that the general lighting is correct, and that no awkward placing of weapons or limbs hide important objects."[49] The camera position was part of this clarity. It was not to be oblique but on the same level as the subject, again giving a sense of directness of both observation and inscription unless it was necessary to "show the way in which the hands and feet are used in the manufacture of any articles."[50] The aim is a maximized scientific visibility. The attention of the viewer is further directed by brief letterpress captions for example, on making an adze: "The end is then cut to the right length, and smoothed," "The back is then similarly trimmed, and chopped close in the same curved line as the handle," and so on (figures 5.5 and 5.6).

The photograph, nevertheless, remains the central and primary document: "Properly taken photographs, with *additional* explanatory letterpress will be found the most satisfactory answers to most of the questions in 'Notes and Queries'" (figure 5.7).[51] For Portman the photograph became, as Sen argues, a "form of interrogation, an extraction of knowledge."[52] The camera therefore not only provided answers to *N&Q* contained in clear explanatory letterpress, but constituted the complete document. Importantly here, the document was constituted through a conscious inversion of the normal relations between text and image. The camera as a machine stood for a scientific authenticity as the producer of those "facts about which there could be no question"; those facts were made visible and legible through the indexical trace of the photograph.

The scientific visibility of the subject matter was performed to the camera, therefore, through a series of focused mediations, what Pinney has described, following Latour, as a "purification" into a "distinct ontological zone," here the anthropological document.[53] This was not the naturalism of im Thurn's concept of a valid document. The production of the document intended to demonstrate scientifically the techniques of, for instance, adze production was dependent on regulative interventions in the arrangement of the subject to be inscribed by the camera, in ways that might be compared with the preparation of a slide of microscopy. Indeed, Portman's close-up photographs of male body scarification have formal visual resonances with slides of bacteria. Through careful posing and positioning, the "data" of the document had to be rendered legible in the form through which it was to be translated—the photograph. Importantly, Portman's position linked strongly to the questions of observation that saturated *N&Q*, but as Tomas has pointed out, "In contrast to the earlier consensus as to what one should *look* for, Portman's definition of 'scientific photographs' placed emphasis on *how* one should *see* the thing looked for."[54] They constituted therefore a visual strategy for producing

The blade is then placed on the haft; strips of "Choura" bark, and sometimes leaves also, are placed over it; and the whole is tied firmly together with the cane.
Observe throughout these photographs the manner in which the feet are made to assist the hands.

822

FIGURE 5.6. M. V. Portman. Making an adze. Carefully posed against a plain background. C. 1893–94, platinum print. ©RAI 822.

particular kinds of knowledge through the active suppression of excessive or destabilizing elements.

The final two statements are in *N&Q* itself, in its third (1899) and fourth (1912) editions, rather than responses to it. As statements in and of themselves they can be treated together because there is little change in Haddon's

816

Another view showing the method of cutting, and the way in which the tool is held,

FIGURE 5.7. M. V. Portman, photograph and text. "Another view showing the method of cutting, and the way in which the tool is held." C. 1893–94, platinum print on card with letterpress text. ©RAI 816.

text. However, what does change is the intellectual framework of anthropology more generally, in which photographic documents were to be made. As Urry has demonstrated, the extensive revisions between the third and fourth editions of N&Q stand for a radical change in the conceptualization and methodologies of anthropology and render it in a clear modern and indeed modernist form.[55]

Yet the instruction for the production of photographic documents remains ambiguous, sitting more comfortably in the third edition than the fourth, despite the fact that by the fourth edition references to photography are scattered through various sections of N&Q such as games and dance. As I have noted already, the statement on photography in the third edition was in two parts: one part was written by physical anthropologist J. G. Garson and, significantly for my argument here, the other was written by A. C. Haddon, a zoologist who was fast becoming a cultural anthropologist.[56] By 1899 attention to the production of photographic documents perhaps became more pressing as photographic technologies became more widespread and the potential for producing visual documents for anthropology expanded.[57] If N&Q was still written for amateurs, the concepts of photographic document were written by those with increasingly proto-professional positions, reflecting the changing structures, legitimacies, and knowledge base of the discipline itself. Thus, in terms of the photographic document the two parts of photographic instruction can be understood as reflecting the sharpening of a nascent division between physical anthropology and cultural anthropology, which had been stirring since at least the 1880s, even if they still enjoyed a certain "theoretical compatibility."[58] While still powerfully inflected with nineteenth-century attitudes to racial and cultural hierarchy (most notable in Garson's contributions), unlike the other two photographic commentators—the romantic racialist im Thurn and the rigid colonial taxonomist Portman—it is Haddon's experience as a scientific fieldworker that is increasingly felt. This position emerges from the shift from an anthropological knowledge understood as vested in the purported ontology of a knowable object, as characterized in im Thurn and Portman's photographs, to a relational position. In this, photographs and the production of documents became part of a dialogic field relation in which the abundance of cultural experience itself was the focus of analysis, yet which had simultaneously to be rendered scientific and objective (figure 5.8).[59]

Haddon echoed im Thurn's concern for the photographic inscription of "living bodies": "It must never be forgotten that when a native is posed for photography he unconsciously becomes set and rigid, and the delicate 'play' of limbs is lost."[60] His field experience in the Torres Strait in 1888–89 and 1898 increasingly shaped his statement on the photographic document. It should be noted, especially in relation to abundance, that the 1898 Cambridge Torres Strait Expedition took a 35 mm Newman and Guardia movie camera and made what was the first anthropological field film.[61] While I shall return briefly to the question of film, it is significant that even if practical engagement was limited, the clear potential in the recording of abundance was already intellectually established, and the extended quotation of the filmic

FIGURE 5.8. A. C. Haddon. Men on the lookout for dugong. Mabuiag, Torres Strait. 1888, albumen print. © Cambridge University Museum of Archaeology and Anthropology N.22795.ACH2.

should be understood too as framing both the intellectual and practical approaches to photography by this date.

While a strong informational base of the document, vested in the mechanical power of the camera, is still central—Haddon warned against taking photographs that "do not teach any thing"[62]—a more flexible position marks his *N&Q* contributions on photography. These latter implicitly acknowledge

the place of the fieldworker in the messiness of everyday life: "The common actions of daily life" and the immediacy necessary for such documents "always seize the first opportunity of photographing."[63]

For Haddon, even during his first expedition of 1888, photographs became part of the relations of fieldwork, even if that relationship remained asymmetrical: "The promise of a print from the negative will often secure a sitting, but this should be regarded as a favour, and not as a right."[64] This small sentence indicates the consciousness of potential multiple lives for the document, as the images made as anthropological documents were almost instantly recoded as family photographs (figure 5.9).

Furthermore, the way that documents were used began to shift. Haddon found Torres Strait Islanders friendly and intelligent companions; most importantly, his fieldwork convinced him that culture was at the root of stages of human development, not biology.[65] For him the photographs were "living illustrations" of the information being imparted, in a dynamic creation of disciplinary knowledge, rather than passive objects of study. This is reflected in the ways in which he used photographic documents. For instance in his publications, photographs and their captions form the crucial links in the creation of a complex document, lending authority and authenticity of the document to the whole project, but also the position of indigenous people as sources of authority, not merely units of information. Even in his reports from the Torres Strait Expedition, published over a thirty-five-year period by Cambridge University Press, the photographs and writing style link to people through a caption style where almost all the subjects are named.[66] None of this, of course, is overtly articulated in Haddon's statement in the third edition of N&Q. However, I would argue that in his instructions about how to photograph, and the production of photographic documents as a fieldwork *experience*, one can see the beginnings of a newly configured visual document for anthropology.

This becomes more marked in the fourth edition of N&Q. While, as I have noted, Haddon's text itself remains largely unchanged, there are some subtle differences in emphasis. While photographic observation of the earlier statements, notably that of Portman, had focused on the individual figure or technology, isolated for scientific analysis—"those facts about which there could be no question"—the attentive looking within anthropology shifted almost imperceptibly to engage with the excess of photographic inscription so that is was "possible to secure views that illustrate several points."[67] It was the moment when destabilizing excess became productive abundance.

The instructions for the "type" photographs of physical anthropology remained in N&Q. However, the language of the document moves from the

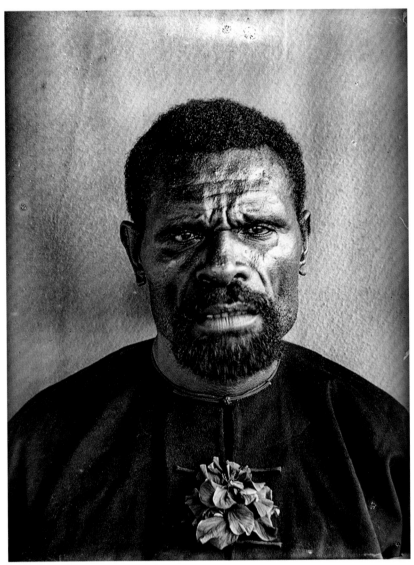

FIGURE 5.9. A. C. Haddon. Anthropological/family portrait of Pasi, one of Haddon's interpreters and friends. Mer, Torres Strait. 1898, silver gelatin print. © Cambridge University Museum of Archaeology and Anthropology N.23108.ACH2.

hard mathematicization of somatic mapping such as outlined by Portman and by Garson in the third edition, toward a more "naturalistic" and perhaps ambiguous rendering. "Besides the stiff profiles required by the anatomist, some portraits should be taken in three-quarter view or in any position that gives a more natural and characteristic pose."[68] It is significant therefore that

Garson's detailed instruction for physical anthropology photography disappeared from the fourth edition. Instead, after a half-page outline, readers were simply referred to the British Association for the Advancement of Science's report of its Anthropometric Investigation Committee of 1909. This mirrors the reduction of the overall section on physical anthropology in the volume; the document, even of the human body, within anthropology was shifting from the biological to the social. The advice continues, developing the theme first introduced by Haddon in the third edition of *N&Q* and in im Thurn's sense of physical and cultural naturalism: "Some unarranged groups, should be taken instantaneously so as to get perfectly natural attitudes."[69] But by far the clearest articulation of this changed anthropological focus, and to which I shall return, is the emphasized passage: "Do not neglect the common actions of daily life, and be very careful that the subject is actually performing the movement; many photographs of craftsmen are spoiled because the subject is looking at the photographer, not at his work" (figure 5.10).[70]

But what really changes the way in which one might read this constitution of the document is the context in which it sits, forming a clear undercurrent in the way that photographic documents might be conceptualized. As

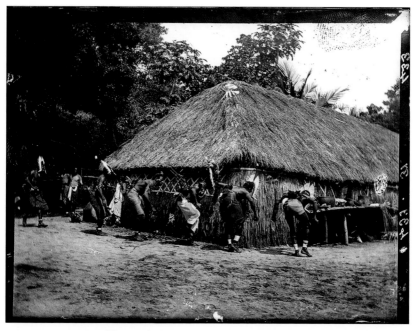

FIGURE 5.10. A. C. Haddon. Not looking at camera. Secular dance. Mer, Torres Strait. May 1898, silver gelatin print. © Cambridge University Museum of Archaeology and Anthropology. N.23158.ACH2.

many commentators have noted, it was the fourth edition that represented a sea change in both underlying theoretical position and methodology. It was edited by the distinguished psychologist, W. H. R. Rivers, whose genealogical method, developed on Haddon's 1898 Torres Strait Expedition, effectively reshaped anthropological thinking. His coeditor was Barbara Freire-Marreco, who had studied the Diploma in Anthropology at Oxford and had undertaken fieldwork in the Pueblos of the American Southwest.[71] The volume still aimed "to promote accurate anthropological observation," but "both in form and contents it differs from them [earlier editions] unavoidably. The needs of anthropology are no longer quite what they were; the methods by which they are to be satisfied are more precise and exacting; and the standpoint, even of the untrained observer, has shifted perceptibly."[72]

This revision, which was some five years in the making, remained aimed at amateurs in the field, but represented the concerns of the new emerging class of professional anthropologists: "its contents . . . rearranged on some scientific scheme of classification, which would clearly show the main divisions of the science, and the relations with one another."[73] The section that had been organized under the term "Culture" was replaced by the largest section of the book, "Sociology," severing links with older nineteenth-century Tylorian models of "culture" and their resonances with evolutionary, comparative anthropology. This change of title for the key sphere of observation and document production marks a radical change. It signals the influences of the new work of Durkheim on the one hand, and on the other, of Rivers himself and his genealogical method, which effectively translated general scientific principles of research procedure into a specifically anthropological methodology. Further, instead of lists of questions to ask, there were "pages of advice on how to collect data," and by implication how to observe and document.[74] In other words the social, which Haddon had introduced into the concerns of the photographic document in 1899, was beginning to emerge as an integrated entity that would mark the classic period of British functionalist social anthropology in the years after World War 1. It was, after all, the fourth edition of N&Q that guided the methods of Bronislav Malinowski, who, in his fieldwork and subsequent account of Trobriand Island society, so brilliantly crystalized the field method in British anthropology.[75]

Continuities, Ambiguities, and Changes

This outline of the statements about photographs and their production raises a number of questions about both the constant and the changing nature of

the document. I want, in this section, to consider the various strands of continuity, ambiguity, and change in the production of photographic documents and ask what a consideration of the photographic document reveals about the gradual shifts in anthropology in its proto- and early-modern phases and, by implication, to consider to what extent scientific changes and developments entangle with their visualizing technologies.

A key focus of all the statements on photography is on the technology. While the details change according to personal predilections and improvements and developments in the photographic technologies available, this concern with instrumentation is a constant through all the statements. Indeed, a large proportion of their texts is taken up with descriptions of suitable cameras, lenses, and chemicals. It is common to all four accounts, their different assumptions about observation and the shaping of anthropological fact notwithstanding, despite the realization that those making photographs would "doubtless wish to spend his time in recording anthropological facts, and not on the operations of photography." These aspects have been almost entirely overlooked by commentators who have read these statements solely in terms of representational practice or seen photographic technology as coarse metaphors of colonial relation, such as a relationship between focal length and cultural distance, or the functionalist implications of the wide-angle lens.[76]

On the surface these technical sections appear to be mere instructions about which camera to use, the kinds of plates or chemicals suitable for tropical or hot dry climates. However, I would argue that, in a way well-recognized in other branches of the history of science, this attention to the instrumentation of cameras, plates, films, chemicals, dishes, trays, dark tents, and focusing cloths is also a discursive parameter that ensures the validity, legibility, and disciplinary functions of the resulting photographs as documents in that they "show things in certain ways."[77] As Portman put it in discussing focusing glasses, "Our object is to get great and accurate detail."[78]

The focus of statements on the production of photographic documents was, however, a fight for a certain perception of the visual document more generally at a moment of uncertainty. "Nothing," as Grimshaw notes, "made the leading figures of the twentieth century discipline in Britain more nervous than the specter of gentleman amateurs, dazzled by scientific instrumentation, collecting and classifying in a museum context."[79] For what marked the new emergent anthropology was a move away from the prosthetics of data collection through instrumentation to an increasing stress on the observing body of the fieldworker. In this, the photographer was also a "document" of engagement and legitimacy, which at one level valorized practices of direct and informed

observation, but which at the same time "contained within it the specter of communication, exchange and presence—all factors that challenged the ethnographer's claims to objectivity."[80]

While these paradigm shifts can be discerned in the making of the document, it must be remembered that much anthropological information, especially that of the mechanical assurance of the photograph, was still created outside the emerging academic discipline, premised largely on the center-periphery relations of the colonial world. John Linton Myres, the Oxford archaeologist, clearly stated that one of the main reasons he founded *Man*, the Anthropological Institute's more "magazine-type" publication, in 1900 was precisely to accommodate "the large mass of small yet important notes from people overseas."[81] At precisely the same period, he established a register of "photographs of anthropological interest" from similar sources that was published in the pages of the *Journal of the Anthropological Institute* though the 1890s. Photography was part of the massive expansion of "anthropological facts," documented in reports, notes and records, and colonial documents, but their alignment within the discipline and the processes of validation of the document were changing radically.

Significantly, the emergence of the new anthropology of the twentieth century coincided, in effect, with the marginalization or even disappearance of the technologies of document making, as the creation of the visual document became effectively internalized within the body of the fieldworker. As Rivers himself remarked, the lone anthropologist in the field "became an embodied scientific instrument."[82] Of course, knowledge and document creation had always been premised on the presence of the observing body and the immediacy of the eyewitness or "the man on the spot" as an appeal to accuracy. But anthropology was moving increasingly to a state of cultural immersion and objective intention simultaneously embodied in the fieldworker, in which observed excess became the experience of abundance. Further, the act of photography itself and the embodied relations between photographer, camera, and subject constituted a network of humans and nonhumans in the Latourian sense from which the document could emerge. For instance, within comments about the avoidance of the camera—which im Thurn significantly sees as anthropologically interesting, if irritating for the photographer— are clear concerns about the inscription of cultural behavior.[83] Likewise, Portman's detailed account of the intersubjectivities of posing subjects or Haddon's tips for focusing and the use of mirrors angled to the lens to photograph unobtrusively reinforce this relationality between photographer, camera, and subject.[84] All are concerned with the way in which "image, author, and

technique joined to create a new form of scientific site." The shifts in this tri-angulated relationship mark the gradual but discernable movements in dis-ciplinary epistemologies and the production of documents. The emerging sites of embodied observation, as opposed to externalized and prosthetic in-strumentation, constituted the body of the fieldworker as the site at which the subjectivities of personal observation and the distanced observer came together.[85]

I have focused on photography, for photography constitutes a significant methodological bridge between nineteenth- and twentieth-century method-ologies and a site of the working out of the ambiguities of the shifting epis-teme. However, one must ask why anthropology did not make more use of film, the potential of which to capture and translate "abundance" through its long quotations, is very much greater that that of photography. Certainly, as I have suggested, anthropologists were interested in film. It first appears in N&Q in the fourth edition (1912), clearly linked to other mimetic technolo-gies such as the phonograph and receives its own two-page section "Kinemat-ography" in the fifth edition of 1929. It is significant that Haddon, who gave so much thought to field photography, was also the first anthropologist to take field footage, in the Torres Strait in 1898.[86]

Haddon's friend and colleague Baldwin Spencer developed the possibili-ties further in his work with Frank Gillen in central Australia in the first de-cade of the twentieth century. But the cumbersome technology of early film sat uncomfortably with the desired method of the lone, almost heroic, indi-vidual fieldworker, immersed in local culture, for "the use of the camera needs a man's whole attention."[87] If the still camera was potentially intrusive and disruptive of this formative method, how much more so the ciné camera? The core organizational principle of British anthropology militated against film, and it is significant that the two pioneers of film in anthropology—Haddon and Spencer—were not working alone. Further, there were technological problems, especially in the early period. Thus overall N&Q opined "The kin-ematograph, invaluable as it is for giving a record of the life of native peoples, involves difficulties which make its use not very practicable in most scientific expeditions."[88] In this period film developed in the contexts of popular science and survey/expeditionary anthropology, where its technical demands could be accommodated. Only in the 1950s and 1960s did film begin to emerge as a serious anthropological tool, and only in the 1970s was a serious, film-based anthropological theory of communication well-established.[89]

Despite its epistemological promise, there seems to have been an intellec-tual resistance to film, too. With the increasing emphasis on the immersion

of the fieldworker and sociological approaches in anthropology, the power of film was perhaps too intrusive on the anthropological discourse itself. Griffiths argues that Spencer was concerned about the power of images and the way in which they come to stand alone, decontextualized, as evidence in indigenous life. "The implicit problem was that a few photographed and filmed images of a cultural group, through their repetition and lack of context, would assume a metonymical relationship to the culture as a whole."[90] In other words, the concern was with predominance of surface over the cultural depth that defined the emerging anthropological paradigm, which I have described in this chapter. This, of course, applies to photographs as well, but film's density and sense of absorption into that fruitful abundance was too destabilizing of the emerging anthropological project.

This concern perhaps explains, in part, the general incongruity of the increasing marginalization of the visual document as part of a more general epistemological unease with the nature and indeed quality of the visual document. Yet it is also the moment when the excess and random inclusiveness of photography might address precisely the abundance of field experience.[91] Although new work in historical and visual anthropology is now rehabilitating photography into the practices of the mid-twentieth-century functionalist anthropologists of the British School,[92] its ambiguity in the production of anthropological document and its insertion into the analytical practices of a field-based anthropology were famously described by Malinowski in his 1932 volume on garden magic in the Trobriand Islands. He wrote: "One capital blot on my fieldwork must be noted, the photographs . . . I treated photography as a secondary occupation and a somewhat unimportant way of collecting evidence."[93] Crucially too, for the status as document in the wider endeavor of cultural excavation, the concept of "document" as a sense of "archive" sat increasingly awkwardly with a method premised on social experience of participant observation and the broadly ahistorical practices of functionalist anthropology.[94]

What is interesting is how the different commentators define themselves in relation to the changing paradigms of anthropological knowledge in a nascent protomodern disciplinary environment. For instance, Haddon himself was a mixture of nineteenth-century and innovative twentieth-century values, which marked this emergence of the new anthropology in ways that are both "archaic and prescient in the emerging modern field-work based anthropology."[95] However, glimmers of this central premise of the fusion of the fieldworker, theorist, and visualizing apparatus of direct observation can be discerned also in the photographic statements of both im Thurn and Portman,

through their concern with long-term engagement and directness of observation and account.

Haddon's comments in the third edition of *N&Q* to "be very careful that the subject is actually performing the movement; many photographs of craftsmen are spoiled because the subject is looking at the photographer, not at his work"[96] emerged as the pivotal statement on the production of photographic documents in anthropology. It sets in play a form of anthropological illusionism of the embodied, yet absent, observer, which set the agendas for the naturalist scientific documents that were core to the disciplinary ethos for much of the twentieth century.[97] But it also demonstrates the way these values began to emerge in the late nineteenth century.

What survives in photographic instruction between the third and fourth editions of *N&Q* points to the precise space of shifting values. Photographic documents gave concrete form to the illusionism of anthropological representation, proclaiming, "This is what you would see had you been there with me—observing"—"You are there . . . because I was there."[98] Thus, photographs became documents of metaphorical force, as privileged sites for communicating a feeling of cultural immersion, a form of substitute for personal experience of fieldwork, authoritating what could have been seen. Yet within this messiness and contingency of human encounter, the embodied fieldworker must remain invisible in order to validate their observation and photography scientifically. It was for precisely these reasons that the statement of the parameters of the image became so important. Photography had not only to record but also to preserve evidential authority and illusion. Through an increasing conflation of photographic naturalism and observational and scientific naturalism,[99] its documents also became, even if unacknowledged, part of the disciplinary machinery that turns highly personal, temporally bound and intersubjective methods of collecting data into convincing evidence.[100]

It is important also to note how the operational theater of the anthropological document transformed from being a centralized resource through which to disseminate anthropological ideas into effectively private documents of fieldwork. Photographs were no longer dispersed through the networks of anthropological interest, through centralized archives of photographs and lantern slides, as they had been in the past, but instead gathered around the fieldworker as the embodied center of anthropological knowledge. When Malinowski, who took the fourth edition of *N&Q* to the field with him, returns from his Trobriand fieldwork, he does not archive his photographs centrally as the earlier generation might have done. Instead he uses them as one of a number of documentary products of fieldwork with which to think through

the analysis of his field material, in other words, to manage the abundance of experience: "In writing up my material on gardens I find that the control of my field notes by means of photographs has led me to reformulate my statements on innumerable points."[101] Thus, the shape, dynamic, and consequence of the archive, as a repository of documentary authority, were refigured as part of the changing perceptions of the place of documentary intensity. As observation was increasingly focused on the body of the fieldworker, photography becomes, not a mediation of the scientific experience, but an extension, a prosthesis of the fieldwork persona, as an integrated and multilayered system of document which is "at once an ethnographic object, an analytical category, and a methodological orientation."[102]

Closing Thoughts

The debates about photographic efficacy and document production that I have described looked in two directions: first, to the amateur and "facts about which there can be no question," but also, second, to the intellectual and methodological standards of the emerging protomodern discipline within a broader socioscientific paradigm. As I have argued, what all these statements demonstrate at one level or another is the merging of object, observation, and technique to constitute a discourse of reliability, authenticity, and legitimacy of document. But they also reflect that resonance of earlier debates in mid-nineteenth century. As Stocking has pointed out, "The scientific styles of late nineteenth century British anthropology [can be seen] as a reflection of the controversies of the 1860s."[103] Consequently, likewise, while debates around the evidential status of photography remain active today,[104] one can argue that they have their roots in the discussion of the nature of the visual document in anthropological science, which first emerged, as I have shown, in the 1890s.

The production of photographs was integral to a wider epistemological debate on the nature of the document, evidence, and thus knowledge that point to the "historicity and disciplinary specificity of evidential protocols."[105] If the statements I have discussed in relation to photographic documents are couched in methodological concerns, they stand for epistemological concerns at a moment of anthropological uncertainly, poised on a cusp between the biologically inflected debates of the nineteenth century and the sociological and culturalist debates of the twentieth. These mark a shift from the absolute truths of Portman to the relative truths of Haddon, and changed from the historical reconstructionism of narratives of origin and evolution with its attendant photographic focus on salvage ethnography to a largely ahistorical functionalist social anthropology. These are not, of course, straightforward but

were in themselves highly negotiated, for "the camera did not solve the problem of objectivity" and the quality of the document in late nineteenth-century anthropology, "it merely entered the debate."[106]

Photographic documents and the modes and means of their production were important players in the emergence of new scientific identities, as new forms of knowledge demand new forms of evidence and require new forms of document. "Just to apprehend such marks as traces of something, as evidence, is already to have gone beyond the stage of merely making statements about the marks themselves; to count something as evidence is to make a statement about something else, namely, about that for which it is taken as evidence," as Pinney puts it; "what *kind* of statement would be relevant to an anthropology in the making?"[107] Anthropology is not alone in this trajectory. While its histories have clear intellectual genealogies, symbiotic relations with colonial ideologies, and points of cross-fertilization with other sciences, thinking about the practices of visual document production reveals broader patterns and sets of practice—of Foucault's "enunciative regularities" perhaps—between anthropology and other field sciences at the very moment of struggle for its own identity and its own methodology. Anthropology simultaneously embraced the practices of a field science and the potential of abundance, while rejecting the epistemological links with the natural sciences in order to define its own identity and language. The production of photographic documents, and the practices and expectations through which they were constituted, form another strand through which epistemological shifts in anthropology, and their broader relations with science, might be both tracked and understood.

Acknowledgments

I should like to thank the following colleagues for their comments and advice in the development of this paper: Lorraine Daston, Faye Ginsburg, Liz Hallam, Gregg Mitman, Roslyn Poignant, Kelley Wilder, and all the participants in the MPI workshop in January 2010.

Notes

1. Anna Grimshaw, *The Ethnographer's Eye* (Cambridge: Cambridge University Press, 2001), 9; Christopher Pinney, *Photography and Anthropology* (London: Reaktion, 2011), 15.

2. James Urry, "*Notes and Queries on Anthropology* and the Development of Field Methods in British Anthropology, 1870–1920," *Proceedings of the Royal Anthropological Institute 1972* (1972): 45.

3. Matthew Engelke, "The Objects of Evidence," *Journal of the Royal Anthropological Institute*, n.s. 14, supplement S1 (2008): S2–S21.

4. Engelke, "Objects of Evidence," S1.

5. Henrietta Kuklick, "The British Tradition," in *A New History of Anthropology*, ed. H. Kuklick, 52–78 (Oxford: Blackwell, 2009), 63.

6. For a broader discussion of the "disciplined eye" in anthropology at this period, see Andrew Zimmerman, *Anthropology and Antihumanism in Imperial Germany* (Chicago: University of Chicago Press, 2001), 172–78.

7. Nineteenth-century anthropology was effectively a temporal discourse of human origin, of evolution, of cultural change, cultural disappearance, and racial hybridity.

8. E. im Thurn, "Anthropological Uses of the Camera," *Journal of the Anthropological Institute* 22 (1896): 184.

9. Alfred C. Haddon, "The Saving of Vanishing Knowledge," *Nature* 55 (1897): 305–6.

10. Mid-nineteenth-century "Anthropology" formed the center of a cluster of interests that embraced, for instance, folklore, archaeology, anatomy, medicine, biology, etymology, and history of religion. See, for instance, George W. Stocking Jr., *After Tylor: British Social Anthropology 1888–1951* (London: Athlone Press, 1995); Henrietta Kuklick, *The Savage Within: The Social History of British Social Anthropology 1885–1945* (Cambridge: Cambridge University Press, 1991). And for the earlier period Efram Sera-Shriar, *The Making of British Anthropology, 1813–1871* (London: Pickering and Chatto, 2013). Arturo Alvarez Roldán has demonstrated the extent to which Haddon brought a scientific biological method to the emergent anthropology in "Looking at Anthropology from a Biological Point of View: A. C. Haddon's Metaphors on Anthropology," *History of the Human Sciences* 5:4 (1992): 21–32.

11. Alfred C. Haddon, *History of Anthropology* (London: Watts & Co., 1910), 153.

12. Alvarez Roldán, "Looking at Anthropology."

13. For an important discussion of "excess" in relation to anthropology, race, and photography, and from which I draw in my usage of the term, see Deborah Poole, "An Excess of Description: Ethnography, Race, and Visual Technologies," *Annual Review of Anthropology* 34 (2005): 159–79.

14. See Pinney, *Photography and Anthropology*, 17–62.

15. See Elizabeth Edwards, *Raw Histories: Photographs, Anthropology, and Museums* (Oxford: Berg, 2001), 27–50; Christopher Pinney, "Introduction," in *Photography's Other Histories*, ed. C. Pinney and N. Peterson (Durham: Duke University Press, 2003), 3.

16. Christopher Pinney, 'What Is It to Do with Photography?' in *Photography's Orientalism: New Essays on Colonial Representation*, ed. Ali Behdad and Luke Gartlan (Los Angeles: Getty Research Institute, 2013), 34.

17. John Lamprey, "On a Method of Measuring the Human Form," *Journal of the Ethnological Society*, n.s. 1 (1869): 84–85. This paper, with its tipped-in albumen prints, was the first photographic illustrated paper published in anthropology. On Huxley, see Edwards, *Raw Histories*, 131–55.

18. Stocking, *After Tylor*, 95.

19. For an extensive discussion of the nature of "facts" see Mary Poovey, *A History of the Modern Fact: Problems of Knowledge in the Sciences of Wealth and Society* (Chicago: University of Chicago Press, 1998). See also Lorraine Daston and Peter Galison, *Objectivity* (London: Zone Books, 2007).

20. See, for instance, Donald Tayler, "Very Lovable Human Beings: The Photography of Everard im Thurn," in *Anthropology and Photography*, ed. Elizabeth Edwards (New Haven: Yale University Press, 1992), 187–92; Amy Cox, "Purifying Bodies, Translating Race: The Lantern Slides of Sir Everard im Thurn," *History of Photography* 31, no. 4 (2007): 348–64; Satadru Sen,

"Savage Bodies, Civilized Pleasures: M. V. Portman and the Andamanese," *American Ethnologist* 36:2 (2009); Elizabeth Edwards, "Performing Science: Still Photography and the Torres Strait Expedition," in *Cambridge and the Torres Strait*, ed. A. Herle and S. Rouse (Cambridge: Cambridge University Press, 1998), 106–35.

21. Annelise Riles, introduction, "In Response," in *Documents: Artifacts of Modern Knowledge* (Ann Arbor: University of Michigan Press, 2006), 6, 11; Kirsten Hastrup, "Getting It Right: Knowledge and Evidence in Anthropology," *Anthropological Theory* 4, no. 4 (2004): 456; Poole, "An Excess of Description," 163.

22. Bruno Latour, "Visualization and Cognition: Thinking with Eyes and Hands," *Knowledge and Society* 6 (1986): 1–40.

23. Alfred C. Haddon, "Photography," in *Notes and Queries on Anthropology*, 3rd ed. (London: BAAS, 1899), 240.

24. As Pinney has famously argued, anthropology and photography have parallel histories. See Christopher Pinney, "The Parallel Histories of Anthropology and Photography," in *Anthropology and Photography 1860–1920*, ed. E. Edwards (New Haven: Yale University Press, 1992), 74–95.

25. M. V. Portman, 'Photography for Anthropologists," *Journal of the Anthropological Institute* 15 (1896): 76.

26. Portman, "Photography for Anthropologists," quoting C. H. Read, Keeper of British and Medieval Antiquities at the British Museum and one of the editors of *Notes and Queries*. At this date Read's department had ethnographic material under its care. Ethnography was not an entirely separate department in the museum until 1946.

27. In the scramble for disciplinary recognition, folk studies in Britain were increasingly marginalized as descriptive and antiquarian. They never managed to acquire the academic respectability, status, and gravitas of other disciplines at the level achieved by their US and mainland European counterparts.

28. See, for instance, Jennifer Tucker, *Nature Exposed: Photography as Eyewitness in Victorian Science* (Baltimore: Johns Hopkins University Press, 2005).

29. For an exploration of the role of photography in the building of this anthropological power base in the nineteenth century, see Roslyn Poignant, "Surveying the Field of View: The Making of the RAI Photographic Collection," in *Anthropology and Photography 1860–1920*, ed. E. Edwards (New Haven: Yale University Press, 1992), 42–73.

30. For detailed consideration of the origins, development, and effect of the four editions of *N&Q* published between 1870 and 1920 and their relationship to earlier questionnaires, see Urry, "*Notes and Queries on Anthropology* and the Development of Field Methods." There were also a series of questionnaires dating from the early nineteenth century onwards that anticipate aspects of *N&Q* in the management of observation; see Sera-Shriar, *The Making of British Anthropology*, 53–79. Similar statements and questionnaires can be found in other scientific traditions, for instance in French and German anthropology, reflecting the methodological preoccupations of those traditions. See Nélia Dias, "Photographier et mesurer: les portraits anthropologiques," *Romantisme* 84 (1994): 37–49; Georg Neumayer, *Anleitung zu wissenschaftlichen Beobachtungen auf Reisen* (Berlin: Robert Oppenheim Verlag, 1875).

31. Significantly *N&Q* was published at a moment of methodological and observational consolidation within British anthropology after the "schism" of the 1860s (Sera-Shriar, *The Making of British Anthropology*, 173–76).

32. See for instance Lorraine Daston and Peter Galison, "Images of Objectivity," *Representations* 40 (Fall 1992): 82.

33. "Introduction," *N&Q*, 1st ed. (London: BAAS, 1874), iv (added emphasis).

34. Stocking, *After Tylor*, 95.

35. Im Thurn went on to have a distinguished colonial service career, ending up as governor of Fiji and high commissioner for the Western Pacific, 1904–11. See R. Daziell, "Everard im Thurn in British Guiana and the Western Pacific," in *Writing, Travel and Empire*, ed. P. Hulme and R. McDougall (London: I. B. Tauris, 2007), 97–117.

36. These lantern slides are now in the National Museums of Scotland, Edinburgh. For a useful account of the lantern slide lecture and its racial and moral discourses, see Cox, "Purifying Bodies."

37. Im Thurn, "Anthropological Uses of the Camera," 184.

38. See Tayler, "Very Lovable Human Beings"; for critiques of that position see Cox, "Purifying Bodies"; Pinney, "Parallel Histories," 78.

39. Im Thurn, "Anthropological Uses of the Camera," 186.

40. Indeed, Dammann's album includes some carte de visite photographs of Arawak and other Carib peoples, in all likelihood the kind of photographs, if not the very photographs, im Thurn described as resembling "badly stuffed animals." See Elizabeth Edwards, "'Photographic Types': The Pursuit of Method," *Visual Anthropology* 3, no. 2–3 (1990): 239–58. See also Poole, "An Excess of Description," 164.

41. Grimshaw, *The Ethnographer's Eye*, x–xi.

42. Im Thurn, "Anthropological Uses of the Camera," 184.

43. See Edwards, "Visualising Science," in *Anthropology and Photography 1860–1920*, edited by E. Edwards (New Haven: Yale University Press, 1992), 108–21; Tomas, "Tools of the Trade," 75–108.

44. Man's photographs are to be found in, for example, the anthropological museums in London, Oxford, Vienna, Berlin, and Hamburg.

45. Christopher Pinney, *Camera Indica* (London: Reaktion, 1997), 68.

46. The anthropometric photographs were undertaken with W. Molesworth, a surgeon-captain in the Indian Medical Service. The following year, Portman and Molesworth published a substantial compendium of anthropometric photographs and related data, rendered systematically on forms and grids. The anthropometric data, in particular, were integrally connected to systems of colonial control (see Sen, "Savage Bodies"). This particular series is, however, beyond the scope of this paper.

47. There are some twenty-six volumes of Portman material at the British Museum, mainly photographs, and substantial collections in the British Library. http://www.andaman.org/BOOK /app-g/textg.htm#britlib (accessed 3 September 2010).

48. Portman, "Photography for Anthropologists," 76 (added emphasis).

49. Portman, "Photography for Anthropologists," 77.

50. Portman, "Photography for Anthropologists," 77.

51. Portman, "Photography for Anthropologists," 76 (added emphasis).

52. Sen, "Savage Bodies," 371.

53. Pinney, "What Is It to Do with Photography?," 34.

54. David Tomas, "Tools of the Trade: The Production of Ethnographic Observation in the Andaman Islands 1858–1922," in *Colonial Situations*, ed. George Stocking (Madison: University of Wisconsin Press, 1991), 93.

55. For the emergence of a modernist anthropology and its visual practices, see Grimshaw, *The Ethnographer's Eye*, 15–31; Urry, "*Notes and Queries on Anthropology* and the Development of Field Methods in British Anthropology."

56. Haddon, like many of his generation, trained in the natural sciences; indeed, it is Haddon, trained as a zoologist and biologist, who is credited with the introduction of the word "fieldwork" into anthropology's lexicon. George W. Stocking Jr., *The Ethnographer's Magic* (Madison: University of Wisconsin Press, 1983), 27.

57. It should be noted that many of the expanding photographic technologies available to amateurs from about 1890 were unsuitable for use in tropical or hot and dry environments. It is for this reason that all three authors devote a considerable amount of space to the discussion of technical matters. Portman, for instance, abhorred handheld cameras for their lack of clarity, and found early film negatives impossible to dry in humid conditions. Likewise early ciné film was difficult and fragile in such conditions.

58. Kuklick, "The British Tradition," 56.

59. Kirsten Hastrup, "Getting It Right: Knowledge and Evidence in Anthropology," *Anthropological Theory* 4:4 (2004): 456.

60. Haddon, "Photography," *N&Q*, 3rd ed., 239.

61. Some four and a half minutes of this film survive, showing fire making and, famously, the reenacted *Malu Bomai* ceremony. See Griffiths, *Wondrous Difference*, 131–48. Clips can be seen at http://aso.gov.au/titles/historical/torres-strait-islanders/notes/ (accessed 13 October 2014). On film, see Mitman, chapter 6, this volume.

62. Haddon, "Photography," *N&Q*, 3rd ed., 238.

63. Haddon, "Photography," *N&Q*, 3rd ed., 240.

64. Haddon, "Photography," *N&Q*, 3rd ed., 240.

65. Jude Philp, "'Embryonic Science': The 1888 Torres Strait Photographic Collection of A. C. Haddon," in *Woven Histories, Dancing Lives: Torres Strait Islander Identity, Culture, and History*, ed. R. Davies (Canberra: Aboriginal Studies Press for the Australian Institute of Aboriginal and Torres Strait Islander Studies, 2004), 93. Relevant to my argument here, Philp also argues convincingly that almost all Haddon's 1888 field photographs were more about Torres Strait history, a visually excavated past, than about the present.

66. Philp, "Embryonic Science," 93.

67. Haddon, "Photography," *N&Q*, 4th ed., 269.

68. Haddon, "Photography," *N&Q*, 4th ed., 270.

69. Haddon, "Photography," *N&Q*, 4th ed., 270.

70. Haddon, "Photography," *N&Q*, 4th ed., 271.

71. W. H. R. Rivers was trained as medical doctor and became an experimental psychologist. Interested in the relations of mind and body, he was responsible for some of the first scientific experiments in cross-cultural psychology, which deeply informed his anthropological method. He is most famous for his work with neurological disorder and trauma during World War I. For an account of Freire-Marreco, amongst the first women to undertake anthropological fieldwork, see Mary Ellen Blair, *A Life Well Led: The Biography of Barbara Freire-Marreco Aitken, British Anthropologist* (Santa Fe, NM: Sunstone Press, 2008).

72. C. H. Read, "Preface," in *Notes and Queries on Anthropology*, 4th ed. (London: Royal Anthropological Institute, 1912), iv.

73. Read, "Preface," *N&Q*, 4th ed., iv.

74. For a discussion of these influences in *N&Q*, see Urry, "*Notes and Queries on Anthropology* and the Development of Field Methods," 51. For a more general discussion of the British anthropology in the period and the influence of Rivers, see Kuklick, "The British Tradition," 52–78.

75. Kuklick, "The British Tradition," 65. This assessment, however, carries something of the "foundation myth" to it. Malinowski's field methods are at least partially anticipated in the work of Haddon, Rivers, Baldwin Spencer, and Diamond Jenness.

76. Martha McIntyre and Maureen MacKenzie, "Focal Length as an Analogue of Cultural Distance," in *Anthropology and Photography*, ed. E. Edwards (New Haven: Yale University Press, 1992), 158–63; Michael Young, *Malinowski's Kiriwina: Fieldwork Photography 1915–1918* (Chicago: University of Chicago Press, 1999), 19–20.

77. Portman, "Photography for Anthropologists," 80.

78. Portman, "Photography for Anthropologists," 81.

79. Grimshaw, *The Ethnographer's Eye*, 3.

80. Poole, "An Excess of Description," 166.

81. Urry, "*Notes and Queries on Anthropology* and the Development of Field Methods," 49.

82. Kuklick, "The British Tradition," 65.

83. Im Thurn, "Anthropological Uses of the Camera," 188.

84. Portman, "Photography for Anthropologists," 76–77; Haddon, "Photography," *N&Q*, 3rd ed., 236.

85. This, of course, is usually positioned in terms of the Malinowskian crystalization of the second decade of the twentieth century.

86. In addition to the film, Haddon's team also made wax cylinder sound recordings. These can be accessed through the British Library Sound Archive.

87. *N&Q*, 5th ed., 379.

88. *N&Q*, 5th ed., 379.

89. Marcus Banks and J. Ruby, "Introduction: Made to Be Seen," in *Made to be Seen: Historical Perspectives in Visual Anthropology*, ed. M. Banks and J. Ruby (Chicago: University of Chicago Press, 2011), 6; Alison Griffiths, *Wondrous Difference: Cinema, Anthropology, and Turn-of-the-Century Visual Culture* (New York: Columbia University Press, 2002), 127–70.

90. Griffiths, *Wondrous Difference*, 156–57.

91. See, for instance, Martin Jay, "Photo-unrealism: The Contribution of the Camera to the Crisis of Occularcentrism," in *Vision and Textuality*, ed. Bill Readings and Stephen Melville (London: Macmillan, 1995), 344–60.

92. See for instance Young, *Malinowski's Kiriwina*; Christopher Morton, "The Initiation of Kamanga: Visuality and Textuality in Evans-Pritchard's Zande Ethnography," in *Photography, Anthropology, and History*, ed. C. Morton and E. Edwards (Farnham: Ashgate, 2009), 119–42; Haidy Geismar, "The Photograph and the Malanggan: Rethinking Images on Malakula, Vanuatu," *Australian Journal of Anthropology* 20, no. 1 (2009): 48–73.

93. Bronislaw Malinowski, *Coral Gardens and Their Magic*, vol. 2 (London: Routledge and Kegan Paul, 1932), 461.

94. Engelke, "The Objects of Evidence," S3.

95. Grimshaw, *The Ethnographer's Eye*, 19–20.

96. Haddon, "Photography," *N&Q*, 3rd ed., 271.

97. This advice was repeated in the 1929 fifth edition of *N&Q*, demonstrating the centrality of this concept in the production of photographic documents. It should be noted that recent work in history of visual anthropology has increasingly reembodied the photographer through the detailed analysis of the spatial dynamics of photographs. See, for instance, Christopher Morton, "Indigenous Agency and Fieldwork Photography," unpublished workshop paper, 2009.

98. James Clifford, *The Predicament of Culture* (Berkeley: University of California Press, 1988), 22. See also Elizabeth Edwards, "Tracing Photography," in *Made to be Seen: Perspectives on the History of Visual Anthropology*, ed. J. Ruby and M. Banks (Chicago: University of Chicago Press, 2011).

99. Tucker, *Nature Exposed*, 7.

100. Engelke, "The Objects of Evidence," S2.

101. Malinowski, *Coral Gardens and Their Magic,* 461. Likewise, E. Evans Pritchard, who worked in Sudan in the 1920s and '30s, deposited his visual archive at Pitt Rivers Museum University of Oxford in the 1960s after they had effectively fulfilled their useful life. A similar pattern marks the donation of photographs from an anthropologist of Southern Africa, Isaac Schapera, to the Royal Anthropological Institute.

102. Riles, *Documents*, 7.

103. George W. Stocking Jr., "What's in a Name: The Origins of the Royal Anthropological Institute," *Man* n.s. 6, no. 3 (1971): 386. These controversies were concerned with the negotiation of monogenesis and polygenesis and about the relations between biology and culture.

104. See Edwards, "Tracing Photography."

105. Engelke, "The Objects of Evidence," S1.

106. Grimshaw, *Ethnographer's Eye*, 25.

107. Paul Connerton, *How Societies Remember* (Cambridge: Cambridge University Press, 1989), 13; Pinney, *Photography and Anthropology*, 15.

A Journey without Maps:
Film, Expeditionary Science, and the Growth of Development

GREGG MITMAN

Almost a decade ago, I learned of a private collection of expedition film that had been digitally restored: approximately four hours of raw footage, documenting the travels and encounters of an eight-member scientific team from Harvard University in the interior region of Liberia and the Belgian Congo in 1926. It was a rare find—a phrase suggestive of how central collection and extraction are to the practices of history, science, and film. Rare enough, in fact, that the *New York Times* found it worthy of an article, published in the spring of 1999. "Oh, no, Uncle Hal! Not the expedition movies again!" opened the article, which described the attic-like hunt for documents, photographs, and motion pictures that a nonprofit filmmaking company had embarked on in their quest to make a film about Harold Jefferson Coolidge, a Boston Brahmin, Harvard primatologist, and leader in the international conservation movement. Among all the expeditions Coolidge had accompanied in the 1920s and 1930s, the Harvard African Expedition to Liberia and the Belgian Congo, where Coolidge bagged his first gorilla, was most cloaked in mystery.[1]

Within a matter of months, I found myself asked to serve as a scholar-consultant on the film project. Twice I agreed; twice I washed my hands of it: all the ethical and political challenges that haunt expeditionary footage—including questions of collaboration, power, exploitation, objectification, and racism—seemed insurmountable. Yet, as I lost interest in the documentary to be made, I found myself drawn, more and more, to the film document itself.

"Every image of the past that is not recognized by the present as one of its concerns threatens to disappear irretrievably," wrote Walter Benjamin.[2] While the ghosts of "cinema's collusion with colonialism" haunt this footage, they are not the only spirits that live there.[3] The footage, as archive, embodies more than the objectifying gaze of science, more than an indictment of anthropology,

and to this we might add, all field science, as, in the words of Jean Rouch, "the eldest daughter of colonialism."[4] In the reaction between chemicals and light, a material trace of life, in movement and abundance, is left. It is the abundance of life—of people and landscapes transformed by an expedition on the move— that haunts me. It is an abundance filled with potentiality: of a landscape to be transformed; of economies, material flows, and livelihoods set in motion; of a contested path to development; and of a film never made. The shooting and later viewing of this expeditionary footage altered—physically, economically, and socially—landscapes and lives. As an object, resurrected and put into circulation once again, after being dead to the world for more than fifty years, it has, in the words of philosopher Michael Polanyi, "the power for manifesting itself in yet unthought ways."[5]

In the last decade, film historians have opened up the relatively uncharted territory of early nonfiction film. And, in doing so, they have broken free from the origin stories of past luminaries—Robert Flaherty, John Grierson, and Pare Lorentz, among others—in which the history of nonfiction film moved along a predetermined course to become the art of documentary.[6] The sheer volume of newsreels, lecture films, and scientific footage, which Grierson condescendingly referred to as "plain descriptions of natural material," that exists in archives around the world suggest that we haven't quite grasped what drove this impulse to document the world. Already a part of the 1898 Cambridge Torres Strait Expedition, still and moving pictures had become thoroughly ingrained into the practices of expeditionary science by the 1920s. Indeed, almost every expedition undertaken on behalf of the American Museum of Natural History after the First World War, from William Douglas Burden's 1926 expedition to the Dutch East Indies in search of the Komodo dragon to Roy Chapman Andrews' hunt for fossil dinosaurs in the Gobi desert, included a film and photographic record of landscapes, wildlife, and the customs and daily life of people encountered along the way.[7] Sometimes the aspirations of industrialists and scientists combined. Citroën sponsored three expeditions across the Sahara, central Africa, and Asia in motor cars, accompanied by geographers, archaeologists, and cameramen documenting on film the physical and economic geography, ancient monuments, and ethnic groups in remote regions of the world. As Sir Percy Cox, president of the Royal Geographic Society, observed, the films were advertisements and testimony to the combined power of science and industry in "bringing various remote and uncivilized portions of the world within the purview and reach of civilization, not only in the interests of" Citroën, but "in the interests of science generally."[8] Citroën's expeditions, like the Harvard African Expedition, undertaken on behalf of the Firestone Tire and Rubber Company, are suggestive of film's place

in expanding the global economic reach of science and industry in the wake of the First World War. This essay embarks on a cinematic journey that follows the extracts of an expedition and of the many lives of a film never made. It is a journey attentive to the structures of political economy, social relations, and scientific practices through which this expeditionary footage came into being and to the vitality of film as both a material object and cultural artifact, created for one purpose, archived for another, and resurrected yet again for quite different reasons.

Documenting the World

In preparing an eight-month expedition to Liberia and the Belgian Congo, Richard Strong, director of Harvard's Department of Tropical Medicine, faced the most practical of questions: how best to allocate time, resources, and labor? Expeditions are, quite literally, weighty affairs, and the Harvard African Expedition was no exception. Devoting one person out of an eight-member team exclusively to take motion pictures and photographs for almost an entire year was no inconsequential decision. Consider the weight of equipment alone. The film stock was transported in 100-foot lots, 500 feet to one large tin. Eight tins, 4,000 feet, packed in a wooden box made up a 60-pound load, the maximum weight for a single porter. Loring Whitman, the Harvard African Expedition's official photographer, shot over 7,500 feet of film and nearly 600 photographs in Liberia. Two porters were needed to carry the film stock alone. Furthermore, this was but a small fraction of the resources and labor required for shooting in the field. And labor was in short supply. The bulk of photographic equipment was in chemicals. Developing film would prove an immense challenge in a country where relative humidity ranges from 90 to 100 percent in the rainy season, and where average rainfall along the coast can reach 200 inches per year. Frogs and mud in developing trays, film hung out to dry for days on end, rusted and mildewed cameras were just a few of the obstacles Whitman would encounter. Why, then, the investment in a film document?[9]

By the 1920s, travel and film, as film historian Paula Amad notes, had become "two of the most modern forms of experiencing the world."[10] In the wake of the Treaty of Versailles, the world appeared rich not only in experiences, but also in valuable natural resources, to enterprising Americans. The Great War had ushered in a new geopolitical era and placed the United States, more squarely than ever before, in the center of emerging international politics in a colonial world. Among members of the Council on Foreign Relations, and in the pages of its journal, *Foreign Affairs*, a liberal American foreign policy was

crafted in the 1920s that linked American global ascendancy, not to territorial expansion, but to economic and cultural dominance abroad.[11]

Film helped to usher in this new global economic reach. The consumption of the world through images and through natural resources went hand-in-hand. The popularity and commercial success of travelogue-expedition films in the '20s—from *Chang* to *Simba*—offered middle-class white Americans a tourist experience of foreign lands and peoples, and a thinly veiled justification of what "backward" countries might become through the investment of American capital, science, and medicine. "Marshaling the objective facts about places, regions, and countries," geographer Neil Smith argues, became a central strategy of a liberal internationalism in the 1920s that would "facilitate efficient policies of resource development, social and economic change, foreign policy, and the like."[12] In this geoeconomic view, which imagined the globe, in the words of geographer Mona Domosh, "as borderless, enabling the smooth ride of capital around the world" and American commercial expansion as benevolent, "facts of the land" from which companies could glean information about regions, resources, and trade potential became paramount.[13]

Documenting the world through photography and film was an instrumental part of this emerging geoeconomic view. In the 1927 film *General Motors around the World*, for example, made by seven camera crews who traveled more than 100,000 miles, dots on a map come to life, revealing to audiences the markets to be had—from the busy streets of Osaka, Japan, to the rugged roads of Lima, Peru—in the expansion of General Motors overseas trade.[14] Similarly, when the physician and Harvard African Expedition member George Shattuck edited the 1935 edition of the Harvard Traveler's Club *Handbook of Travel*, which included a number of chapters on hygiene, natural history collecting, and other subjects written by Shattuck's Liberian travel companions, he included a lengthy chapter on still and motion picture photography with a focus on the tropics. Designed as an indispensable guide for the "intelligent" traveler, the *Handbook of Travel* was to make the "casual pleasure trip of permanent and real value" through the "gathering of objects and facts."[15] With the introduction of Bell & Howell's spring-driven 35 mm Eyemo motion picture camera in 1925, the preferred choice of the Harvard African Expedition, the collecting of facts about people and the land became possible, even for amateurs like Whitman, a first-year medical student and head photographer for Harvard's student newspaper, *The Crimson*.

During the 1920s, before documentary as a self-defined genre had come into being, multiple ways of seeing were at play in the field. In shots that Whitman took of expedition members with their pets, we see stylistic conventions that had come to characterize the evolving tradition of commercial

travelogue-expedition films. We also know from correspondence that Strong sought out the advice of Terry Ramsey, who had edited and titled Martin and Osa Johnson's blockbuster, *Simba*, to further his hopes of turning the "raw" footage of Liberia into a "creative treatment of actuality."[16]

But Whitman's films never became part of either the economy or the history of the motion picture industry. In the late 1920s, they circulated among a network of white, wealthy, mostly Harvard-educated physicians, scientists, politicians, and business leaders—at luncheons of the Harvard Traveler's Club, trustee meetings of the American Museum of Natural History, and private gatherings of the Round Table in St. Louis, where travel, business, and adventure were subjects of the day.[17] These networks of viewers were the same power networks that extended the reach of American business into Africa and Latin America in the 1910s and 1920s. Later, the films survived only as home movies. Loring Whitman's son recalls how his father would treat the family on special occasions to a showing of some of his African movies, before they were put into family storage for over fifty years. The footage is thus both artifact and evidence of how the logic and interests of commerce, science, and travel shaped observational modes of seeing as the expedition moved through the Liberian landscape.

Since its inception in 1913, Harvard's Department of Tropical Medicine was indebted to the financial backing of individuals like William Cameron Forbes, former governor general of the Philippines and chairman of the board of United Fruit Company, and Edward Atkins, a major investor behind the transformation of the Cuban sugar cane industry. Indeed, in a letter written to Forbes in 1915, Strong referred to the work of the department as "something in the nature of a trust."[18] It was an apt description. Almost every expedition Strong led to Latin America in the 1910s and 1920s as department head and director of the Laboratories of the Hospitals and of Research Work at United Fruit was aimed at securing "exact information concerning tropical America, one of the few large areas of the world now awaiting development." And film was already becoming an instrumental part of American commercial and scientific expansion in the tropics. Oakes Ames, Harvard professor of economic botany, expressed his opinion to Strong in 1915 that the "moving picture machine" was the only way to satisfactorily educate students in the "operations of sugar production, the manufacture of tea," and other commercial processes in the tropics that they hoped to teach in courses that would eventually become part of Harvard's Institute of Tropical Biology and Medicine.[19] The documentation of "raw materials into consumable goods," as Tom Gunning notes, had become a staple of actuality films prior to World War I, and enacted a basic narrative of industrial capitalism. Such subjects

continued to be important in scientific and industrial film, long past the elevation of documentary to a high art form by Grierson and others in the 1920s.[20]

Even before Strong and his colleagues set foot in Liberia, before Whitman picked up his camera and exposed the first roll of film to the tropical sun, certain ways of looking structured how the expedition moved across the landscape and altered the lives of people in its path. And it was a view bound to a new geoeconomic imagination made possible by the opening of the Panama Canal and the ascendancy of American economic expansion in the aftermath of the Great War.

Surveying the Field

In the fall of 1923, in a confidential memo now located in the Strong archives, C. F. Baker, dean of agriculture at the University of the Philippines, alerted the Hon. W. Cameron Forbes to a situation that would set in motion the Harvard African Expedition: "The United States is now using more than a billion dollars gold worth of tropical products per year, and many of these products are essential in basic industries . . . The most important of all these products . . . is rubber."[21]

Americans owned 85 percent of the world's automobiles in the early 1920s, and consumed 75 percent of the world's rubber supply, 80 percent of which went into automobile tires. Yet the United States grew only 1 percent of the world's rubber under its flag. Britain, which controlled 77 percent of the world's rubber production, had a virtual monopoly on the industry. In 1923, under pressure from Harvey Firestone, the U.S. Congress appropriated $500,000 to survey and find suitable growing areas in the world to break American dependence on Britain's control of the world rubber trade. "American oil men had been prospecting and operating in foreign lands for years," argued Firestone, "but the rubber industry has been backward in caring for its own needs."[22] Although Firestone initially set his sights on the Philippines as the place to grow rubber under the American flag, immigration law and property restrictions there quickly dashed those hopes. Firestone subsequently turned to Liberia. By 1925, three separate agreements granting Firestone rights to an old British rubber plantation at Mt. Barclay for experiments in rubber production, a ninety-nine-year lease of up to one million acres of rubber-producing land, and a $300,000 commitment by the Liberian government to improve the harbor in Monrovia were making their way through the U.S. State Department. It was at that moment that Richard Strong, on his own initiative, showed up at Firestone's doorstep.[23]

Significant natural, cultural, and political obstacles stood in the way of Firestone's success in Liberia—not the least of which included endemic human and plant diseases that threatened labor production and the healthy survival and growth of imported rubber plants. Strong had spent the better part of a decade studying tropical diseases in Latin America in the interests of United Fruit. Africa proved a new challenge to American commerce and medicine. Within six months after his meeting with Firestone, Strong had organized an eight-member team that included some of the best minds in medical entomology, tropical medicine and botany, mammalogy, and parasitology to conduct a four-month biological and medical survey of Liberia, along with travel to the Belgian Congo for comparative purposes.

Although territorial maps, wedded to a geopolitical view of empire, had been central to the surveying enterprises of nineteenth-century scientific expeditions, their production and usefulness were becoming antiquated to the field sciences and to an emerging view of economic imperialism.[24] Not a single accurate map existed for the interior of Liberia when Strong began organizing the expedition. The best the U.S. State Department could come up with was an unpublished, "unreliable" 1916 map prepared by the War College Division. It was a map the British novelist Graham Greene described in his own Liberian travelogue as so "inaccurate—large blank spaces were filled with the word 'Cannibals'—that it would be useless, perhaps even dangerous, to follow." No one on the expedition was trained in geography, and not a single person had extensive mapping or survey experience. And yet they journeyed for more than seven hundred miles in Liberia through dense tropical jungle on foot and along trails and uncompleted roads with but a compass, pedometer, and porters as surveying instruments and guides, yet burdened themselves with cameras, tripods, and film.[25]

The motion picture camera had displaced the surveyor's theodolite on the Harvard African Expedition, as it had elsewhere across the globe. In the creation of Britain's Empire Marketing Board in 1926, for example, films, not maps, were the tools enlisted to promote scientific research and economic development in the British colonies. They were evidence of a changing world. As Thomas Baird, of the EMB's film unit remarked, "Schools were teaching geography very well with maps, globes, and wall pictures," but they had "no instrument of observation which could provide the basis for discussion of the vital issues of modern life."[26] "The patient and laborious accumulation of facts, the skillful enlistment of scientific research, and economic investigation" were all critical, argued the secretary of the EMB, to a new "biological conception of government" emerging in the interwar years that saw living people, not "in terms of machinery and organization," but in "terms of growth

and nurture." Ecology and tropical medicine—aided by the motion picture camera and the microscope—became the new agents of economic empires.[27]

The survey of tropical environments, and their transformation into productive lands, required a different cartography from the mapping of territory and conquest. This was a cartography of populations and processes. Surveying economy, both natural and human, dictated a different mode of observation than mapping physical space. The expedition moved through particular landscapes, surveying, sampling, and transforming them. Movement was, after all, the principle of development that guided expanding economies, living organisms, and, one might add, film technology. The motion picture camera, like the expedition, and American capital, was always on the move. Journeying up the Du River, or panning across the landscape—and such pans are numerous in the surviving footage—the viewer becomes part of an unfolding landscape.

In this journey without maps, a view of a movement forward in time, rather than backward, prevails. The mission of the camera on the Harvard African Expedition is not one of salvage ethnography. If it is a record of the past, it is only out of service to the future. A discourse of development, of envisioning what a landscape and people will become, is pervasive in Strong's diaries and official record of the expedition. Through the vision of Harvey Firestone and the promise of science and medicine, "a new era of prosperity in the development of the country and the welfare of its people as a whole" awaited Liberia, wrote Strong.[28] The motion picture camera captured more effectively than any static map or still photograph this anticipation of what lay ahead. When Whitman climbed atop a "hill in back of camp" at Firestone Plantation #3 to get a "bird's eye view of things," he was witness to a landscape in transition (figure 6.1). "It is rather remarkable to realize that this whole clearing was virgin forest in November," he wrote in his journal. In the juxtaposition of Plantation #3 footage against similar panoramas of the Liberian jungle, the viewer senses what Liberia will become.[29] At about the same time, Firestone sponsored its own motion picture expedition to provide "educators and students" a "moving panorama" that was a "living record" of Liberia's "changing world."[30]

By the 1920s, film had come to play an instrumental role in the visualization of life, from the cellular features of the microscopic world to the panoramic view of ecological communities. We should be careful, as Hannah Landecker reminds us, not to decouple scientific, cinematic, and, I would add, economic practices from one another. Film's affinity for life itself became a focus of attraction and contemplation.[31] Henri Bergson's vitalism, which so informed Siegfried Kracauer's association of film with the "flow of life's rendition of the

FIGURE 6.1. Large-scale clearing for the Firestone plantations, capturing a "birds-eye view" of a land-scape in transition. Loring Whitman. 6 August 1926. Courtesy of Indiana University Liberian Collections.

everyday," was itself beholden to turn-of-the-century life sciences, and to a philosophy, not of machines, but of living beings.[32] Bergson rejected a mechanical notion of time as a series of discrete, divisible moments—captured in the still plates of Étienne-Jules Marey's chronophotograph. Time was instead an endless flow. "Duration," Bergson wrote, "is the continuous progress of the past which gnaws into the future and which swells as it advances."[33] Here was an organic notion of time and development, one that echoed across the human and life sciences. This penchant for organicism was coupled, I suggest, with what visual anthropologist Elizabeth Edwards describes as "expansive visualizations" where the control of excess in the visualization of the object of study gave way to an engagement with abundance, the scientific potential of the messiness of everyday human existence.[34]

The practices of looking at work on the Harvard African Expedition give us a glimpse into a vision of development coming into view. Reordering the abundance of life in the tropics into a new path of development and into a new integrated economy of nature and nation through tropical biology and medicine was Strong's mission. But while he saw the luxuriousness of life in Liberia as its greatest asset, it was also, in his view, its greatest impediment to progress. As they moved from village to town, Strong and his colleagues were continually on the watch for tropical diseases. The following account from Strong's diary is a description of a typical day:

I went to Congotown Saturday . . . The inhabitants live in either mud thatched houses or palm thatched houses in groups of a dozen or so or scattered singly. I had Whitman take some pictures. I made an important finding from a medical standpoint. Among a group of people gradually collecting around us, some forty people, I noticed one girl of some 8 years of age who appeared sickly to me and I asked a woman who proved to be her foster mother (really a slave child) what was the matter with her. She said she had gravel. I gave the woman a clean bottle and told her to take the child away and get me a specimen of her urine, as from her history I suspected she might have Schistosomiasis. The woman returned several times without the specimen but finally by persistence one was obtained. This morning, after centrifuging the specimen and examining microscopically, numerous motile miracidia which had just hatched from the ova, as well as numerous lateral spined ova were found. This is our first official case in Africa and the first definite knowledge of the disease in Liberia. . . . I have asked George to get this child into one of the mission hospitals and cure her with one of our new antimony compounds. . . . In another part of the town George called my attention to a disease of the Mandioca (cassava) plants growing about the houses. . . . I took Whitman back yesterday afternoon and had him make some photographs of the diseased and healthy plants.[35]

The passage from Strong's diary and Whitman's accompanying still photographs offer a look into the medical gaze at work on the expedition, one that foregrounds the ecology of disease in the landscape (figure 6.2).

In the surveying, sampling, and objectification of life on the expedition—be it people, plants, or animals—photography and film served different ends. The medical photographs that Strong instructed Whitman to take hark back to the disciplined eye and control of visual excess so characteristic of nineteenth-century anthropometric photography.[36] Whitman's medical photographs were beholden to a static taxonomy of tropical diseases, in which the outward signs of pathology were connected visually, often on a single page, with the hidden, interior spaces of bodily tissue, where parasites such as *Onchocerca volvulus* dwelled. It constitutes a gathering of facts, not about the living, but of the soon-to-be-dead. The photographs reveal an eye searching for diseased landscapes, whereby tropical pathologies would have to be overcome, in order for Liberia's natural resources—people, plants, and animals—to be fully realized.[37] Indeed, Strong regarded the high rate and severity of malaria infection along the coast, and the prevalence of tropical diseases such as yellow fever, schistosomiasis, and onchocerciasis, among others to be among the greatest obstacles to development.

Maintaining a healthy population of workers was the greatest impediment to the commercial expansion of American industry in the tropics. This would

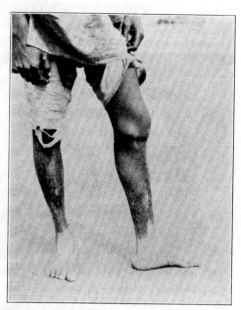

No. 182. — Tumor produced by *Onchocerca volvulus*, Case 498

No. 183. — Photomicrograph of larval form of *Onchocerca volvulus;*
moist film preparation made from cut section of tumor

FIGURE 6.2. Whitman's still photography disciplined excess in rendering a visual taxonomy of tropi-
cal disease. From Richard P. Strong, ed., *The African Republic of Liberia and the Belgian Congo, Based on the
Observations Made and Material Collected During the Harvard African Expedition, 1926–1927* (Cambridge:
Harvard University Press, 1930), vol. 1, p. 246.

be the payoff of tropical medicine. And still photography offered a catalogue of the diseases that would potentially threaten Firestone's foreign investment.

The moving pictures Whitman took, in contrast to his still photography, served quite different ends. Unlike photography, film captured the movement of life in all its diverse forms. Movement is inherent to life and development. It is also inherent to labor and capital. But without labor, the material flows necessary to set Liberia on a new path of economic growth could not be set in motion. Strong understood this well. Although raw materials were abundant in the tropics, labor was not. Liberians at work—constructing roads, weaving cotton, pounding rice—dominate the images contained in the expedition films. Why the preoccupation with people at work on a "biological and medical survey of Liberia"?

Documenting labor in the field figured into Strong's assessment of the merits of different populations as a potential workforce for Firestone. In the official published record of the expedition, Strong included a lengthy discussion of the ethnological groupings of interior Liberian peoples—Mandingo, Kru, and Gola. His valuation of different ethnic groups within what was an explicit hierarchical classification scheme was dependent on blood relations, dress, literacy, religion, and craft skills. The Vai, a subgroup of the Mandingo, were, Strong reasoned, "superior intellectually" and "one of the most progressive groups in the native population." Their knowledge of Arabic, their own written language, their skills in farming and weaving all made them, Strong wrote, "an important civilized and important civilizing element in Liberia."[38] Compare this description to what Strong had to say about Americo-Liberians, who ruled the country and lived on the coast: "the Americo-Liberians are not good agriculturalists or gardeners. Physically they are lazy . . . Nothing of any importance has been done by [them] to improve the conditions of the natives. On the other hand, much has been done which has actually retarded their development. Liberia," Strong concluded, "cannot be successfully developed without the aid of interior tribes."[39]

The visual survey of labor amassed by Whitman did more than offer up evidence for Strong's subjective valuation of ethnic groups and their potential worth for Firestone. (By 1928, 20,000 Liberian men were working 35,000 acres of Firestone rubber plantations.) The footage, taken as a whole, also offered a record of labor as a scarce commodity in the Liberian interior.

Male labor *was* in short supply. In the eastern and southern sections of Liberia, the expedition resorted to the use of women porters because of the absence of men in the villages. Thousands of men from Sinoe and Maryland counties in the southeastern part of Liberia were being shipped through coerced labor recruitment in the 1920s to work the cocoa plantations on the

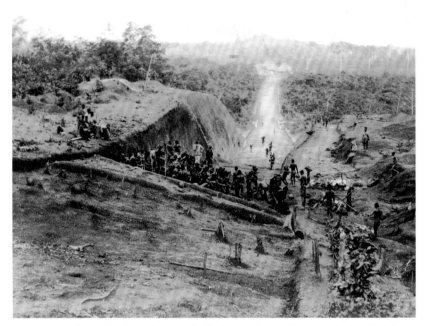

FIGURE 6.3. The motion picture footage and still photographs that Whitman took of road building in the interior became part of a documentary record Strong began to collect of forced labor practices. Loring Whitman, 28 September 1926, still photograph. Courtesy of Indiana University Liberian Collections.

Spanish island of Fernando Po. Extensive road building using corvée labor drew another estimated 6,000 men from their local villages during the same decade.[40] Marcus Garvey, leader of the Universal Negro Improvement Association and the back-to-Africa movement, lambasted the military and political supremacy of black America-Liberians "who keep the Natives poor, hungry, shelterless and naked, while they parade themselves in the tropical sun in English frock coats and evening dress."[41] Strong himself was accumulating evidence of conditions of oppression by the America-Liberian government on interior ethnic groups. The footage of road crews, women working on government farms, women in pawn, and porterage of district commissioners became part of the increasing weight of documentary evidence Strong amassed to convince U.S. government officials to take a more active stand against labor abuses in Liberia (figure 6.3).

The cascade of events, and the complex racial politics and motives that led to a 1930 investigation by the League of Nations into the existence of slavery and forced labor in Liberia, are beyond the scope of this essay.[42] Suffice it to say that Strong was deeply troubled and moved into action by these

encounters of labor abuse documented on film. Before departing from Monrovia in November 1926, Strong wrote to Assistant Secretary of State William Castle: "The original purpose of my visit to Liberia was solely to make a biological and medical survey of a little known country. The distressing conditions found to exist here, particularly in the interior, . . . have been a very great surprise to me, and I feel it has become my duty upon my return to take up with the Department of State a discussion of the situation."[43] Strong followed through on his plan. His friend and patron William Cameron Forbes arranged for Strong to be an overnight guest of President Coolidge at the White House in February 1928. It was on that occasion that Strong impressed upon President Coolidge the conditions of the people living in the interior of the country and the "excessive abuses" inflicted upon them by the government's Liberian Frontier Force, without any "redress."[44] Castle replied shortly after the meeting that the "President was most interested and that those talks have very much roused his concern for that country."[45] At the same time, Strong went public with his accusations, publishing an editorial in the *Boston Herald*, arguing that the conditions of forced labor "are not such as would receive either the approbation or the respect of the civilized world."[46] Eighteen months later, on 8 June 1929, the U.S. State Department dispatched a memorandum to the American minister in Liberia for delivery to the president of Liberia that would set the League of Nations inquiry into motion. It read: "I am directed by the Secretary of State to advise your Excellency that there have come to the attention of the Government of the United States from several sources reports bearing reliable evidence of authenticity which definitely indicate that existing conditions incident to the so-called 'export' of labor from Liberia to Fernando Po have resulted in the development of a system which seems hardly distinguishable from organized slave trade, and that in the enforcement of this system the services of the Liberian Frontier Force, and the services and influences of certain high Government officials, are constantly and systematically used."[47] As the League of Nations investigation into slavery heated up, Strong released still photos from the documentary footage of forced labor practices to the press, resulting in exposés in the *Boston Sunday Post* and the *Boston Globe* (figure 6.4).[48]

But before we resurrect this footage as a document of human rights abuses, we also need to remind ourselves of the conditions of its production. Firestone had overestimated the ease with which he could recruit a labor force to work on the plantations. His success in securing workers depended greatly upon whether the Liberian government could be pressured into abandoning its lucrative export trade in, and practice of, forced labor.[49] Strong was in Liberia, in part, to help Firestone secure a healthy labor force. He was also keenly aware of

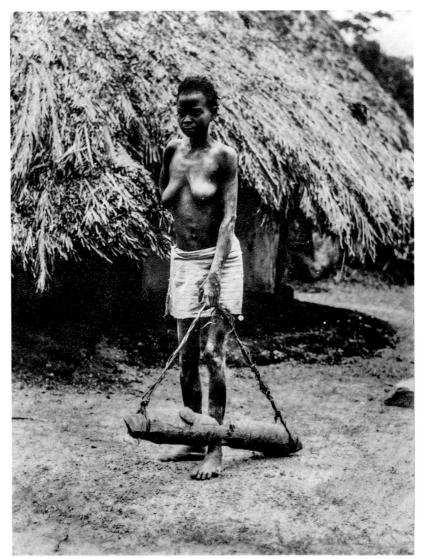

FIGURE 6.4. This still photograph of a woman in pawn, also captured on film, found its way into the *Boston Sunday Post* in Strong's effort to mobilize American support for the League of Nations investigation into slavery in Liberia. Loring Whitman, 6 September 1926. Courtesy of Indiana University Liberian Collections.

Firestone's labor needs. Although Strong may have been moved to action by what he believed to be humanitarian intentions, he himself resorted to forced labor practices. As the expedition reached Towya, a town near the southeastern Liberia coast, expedition members became desperate. Few men could be found in the villages, and those hired often ran away, abandoning their cargo.

At times, Whitman alone transported the loads across rivers that proved unmanageable for shorter women and children. When they finally secured a group of men, they tied them up with strings or vines. "It was quite a merry caravan," Whitman wrote in his diary. "Eighteen men in chains (I mean ropes) with three white men armed to the teeth—ready to shoot to kill—a pretty picture." Whitman couldn't help but reflect on how the image was not unlike "years ago when many such scenes took place," where "whites with whips and crude guns drove their way thru the forests: the slave traders."[50] But it was an image he chose not to document on film.

Intimate Resistances

Surveying the landscape for disease and labor was but a first step in the projected transformation of Liberia's people and economy. The motion picture camera documented the world of Liberia as it was—or so expedition members believed—and projected into the future an anticipation of what it might become. The narrative of development was intrinsic to the expedition's mission; it sought more than just a record, more than just a survey; it also sought to intervene. The expedition sometimes slowed its movement. At stopping points along the journey, observation and intervention intertwined. In Krutown on the outskirts of Monrovia, on Plantations # 2 and #3, in Gbarnga, and in Tappita, among other villages, medical clinics were set up, populations were sampled, and experimental drugs were given.

In these close-up encounters, where something needed to be extracted from another's life—blood, urine, tumors, or even a simple photograph—the mapping of population and processes that so informed the visual and disciplinary logic of the expedition broke down. And it broke down because "the magical fact of the camera is," as Grierson noted long ago, "that it picks out what the director does not see at all, that it gives emphasis where he did not think emphasis existed."[51] Unlike Whitman's medical photographs, so reminiscent of practices in nineteenth-century visual anthropology, where the excessive inscription of the photograph was tightly controlled to render it a scientific document, in his moving pictures, Whitman documented life in all its abundance, contingency, and resistance. Whitman's diary is full of descriptions where the expedition had to cajole people into getting pictures or samples taken. In Krutown, "we had to coax our subjects to have their spleens palpated and their ears pricked," recorded Whitman.[52] The inquiring looks of children, the fleeting stare of a woman, are reminders that extraction always entails some form of resistance (figure 6.5). And there were many layers of extraction at work on the expedition: from the taking of photographs to the harvesting

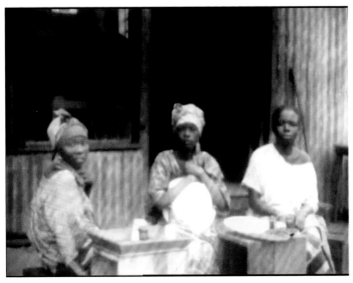

FIGURE 6.5. The fleeting stare of a woman is a reminder of the intimate resistances and lives of individual subjects present in Whitman's motion picture record. Loring Whitman, Monrovia, n.d.. Still from 35 mm Eyemo camera. Courtesy of Indiana University Liberian Collections.

of blood, tumors, and latex. The Harvard African Expedition was in Liberia, after all, in the service of American extractive industry.

In these intimate resistances, the logic that treats humans as capital—as biological reserves of rare diseases or cheap labor—is unsettled. Strong saw biological abstractions where the camera captured elements of individual human lives. The camera, as Deborah Poole suggests, had introduced "the twin menace of intimacy and contingency" in early ethnographic, and I might add, expedition film. Consequently, it also introduced "the possibility (however remote) of acknowledging the coevalness and, thus, the humanity of their [the scientists'] racial subjects."[53] Whitman never achieved, and never really tried, effacing himself from behind the camera lens. He never searched for complete transparency; the countless exchanges of looks between Whitman and his photographed subjects make that clear. Indeed, his footage resembles home movies more than an official documentary record of the Harvard African Expedition. Like other travelogues of the period, Whitman's footage often "captured moments in which interacting in the traffic of daily life takes precedence over acting in an official capacity."[54] It leaves open the possibility of recovering the stories of those individuals whose lives and the places they called home were recorded on film.

Among the 476 still photographs of people, customs, crafts, diseases, and landscapes in the published account of the expedition, only one contains a caption with an actual person's name (figure 6.6). The caption reads, "Plenyono Wolo, son of a Vai chief, and his wife." In the Harvard University archives, another photograph exists. It too, is of Plenyono Wolo, not dressed in allegedly Vai garb, but in Harvard graduation robes (figure 6.7). In the juxtaposition of these two shots—one of the basic elements of film grammar—a story, quite different from the photo caption, is set in motion.

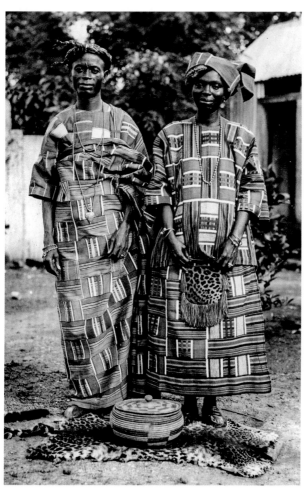

FIGURE 6.6. Plenyono Gbe Wolo dressed by Strong in a different life. Loring Whitman, 23 July 1926, still photograph. Courtesy of Indiana University Liberian Collections.

FIGURE 6.7. Plenyono Gbe Wolo in Harvard graduation robes. 1917. Pleynono Gbe Wolo Papers. Courtesy of Harvard University Archives.

Wolo was not the son of a Vai chief. He was the son of an esteemed para-mount chief of the Kru people. He was educated by American missionaries, worked his way on a boat to America, completed a B.A. with honors from Harvard University in 1917, earned an A.M. in 1919 from Teachers College, Co-lumbia University, and received a B.D. degree at Union Theological Seminary

in 1922. In 1919, he helped conduct an economic survey in Liberia for American commercial interests. Three years later, he returned to Liberia, with financial backing from a number of American patrons, including Harvard president Abbott Lawrence Lowell, to open a day school in his home village of Grand Cess. His patrons believed that Wolo, like his Harvard brethren in science, or American missionaries in finance, had returned to Liberia as an emissary of American education and religion to guide "his people" into the "acceptance of such elements of . . . civilization as are adapted to his people's psychology and situation."[55] But neither Wolo's patrons nor Strong displayed much, if any, respect or appreciation for Wolo's own motives and aspirations in returning to Liberia. To them, he was an instrument of American commercial and educational interests abroad. Correspondence among his American patrons reveals their fears that he had, upon his return, "succumbed to the drag of native inertia" or "reverted" to the ways of witch doctors and devil spirits.[56]

But Wolo had hopes and desires of his own. He had already navigated a difficult road. The Methodist missionaries he was educated by looked upon him, and other indigenous peoples of Liberia, as "children."[57] He worked his way through Harvard as a waiter in hotels and dinner clubs, reminded that the upper-class white men he served were his classmates but never his equal in their eyes. Intrigued by the plight of blacks in America, he traveled to North Carolina, working for a summer as a common laborer, to see and experience the realities of segregation in the Jim Crow South. He returned home to Liberia to confront the harsh reality that the "moral attitude of the United States toward" his country worked "chiefly for the advantage of" those in power and not for the welfare of his people. The Kru had been locked for over a century in conflict with the Americo-Liberian government, whose ruthless treatment and repressive native policies led to a Kru rebellion in 1915. The revolt was violently suppressed by the Liberian Frontier Force, backed by an American gunboat. Despite, or perhaps because of, this history, Wolo worked hard to enlist the interests of the United States government and industry in ways that would leverage greater power, educational opportunities, and economic security for the interior peoples of Liberia.[58]

Although Wolo brokered many of the arrangements in Liberia for the Harvard African Expedition, walked with Strong through the streets of Monrovia, and sat among his Harvard "brothers" at a dinner organized by the Liberian president, Charles Dunbar King, Strong never acknowledged what the camera recorded: the traces of Plenyono Gbe Wolo's individual life. Wolo's biography did not quite fit with Strong's mental and visual map of the ethnic groups of Liberia, in which the Kru people are "deemed not particularly

intelligent as a race," and are only ever displayed photographically as medical subjects.[59] Perhaps Kru was not a lineage Strong believed suited to a Harvard alum, and so, whether purposefully or born of disregard, he dressed Wolo in a different life. Indeed, it is striking how absent Wolo is from the expedition footage: two still photos and a fleeting glance of him in footage of a medical clinic in Krutown, which Wolo helped arrange, are all that exist in the documentary record the expedition left behind. But such has often been the case in expeditionary records, where the critical labor of go-betweens, instrumental in the production of scientific knowledge, is all but erased.[60]

The magic of the camera, revealed in the haunting expedition footage and still photographs, is not that it recorded an objective, scientific record of Liberia, as Strong had intended. The magic is that it recorded the expedition's own subjective valuation of life in the service of capital. And, in the abundance of life that Whitman captured on film lies the potential for multiple retellings of the lives and places silenced and erased from the official documentary record of the Harvard African Expedition.

Epilogue

What are the consequences of reanimating the life of the Harvard expedition footage, which had long been dead and forgotten? In 2012, I traveled to Liberia with the expedition footage on a laptop and an iPhone. I was accompanied by Emmanuel Urey, a member of the Kpelle people, who grew up in Liberia during a brutal fourteen-year civil war. Through a triangulation of the motion picture record with expedition diaries, we began retracing the expedition journey. We were eager to find what historical memory remained of people and places documented in the expedition footage, whose voices had been silenced, first by the expedition members themselves, and then by the ravages of war.

Everywhere we traveled, paramount chiefs, clan chiefs, elders, and local villagers clamored to watch the footage and share their stories with us. We met a paramount chief who cried upon seeing his father alive once more on film. "My heart is like my face smiling," he explained to us in Kpelle. We met women eager to reclaim the scenes of traditional weaving practices documented by the Harvard expedition as they seek to revive craft traditions in their efforts toward cultural renewal and women's empowerment. We met communities of people, like the Bassa, evicted from their ethnic homelands with the arrival of Firestone, who spoke painfully upon watching traditional dances being performed by their great grandfathers and grandmothers, of the wounds yet to heal. Even Emmanuel's father, who was around sixteen years of age

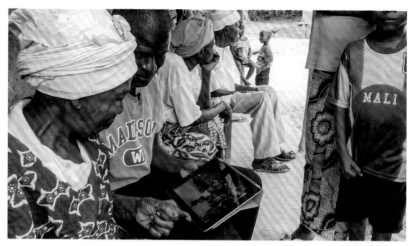

FIGURE 6.8. The many lives of the expedition footage. Upon seeing the footage, Nyamah Yarkpawolo recounts to Emmanuel Urey a story about the dancing and singing of Kpelle songs that existed before the arrival of the radio. Sarita Siegel, 25 June 2013. Still from Canon XF300.

when the expedition passed within a day's walk to his village, relived in the memory of his body the scenes of building roads by hand.

The Harvard expeditionary footage of Liberia, once a valuable scientific commodity, has thus taken on a new life in post–civil war Liberia. It is a life imbued with new cultural and historical meanings. "Once unleashed from their historical moment and original intention," as Faye Ginsburg notes in this volume, films and photographs "often promiscuously violate social and epistemological boundaries; they can move rapidly from the domain of scientific records to that of legal evidence or to the realm of personal narrative, accumulating a kind of biography in the process."[61] We do not yet know where this new life of the expedition footage will end. But we do know that in this second life, it will generate stories and future imaginings told for the first time by descendants of ancestors whose voices might come alive again and who were much more than mere objects of the expedition's scientific gaze.

Notes

1. Carey Goldberg, "Filmmakers Study a Man Who Studied Apes," *New York Times*, 23 March 1999.

2. Walter Benjamin, "Theses on the Philosophy of History," in *Walter Benjamin Illuminations: Essays and Reflections*, trans. Harry Zohn, ed. Hannah Arendt (New York: Schocken Books, 1968), 255.

3. Paula Amad, "Cinema's 'Sanctuary': From Pre-Documentary to Documentary Film in Albert Kahn's 'Archives de la Planète' (1908–1931)," *Film History* 13 (2001): 138–59.

4. Quoted in Mike Eaton, ed., *Anthropology-Reality-Cinema: The Films of Jean Rouch* (London: BFI, 1979), 33.

5. Quoted in Hans-Jörg Rheinberger, "Cytoplasmic Particles: The Trajectory of a Scientific Object," in *Biographies of Scientific Objects*, ed. Lorraine Daston (Chicago: University of Chicago Press, 2000), 294.

6. See, e.g., Paula Amad, *Counter-Archive: Film, the Everyday, and Albert Kahn's Archives de la Planète* (New York: Columbia University Press, 2010); Lisa Cartwright, *Screening the Body: Tracing Medicine's Visual Culture* (Minneapolis: University of Minnesota Press, 1995); Vinzenz Hediber and Patrick Voncerau, eds., *Films That Work: Industrial Film and the Productivity of Media* (Amsterdam: Amsterdam University Press, 2009); Daan Hertogs and Nico de Klerk, eds., *Uncharted Territory: Essays on Early Non-Fiction Film* (Amsterdam: Nederlands Filmmuseum, 1997); Karen Ishizuka and Patricia Zimmerman, eds., *Mining the Home Movie: Excavations in Histories and Memories* (Los Angeles: University of California Press, 2008); Hannah Landecker, "Cellular Features: Microcinematography and Film Theory," *Critical Inquiry* 31 (2005): 903–37; Kirsten Ostherr, *Medical Visions: Producing the Patient through Film, Television, and Imaging Technologies* (New York: Oxford University Press, 2013); Alexandra Schneider, ed., *Virtual Voyages: Cinema and Travel* (Durham: Duke University Press, 2006); Patricia R. Zimmerman, "Geographies of Desire: Cartographies of Gender, Race, Nation, and Empire in Amateur Film," *Film History* 8 (1996): 85–98.

7. See, e.g., Gregg Mitman, *Reel Nature: America's Romance with Wildlife on Film*, 2nd ed. (Seattle: University of Washington Press, 2009).

8. Joseph Hakin, "In Persia and Afghanistan with the Citroën Trans-Asiatic Expedition," *Geographical Journal* 83 (1934): 361. On film and the Torres Strait Expedition, see Alison Griffiths, *Wondrous Difference: Cinema, Anthropology, and Turn-of-the-Century Visual Culture* (New York: Columbia University Press, 2002). On the Citroën expeditions, see Peter J. Bloom, *French Colonial Documentary: Mythologies of Humanitarianism* (Minneapolis: University of Minnesota Press, 2008), 65–94.

9. Information on film stock and transport was calculated from notes in Loring Whitman's diary (hereafter LWD), courtesy of Randal Whitman, and Loring Whitman, "Photography," in *The African Republic of Liberia and the Belgian Congo, Based on the Observations Made and Material Collected During the Harvard African Expedition, 1926–1927*, ed. Richard P. Strong (Cambridge: Harvard University Press, 1930), v. 2, 1048–52. While Loring Whitman was the official photographer, Harold Coolidge also shot private "home" movies on the expedition.

10. Amad, "Cinema's 'Sanctuary,'" 143.

11. On this emerging geoeconomic view, see Neil Smith, *American Empire: Roosevelt's Geographer and the Prelude to Globalization* (Berkeley: University of California Press, 2003); Mona Domosh, *American Commodities in an Age of Empire* (New York: Routledge, 2006); Emily Rosenberg, *Financial Missionaries to the World: The Politics and Culture of Dollar Diplomacy, 1900–1930* (Durham: Duke University Press, 2003).

12. Smith, *American Empire*, 184.

13. Mona Domosh, "Geoeconomic Imaginations and Economic Geography in the Early 20th Century," *Annals of the Association of American Geographers* 103 (2013): 944–66.

14. "Auto's Varied Uses Shown," *New York Times*, 27 January 1928. See also "Auto Film Shows World on Wheels," *New York Times*, 26 January 1928; Rick Prelinger, *The Field Guide to Sponsored Films* (San Francisco: National Film Preservation Foundation, 2006).

15. Glover M. Allen, ed, *Harvard Traveler's Club Handbook of Travel* (Cambridge: Harvard University Press, 1917).

16. The phrase comes from John Grierson's definition of documentary. John Grierson, in *Grierson on Documentary*, ed. and compiled by Forsyth Hardy (London: Faber and Faber, 1966), 13.

17. See, e.g., George Shattuck to Richard Strong, 29 September 1927, E. Mallinckrodt to Richard Strong, 15 December 1927, African Expedition—Correspondence, State Department & White House Folder, box 2, Richard Pearson Strong Papers, Francis A. Countway Library of Medicine, Harvard University (hereafter RPSP).

18. Richard Strong to William Cameron Forbes, 1 November 1915, bMS AM 1364 (278), William Cameron Forbes Papers, Harvard University (hereafter WCFP).

19. Thomas Barbour to Richard Strong, 24 May 1922, "Institute for Research in Tropical America," box 20, RPSP; Oakes Ames to Richard Strong, 28 January 1915, box 20, "Ames, Oakes Folder," RPSP.

20. Tom Gunning, "Before Documentary: Early Non-Fiction Films and the View Aesthetic," in *Uncharted Territory: Essays on Early Non-Fiction Film*, ed. Daan Hertogs and Nico de Klerk (Amsterdam: Nederlands Filmmuseum, 1997), 17.

21. Baker to Forbes, 3 September 1923, "Ames, Oakes Folder," box 20, RPSP.

22. Harvey S. Firestone, *Men and Rubber: The Story of Business* (Garden City, NY: Doubleday, Page & Co., 1926), 255.

23. Strong began considering an expedition to Africa in the summer of 1924, with the intent of testing Bayer 205, a German preparation against sleeping sickness, whose secret formula had recently been discovered by the French pharmaceutical firm, Poulene Freres. See Strong to Forbes, 23 June 1924, bMS AM 1364, Folder 279, WCFP. On his meetings with Firestone, see Strong to Joseph Grew, 19 January 1926, African Expedition—Correspondence, State Department & White House Folder, box 2, RPSP.

24. On the importance of mapping to the geopolitics of empire, see, e.g., Mathew H. Edney, *Mapping an Empire: The Geographical Construction of British India, 1765–1834* (Chicago: University of Chicago Press, 1997); D. Graham Burnett, *Masters of All They Surveyed: Exploration, Geography, and a British El Dorado* (Chicago: University of Chicago Press, 2000).

25. See Joseph Grew to Richard Strong, 24 March 1926, African Expedition—Correspondence, State Department & White House Folder, Box 2, RPSP; Graham Greene, *Journey without Maps* (New York: Penguin Classics edition, 2007), 42.

26. Thomas Baird, "Films and the Public Services in Great Britain," *Public Opinion Quarterly* 2 (1938): 98. It was in the Empire Marketing Board's film unit that John Grierson got his start and the acclaimed British movement in social documentary began.

27. Sir Stephen Tallents, "Unpublished Memoirs," file 25, Stephen Tallents Papers, Institute of Commonwealth Studies, London. My thanks to Paul Erickson for this reference.

28. Strong, *The African Republic of Liberia*, vol. 1, 11.

29. LWD, 12.

30. James C. Young, *Liberia Rediscovered* (Garden City, NY: Doubleday, 1934), 70; "Tells Firestone Dealers About Liberian Rubber," *New York Times*, 3 April 1927, p. XX16; "Firestone Rubber on the Screen," *New York Times*, 10 March 1927, 40. Although 250,000 feet of film were shot, no lasting record of this film document seems to have survived.

31. Landecker, "Cellular Features."

32. Amad, *Counter-Archive*, 302.

33. Henri Bergson, *Creative Evolution*, trans. Arthur Mitchell (New York: H. Holt and Co., 1911), 7.

34. Edwards, chapter 5, this volume.

35. Richard Pearson Strong Diary, typescript, 1926–1927, GA 82.4, Francis A. Countway Library of Medicine, Harvard University (hereafter RPSD), 30–32.

36. See, e.g., Elizabeth Edwards, *Raw Histories: Photographs, Anthropology, and Museums* (Oxford: Berg, 2001).

37. On visualizing the tropics as a landscape of disease, see Nancy Stepan, *Picturing Tropical Nature* (Ithaca, NY: Cornell University Press, 2001).

38. Strong, *The African Republic of Liberia and the Belgian Congo*, 56.

39. Strong, *The African Republic of Liberia and the Belgian Congo*, 40, 46.

40. Ibrahim Sundiata, *Brothers and Strangers: Black Zion, Black Slavery, 1914–1940* (Durham: Duke University Press, 2003); Sundiata, *Black Scandal: America and the Liberian Labor Crisis, 1929–1936* (Philadelphia: Institute for the Study of Human Issues, 1980).

41. Quoted in Sundiata, *Brothers and Strangers*, 79.

42. Cuthbert Christy, Charles S. Johnson, and Arthur Barclay, *Report of the International Commission of Inquiry into the Existence of Slavery and Forced Labor in the Republic of Liberia* (Washington, DC: GPO, 1931).

43. Richard Strong to William Castle, November 1926, RPSD, 159.

44. Richard Strong to the president, 21 February 1928, African Expedition—Correspondence. State Department & White House Folder, box 2, RPSP; Richard Strong to William Cameron Forbes, 4 February 1928, folder 280, bMS Am1364, WCFP.

45. William Castle to Richard Strong, 24 February 1928, African Expedition—Correspondence. State Department & White House Folder, box 2, RPSP.

46. Richard Strong, "Conditions in Liberia," *Boston Herald*, 14 January 1928.

47. Christy, *Report of International Commission of Inquiry*, 4.

48. "Wives Pawned into Slavery!" *Boston Sunday Post*, 18 January 1931; "Slavery of Liberia Bared in Report," *Boston Globe*, 27 September 1930.

49. Sundiata, *Brothers and Strangers*, 97–139. In 1928, Raymond Leslie Buell, director of the Foreign Policy Association, suggested that by establishing a Labor Bureau that agreed to supply "annually a total of 10,000 men to the Firestone Plantations," a system would result that employed methods no different from those used to secure men for "road work or for Fernando Po." Raymond Leslie Buell, *The Native Problem in Africa*, 2nd ed. (London: Frank Cass & Co., Ltd., 1928), 834. Strong took great exception to Buell's allegations and told Assistant Secretary of State William Castle that he seriously considered attending "The Problems of Africa" conference at the Institute of Politics held in Williamstown, Massachusetts, in August 1928 to rebut a speech Buell was planning to make indicting Firestone's operations in Liberia. In the end, Strong thought his presence would only draw further attention to Buell's talk, and so he stayed home. See Richard Strong to William Castle, 26 September 1928, African Expedition—Correspondence, State Department & White House Folder, box 2, RPSP.

50. LWD, 84.

51. John Grierson, "Flaherty," in *Grierson on Documentary*, edited by Forsyth Hardy (London: Faber & Faber, 1966), 141.

52. LWD, 17, 91.

53. Deborah Poole, "An Excess of Description: Ethnography, Race, and Visual Technologies," *Annual Review of Anthropology* 34 (2005): 164.

54. Nico de Klerk, "Home Away from Home: Private Films from the Dutch East Indies," in *Mining the Home Movie*, ed. Karen Ishizuka and Patricia Zimmerman (Los Angeles: University of California Press, 2008), 154.

55. G. A. Johnston Ross to Rev. Anson Phelps Stokes, 18 April 1922, folder 4, P. G. Wolo Papers, HUG 4879.405, Harvard University Archives (hereafter PGWP). Biographical information on Wolo's life has been gathered from PGWP. See also "Plenyono Gbe Wolo," *Harvard Class of 1917: 25th Anniversary Report* (Cambridge: Harvard University Press, 1942), 1018–20.

56. A. B. Parson to President A. Lawrence Lowell, 7 August 1926, folder 433, UAI5.160 series 1925–1928, Harvard University Archives; Ross to Dickerson, 1 April 1929, folder 7, PGWP. See also Caroline Ross to Walter, 18 August n.d., folder 2, PGWP.

57. C. K. Bolten to C. E. Dickerson, 17 April 1922, folder 4, PGWP.

58. "Confidential: Memorandum for Conference with Hon. William Phillips," n.d., 2, folder 1, PGWP. On the Kru rebellion, see Sundiata, *Black Scandal*, 18–19.

59. Strong, *The African Republic of Liberia and the Belgian Congo*, 50.

60. See, e.g., Simon Schaffer, Lissa Roberts, Kapil Raj, and James Delbourgo, eds., *The Brokered World: Go-Betweens and Global Intelligence, 1770–1820* (Sagamore Beach, MA: Science History Publications, 2009).

61. Faye Ginsburg, chapter 7, this volume.

Archival Exposure:
Disability, Documentary, and the
Making of Counternarratives

FAYE GINSBURG

The reason [photographs] enjoy such status is due to the fact that as soon as they have appeared in the world it is impossible to dismiss them. Their presence cannot be subsumed under the reign of a higher authority. They are independent. The limits of their interpretation are not determined in advance and are always open to negotiation. They are not restricted to the intentions of those who would claim to be their authors or of those who participate in their production.

ARIELLA AZOULAY, *The Civil Contract of Photography* (2008), 179

I use the phrase "archival exposure" in my title to draw attention to the ways in which photographs and films of people with disabilities—originally made as "visible evidence" of their imagined inferiority during the Third Reich—have been exposed in recent documentaries as a way to reverse the work of stigmatization that shaped their original creation.[1] At the time that they were first made—whether as medical records or as propaganda—they circulated as ways to isolate the disabled (along with many other categories of people) from the human community in the name of eugenics, drawing on the signifying practices of scientific documentation current at the time as a means to render such documents authoritative and persuasive.[2] In the postwar period, these kinds of photographs and films have been resignified as evidence of the brutal treatment of the disabled under Hitler. These acts of recuperation of such archival material, I argue, serve as kind of "visual activism" in an effort to build a contemporary sense of community that welcomes the very category of people that had been despised.[3] This kind of action, Ariella Azoulay argues, creates a set of social relations that constitute the civil contract of photography, inviting relationships among those represented and viewers.[4] These archival images, reframed via contemporary narratives that valorize inclusion of difference, take on renewed significance as central elements in cautionary tales about the possibilities and perils of documentary photographs

and films as they circulate in the world. They become documents that bear witness to the dangers of excluding any particular group of people from the human community. This kind of project, directed at transforming the evidentiary status of photographic and filmic archives originally gathered under the sign of both science and eugenics, is part of a broader range of acts of resignification—the social practice of photography and film—being carried out by scholars, artists, and activists from indigenous and other minoritized and formerly colonized communities who are reclaiming records made as part of colonial scientific practice.[5]

These archives, meant to document the world while also authorizing colonial or racist projects through "demonstrating" imagined inferior racial status and/or disappearing cultural worlds, are not only being reframed as evidence of inhumanity and discrimination. In some cases, they have also been embraced as family photos, providing some of the few filmic and photographic records available of relatives of a prior generation, profoundly reversing what First Nations artist, curator, and writer Gerald McMaster has aptly called, in a different context, "colonial alchemy."[6]

In this essay, I focus primarily on two extraordinary documentary filmmakers who are working with the archive of Third Reich films and photographs that stigmatized disability, rendering visible alternative understandings—particularly ones which resignify these documents via "family frames"[7]—through a process of "mediated kinship."[8] In these media-driven projects, kinship is established, and even extended beyond the boundaries of the biological family. They constitute unnatural family histories, made public through documentaries that become what I think of as parables of possibility because of the alternative cultural scripts they offer. These films, I argue, work through a logic of existential embrace and reversal of stigma strongly identified with the new social movements of the postwar era (often reductively referred to as identity politics).[9] They speak back to the cultural, visual, and biomedical regimes that too often have defined the lives of people and their families who are living with an embodied difference, in ways that are far more flexible and inclusive than that of prior generations. In doing so, they address the human costs of the exclusion and denial of people with disabilities in the past by practitioners of Nazi "science." By asking audiences to imagine how particular forms of documentary film and photography originally came into being as forms of legitimate scientific evidence for unspeakable practices, these works make clear that these films and photographs are not passive documents. Such projects make clear that photographs and films have agency, grounded in powerful cultural narratives and counternarratives that

have histories and consequences.[10] As the editors of this volume underscore in their introduction, the "biographies" that are attached to photographic and filmic "epistemic objects" are compelling because of the "polysemy of their accumulated histories, created for one purpose, archived for another, and re-interpreted for yet another."[11] Indeed, in the case of some of the material I examine here, the agency of some photographic and filmic evidence—what some call atrocity images—is considered sufficiently powerful in a negative sense that the question is raised: Should this material be destroyed? Can they ever be recuperated in ways that override the violence they depict?

My analysis is grounded in how these kinds of documentary projects op-erate as "technologies of personhood,"[12] a concept that draws on Foucault's understanding of technologies as methods that can "permit individuals to ef-fect by their own means or with the help of others a certain number of oper-ations on their own bodies and souls, thoughts, conduct, and way of being, so as to transform themselves in order to attain a certain state of happiness, purity, wisdom, perfection, or immortality."[13] I focus here on two key and in-tertwined technologies that have played expanding roles over the last century in reframing contemporary personhood, especially in relation to the category of disability: eugenic biomedicine and documentary media. My work interro-gates how transformations in these fields shaped ideas about the boundaries of identity. In the case of biomedicine, we are living in what some have called the second "age of biology," an era dominated by new knowledge of things genetic. Its impact on daily life over the last century has been felt through the early twentieth-century establishment of practices based on eugenic prac-tices, sterilizing or removing members of certain populations deemed inferior or unfit, and continuing into the late twentieth- and early twenty-first-century routinization of practices such as prenatal genetic testing.[14] As historians of science have cautioned us, the new genetics of the late twentieth and twenty-first centuries exists in the shadow of the last century's eugenics, haunting the present like a "ghost in the machine."[15]

Media, Technologies of Personhood, and Cautionary Tales

Over the last century, exhilarating transformations have occurred in visual media technologies as an extension of the human capacity for documenting, witnessing, testifying, and storytelling, all forms for the production and cir-culation of new social facts as well as narrative invention. These changing "techne," including shifts from photography to 16 mm film to analog video to the proliferation of digital platforms, are identified with particular forms

of evidence, historicity, narrative, and poetics.[16] Photography and film, for example, were used to document and justify eugenics projects in prewar Europe and the USA, and they continued to play a significant role in the Nazi era, including as evidence used by the infamous Dr. Josef Mengele during his tenure as medical officer at Auschwitz-Birkenau from May 1943 until March 1945.[17]

This visual legacy has not only been claimed and resignified as evidence of the routinization of the horrors of the Holocaust; more recently, these documents have been taken up by scholars and documentary makers as part of the retelling of the intimate histories of survivors for whom such footage, ironically, may be one of the few fragile forms of material connection to their former lives.[18] These projects raise questions of ownership of such documents: do they belong to the archive that houses them or to the people represented in the works? And what are the ethics of circulation?[19] Should they continue to be seen as cautionary tales for contemporary or future generations, or be destroyed out of respect for the dignity of those whose images were made in a humiliating context and without their consent? In this process of reclamation, witnessing, and the creation of counternarratives, it is important to account for the impact of small-format, inexpensive, widely available media-making technologies—beginning with analog video in the 1980s, and the Internet and other digitally based forms that first emerged in the 1990s. These have had remarkable effects as media technologies that enabled the expansion of documentary, and as "technologies of personhood" that could encompass and give public visibility to new cultural subjects whose lives previously had been stigmatized and/or rendered invisible in public space.[20]

In tracing the transformative trajectory of the changing status of the documentation of people with disabilities through such works, I rely on an understanding of media objects as polysemic, gaining new meanings as they follow unruly and constantly transforming paths over historical time, and as they enter into unanticipated social and cultural domains and take on new and different forms of authority. Once unleashed from their historical moment and original intention, media forms often promiscuously violate social and epistemological boundaries; they can move rapidly from the domain of scientific records to that of legal evidence or to the realm of personal narrative, accumulating a kind of biography in the process.[21] The films I discuss here engage in the transformation of these photographic and filmic records, serving, loosely, as "cautionary tales." I borrow that term from its use in folklore studies to describe a traditional story meant to warn the audience of particular kinds of risk—the taking for granted of apparent normalcy for example—as a danger that can be destructive not only to the individual but to a whole community.

Gray Matter and the Civil Contract of Photography

The 2004 documentary *Gray Matter*, by American filmmaker Joe Berlinger, offers an exemplary demonstration of how photographic archives can be powerfully reanimated in a new historical moment, serving purposes that subvert their original intention to classify children with disabilities who were then killed in order to use their brains for research. Berlinger, who early in his voiceover of the film confesses to being "obsessed with the brutality of the Holocaust," traveled to Vienna in 2002 to witness a funeral for the human remains (mostly preserved brains) of 789 infants and children who had disabilities such as epilepsy, diabetes, and Down syndrome, or who were simply orphaned or the "wrong" religion—many of them Jewish—and who died from brutal treatment in 1940–45, after being experimented upon by forensic psychiatrist Dr. Heinrich Gross (eventually nicknamed "the Austrian Dr. Mengele").[22] Evidence shows that Gross oversaw the killing of these young people at the Am Spiegelgrund children's hospital in Vienna when it served as a Nazi-era "euthanasia" clinic. Under the sign of medical research, the children were documented photographically with head shots and their names and ages, were used for experiments into congenital and hereditary abnormalities, and were then killed with large doses of barbiturates. Once the children were dead, Gross had their brains dissected or preserved in glass jars and labeled with their names, diagnoses, and the dates of their very short life spans.

Until their dignified and humane burial in 2002, documented in this film, they were used as scientific data for over half a century by Gross and others. Not until 1998, when the source of Gross' medical library was finally discovered and disclosed, did use of these ill-gotten human remains in published scientific papers cease.[23] For Berlinger, and for most viewers of this film, more shocking than the grim story of the facts of Nazi "medicine," which by now are no surprise, was the fact that these brains were considered legitimate scientific evidence for so long after the war, and that Gross, rather than being tried as a war criminal, continued to work in Austria as a medical expert for the court system well into the late twentieth century. As we see in the documentary, Gross—who was alive and around ninety years old at the time of filming in 2004—was never successfully prosecuted despite several efforts to do so, and despite the existence of definitive proof of his activities. Several Austrian historians in the film suggest that Gross had been protected by the many Nazi sympathizers who remained in the Austrian establishment despite the outcome of World War II. He lived freely in Austria and was even awarded the Honorary Cross for Science and Art in 1975 (although he was

eventually stripped of that honor in 2003) and collected a comfortable pension until his death in 2005. In the film, despite his best efforts, Berlinger does not succeed in finding Gross, but he does meet survivors of Am Spiegelgrund whose compelling and tragic stories—documented in the film—are far more significant in underscoring the danger at the heart of this cautionary tale than the confrontation that never happens.

In the film, we are able to see how the use of photographs in this whole process is central to a project of archival exposure and restitution. The opening sequence of the film shows the compelling appropriation by young Austrians of black-and-white archival photographs taken from the Am Spiegelgrund archive of the medical records of the disabled children killed by Dr. Gross, with the first name and first initial of the last name printed under the image, followed by the age of the child at the time of death (figure 7.1). The photographs have been enlarged to a three-foot-by-three-foot format that removes them from the status of the archival document. The young people—mostly teenagers—hold these photos of children they never knew in their arms while lined up on the street in silent but eloquent testimony to lives lost, an effort to honor and remember these victims, offering a very belated recognition of them as their remains are finally given a proper burial. In the words of one witness to the 29 April 2002 event: "As the mourners walked to the grave site, the names of the dead and their ages were read out repeatedly, and high school students stood in a column carrying photos of the dead, taken from their medical files."[24] Lined up along the street leading from the chapel to the cemetery where the burial was held, these citizens bear silent testimony to lives of these children they never knew by holding their photographic images in their arms, an eloquent visual homage to lives lost, an effort to honor and remember these victims. Removed from their original context of stigma and science, these photographic images are now literally embraced in the arms of those protesting Gross' work and Austria's Nazi legacy as a key element of the ritual accompanying the burial of these human remains in Vienna.

The film also generates a clear case for the power of film and photography as a technology of governmentality in the construction of "scientific" arguments that supported the Nazi project. In the opening section, we see not only the photos of the individual children sacrificed at Am Spiegelgrund as the participants in the burial ceremony organize themselves for the event, but also segments of a Nazi propaganda film that used documentary footage of people with evident disabilities, including footage of what appears to be a medical procedure being carried out in a clinical setting despite the patient's resistance. If the visual structure were not enough to persuade viewers that

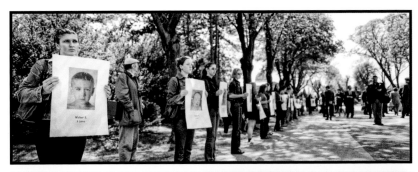

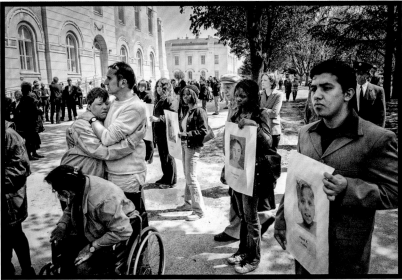

FIGURE 7.1. Austrian participants in the ceremonial reburial in 2002 of the remains of the children killed by Dr. Heinrich Gross hold enlarged photos of the victims, taken from medical records, to memorialize their lives. Photographer: David Reinhard, 2002. Photo courtesy of Milli Segal.

such people were *"lebensunwertes Leben"*—life unworthy of life, the voiceover (translated) for these images makes this clear:[25]

> After seeing these images, one cannot help but want to prevent the multiplying of these poor creatures. If we can prevent the reproduction of such deformities of the human mind and body, we are doing a great deed, for which our children and our children's children will be thankful.

These are then followed by images of long lines of robust young "Aryan" men marching in military order, shirts off; after that we see Hitler speaking to a huge mass of people, cut from various angles, and then riding through a city where hands are raised in salute.

One of the speakers at the funeral for the children's remains, Dr. Werner Vogt, a physician who had gathered evidence against Gross in the 1970s, offered a counterpoint. The ceremony "destroys a secret Austrian proclamation that goes as follows: 'Let's forget the murders; let's forgive the perpetrators and thousands of silent confidants.'"[26] Thus, as a cautionary tale, *Gray Matter* focuses on Austria's collective denial of its own participation in such atrocities, as well as those who struggled against that historical tendency, suggesting that those who fail to come to terms with their past continue to harbor this toxic sensibility.

Toward that end, the documentary not only reminds us of the Nazi use of photography and film to document as well as justify genocidal practices carried out in the name of systematic racial "purification." It also shows us how the photos are resignified, almost sacralized, in this public demonstration of kinship in the broadest sense with these disabled victims of Dr. Gross, while contemporary Austrian citizens insist on their connection to them and reject the dishonorable past that allowed for the inhumanity visited upon them. The photographs as evidence and as material objects are central to this counter-hegemonic effort to resituate this historical silencing; the enlarged images of the children's faces held in the hands of contemporary youngsters, more than any other part of the ceremony, bear witness to the fate of the Am Spiegelgrund children, in a way that makes their lives and the normalized idea of science that prevailed at the time a matter of public concern. Here, the photographs, as a group representation of the victims, act as visual correlates to linguistic performatives. Those who thought to engage with the Am Spiegelgrund photographic archive and repurpose the documents in a way that powerfully acknowledges the humanity of each and every child represented have provided a vivid example of a project that is able "to tease out some new ways of negotiating this difficult material not one photograph or film frame at a time, but in large groups" (Mitman and Wilder, chapter 1).

This act of repurposing and the literal public embrace of these photographs is an instantiation of what scholar of photography Ariella Azoulay calls "the civil contract of photography." She argues that all photographs bear the traces of the initial encounter between the photographer and the subject photographed. When that encounter is one shaped by injustice, the context imposes an obligation on the viewer to imagine what relationship we might have to the person in the photo and his or her circumstances, establishing even for the abject and stateless subject, what Azoulay calls the shared citizenry of photography.

The civil contract of photography shifts the focus away from the ethics of seeing or viewing to an ethics of the spectator, an ethics that begins to sketch the contours of

the spectator's responsibility toward what is visible. The individual is not confined to being posited as the photograph's passive addressee, but has the possibility of *positing herself* as the photograph's addressee and by means of this address is capable of becoming a citizen in the citizenry of photography by making herself appear in public, coming before the public, and entering a dialogue with it by means of photographs, which despite their power, are often both silent and silenced.[27]

In ways that Heinrich Gross and his colleagues could never have imagined, the photos are displayed not as scientific documentation of his "specimens" but rather are resignified and made more resonant in a context of repentance, memorialization, and recognition. In the move from the archive to the street, these photographs—which the film enables us to see in action so to speak—are transformed from signs of "life unworthy of life" to triggers of Azoulay's citizenry of photography.

Liebe Perla: The Hazards and Possibilities of Archival Exposure

I now want to turn to a second documentary that builds on this kind of "citizenry of photography" for those engaged in documenting, circulating, and viewing the world. It is another kind of cautionary tale, in which a search for the archival film footage taken by the Nazi doctor Josef Mengele—who had been involved in experimenting on those with disabilities—plays a central role. The film, *Liebe Perla*, is an astonishing 1999 documentary by Israeli filmmaker Shahar Rozen, structured around the relationship between two women linked by their size and their histories.[28]

Hannelore Witkofski, a short-statured German woman and disability activist, born in the postwar period, sets out on a quest to understand the fate of people like herself during the Nazi period.[29] During the process, she tracks down and befriends Perla Ovitz, the only surviving member of her ten-member Hungarian Jewish family. Seven of the family members were little people and before World War II they had formed the Lilliput Troupe, performing music throughout Eastern and Central Europe. Because of their genetic condition, congenital spondyloepiphyseal dysplasia, her family had been of interest to Josef Mengele, who ran the infirmary at Auschwitz-Birkenau for twenty-one months, beginning in May 1943. There, he carried out human experimentation on identical twins and people with genetic abnormalities, often filming and photographing them as naked specimens before and after experiments. In Perla's view, the Ovitz family survived Auschwitz only because Mengele chose to keep them alive for his "experiments." As she explained in a 1999 interview,

"We were the only family who entered a death camp and emerged together. If I ever questioned why I was born a dwarf, my answer must be that my handicap, my deformity, was God's way of keeping me alive."[30]

At the time of filming, Perla was eighty years old and living in Israel. When she tells Hannelore, her new German friend, about the humiliating experiences that she and her family endured, including her strong memories of being filmed naked for Mengele's research archives in 1944, Hannelore sets out on a quest: to go from archive to archive in Germany, and eventually to Auschwitz-Birkenau in Poland, to find this footage and restore it to Perla, whom she regards as the rightful owner of her image, raising an essential question about films and photographs that "document the world" against the wishes of those who are being represented.[31] As Hannelore expresses it in the film, reading aloud one of her letters to Perla: "Today is our last day in Auschwitz. We did not find the film. Often I hoped that if I do find it, as soon as I open the box, it would crumble into dust. I'm afraid that someone in some archive or other or in some attic would find it and show it. . . . The film belongs to you, and you alone."

At one archive, Chronos Films, Hannelore succeeds in finding other film footage of short-statured people at Auschwitz lined up in their striped camp uniforms and marching towards the camera. In a remarkable moment in the film, as the archivist runs the film for her, she recognizes a face among the anonymous bodies in striped clothing marching in the camp, restoring personal identity and history to this dehumanizing footage (the face was that of Ludwig Feld). However, despite Hannelore's efforts, she is unable to locate the footage that Perla remembers. Toward the end of the film, Perla receives word from Yad Vashem, the Holocaust memorial in Jerusalem, that they have found something of hers, leading the viewer to briefly imagine that the films have at last been found. She and Hannelore arrive there to find that it is not the missing footage after all; far better, it is a box containing her family's handmade musical instruments—adjusted to their small size—which they had used on their European tours.

It is not surprising that Hannelore is unable to locate the films that Perla remembers. According to filmmaker and archivist Yael Hersonski, "Facing imminent defeat in 1945, Nazi authorities went about systematically destroying records of their crimes, including the demolition of concentration camps and the mass murder center, Treblinka. As part of this cover up, 90% of Nazi film footage was destroyed in the final days of the war."[32] The films lost in that process included Nazi propaganda films, created to extol the virtues and power of the Nazi Party and Hitler, or to show Jews, gypsies, and the disabled as subhuman, works which have received the bulk of attention in

the literature,[33] as well as documents and data collected by people such as
Josef Mengele, who hoped to use the "findings" based on his "experiments"
at Auschwitz for his academic advancement. During the war, he sent all his
materials—including films and photographs—to his mentor Dr. Otmar Frei-
herr von Verschuer (the wartime director of the Institute for Anthropology,
Human Hereditary Teaching and Genetics at the Kaiser Wilhelm Institute),
who ended up destroying these materials in 1945, recognizing that these could
be used as incriminating evidence.[34]

Hannelore's journey through the archives shapes the documentary, in-
viting us to contemplate the complex and fundamental questions raised by
photographic and filmic documents produced under the most racist and op-
pressive conditions. Can they ever be transformed in a kind of ritual process
of redemption? Or, as some scholars suggest, is it better that they never be
seen again, saving those portrayed in the films from reexperiencing the initial
humiliation?

In a meditative analysis of this film, Holocaust scholar Sara Eigen writes:
"*Liebe Perla* itself manages much of the work that would be demanded of the
lost film, if found: it deftly manages some creative play with archival exposure
to serve history and to re-open the case against the Nazi-era and post-war
German medical communities, all without exploiting the lost film's actual im-
ages as historical evidence. Hannelore's assertion of Perla's rights seem right
and good; history has been served by *Liebe Perla*, and historians should re-
turn the favor by allowing the film to remain lost."[35] Amplifying this dis-
cussion of the film and the questions it raises regarding "archival exposure,"
historian Susan Crane asks: "Have Holocaust atrocity photographs reached
the limits of their usefulness as testimony?" She argues for their repatriation,
rather than for unconditional public access given that "few of the victims of
the Shoah pictured in either the best known or the least circulated images
were willing subjects."[36]

Beyond the question of the films themselves, *Liebe Perla* reminds us that
neither the films nor the historical circumstances in which they were made
are safely behind us. Rozen does not leave us with an assured sense that Nazi
ideas are a thing of the past, as we see evidence of some of the prejudices
toward people with disabilities that Hannelore encounters in contemporary
Germany. Additionally, Hannelore's archival work reveals evidence of some
of the material links between Germany's Nazi past and the present. In one
scene, shot in the library at the Max Planck Institute in Berlin (previously the
Kaiser Wilhelm Institute), she studies archives that make clear that Mengele
and his mentor, Dr. Verschuer, had collaborated around Mengele's Auschwitz
"research." After the war, rather than being punished as a war criminal, Ver-

schuer went on to lead the Institute for Human Genetic Research at the University of Münster. In the film, as Hannelore sits in the archive quietly reading aloud to her companion from Verschuer's obituary in 1969, she notes, ironically, that he was celebrated more than twenty years after the war "for his contributions toward humanistic eugenic research."[37] Indeed, it was only in 2001, two years after this film was made, and more than sixty years after the war, that the Max Planck Institute issued an apology to the few remaining survivors of Mengele, Verschuer, and other Nazi scientists. In his speech at the Max Planck Institute on the occasion of the apology, Auschwitz survivor Jona Laks made clear that revelation is not sufficient insurance against the possibility of recurrence: "It was inside our planet and a part of it, perpetrated by human beings against the lives of other human beings. It was here, amongst us. There is no guarantee that it will not return again."[38]

Gray Matter and *Liebe Perla* bear witness to the capacity of contemporary Germans and Austrians to resignify Nazi film and photography taken originally as scientific evidence, so that these representations that once undergirded the Nazi world are transformed into documents *of* that world. But they also alert us to the histories of dangers to the community—threats that may continue in new form. To return for a moment to Azoulay, such documents retain "the power to remind citizens that what brings them together, what motivates them to look at photographs, is the common interest, the *res publica*."[39] In that way, they serve as parables of possibility, through the act of archival exposure.

Conclusion

It goes without saying that we are far removed from Mengele's film footage in the use of contemporary media technologies to include or exclude the disabled in the life of specific communities, whether these be national, local, or virtual. The hegemonic authority of "science" and "biomedicine" buttressed the interpretive frames that gave Nazi film and photography its pernicious authority at a particular historical moment. The impossibility of tethering such media permanently to their foundational frameworks is part of their unruly productivity, as future generations refuse to let unacceptable narratives shape their interpretation, no longer allowing them to objectify and dehumanize certain classes of people—in this case, those with disabilities. The passion with which archival footage is repositioned through idioms of kinship, citizenship, and human rights is an index of the continued power of these images, and the fear that without their radical resignification, they can continue to wreak damage, like nuclear toxins. In the hands of the people whose

activities we witness—the Austrian citizens who carry the photographs of Dr. Gross' victims, Hannelore and Perla in their efforts to understand, expose, and put to rest the past—these images and the people they represent can have a redemptive second life, documenting the world in an entirely different way from what was originally intended.

Whereas phenotypic evidence, captured on film, was once used by eugenicists to make the case for an underlying pathology they imagined lurked within individual disabled bodies and potentially in the body politic, the filmmakers discussed here refused to allow such reductive interpretations of the body to separate the disabled from their social worlds. Instead they take the risk of visibility to create a sense of kinship that is neither genealogical nor familial, creating relationships across a range of boundaries, called into being through the relations produced among the "citizenry of photography."

In any polysemic tradition, there are always new ways to take the risk of imagining community where exclusion once existed. The recent media practices I have discussed provide a counterdiscourse to one of the more extreme examples of stratification that for so long has marginalized the disabled. It is not only the acceptance of difference but also the recognition of relatedness that makes these works potentially radical in their implications as cultural forms that endeavor to constitute both in a revised understanding of history. Displacing the frameworks of exclusion, stigma, and Nazi science that initially framed the photographic and filmic documents addressed in the films, these documentaries offer counternarratives and—via a strategy of archival exposure—parables of possibility with a clear eye, and a cautionary backwards glance at history.

Notes

1. For further reading, two key works on disability and photography are David Hevey, *The Creatures Time Forgot: Photography and Disability Imagery* (London: Taylor & Francis, 1992), and Rosemarie Garland-Thomson, "The Politics of Staring: Visual Rhetorics of Disability in Popular Photography," in *Disability Studies: Enabling the Humanities*, ed. Sharon L. Snyder, Brenda Jo Brueggemann, and Rosemarie Garland-Thomson (New York: Modern Language Association of America, 2002).

2. These include portraying subjects in clinical settings in a dehumanized manner, i.e., not in a context where we see them in a relationship with kin or friends. In the case of documentary film, such images are accompanied by an authoritative male voiceover discussing the human subject only in terms of pathology. For further discussion as to how photos are given scientific authority, see papers by Elizabeth Edwards (chapter 5) and Jennifer Tucker (chapter 2) in this volume. For an important creative intervention into the portrayal of people with disabilities in photography, see Nancy Burson's remarkable color portraits of people with craniofacial differences, http://nancyburson.com/pages/fineart_pages/craniofacial.html (accessed 23 August 2013).

3. Rosemarie Garland-Thomson, *Staring: How We Look* (Oxford: Oxford University Press, 2009).

4. Ariella Azoulay, *The Civil Contract of Photography* (New York: Zone Books, 2008).

5. For some exemplary works, see Elizabeth Edwards, *Raw Histories: Photographs, Anthropology, and Museums* (Oxford: Berg, 2001); Lucy Lippard, ed., *Partial Recall: With Essays on Photographs of Native North Americans* (New York: New Press, 1992); Jane Lydon, *Object Lessons: Archaeology and Heritage in Australia* (Melbourne: Australian Scholarly Publishing, 2005); and Christopher Pinney, *Photography and Anthropology* (London: Reaktion Books, 2011).

6. Gerald McMaster, "Colonial Alchemy: Reading the Boarding School Experience," in *Partial Recall: With Essays on Photographs of Native North Americans*, ed. Lucy Lippard (New York: New Press, 1992), 77–87.

7. Marianne Hirsch, *Family Frames: Photography, Narrative, and Postmemory* (Cambridge: Harvard University Press, 1997).

8. Rayna Rapp and Faye Ginsburg, "Enabling Disability: Rewriting Kinship, Reimagining Citizenship," *Public Culture* 13, no. 3 (2001): 533–56.

9. For an excellent overview of identity politics and intersectionality, please see Kimberlé Williams Crenshaw, "Mapping the Margins: Intersectionality, Identity Politics, and Violence Against Women of Color," in *Critical Race Theory: The Key Writings That Formed the Movement*, ed. Kimberlé Crenshaw et al. (New York: New Press, 1995), 357.

10. W. J. T. Mitchell. *What Do Pictures Want?: The Lives and Loves of Images* (Chicago: University of Chicago Press, 2005).

11. Mitman and Wilder, chapter 1, this volume.

12. Toby Miller, *The Well-Tempered Self: Citizenship, Culture, and the Postmodern Subject* (Baltimore: Johns Hopkins University Press, 1993).

13. Michel Foucault, "Technologies of the Self," in *Technologies of the Self*, L. H. Martin, H. Gutman, and P. H. Hutton, eds. (Amherst: University of Massachusetts Press, 1988), 12.

14. Over the last two decades, assisted reproductive technologies (ARTs) have supported a growing potential for individualized "neoeugenics" in the technologically advanced West where we find the routine use of genetic testing by individual couples and their choice to abort fetuses with genetic anomalies diagnostic of particular disabling conditions. Although U.S. genetic counselors are trained to express neutrality about the choices a pregnant woman and her partner may make around amniocentesis testing, the very existence of such a technology and the offer of such tests under the terms of consumer choice are premised on the desire for normalcy and fear of unknown abnormalities as argued by Rayna Rapp (1997). As Rapp and I have argued elsewhere, this normalizing discourse about disability that has emerged with the proliferation of reproductive technologies stands in distinction to the one accompanying the expansive, democratizing language of civil rights that has shaped the disability rights movement in particular, and especially its critique of the history of eugenic practices. As a result, almost all "modern parents" might find themselves facing the contradictions created by progress in both biomedicine—premised on selecting against certain disabling conditions—and social movements founded on expanding democratic inclusion of all citizens, regardless of bodily, emotional, or intellectual conditions. Rapp and Ginsburg. "Enabling Disability."

15. Sander L. Gilman, "The New Genetics and the Old Eugenics: The Ghost in the Machine" *Patterns of Prejudice* 36, no. 1 (2002): 3–4.

16. In *The Question Concerning Technology*, Heidegger draws on the etymology of *techne*: its roots are in the Greek *techne*, which is "the name not only for the activities and skills of the

craftsman but also for the arts of the mind and the fine arts." For the Greeks, *techne* was inti-mately linked to *poiesis*, the poetic, and thus linked to the "bringing forth" so essential in the pursuit of aletheia/veritas/truth. See Martin Heidegger, *The Question Concerning Technology, and Other Essays* (New York: Harper Perennial, 1982).

17. Mengele had a Ph.D. in physical anthropology from the University of Munich and even-tually worked as the assistant of Dr. Otmar Freiherr von Verschuer, a leading scientific figure widely known for his research with twins. Mengele is reported to have experimented on three thousand sets of twins at the camp. He performed surgery without anesthetics, blood transfu-sions from one twin to the other, deliberately injected lethal germs into the twins, and performed sex change operations. Mengele was also interested in heterochromia, a condition in which an individual's two irises differ in coloration. He collected the eyes of his murdered victims, in part to furnish "research material" to colleague Karin Magnussen, a Kaiser Wilhelm Institute re-searcher of eye pigmentation. See United States Holocaust Memorial Museum, "Josef Mengele," *Holocaust Encyclopedia*, http://www.ushmm.org/wlc/en/article.php?ModuleId=10007060, ac-cessed 13 January 2012. On Mengele and his practices, photographic and otherwise, see Robert Jay Lifton, *The Nazi Doctors: Medical Killing and the Psychology of Genocide* (New York: Basic Books, 2000).

18. This process of resignification of documentary evidence over time is discussed in a num-ber of papers in this volume. See, for example, chapters by Elizabeth Edwards (chapter 5) and Gregg Mitman (chapter 6).

19. On the resignification and recirculation of photographs, see Susan Crane, "Choosing Not to Look: Representation, Repatriation, and Holocaust Atrocity Photography," *History and Theory*, 47, no. 3 (2008): 309–30.

20. See Faye Ginsburg, "Screen Memories: Resignifying the Traditional in Indigenous Me-dia," in *Media Worlds: Anthropology on New Terrain*, ed. Faye Ginsburg, B. Larkin, and L. Abu-Lughod (Berkeley: University of California Press, 2002), 39–56.

21. For a full discussion of this idea, and of "media worlds" more generally, see the introduc-tion to Ginsburg, *Media Worlds*, 5.

22. For details, see Virginia Heffernan, "'Gray Matter': A Driven Filmmaker and His Grim Subject," *New York Times* (23 April 2005), http://www.nytimes.com/2005/04/12/arts/television /12heff.html?pagewanted=print (accessed 20 July 2009).

23. Steve Erlanger, "Vienna Buries Child Victims of the Nazis," *New York Times* (29 April 2002), http://www.nytimes.com/2002/04/29/world/vienna-buries-child-victims-of-the -nazis.html (accessed 2 February 2015).

24. Quoted in Erlanger, "Vienna Buries Child Victims,"

25. Joe Berlinger, director, *Gray Matter* (television documentary) (Third Eye Motion Picture Company, 2004; distributed by New Video Group), 1:58–3:22.

26. Quoted in Erlanger, "Vienna Buries Child Victims."

27. Azoulay, *Civil Contract*, 131.

28. Shahar Rozen, *Liebe Perla*, 53 minutes (Tel Aviv: Eden Productions, 1999).

29. In her excellent article on the film, Barbara Duncan writes that "Hannelore Witkofski, in an interview for the film magazine, *Documenter* (www.documenter.com/issue04/041acgb .htm) clarified her conditions for being filmed, drawing the line at the privacy of her home: "I didn't want any type of 'home story,' because of my experiences with how disabled persons are presented in the media, how they are shown. So imagine, this cute picture of a short-statured woman cooking on a very short oven with a small soup. It would be a kind of children's movie,

like a fairytale. So it was for me, very important to save my privacy. . . . And on the other side, (I wanted) to bring my work to the center, because working people with disability, this is absolutely uncommon in the public view. Disabled people are poor, they suffer, but they don't work." Barbara Duncan, "Liebe Perla: A Complex Friendship and Lost Disability History Captured on Film," *Disability World: A Bi-Monthly Webzine of International Disability News and Views*, 9 (July–August 2001), http://www.disabilityworld.org/07-08_01/arts/perla.shtml (accessed 20 July 2009).

30. Quoted in Yehuda Koren and Eilat Negev, *In Our Hearts We Were Giants: The Remarkable Story of the Lilliput Troupe* (New York: Da Capo Press, 2005), 274.

31. Crane, "Choosing Not To Look," 309.

32. Yael Hersonski, *Study Guide to a Film Unfinished* (2010), http://www.afilmunfinished .com/film.html.

33. Among the most well-known filmmakers was Leni Riefenstahl, whose filmic rendition of the infamous 1934 Nuremberg rally, *The Triumph of the Will*, followed by *Olympia* (1938), made her a key figure in the Nazi hierarchy. Other notable works include Veit Harlan's *Jew Suss* (1940) and Fritz Hippler's *The Eternal Jew* (1940).

34. United States Holocaust Memorial Museum, "Josef Mengele."

35. Eigen ends her article with this eloquent articulation of closure around the question of the missing film. "Perla Ovitz died in 2001, the last of her immediate family, the only known remaining witness to the film that she hoped to locate and destroy." Sara Eigen, "Liebe Perla, Memento Mori: On Filming Disability and Holocaust History," *Women in German Yearbook: Feminist Studies in German Literature and Culture* 22 (2006): 18.

36. Crane, "Choosing Not to Look," 309.

37. For an excellent overview of the role that the Kaiser Wilhelm/Max Planck Institute played in Nazi science before, during, and after the war, see William E. Seidelman, "Science and Inhumanity: The Kaiser-Wilhelm/Max Planck Society," *If Not Now* 2 (Winter 2000), http:// www.baycrest.org/journal/ifnot01w.html, revised 18 February 2001. http://www.doew.at/thema /planck/planck1.html (accessed 21 July 2009). The apology on behalf of the institute's role in such projects occurred at a conference sponsored by the Max Planck Presidential Commission, which was established to investigate the institute's activities from 1933 to 1944. On 7 June 2001, Max Planck president Hubert Markl offered survivors of concentration camp experiments "the deepest regret, compassion, and shame at the fact that crimes of this sort were committed, promoted, and not prevented within the ranks of German scientists. The Max Planck Society, as the Kaiser Wilhelm Society's 'heir,' must face up to these historical facts and its moral responsibility." Markl's admission was followed by emotional speeches by two victims of Nazi physician Josef Mengele's infamous "twins" experiments at the Auschwitz-Birkenau death camp. See Robert Koenig, "Max Planck Offers Historic Apology," *Science* (12 June 2001), http://sciencenow.science mag.org/cgi/content/full/2001/612/3 (accessed 21 July 2009).

38. From Jona Laks' speech in his role as the chairman of the Organization of the Mengele Twins on the occasion of the opening of the symposium entitled "Biomedical Sciences and Human Experimentation at Kaiser Wilhelm Institutes—The Auschwitz Connection," Berlin, 7 June 2001, http://www.mpg.de/english/illustrationsDocumentation/documentation/pressReleases /2001/bs_laks_e.htm (accessed 10 October 2009).

39. Azoulay, *Civil Contract*, 131.

Reverse—Cardboard—Print:
The Materiality of the Photographic Archive and Its Function

STEFANIE KLAMM

Archaeological and art historical institutions, libraries, and museum collections present themselves as containing the complete remains of the past in photographic images. With regard to cultural monuments, the nineteenth-century ambition to comprehensively document everything can be most prominently seen in collections produced by state-financed and homogeneous enterprises like the Meßbildkampagnen in Germany or the Mission Héliographique in France, but also in more heterogeneous general archives of libraries, university departments, and museums. Many modern art historical and archaeological institutions have compiled vast archives of nineteenth- and early twentieth-century photographs reproducing historical monuments and archaeological sites.[1] They were created at a time when art history and archaeology came into being as professional university disciplines focused on material objects. Their first action as disciplines was to draw together the material basis for their research, thereby defining the scope as well as the canon of the disciplines. Since the objects of research were dispersed across different museums, collections, and institutions, consolidation was possible only with the aid of reproductions. Photography offered itself as a practicable means for the comprehensive end of assembling the largest possible image archive.

The impulse was not to strategically acquire a few representative photographs but to accumulate as many photographs as possible in order to represent a complete record of archaeology or art history. In spite of the almost daily use such archives endure, they often occupy a shadowy existence in contemporary research. Originally assembled as reference materials and iconographical reservoirs for art historians and archaeologists, arranged according to genre, type (architecture, sculpture, relief, painting, vases), and epoch (and—in the case of

art history most prominently—artists), today the provenance, context, and materiality of these archival photographs are often forgotten or ignored. This paper explores the materiality of these photographs as they were subjected to standardization and organization in art historical and archaeological archives.

Such photographic archives were typically treated as repositories of iconographic order. This was bolstered by the assumption, developed in the nineteenth century, of "the photograph as a fact."[2] Collecting meant acquiring knowledge, "to know the world through possession of its images."[3] Therefore, the photographs appeared as transparent and invisible equivalents to the objects, quasi naturalized.[4] They became the "original" objects of research.[5] Thanks to the power of the medium and its supposed mechanical character as an instrument to depict reality objectively, the photographic biographies as objects became nearly invisible in the organization of the archive. This transparency seemed to allow the viewer to look through the material photograph to directly consider the artifact it depicted, thus guaranteeing its neutrality and documentary value.[6] Substantial research in recent years has shown that this objectivity is a constructed one and that photographs have to be seen "as cultural documents offering evidence of historically, culturally and socially specific ways of seeing the world."[7]

Thus, photographs are not just containers for images. Recent scholarship has broadened to approach the material aspects of the photographic process by addressing questions of chemical development, emulsion, printing techniques, retouching, framing, mounting, and presentational forms.[8] A photograph is a material three-dimensional object, usually mounted on cardboard, that carries "marks of its own history"—stamps, signatures, and labels—that provide evidence of its practical function and use.[9] In this respect, as Elizabeth Edwards has pointed out, photographs are active and social entities that exist in social and cultural contexts.[10] Photographs are always embedded in concrete practices of uses, production, reproduction, and display, thus their materiality and likeness "were emergent from and constitutive of the shifting sets of social, cultural, and economic relationships through which the photographs were produced, and which they themselves produced."[11] This applies not only to the making of a photograph, but also to the history of its subsequent uses. How scholars have interacted with the archives over time, including the historian investigating them today, impacts on the photographs.[12] This essay uncovers some of those complex scientific and social contexts in which photographs are embedded both when they are made and over the time they are used. It is through their materiality that the photographs have agency, and the archive material has a "social biography."[13]

Transformed Photographs

This chapter examines questions about the materiality of photographs on the basis of examples taken from the Fotothek—the archaeological photo archive in the Winckelmann-Institut, the department of classical archaeology at Humboldt University, Berlin.[14] As Kelley Wilder has discussed in this volume and elsewhere, the photographic specificity—the why, when, by whom, and how a photograph was taken—often disappears behind the artifact being depicted in these photographs. Photographers, printing processes, and the date the photograph was taken are assigned only minor, if any, importance.[15] To correct this material disappearance of photographic information, I address who exactly made those photographs, and by whom and why they were collected. The aim is to understand how the photographic archives shaped the way scholars looked at the monuments depicted. To do this, I will also examine the purposes for which the photographs were used in the past, and are still being used today. What was this photographic archive for? Were the photographs teaching tools, repositories for a possible future reconstruction of the monuments, or reservoirs of knowledge fit for scholarly study? Investigating these often overlooked traits of archaeological photographs allows recovery of the particularity and materiality of them that is often effaced through the construction of these archival collections for academic study and research.

The first, and perhaps most striking, aspect of the photo archive at Humboldt University is the haphazard organization of photographs in archival storage boxes. Boxes of photographs are labeled according to the subject, genre, and location of the subjects of the images, without distinguishing between contextual or material differences in the photographs themselves. In practice, this means that photographic prints produced at different times and for distinct purposes (thus having different origins) are often mixed indiscriminately together in one box. This classification takes what was originally a very heterogeneous collection of objects and imposes homogeneity on them, governed by art historical or archaeological disciplinary values, at the expense of contextual and material features of the photographs. By dispensing with the photograph as a photograph, the archive has an active character, transforming the photograph into a document.[16] The creation and standardization of the "document," its organization, distribution, and accession, is defined by the actors within the archive (or the discipline) and their interests, who through the structuring and preparation of knowledge have control over social and cultural memory.[17] The different contexts, e.g., of production and distribution, which are homogenized by the institutional practice expressing mutual values, account for the alterability of the photographs' meaning, be-

cause the photographs are shaped in different ways by the way they have been organized in the past, their transformation into different contexts, and the spaces in which they reside in the institution.[18] Not only do the photographs have their own biographies, but they also tell the biographies of institutions.[19]

Photographs do not just come into being. Many actors with different intentions participate in the creation of the document. The act of photographing and the photographer are distinct from the person who commissions or distributes the photographs or transfers them to the archive.[20] Therefore, context and functions are important to the decoding of photographs, since they are made for specific audiences. Through this process "photographic images are decontextualized and recontextualized into photographic documents" taking on new functions and meanings.[21] It is the physicality of the photograph and in particular the cataloguing, labels, and mounting that give a functional context through which the photograph is transformed into an authoritative, archival document.[22]

Creating Meaning without a Catalogue

One essential part of context in the creation of photographic documents is the catalogue, as this chapter and the following chapters by Wilder (chapter 9) and Blaschke (chapter 10) demonstrate. Little attention has been paid to classification schemes applied to photographic archives in archaeology and art history. Photographic archives of archaeological objects adopted the overarching schemes of order in archaeology, based on conventions, such as the duration of certain periods and strict chronological order, both of which were fundamental for the formation of the discipline of archaeology in the nineteenth century. Like Pinney's anthropological archives, archaeological photographs were confined within "the archival grid," pretending to transform them into self-evident facts.[23] The archive catalogue thus gives each photograph its place in a larger systematic order, or it would, except that in the case of Winckelmann-Institut Fotothek, there was no catalogue. Instead, the classification scheme unfolded in the physical arrangement of the boxes grouped by sections in the room, demonstrating the powerful and active role of the physical space of the archive. Although photographs were filed according to material, object type, place, and epoch, the cataloguing system was composed merely of this activity of filing into boxes.[24] The only way a scholar could research across the archive was to browse through every single box. The user had to specify in advance what he or she was looking for and then look for the appropriate box in the room. Only by searching through the box was it finally possible to find the required photograph. Browsing in this way was

necessitated by the archive structure, which in turn through its system of or-
der structures the kind of questions that a researcher can ask, and imposes on
researchers a specific way of questioning and a certain research approach.[25]

This absence of a catalogue was partly due to the organizational circum-
stances of the archive's origins. It comes from the original Archäologischer
Lehrapparat (archaeological teaching apparatus), founded in 1851 by the first
chair of classical archaeology at Humboldt University, Eduard Gerhard (1795–
1867). Gerhard, being very much in favor of establishing archaeology as a dis-
cipline based not only on texts but on the material remains of antiquity, was
keen to collect as many reproductions of antique artifacts as possible, since
relying on material remains of the past meant repositioning archaeology as a
discipline based on reproductions. Reproductions in this case were not only
photographs but other visual materials too, such as drawings, maps, models,
and plaster casts, which were only later separated from the photographic ma-
terial into their own ephemera collection. Although there was no catalogue,
the archaeologists kept an inventory and noted down all the materials that
found their way into the Lehrapparat. Books, plaster casts, maps, antique ar-
tifacts, prints, and photographs were divided by an inventory that differen-
tiated between books, visual reproductions (drawings, photographs, maps),
and plastic three-dimensional objects (plaster casts and casts of cameos, but
also antique coins, terracotta, and sherds).[26] But since the department always
lacked sufficient employees to cope with the number of acquisitions obtained
by Gerhard and his successors, the acquisitions were never completely invento-
ried. Until 1911 the problem was exacerbated by the dual role of the professor,
who was also director of the museum of antiquities.[27]

In the inventory, photographs were noted not in single entries but in sets,
such as "20 photographic prints showing views of Athens." If they were given
to the department as a donation, the name of the donor was considered impor-
tant and written down. For instance, there were some photographs bequeathed
by archaeologist and classicist Ernst Curtius (1814–96), who held the Berlin
Chair of Archaeology from 1867 to 1896, or the Ministry of Education's gift of
310 photographs from the Meßbildanstalt. If the photographs were bought
from photographic publishers, the name of the publisher was noted, like the
sets from Alinari and Giraudon, which I will discuss later in this essay. Apart
from this, the photographs were rarely described in any more detail. As in fig-
ure 8.1, the inventory just has four columns containing a sequential number, a
general description of the sets of photographs (and their quantity), the infor-
mation from whom they were received, and the date of entry in the archive.

The scant inventory information elided the photographs as photographs, giv-
ing only information about the archaeological object. The inventory mentions

FIGURE 8.1. Inventory book of the Lehrapparat, department of classical archaeology Winckelmann-Institut, Humboldt University, Berlin.

the topographical place or the location of the artifact, or includes the identifi-cation of a general type to which the artifact belonged according to archaeo-logical analysis, such as Athens or Florence. No single description allowed a researcher to pluck a particular photograph out from among its companions in the box. This was clearly not the aim of the inventory, or of its intended re-searchers. The inventory was more a list of incoming objects in the order of their acquisition, not a system of classification, or a catalogue. It is not very sur-prising to find that the inventory for the photographs was retained only until the early 1930s and then abandoned.[28]

The archive was retained, though, and grew after the 1930s even if not with

FIGURE 8.2. The room of the photo collection, department of classical archaeology Winckelmann-Institut, Humboldt University, Berlin.

the same rapidity. It was and still is working material, since photographs are still a part of the practice of teaching and researching archaeology. The collected photographs function as a reservoir of images that the archaeologists access if they want to demonstrate the wealth of objects related to the discipline and inform themselves comprehensively about a particular area. But each researcher has to make sense of the archive for him- or herself.

In the absence of a catalogue, order is dictated instead by the room arrangement. Figure 8.2 shows how boxes and files are arranged on shelves and cupboards lining the walls, except where the two windows allow in light. Each box is encased in dark green cloth, and has the same type of label, giving the room a regimented and unified look. The lower parts of the shelves contain drawers in which oversized photographs are stored. The center of the room is dominated by a large table under which are stored large format photographs and atlases of images. These large works can be identified from a list attached to the inside of the door. This dramatic space makes it impossible to find a specific photograph without being influenced by the existing order of the room and without aligning oneself with it. In this sense, the archive as a "disciplined space" is expressed by the stacking system and the labeling of the boxes, which gives them a certain place in the arrangement of the shelves, and

thereby forces the user to take a certain position towards the photographs.[29] Because there is no catalogue, the only way to find photographs of a certain subject is to walk along the rows of boxes. Due to the archaeological filing organized around different types or genres, the boxes about one topographical area, for instance, are divided, and the researcher has to go to several different places in the room to compile an overview of a certain location. Thus, the archival knowledge is sedimented and presented through a constellation of data, like boxes, labels, card mounts, and inscriptions. This particular data offers insights into the history of the photographs from the moment of their making and into their passage into the boxes in the Fotothek (figure 8.3).[30] Therefore the materiality of the archive is in Edwards' terms, "resourceful," in that the archive and its photographic documents are material manifestations of the social relations of archaeology.[31]

But the archive itself is more contradictory than it seems at first glance. As Gillian Rose has argued, the order can be disrupted again and again by different users and the images themselves, which interfere and interrupt spatial conditions. Photographs and the room itself have a certain "agency" of their own, which can play out.[32] The two rooms where the photographic archival collection is housed are also the social meeting rooms of both the staff and

FIGURE 8.3. Boxes containing photographs in the Fotothek, department of classical archaeology Winckelmann-Institut, Humboldt University, Berlin.

the students of the institute. Receptions are held here, and celebrations too, complete with wine and snacks. There is no restriction to admission to this room at all. Everyone who enters the institute can go there, pick out any box or file, and distribute the mounted photographs across the big table in the middle of the room. They may combine, juxtapose, and isolate the images in new ways and replace them in any order in the box. The user can literally do with the photographs what he or she wants.[33] Thus, the space where the archive is kept is a relatively unregulated space that encourages the practice of comparing photographs. The researcher can look for something that is not in the order of the archival system, destabilizing it for his or her own narrative, to produce new knowledge.[34] In this way, the presence of the researcher gives meaning to the archive and determines what is seen and read into the archive. After he or she has placed the photographs back in their boxes, and returned the boxes to the shelves, however, the physical organization of the room reestablishes itself.

The researcher does not necessarily begin with a blank slate, however, with regard to the interpretation of archival photographs. The material qualities of the photographs play an important role. All photographs are glued on similar grayish or beige mounts without regard to their size, subject, or condition. The quality of the cardboard varies a little (but not much) according to the age of the cards. The fact that photographic prints in archives are often mounted on cardboard has a homogenizing effect. This accounts for a "certain monotony" that produces a shared meaning between the photographs.[35] The same holds true for the frequently isolated character of the object in these photographs, predominantly situated in front of a blank background as a decontextualized "specimen."[36]

But the mounts are marked by different stamps and inscriptions, all of which tell us something about the way these photographs were collected and arranged. Stamps refer to previous owners or even the photographer. Photographer's names or the names of photography studios were also occasionally written on the negative, and can be seen on the positive. Stamps can indicate when the photograph entered the archive. They also serve to legitimate sets of photographs as scientific in context and therefore ensure their usability in scientific practices. Annotations on the back of the cardboard mount indicate where the photograph is from as well as other photographic archives or publications where it has been used or was kept. Hence these various forms of inscription help to authorize the photographs and institutionalize them in the archive's system.[37]

Stamps and inscriptions give hints about the photographs' "physical trajectories" and the reasons why the prints are assembled in the archival collection,

integrating them into the larger narrative of the archive. They are marks of constant engagement with photographs, accounting for their value as documents and situating the photographs in place and time.[38] The annotation systems on photographs and their paper backgrounds give contextual information about the artifact displayed—where it is kept, which epoch it belongs to, and so on—that ensures the credibility of the photographs. Without mounting, stamps, and annotations these various photographs would not form a system.[39] These material features are still rarely mentioned in publications and exhibitions, and they also often escape the descriptive standards in catalogues, which are usually aimed at the artifact depicted and only disclose the iconographical content of the photographs without taking into account their various origins or contexts.[40]

Through written inscriptions on the mounts, the "archive produces the photographs in particular ways."[41] It thereby "transforms, recontextualises and adds meanings to the photographic document."[42] Names and titles allude to certain interpretations and create certain contexts in which the photographs can be evaluated, but only if one knows how to read these clues. Only trained eyes of the discipline would recognize the underlying system or the appropriate contexts. Otherwise all the photographs in the box look very much the same, made equal by their similar mounting, although they represent very different types of photography, were produced at different times, and made with different intentions. Allan Sekula argues that this sort of disappearance into an archive strips the photograph of certain parts, and much of the richness, of its meaning.[43] But whereas Sekula describes this transformative process as a reduction of complexity of the individual photograph through a disappearance of context, the physical appearance of the photographs shows that Sekula's distinction between a previous and "more authentic" use and a less authentic or less complex reuse in the archive is too simple a reduction. Privileging an "original" use does not take seriously the photograph as a material object. When a photograph enters an archive, it takes on a different kind of richness through its new contexts, enabling different uses through its transformations.[44] Instead, the archive offers a physical space in which multiple meanings of the photographs are constantly being shaped and reshaped.[45]

The Mixed Box

As an example, I selected boxes that feature photographs of Olympian temple sculpture. The excavation of the ancient sanctuary in Greek Olympia was one of the major undertakings of German archaeologists from the last third of

the nineteenth through well into the twentieth century. The first dig took place from 1875 to 1881, but it was renewed subsequently in the twentieth century. The excavation results had a major influence on contemporary German culture and society. The enterprise was declared an excavation of the German Empire and was funded by Parliament as well as by the Prussian court. It set standards for state-financed archaeology in Germany and was an enterprise of national prestige in a time of strong international competition among all fields of science, industry, and culture. This survey of Olympia was, as Mitman and Wilder have written in the introduction, a display of cultural patrimony. It was a question of national rivalry with France, coming a few years after the Franco-Prussian war of 1870–71 and following the unification of the "Reich." Olympia offered an opportunity to demonstrate the ability of Germany to conduct spectacular research projects and to establish itself among the European powers.[46]

A wide range of photographs has been produced over the years, partly depicting the same artifacts, and prints of them are now assembled in the boxes of the Fotothek. In order to fit into the box, the mounted photographs have roughly the same size. Inside their box they are indiscriminately ordered and, as previously mentioned, anyone can reorder them. On every return to the study room, a researcher is confronted with a new order in the box. The photographs discussed here stem from three boxes depicting primarily sculptures of the Eastern pediment and the metopes of the temple of Zeus in Olympia (figure 8.4). The mounts, stamps, and annotations make clear that these photographs were produced by different photographers on a variety of dates.

Multiple photographs of one artifact, or placing multiple items in one photograph, enables the formation of a synthesis out of different views. It is the comparison not only of two artifacts or reproductions but of many that lies at the heart of the comparative method in archaeology and art history. The unifying character of the photographs as flat, mostly monochromatic, having a standardized format, and depicting an artifact from particular angles helps to make this synthesis possible.[47] By reducing the complexity of the artifact with the help of monochrome imaging and the miniaturization of the photographic prints, research objects appear more manageable and, in this standardized form, comparable for disciplines like art history and archaeology, which rely on the comparative visualization of their objects. Seeing multiple artifacts together and preferably all at once is the prerequisite for acquiring knowledge about the past. The comparison of different artifacts together gives access to the characteristics of these objects. It allows classification according to time and space as well as the producer of the artifacts. This is done by comparing formal aspects and the meaning of any motifs on the

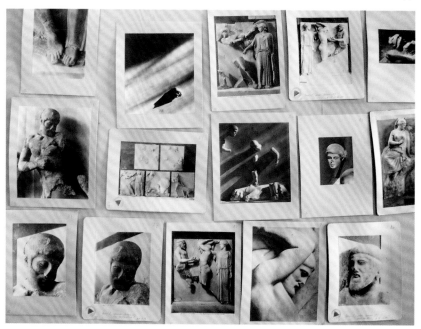

FIGURE 8.4. Typical arrangement of photographs of sculptures from the metopes of the Temple of Zeus in Olympia.

artifacts. Thus, the photographs served to decontextualize the artifacts and reduce their distinctive characteristics, while at the same time homogenizing them through equal sizes and formats. Photography created and enforced comparability.[48]

The photographs of Olympian sculpture can be grouped into several categories. First, there are photographic images depicting the sculptures in a museum context, set up for a public presentation (figure 8.5). Their caption, "Ed. Alinari," tells us that these images were made by one of the largest photographic publishing houses in nineteenth-century Europe, founded by the Italian brothers Alinari in 1852. The Alinaris undertook systematic photographic campaigns of landscape views and important monuments and works of art first in Italy, and then across Europe. The photographs were later sold in Europe and around the world to individuals as well as art historical and archaeological institutions. Their images of architecture and monuments were influenced by visual traditions set by the Grand Tour and prevailing ideas of reproduction handed down from engraving compilations and views. At the same time, they managed to keep the unity of their photographs, preferring a centralized view with as few outer influences as possible and clarity in the image's message.[49] Their success, due partly to this uniform style, and partly to the high quality

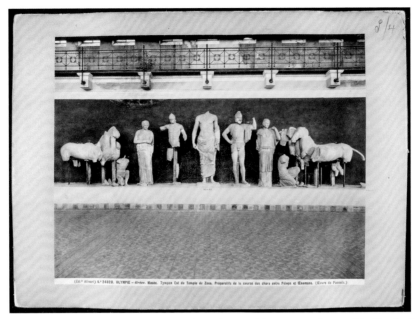

FIGURE 8.5. Photographic image depicting the sculptures of the Eastern pediment of the Temple of Zeus in the museum at Olympia. Edizione Alinari, c. 1900. Albumen print.

they maintained in printing, is evident as almost every major art historical and archaeological photo archive contains many Alinari photographs.

The Alinari photographs are the only items in this box that contain captions on the prints themselves giving information about what is depicted. Most other labels and descriptions are on the reverse of the mount so that the image and data cannot be consulted at the same time. On the one hand this separation resembles the procedure in engraving cabinets or photographic collections in museums with their aesthetic presuppositions, and on the other hand it alludes to the primacy of the visual information for the archaeologist using, for instance, stylistic and typological methods.[50] In stylistic analysis the formal features like clothing details, body placement, and ornament were often used to distinguish a particular artist. In typology the focus was laid more on the shape and overall form of the artifacts and their details, which were examined in their various forms and which ultimately identified object "types." Both resulted in the establishment of a chronology and interconnection of the artifacts as a basis for historical explanation. This means that all relevant information has first of all to be taken out of the artifact via its image (mostly) only after the image's importance for the argument is set. Additional information based on the context and location of the finding of the artifact becomes

necessary. Furthermore, the lack of captions on the prints turned out to be helpful for the use of the mounted photographs in exams where the examinee was and still is supposed to identify and contextualize the artifacts shown in the image.

Another set of photographs in the same box is mounted in a different way, on a paper board with rounded edges. Stamps on these photos reveal that they are part of a separate collection made by the German Archaeological Institute (DAI) in Athens (founded in 1874). This affiliation is indicated by the stamp and the scratched number on each negative, indicating that the photograph belongs to a group specifically made for the archaeological institution. The photographic archive of the DAI differed from most other archaeological ones since it consisted mainly of photographs that were deliberately made by the archaeologists themselves or by other employees of the institute and later by a photographer working for the institution and for the archive from around 1886 onwards. The institute began to sell its photographs in 1891, and lists of them were subsequently published in archaeological journals.[51] Unlike that of the DAI, most photographic archives at universities were and are made up of a conglomerate of photographs bought from different commercial photographers (to a larger extent) and photographs made specifically for archaeological purposes (only to a small extent).

The DAI archaeological photographs, unlike those of the Alinari, were taken either by the archaeologists themselves or under their very close supervision, and were directly produced to serve the interests of the scientific community. One can see this intention clearly in the iconography of the images as well as in the subject matter and composition of the photographed materials. These photographs not only depict spectacular pieces, dramatically lit for effect, but focus especially on obscure and very fragmented pieces which were nonetheless of great importance for archaeological research. Figure 8.6 shows just such a fragment, depicted in even light. These fragments are valuable because they are found only in projects like the DAI photographs, since no commercial agency like the Alinari would bother to photograph such an unrecognizable object. The photograph also reveals parts of the working process of photographing objects. In the background of the photograph, a person can be seen holding a black blanket that serves as a neutral background, instead of the storage area in which it is taken. As a result, the photograph has not been masked and the sculpture isolated, but the working process is still visible. Features like this and the official stamp can be seen as symbols that align them with a process of systematic scientific collection, ensuring their documentary value for archaeologists.

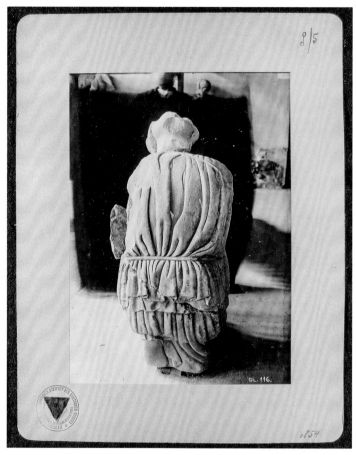

FIGURE 8.6. Photograph of pedimental sculpture from Olympia made for the DAI, showing the rounded corners and stamp typical of these images. c. 1900. Albumen print.

Stamps also display ownership and provide clues to the photograph's provenance, for instance, whether they were bequeathed by a scholar from his or her library or were once part of a different collection.[52] This is the case with two other sets of photographs originating from distinct photographic campaigns. The first is a set of photographs of Olympian sculptures—a collaboration between the photographer Walter Hege (1893–1955) and the archaeologist Gerhart Rodenwaldt (1886–1945), who was chair at the department for classical archaeology at Berlin University in the 1930s (figure 8.7a, b). The men worked together to produce a popular book about Olympia that was published in 1936 in conjunction with the Berlin Olympics.[53] Before Hege's tour to Greece in 1935, he and Rodenwaldt experimented with different ways of taking photographs of sculpture using the Berlin plaster cast collection.

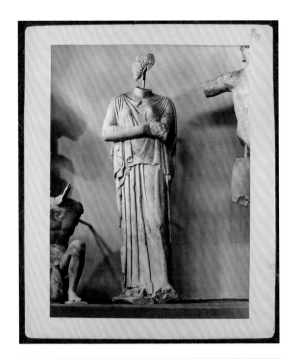

FIGURE 8.7A. Photograph of pedimental sculpture from Olympia. Walter Hege, c. 1935. Gelatine silver print.

FIGURE 8.7B. Verso of Hege print (figure 8.7a), showing copyright stamp in bold.

FIGURE 8.8. Photograph of the sculptural fragments of a metope from Olympia in raking light. Walter Hege, c. 1935. Gelatine silver print.

At the dig, where Hege was accompanied by Rodenwaldt and other archaeologists from the DAI, Hege produced photographs that look quite distinctive, one might even say opposing the methodology of the other "document" pictures in that they show clearly artistic intentions. The sculptures were carefully illuminated, and depicted from unusual angles. The photographer tried to animate the artifacts with strong lights and shadows, bringing out the expressive characteristic of sculptures, as in figure 8.8, where only a few fragments are effectively illuminated by strong raking light, giving them a

powerful stage atmosphere.[54] Because of the distinctiveness of the photography, Hege was named coauthor of the book with Rodenwaldt, and the cardboard mounts of the photographs in their box in the Fotothek bear a stamp with his name on the back as copyright holder. The curious lighting of these documents was intentional on the part of the authors, who aimed to gain a "deeper grasp of Greek sculpture" through these particular photographs.[55] As the archaeologist Rodenwaldt put it, "A good photograph is far from being an objective reproduction. It bears the conception of the artist or the interpretation of a scholar."[56] Hege had, then, a representative and characteristic rather than an objective perception of the artifacts. His approach investigates the "essential" features of the sculpture, offering a strong emotional identification with it.[57] However, the photographs produced by the setups using extreme effects of light and shade as well as showing a very strong artistic expression often were not the photographs that were eventually published.[58]

The final group of Olympian photographs that I will look at is a series of photographs marked by the annotation "(Hamann 7-10)" or "(Hamann 10a)" on the back of their cardboard mount. These notations allude to Richard Hamann (1879–1961), art historian and founder of Foto Marburg, one of the first art-historical projects to document art and architecture photographically in systematic campaigns.[59] In 1913, Hamann founded the photo archive at the art historical institute at Marburg University. It developed in the 1920s into one of the biggest and most important suppliers of art history photographs, including a publishing house for distributing prints and publications. Foto Marburg soon dominated the market for art historical photographs, and today has holdings of approximately 1.7 million negatives. Hamann had a near-monopoly over certain types of architecture or art works, and specialized in architectural sculpture. It was his goal to become the world's main supplier of images relating to the science of art. He did this by producing a photographic museum of as many artifacts as he could, but also by photographing the totality of single objects, capturing all possible details from all possible angles under the most neutral lighting. The archive created the illusion of complete, objective coverage.[60]

Hamann, who was also a photographer, went to Olympia to photograph the sculpture for an archaeologist (as did Hege), Ernst Buschor (1886–1961). Hamann and fellow photographer Hanns Holdt (1887–1944) traveled through Greece in 1923 to publish an illustrated volume. They assembled a multitude of images, moving around the sculptures with the help of the photographs, in an attempt to re-create the intention of the sculptor.[61] Hamann's visual method answered directly to the needs of art historians, focusing on the object and the maker's intentionality without any contextualizing information. His aim

was to grasp the object with the help of photography and to show the intention of the maker through a conscious arrangement of lighting, angle, and objects in the image but without any artistic intervention from the part of the photographer. This method, as he claimed, allowed new ways of conceiving the object (figure 8.9a, b).[62]

In contrast to Hege, for Hamann it was not the single photograph that was important. Meaning was built only through a series. He focused on details to an extreme extent, producing up to 450 images per monument, often of formerly unknown or unpublished monuments and artifacts. Multiplicity put the single image into perspective. Appropriating the work of art in Hamann's view took place through the act of photographing, and through the production of masses of views and details.[63] Seriality in this sense seemed a necessary ingredient of art historical research, concerned as it had been with the development of methods reliant on comparison. A standardization of formats and views, as I have previously stated, contributed to the use of this method.[64] Moreover, photographing was, in Hamann's opinion, an integral part of research and one of the discipline's most essential tasks, even more important than producing text.[65]

It is the variety of these four types (and many more) of photographs that allows researchers now and will allow them in the future to find the Fotothek useful and make their own synthesis out of the different photographs available. Although each set of photographs discussed here carries visible marks originating from its original intent, in the archive it is abstracted from that provenance by the physical system of the archive. The abstraction, and the standardization of their size (despite differences in their original formats), permits them to be sorted into cases and folders that allow flexibility of examination and ease of transportation to the central table. The photographs in the *Fotothek* boxes originated at different times and were made by different photographers who exhibited very different agendas. The box thus becomes a "synthetic object of linked but separate parts."[66] They all represent the same archaeological objects—pedimental sculpture or metopes from the temple of Zeus in Olympia—although conceived in radically different ways through photography. The box, acting as an ad hoc catalogue, creates a new entity out of the photographs by giving them order and classification through labeling, and homogenizes them by making diverse images into a unit, even though the assembled photographs incorporate different, sometimes even opposing, values.

In its sheer materiality of order (in boxes and drawers) and by inviting the user to place the card-mounted photographic prints of different origins and contexts next to each other, the archive fosters a multiplicity of perceptions.

FIGURE 8.9A. Photograph of pedimental sculpture from Olympia. Richard Hamann/Hanns Holdt, c. 1923. Gelatine silver print.

FIGURE 8.9B. Verso of figure 8.9a with inscriptions.

While photographs of the same artifacts represent different historical approaches to the archaeological object and to what was perceived as an archaeological photograph, they also show that all of these images could still be used for archaeological research. Despite their variety, they could all be considered as reference material for archaeology. The authority of these images was derived from the reputation and reliability of the people involved in making, distributing, and archiving the photographs. It was what impelled the photograph into the archive in the first place. However, thanks to the transparent quality of photographs, all sorts of images, from the professional discipline-laden to the commercially produced photograph, could be absorbed into the scientific grid.[67] This makes the apparent timelessness of the archive striking. One can go, look for a certain monument or work of art, and draw from all of these photographic objects of varied origins and contexts. Their heterogeneity is replaced by the suggestion of an artificial sense of homogeneity, organized at the user's end by the physical space of the archive. The boxes and mounts, the system, in fact, lends an appearance of timelessness with regard to the photographs' materiality that seems to guarantee their future usability, and their ability to uncover features, and in them new areas of study, which were not seen before. It is this deep time aspect of the photographic record of archaeology, as well as its comprehensiveness, that lends the archive authority.

A unifying feature of many archives is the idea of absolute completeness, the possession of all imaginable documents, which in its impossibility threatens the consistency of the archive.[68] This is in particular essential in an assembly like an archive of photogrammetric images. Authority in this case is based on the absence of gaps. Its status and power grow with the volume of material collected. Perhaps this is why so many documenting projects claim to encompass the "Earth and all that is in it," as Mitman and Wilder write in the introduction to this volume. Archaeology is no different. If only every known archaeological artifact could be captured in the archive in photographic form, the institutional archival collection would gain much power through their function as evidence.[69] But the main threat of the idea of the archive's completeness is the potential inconclusiveness of the ways of looking at an artifact. Here, the multiplicity of the photographs assembled in the Fotothek clearly shows that what could count as an archaeological document not only is but always was debated. Completeness was certainly the aim, but it was impossible to verify, in this case through the lack of any catalogue. But owning whole series of documents legitimized the notion of completeness of the archive, even while all those highly different groups of photographs are authorized by belonging to the archive.[70]

The Meßbildkampagnen

Archaeological photographic surveys like the ones mentioned above did not spring out of nothing. Although contextualizing elements (such as written remarks) that explain their organization are rarely found within these haphazard collections of photographs, additional written sources give us the broader programmatic context of different missions to photograph historical monuments and art works throughout Europe that founded these archives in the second half of the nineteenth century. These enterprises captured the endangered architectonic heritage of an individual nation's cultural memory in order to preserve it through the photographic record. They formed the core of a national historical conscience and helped to create a territorial identity.[71] The Mission Héliographique in France and the Königlich preußische Meßbildanstalt in Prussia represent two of those nationally oriented enterprises. For the Mission Héliographique, the Paris Commission des Monuments Historiques assigned five photographers in 1851 to undertake a complete photographic documentation of all French monuments as a basis for their restoration in the framework of a national preservation movement.[72] Although the Mission Héliographique is perhaps better known, the campaigns of the Königlich preußische Meßbildanstalt were quite similar in their aims. Initially aimed at archiving only Prussian heritage with the help of photogrammetric technology, the scope was quickly broadened to include the whole of the German Reich, followed by expeditions to Greece and the Levant.[73]

A jumble of photographic prints from one of the Meßbild campaigns is kept separately from the other photographic boxes as part of the Fotothek. It stands out in many ways from the sets of photographs examined earlier, since it was as a group created as part of a programmatic and systematic campaign. The Meßbildanstalt, founded in 1885 by Albrecht Meydenbauer (1834–1921) in Berlin, was the first institution worldwide to use photogrammetric documentation of architectural heritage. After an accident at the Wetzlar cathedral in 1858, Meydenbauer developed the idea that time-consuming direct measurement of sites could be replaced by indirect measurements using photographic images. Between 1885 and 1920, the institute produced records of about 2,600 objects from nearly 20,000 photogrammetric images on glass plates.[74] They focused first on architecture in and around Berlin as well as in the Prussian territories until 1900, and then afterwards extended to sites abroad like Athens, Baalbeck-Lebanon, and Istanbul.[75] Meydenbauer was quite content to follow his idea of a "world monument archive"—to unite the most important monuments of human history combining heritage with comprehensive documentation.[76]

The preserved photographic prints in the Fotothek belong to an expedition to Greece undertaken by Meydenbauer's successor, the architect Theodor von Lüpke (1873–1961), on behalf of the Greek and German governments.[77] He and two assistants traveled through Greece from April to July 1910, taking 600 photographs of mainly antique sites and monuments, along with a few Byzantine churches. The aim was to incorporate all important ancient and medieval places and buildings.[78] It was also on this occasion that photographs were taken of the excavation site at Olympia.

The photographic prints of the expedition to Greece are organized in alphabetical order according to the name of the archaeological site. Within each category of place they are arranged according to geographical directions and to the various architectural remains that they depict. The photographs of Olympia frame the ruined remains in their surroundings, the contemporary Greek countryside (figure 8.10). They focus on the structure and composition of space, offering an excellent overview.[79] By this they provide an overall impression of the remnants of the earlier nineteenth-century excavation sites rather than details of the monuments themselves. Nonetheless, the collection still attempts to encompass a view of all major architectural features of monuments like the temples of Zeus and Hera, depicting their architectural characteristics in a very monumental way. Thanks to the photogrammetric technology, the photographs have a great sharpness and depth of field, which makes the foreground and background equally visible. The prints amplify this effect in their wealth of detail.[80] These were the characteristics that made them so valuable in the eyes of the archaeologists and art historians, much more than the possibility of exactly fixing and transfering the dimensions given in the photographs into numbers. Being mounted on a 50 × 50 cm cardboard, they themselves are monumental in their presentation.

Only two photographs represent something other than the excavation site. One is a view into the main hall of the museum at Olympia showing the architectural sculptures from the temple of Zeus, and the other reproduces one of the most important finds, the so-called Hermes of Praxiteles (figure 8.11). Both photographs are exceptional for the program of the Meßbildanstalt, which typically exhibited only architecture and no other categories of archaeological finds. Their existence underlines the prominent position the Olympian finds held in contemporary culture and society.[81] By two different numbers on the back of their mounts the prints in the Fotothek are identifiable as Meßbilder.[82] In the center of the mount a stamp points to the affiliation of the whole series to the overall photographic archive of the archaeology department. They are organized separately, a condition of their belonging to an external classification system—that of the Meßbildanstalt. There, they

FIGURE 8.10. Meßbildanstalt (photographer: Carl Siele). Photogrammetric photograph of excavation site at Olympia showing the temple of Hera. 1910. Gelatine silver print.

would be a seamless part of a systematic photographic documentation of archaeologically relevant topographical sites. In the Fotothek, however, they are separated by the unusual size of their mounts and kept in a drawer.

There are several reasons for these photographs' departure from architectural subjects, and for their being placed in the photographic archive of the department of classical archaeology. Unlike other campaigns of the Meßbildanstalt, the expedition to Greece was commissioned by the Greek government, which wanted photographs of their cultural heritage to display at the Tenth International Art Exhibition in Rome in 1911. The government intended to present antique and medieval Greek culture as a symbol of the nation's achievements. In this exhibition, plaster casts of Greek sculptures were to be erected alongside the photographs of the buildings for which those sculptures were made and with the landscapes where they originated. Therefore, these

FIGURE 8.11. Meßbildanstalt (photographer: Carl Siele). The Hermes of Praxiteles. 1910. Gelatine silver print.

photographs not only served an archival function, but also contributed to the political and economic agenda of presenting Greek culture in the best possible way.[83]

The political and economic agenda did not, however, completely replace the function of the photogrammetric images, which were not only intended to work as visuals as in the case for the archaeologists, but as substitutes for building measurements offered all at one glance. Monuments were photographed with the greatest detail and accuracy to form an archive of cultural heritage. Albrecht Meydenbauer's idea was as much about the future as about the past. He believed that the photogrammetric images and the precise measurement of monuments would guarantee their reconstruction should they someday suffer damage. Thus, Meydenbauer's intention was less that the photographs would be used in the present (in fact they were never used as models

for a building survey) than that after their forthcoming destruction in the event of a possible future reconstruction they would function as models for these reconstructions and thus be transformed into numbers.[84] That's why—as Meydenbauer argued—the position of the camera was not intended to create "beauty."[85] Therefore, material permanence and legibility of the plates in the archive was crucial.[86] However, von Lüpke and his staff lacked the manpower to accomplish the basic measurements that were required to extract the necessary data.[87] Instead, the photographs were to be disseminated in different contexts and uses.

One of these was exhibitions. For the Roman show, some prints from the Greek expedition were monumentally enlarged (up to 120 × 150 cm), mounted and hung on the wall in a golden frame, clearly displaying their representational function. But most of the photographs were mounted as contact prints on double-sided plates that were fixed on revolving pedestals allowing visitors to browse through the 512 prints. Such exhibitions helped to market the photogrammetric images, as there were hardly any catalogues available. Before the exhibition traveled to Italy, the photographs made for Rome were previewed in Berlin in February and June 1911, where imagery from Greece was also represented (figure 8.12).[88] The presentation of the photogrammetric images was

FIGURE 8.12. Installation of Meßbildanstalt photographs on revolving pedestals, exhibition Berlin 1911. Courtesy of Brandenburgisches Landesamt für Denkmalpflege und Archäologisches Landesmuseum, Bildarchiv Meßbildanstalt, Neg.-Nr. 26024 / Sep. 92.

intended to demonstrate the possibilities of the new technology but also the aesthetic quality of the photographs, as contemporary reviews of the exhibition noted. Embedding the monuments in the landscape, the photographs followed the long-established tradition of depicting classical ruins as well.[89]

Prints of the Meßbildanstalt—and especially of the Greek campaign—were sold both for study purposes and as decorative objects.[90] They served a strong educational purpose as well. Thus, Theodor von Lüpke was very excited about the many visits by school classes and students to the Berlin exhibition. He hoped that the display would also spread the news about many of the other photographs the Meßbildanstalt contained. He therefore was especially concerned about the usability of the photographs.[91]

It is little surprise that Meßbilder are found in the photographic archive of the archaeological department. The specific characteristics of the photogrammetric photographs, especially their richness of detail and precision and their ability to picture fore-, middle- and background at the same time, enhance their qualities as research aids. Archaeologists valued them as scientific research materials. In preparation for the expedition, minister of finance Reinhold von Sydow sent a proposal to obtain financing, arguing that the resulting photographs would become indispensable for comparative purposes for German museums and institutions. They would also make largely obscure buildings and remains known.[92] Thus the photographs were intended to teach students of archaeology and architecture visual perception, and thereby contribute to their conception of Greek architecture and enhance their understanding of it. This ensures the group's separate and elevated status in the corpus of visual archaeological teaching material in the *Fotothek* at Humboldt University.

Conclusion

This essay has given an idea of what happens when a researcher opens the cupboards and unpacks the boxes of a photographic archive. The researcher inevitably sees the results of archival and discipline standardization in place of the heterogenous biographies of photographic objects, laden, as Elizabeth Edwards writes in this volume (chapter 5), with disciplinary presumption. Photographs placed together in the same box often in fact originate from very different contexts, times, and photographers, and were originally produced for very different purposes and functions. Even if the photographs were primarily conceived of to constitute a distinct and coherent archive, as in the case of the Meßbildanstalt prints, they later moved around and took on different functions, remaking them as documents to suit the purpose of a specific archive. Therefore, the photographs assembled in an archive embody a

tension between the original documenting impulse, the archival purpose, and their highly heterogeneous character as objects—a tension that is unstated, if not actively suppressed, by the ordering of the archive through its physical space. It is essential to the project of an archive to efface the individual and heterogeneous natures of its objects to allow their standardization. However, as we have seen in the case of archaeological photography archives, this archival standardization can also efface important details of the history, context, and uses of the objects themselves that document the presumptions of a discipline.

Acknowledgments

I am grateful to Kelley Wilder and Gregg Mitman for inviting me to participate in this volume. I would also like to thank the participants of the preceding workshops for their immensely helpful comments, in particular Kelley Wilder and Elizabeth Edwards. My sincere gratitude goes to the staff of the department of classical archaeology, Winckelmann-Institut, Humboldt University, Berlin, in particular Veit Stürmer and Antonia Weiße.

Notes

1. See, for photographic archives in art history and their features, Costanza Caraffa, ed., *Photo Archives and the Photographic Memory of Art History* (Berlin: Deutscher Kunstverlag, 2011), especially the introduction by Costanza Caraffa, "From 'Photo Libraries' to 'Photo Archives': On the Epistemological Potential of Art-Historical Photo Collections," in *Photo Archives and the Photographic Memory of Art History*, 11–44.

2. Joan M. Schwartz, "'Records of Simple Truth and Precision': Photography, Archives, and the Illusion of Control," in *Archives, Documentation, and Institutions of Social Memory: Essays from the Sawyer Seminar*, ed. Francis X. Blouin Jr. and William G. Rosenberg (Ann Arbor: University of Michigan Press, 2006), 74.

3. Schwartz, "Records," 74f.

4. Elizabeth Edwards, *Raw Histories: Photographs, Anthropology, and Museums, Photographing Objects* (Oxford: Berg, 2001), 56; Schwartz, "Records," 74f.

5. Heinrich Dilly has argued that it is not the works of art but instead the photographic reproductions that form the object of art history's analysis. Heinrich Dilly, "Lichtbildprojektion—Prothese der Kunstbetrachtung," in *Kunstwissenschaft und Kunstvermittlung*, ed. Irene Below (Gießen: Anabas-Verlag 1975), 153–72, esp. 153.

6. Kelley Wilder, "Looking Through Photographs: Art, Archiving, and Photography in the Photothek," in *Fotografie als Instrument und Medium der Kunstgeschichte*, ed. Costanza Caraffa (Berlin: Deutscher Kunstverlag, 2009), 117–28, esp. 118–23. Geoffrey Batchen has argued in the same direction: "In order to see what the photograph is 'of' we must first suppress our consciousness of what the photograph 'is' in material form." Geoffrey Batchen, *Burning with Desire: The Conception of Photography* (Cambridge: MIT Press, 1997), 2; see also Elizabeth Edwards and

Janice Hart, "Introduction: Photographs as Objects," in *Photographs Objects Histories: on the Materiality of Images*, ed. Elizabeth Edwards and Janice Hart (London: Routledge, 2004), 1–15.

7. Gillian Rose, "Practising Photography: An Archive, a Study, Some Photographs, and a Researcher," *Journal of Historical Geography* 26, no. 4 (2000): 556.

8. Batchen, *Burning*; Edwards and Hart, "Introduction"; Edwards, *Raw Histories*; Elizabeth Edwards, "Photography and the Material Performance of the Past," *History and Theory* 48 (2009): 130–50; see also Caraffa, "From 'Photo Libraries,' " 12, 24f, 37.

9. Edwards and Hart, "Introduction," 1.

10. Edwards and Hart, "Introduction," 1; Edwards and Hart, "Mixed Box: The Cultural Biography of a Box of 'Ethnographic' Photographs," in *Photographs Objects Histories: On the Materiality of Images*, ed. Elizabeth Edwards and Janice Hart (London: Routledge, 2004), 48.

11. Edwards and Hart, "Introduction," 2; Edwards, "Photography and the Material Performance," 145. For photographs as "social constructs," see also Rose, "Practising Photography"; and Joan M. Schwartz, " 'We Make Our Tools and Our Tools Make Us': Lessons from Photographs for the Practice, Politics, and Poetics of Diplomatics," *Archivaria* 40 (1996): 40–74.

12. Rose, "Practising Photography," 556.

13. Edwards and Hart, "Introduction," 5; Edwards, *Raw Histories*, 28.

14. For a similar analysis of the art historical photo archive of the Kunsthistorisches Institut in Florenz, see Caraffa, "From 'Photo Libraries,' " esp. 22–25.

15. Wilder, "Looking through Photographs," 117–28.

16. Schwartz, "We Make Tools."

17. Jacques Derrida, *Archive Fever: A Freudian Impression*, trans. Eric Prenowitz (Chicago: University of Chicago Press, 1996); Wolfgang Ernst, *Im Namen von Geschichte: Sammeln—Speichern—Er/Zählen; Infrastrukturelle Konfigurationen des Deutschen Gedächtnisses* (Munich: Fink, 2003).

18. Edwards and Hart, "Mixed Box," 49; Edwards, "Photography and the Material Performance," 135; Caraffa, "From 'Photo Libraries,' " 24f., 37f.

19. Caraffa, "From 'Photo Libraries,' " 38.

20. Schwartz, "We Make Tools," 42, 48.

21. Schwartz, "We Make Tools," 46, 50, 51f. 55, 62.

22. Schwartz, "We Make Tools," esp. 42 and 45. Tiziana Serena has argued that the value of a photograph as document is very much bound to "practices of inscription." Tiziana Serena, "The Words of the Photo Archive," in *Photo Archives and the Photographic Memory of Art History*, ed. Costanza Caraffa (Berlin: Deutscher Kunstverlag, 2011), 57–71.

23. Christopher Pinney, "The Parallel Histories of Anthropology and Photography," in *Anthropology and Photography 1860–1920*, ed. Elizabeth Edwards (New Haven: Yale University Press, 1992), 90.

24. There was a slightly different approach with the slide collection, which was mainly used as a teaching device. Here a more extensive catalogue is held, grouping the slides together according to type, place, and date (if known). It was also not the single slide that was listed but larger or smaller groups of slides. The characteristics I described here distinguish those kinds of archaeological (or art historical) archives from other museums or collections where photographs were registered as singular objects and often counted as "art." They are mostly valid for collections serving mainly research, e.g., university collections or photographic archives compiled as research tools next to museum's object collections. When Gillian Rose writes about the catalogue as identifying places and people and its "resolute listing of the real" that makes "both

the archive and the researcher fade into unimportance as the 'real' past erases the present," this function is taken over only partly in my case by inscriptions on the mount of the photograph itself. Rose, "Practising Photography," 560.

25. Rose, "Practising Photography," 560.

26. The first inventory book of the Lehrapparat is still owned by the department of classical archaeology, Humboldt University, Berlin. Only in 1927 was there a separate category introduced for photographs.

27. For a history of archaeology at Berlin University see Adolf Heinrich Borbein, "Klassische Archäologie in Berlin vom 18. zum 20. Jahrhundert," in *Berlin und die Antike: Architektur, Kunstgewerbe, Malerei, Skulptur, Theater und Wissenschaft vom 16. Jahrhundert bis heute: Aufsätze: Ergänzungsband zum Katalog der Ausstellung "Berlin und die Antike,"* ed. Willmuth Arenhövel and Christa Schreiber (Berlin: Wasmuth, 1979), 118–23, 125f.; and Henning Wrede, ed., *Dem Archäologen Eduard Gerhard 1795–1867 zu seinem 200. Geburtstag* (Berlin: Arenhövel, 1997). For a short history of the Lehrapparat under Eduard Gerhard, see Veit Stürmer, "Eduard Gerhards 'Archäologischer Lehrapparat,'" in *Dem Archäologen Eduard Gerhard 1795–1867 zu seinem 200. Geburtstag,* ed. Henning Wrede (Berlin: Arenhövel, 1997), 43–46.

28. See Stürmer, "Archäologischer Lehrapparat" and the inventory book kept by the department of classical archaeology, Humboldt University, Berlin.

29. Rose, "Practising Photography," 558f., quote 559.

30. Caraffa, "From 'Photo Libraries,'" 24f.

31. Elizabeth Edwards, "Photographs: Material Form and the Dynamic Archive," in *Photo Archives and the Photographic Memory of Art History,* ed. Costanza Caraffa (Berlin: Deutscher Kunstverlag, 2011), 47–56.

32. Rose, "Practising Photography," 558, 561, 565–69.

33. Elizabeth Edwards has called this characteristic "acts of re-ordering, re-captioning, and re-interpretation." Edwards, "Photography and the Material Performance," 147f. Gillian Rose describes a very different embodiment practice in the print room of the Victoria and Albert Museum in London as producing "a grotesquely intrusive body only to make me as unobtrusive as possible," which holds true for most museum collections. Rose, "Practising Photography," 561f. Most collections in research institutions, on the other hand, follow more the model of barely restrained access I have described here. The space of the photographic archive I am describing here has a lot in common with the researcher's study Rose describes as a second space that works differently than the archive. Both in a sense allow a more personalized access to and handling of the photographs. Rose, "Practising Photography," 562–64.

34. Rose, "Practising Photography," 565, 567.

35. Rose, "Practising Photography," 560; for mounting see also Edwards and Hart, "Mixed Box," 55f.

36. Wilder, "Looking through Photographs," 123.

37. Serena, "Words," 59, 63, 65.

38. Edwards and Hart, "Introduction," 12f.; Edwards, "Photography and the Material Performance," 141–45; Serena, "Words."

39. See Wilder, "Looking through Photographs," 123; Serena, "Words," 67f.

40. See, e.g., Ludger Derenthal and Christine Kühn, eds., *Ein neuer Blick: Architekturfotografie aus den Staatlichen Museen zu Berlin* (Tübingen: Wasmuth, 2010). Caraffa, "From 'Photo Libraries,'" 41f., exposes the difficulty of including this kind of information in the cataloguing.

41. Rose, "Practising Photography," 566.

42. Serena, "Words," 70.

43. Allan Sekula, "Reading an Archive: Photography between Labour and Capital," in *The Photography Reader*, ed. Liz Wells (London: Routledge, 2003), 444; Allan Sekula, "The Body and the Archive," in *The Contest of Meaning: Critical Histories of Photography*, ed. Richard Bolton (Cambridge: MIT Press, 1989).

44. Rose, "Practising Photography," 569n16.

45. Caraffa, "From 'Photo Libraries,' " 25.

46. For a history of the archaeological activities at Olympia and their political context, see Berthold Fellmann, ed., *100 Jahre deutsche Ausgrabung in Olympia* (Munich: Prestel, 1972); Peter Cornelius Bol and Herbert Beck, eds., *Olympia: Eine archäologische Grabung* (Frankfurt am Main: Liebighaus, 1977); Suzanne L. Marchand, *Down from Olympus: Archaeology and Philhellenism in Germany, 1750–1970* (Princeton: Princeton University Press, 1996), 77–91; Suzanne L. Marchand, "The Excavations at Olympia, 1868–1881: An Episode in Greco-German Cultural Relations," in *Greek Society in the Making, 1863–1913*, ed. Philip Carabott (Aldershot, UK: Ashgate, 1997), 73–85; Helmut Kyrieleis, ed., *Olympia 1875–2000: 125 Jahre Deutsche Ausgrabungen*, Internationales Symposion, Berlin 9–11. November 2000 (Mainz: von Zabern, 2002); Henning Wrede, "Olympia, Ernst Curtius und die kulturgeschichtliche Leistung des Philhellenismus," in *Die modernen Väter der Antike: Die Entwicklung der Altertumswissenschaften an Akademie und Universität im Berlin des 19. Jahrhunderts*, ed. Annette M. Baertschi and Colin G. King (Berlin: De Gruyter, 2009), 165–208.

47. Wilder, "Looking through Photographs," 125f.; Edwards, *Raw Histories*, 58.

48. Lena Bader, Martin Gaier, and Falk Wolf , eds., *Vergleichendes Sehen* (Paderborn: Fink, 2010); Angela Matyssek, *Kunstgeschichte als fotografische Praxis: Richard Hamann und Foto Marburg* (Berlin: Mann, 2009), 19.

49. Filippo Zevi, ed., *Alinari: Photographers of Florence 1852–1920* (Florence: Alinari et al., 1978); Michele Falzone del Barbarò and Monica Maffioli, eds., *Das Italien der Alinari: italienische Kunst und Kultur in den Aufnahmen der Fratelli Alinari, Florenz, 1852–1920* (Florence: Alinari, 1988); Arturo Carlo Quintavalle and Monica Maffioli, eds., *Fratelli Alinari: fotografi in Firenze, 150 anni che illustrarono il mondo 1852–2002* (Florence: Alinari, 2003).

50. This method contrasts the procedures of the English survey movement noticed by Elizabeth Edwards, where labels and photographs were juxtaposed to keep the relevant information immediately present. Edwards, "Photography and the Material Performance," 142–45.

51. For a history of the photographic archive at the DAI, see Michael Krumme, "Der Beginn der archäologischen Fotografie am DAI Athen," in *Diethnes Synedrio aphieromeno ston Wilhelm Dörpfeld: ypo tin aigida tou Ypourgeiou Politismou*, Lefkada 6–11 Augoustou 2006, ed. Chara Papadatou-Giannopoulou (Patra: Peri Technon, 2008), 61–78.

52. Stamps also provide insights into the history of an archive. The stamp in figure 8.6 reveals not only that the photograph was once in the archive of the DAI, but also that it had been there during the Third Reich. The Prussian eagle in the center of the stamp holds the National Socialist Party's emblem, the swastika. The emblem was later on, after the Third Reich, probably in East Germany, covered by a black triangle to stash away this part of German history.

53. Gerhart Rodenwaldt and Walter Hege, *Olympia* (Berlin: Deutscher Kunstverlag 1936); Matthias Harder, *Walter Hege und Herbert List: griechische Tempelarchitektur in photographischer Inszenierung* (Berlin: Reimer, 2003), 108–16. The photographer Walter Hege supplied a great number of reproductions of art and architecture for German art history and archaeology and had an ambivalent relationship with National Socialism. His illustrated books were very

popular in the Weimar Republic and the Third Reich, defining German identity. For a characterization of Hege and an illumination of his career under the National Socialists, see also Friedrich Kestel, "Walter Hege (1893–1955): 'Race Art Photographer' and/or 'Master of Photography'?," in *Art History through the Camera's Lens*, ed. Helene E. Roberts (New York: Gordon and Breach Publ., 1995), 283–316; and Angelika Beckmann and Bodo von Dewitz, eds., *Dom, Tempel, Skulptur: Architekturphotographien von Walter Hege* (Cologne: Wienand, 1993), especially the article by Gerhild Hübner, "Walter Heges Blick auf die griechische Antike," 41–52.

54. Hege's photographs oscillate between the emphasis on the fragmented object influenced by the German modernist art movement Neue Sachlichkeit and the use of light achieved with movable lamps as well as the concentration on gazes and facial expressions to elevate as well as dramatize and animate the depicted sculptures. See also Barbara Kopf, "Skulptur im Bild: Visuelle Dokumentation und deren Beitrag zur Entwicklung der archäologischen Wissenschaft," in *Verwandte Bilder: Die Fragen der Bildwissenschaft*, ed. Ingeborg Reichle (Berlin: Kadmos, 2007), 149–68, esp. 158–63.

55. "Tieferes Erfassen der griechischen Plastik," Gerhart Rodenwaldt about his collaboration with Hege: Gerhart Rodenwaldt, minutes of a meeting of the Archäologische Gesellschaft zu Berlin, 4 June 1935, in *Archäologischer Anzeiger* (1935): 357, quoted in Harder, *Hege*, 53.

56. "Eine gute Photographie ist weit davon entfernt, eine objektive Wiedergabe zu sein. Sie bedeutet die Auffassung eines Künstlers oder die Interpretation eines Gelehrten." Rodenwaldt, "Minutes," 356, quoted in Harder, *Hege*, 53.

57. Harder, *Hege*, 78, 84–86, 98, 110–12; Kestel, "Walter Hege."

58. Harder, *Hege*, 100; see the choice of photographs in the book *Olympia* in comparison with figure 8.8. Rodenwaldt and Hege, *Olympia*.

59. For an extensive treatment of this photographic archive see Matyssek, *Kunstgeschichte*.

60. Matyssek, *Kunstgeschichte*, 47–53, 220–23, 293.

61. Matthias Harder, ed., *"Wanderer, kommst Du nach Hellas . . .": deutsche Photographen sehen Griechenland in der ersten Hälfte des 20. Jahrhunderts* (Thessaloniki: Museum für Photographie, 1997), 25; Matyssek, *Kunstgeschichte*, 231–33.

62. Matyssek, *Kunstgeschichte*, 213–18. In his written accounts, Hamann distanced his approach very much from Walter Hege's psychologizing and monumentalizing images, but the two were unified in their approach of following the intention of a specific work of art; furthermore, their prints are often indistinguishable. Matyssek, *Kunstgeschichte*, 261–67.

63. Matyssek, *Kunstgeschichte*, 54, 220–23, 224–30; Angela Matyssek, "Kein Singular: Fotografie und Übersicht," in *Wege zur Moderne: Richard Hamann als Sammler*, ed. Agnes Tieze (Munich: Edition Minerva, 2009), 190, 209, 212.

64. Matyssek, *Kunstgeschichte*, 54f., 233–36, 238.

65. Matyssek, *Kunstgeschichte*, 71, 223f., 288f, 273–77.

66. Edwards and Hart, "Mixed Box," 47.

67. See for these points Edwards, *Raw Histories*, 32f., 38, 40; Schwartz, "We Make Tools," 45.

68. See Caraffa, "From 'Photo Libraries,' " 21.

69. Derrida, *Archive Fever*; Matyssek, *Kunstgeschichte*, 21, 53.

70. Derrida, *Archive Fever*; Matyssek, *Kunstgeschichte*, 53.

71. For an overview of respective enterprises worldwide, see Joan M. Schwartz and James R. Ryan, eds., *Picturing Place: Photography and the Geographical Imagination* (London: Tauris, 2003).

72. Anne de Mondenard, *La Mission Héliographique: cinq photographes parcourent la France en 1851* (Paris: Monum, Éd. du Patrimoine, 2002).

73. Reiner Koppe, "Zur Geschichte und zum gegenwärtigen Stand des Meßbildarchivs," in *Architekturphotogrammetrie gestern—heute—morgen: wissenschaftliches Kolloquium zum 75. Todestag des Begründers der Architekturphotogrammetrie Albrecht Meydenbauer, in der Technischen Universität Berlin am 15. November 1996*, ed. Jörg Albertz and Albert Wiedemann (Berlin: Technische Universität, 1997), 41–58.

74. The glass plate negatives were 40 × 40 cm and 30 × 30 cm in size, and the resulting photographs were mainly sold as contact prints.

75. Koppe, "Zur Geschichte."

76. Albrecht Meydenbauer, *Handbuch der Meßbildkunst in Anwendung auf Baudenkmäler- und Reise-Aufnahmen* (Halle: Knapp, 1912), v; Peter Geimer, "Bild und Maß: Zur Typologie fotografischer Bilder," in *Einführung in die Kunstwissenschaft*, ed. Thomas Hensel and Andreas Köstler (Berlin: Reimer, 2005), 164; Matyssek, *Kunstgeschichte*, 116–18.

77. Reiner Koppe, *Griechenland: 1891/1892 und 1910 in Messbildern* (Ruhpolding: Verlag Franz Philipp Rutzen, 2008). There was also an earlier expedition to document the Athenian acropolis 1891–1893 under Albrecht Meydenbauer. For this and the following, see also Herta Wolf, "Das Denkmälerarchiv Fotografie," in *Paradigma Fotografie: Fotokritik am Ende des fotografischen Zeitalters*, vol. 1, ed. Herta Wolf (Frankfurt am Main: Suhrkamp, 2002), 349–75.

78. Theodor von Lüpke, summary about the Greek journey, in Koppe, *Griechenland*, 21–24.

79. Geimer, "Bild und Maß," 165f.

80. Matyssek, *Kunstgeschichte*, 80.

81. See Marchand, *Olympus*, 85, 87–91.

82. A small label on the upper left edge records the number of the photograph in the printed series, while a second number written with pencil onto the lower left edge gives the inventory number of the negative of the Meßbildanstalt.

83. Koppe, *Griechenland*, 13f.; Matyssek, *Kunstgeschichte*, 80.

84. Ernst, *Im Namen*, 981–84; Geimer, "Bild und Maß," 163–65; Matyssek, *Kunstgeschichte*, 110–21. With the English Survey Movement, Elizabeth Edwards has analyzed a similar but distinct approach to the relationship between past and present. The survey photographers were worried about the "potential loss of the future" that was supposed to be counteracted by the photographs. Edwards, "Photography and the Material Performance," 133.

85. Also Meydenbauer conceded that the "Messbilder" had an aesthetic value, which in his eyes was to make them appealing to laymen as well. Ernst, *Im Namen*, 956–58, 970–73; Geimer, "Bild und Maß," 169f.

86. Accuracy of the photographs was achieved through written guidelines that explained how to photograph, the concern for preservation embodied in material precautions of image making. For anthropology, see Edwards, "Photography and the Material Performance," 137–40.

87. Koppe, *Griechenland*, 13f.

88. Koppe, *Griechenland*, 14–16; Matyssek, *Kunstgeschichte*, 115; Wolf, "Denkmälerarchiv," 357–62.

89. See Koppe, *Griechenland*, 26f. for reviews; Geimer, "Bild und Maß," 169f.

90. A sales catalogue for the photographs resulting from the expedition to Greece, *Verzeichnis der Aufnahmen aus Griechenland vom Jahre 1910*, with printed thumbnails and an image compendium, *Bilderheft der Königlichen Meßbildanstalt*, was published by the Meßbildanstalt to publicize the holding. In this compendium 443 images out of 680 glass plates from both the series of 1893 (the Meydenbauer photographs of the Athenian acropolis) and 1910 were depicted in small scale. See Koppe, *Griechenland*, 16; Wolf, "Denkmälerarchiv," 357–62, 373–75.

91. Theodor von Lüpke, summary of the Greek journey, in Koppe, *Griechenland*, 24. It was no accident that after World War I the Meßbildanstalt was transformed into an institution for the distribution of photographic reproductions of artworks, paying only limited attention to photogrammetric photographs. It was eventually incorporated into a publishing house, which was supposed to contribute by publishing and merchandising the photographs. Thus, the photographic archive was transformed into an image bank that was to distribute photographs widely to schools, universities, and other public institutions. See Wolf, "Denkmälerarchiv," 367–75.

92. Letter from Prussian minister of finance Reinhold von Sydow to Emperor Wilhelm II, 1910, published in Koppe, *Griechenland*, 20. Scientific support for the expedition, in the form of archaeologists, architects, or historians who would constantly accompany the journey, was desired, but not received. Theodor von Lüpke, summary of the Greek journey, in Koppe, *Griechenland*, 23f.

Photographic Cataloguing

KELLEY WILDER

[GMC-F205] A half plate glass negative of hickory-shafted golf clubs taken by John Fairweather, ca. 1900.

[ALB2-244] Urns found near Law Park, St Andrews, a photographic print attributed to Thomas Rodger, ca. 1859.

[ALB8-91-2] An albumen print of a Sun Fish, St Andrews Bay. Specimen from the Museum of the St Andrews Literary and Philosophical Society, photographed by Dr. John Adamson.

[ALB31-6B] An anonymous photograph of a painting by Hans Memling 1485.

[DWT-158] Several lantern slides by Valentine and Company Lantern Slide Department, from the series 'Greenland's Icy Mountains' ca. 1890.

[ms29951-10-50] An albumen print bearing the Giorgio Sommer blind stamp showing a display of surgical instruments from the National Archaeological Museum in Naples.

If you look into the photographic holdings of the special collections of the St Andrews University Library, you find the most extraordinary assortment of things. Not only do the photographs span the history of photographic processes, a telling tale in itself, but they run the gamut of possible pictorial subjects. Describing what these images "are" leads to a long, complicated, and discipline-laden list: glass and paper; salt print, silver gelatin, and lantern slide; portrait, landscape, and still life; science, documentary, and art; golf clubs, urns, and butterflies. These descriptions arise from shifting attention between the material of the photographs, the original contexts in which they were taken, and the pictorial subjects that they depict. To deal fully with the implications of these different methodological approaches to all types of photography would require an essay of truly enormous scope. This essay limits itself to considering only photographs of objects—what Norman Bryson called the "overlooked."[1] It is a category of images that has been created (and over-

looked) since the inception of photography and that connects deeply with photographic practices of documenting, archiving, and above all cataloguing.

Each item listed above comes from the online catalogue of the St Andrews Library Photographic Archive and acts as a window onto the myriad practices of knowledge creation by a very unique sort of documentation—photographic cataloguing. As Joan Schwartz points out, the relationship between photography and modern archival classification has been around since 1839. In August of that year France's minister of the interior, Tanneguay Duchâtel, presided over both the purchase of the new invention of photography and the institution of new French archival standards for historical documents based on provenance, or the hierarchy of the *fonds*. These two practices, photography and archival organization, share nineteenth-century assumptions about the nature of knowing, and both also promise to control the flow of that knowledge.[2] They present ways of ordering considered by many museum staff and researchers as "natural," and that are often therefore treated as unproblematic.[3] It didn't take long for the two practices to become conflated, with photographs of objects driving the organization of library and archival catalogues.[4] Such practices have been deployed across disciplines and continents, stretching from the National Archaeological Museum, Naples, to the stores of Dundee's Museum of Zoology, and reach back as far as William Henry Fox Talbot's 1840s calotypes of millinery, glass and porcelain objects, and forward to digital museum catalogues like St Andrews'.

While lists, records, graphs, tables, and other tools feature in studies of bureaucratic structures and their relationships to ideologies, norms, and power, photography often takes a back seat in spite of its central role in documenting and cataloguing objects both in the archive and in the world.[5] Photographic catalogues are complicated because they are made up of documents but are also themselves documents that create objects of study even while they are objects themselves that require study.[6] On the one hand, photographic cataloguing is about the act of documenting material objects like botanical specimens, museum objects, and manufactured items. When photographic catalogues are complete or, since completion is rarely achieved, when they have matured, the catalogue then stands as a document about underlying assumptions about how we acquire knowledge that are deeply inscribed in photographic practices. Many photographic catalogues depict things, either natural or manmade, that present a scientific and objective face, but like the decorative and aesthetic images alongside which they are catalogued, they display subjective values in their very creation. The same can be said of the photographic catalogue itself. The process of collection, cataloguing, and recataloguing causes

these documents to be in a state of constant becoming, and is a site of layers of documentary impulses and documentary images.[7] Not only does a short list of photographs of objects from the St Andrews catalogue enshrine certain aspects of photographic practice, it makes explicit the many ways in which the documenting impulse is inscribed and reinscribed in practices of making, collecting, cataloguing, writing about, and digitizing photographs.

Although this list is in its particularities unique to St Andrews University Special Collections, its diversity of content is familiar to anyone who has looked after a modern archive, accruing as they are photographs at seemingly every turn. Each entry is a possible catalyst for a discussion about photography and its enticing promise to bridge with one technological leap the chasm between the desire for the comprehensive catalogue and its practical execution. Taken individually, any one photograph might be the subject of a long discussion of the notion of the one-to-one correlation of photographic documents with reality.[8] Discussions like these, focused as they are on the compelling textual surround of photography, often concern themselves with a particular link to reality based on causal grounds, known to visual culture specialists as the indexicality argument. While a focus on photographic catalogues as objects incorporates the assumptions of indexicality, this paper attempts to explore how photography works materially for and on researchers in archives.[9] Each photograph could, instead of being seen as a link to the real world, be seen as being deeply embedded in constantly changing archival documenting practices, from the middle of the nineteenth century to present-day digitization. This is especially so in the case of photographs in or as catalogues, which are both institutional and bureaucratic objects steeped in disciplinary norms. If André Malraux is right in his assertion that "history is that which is photographable," we should take very seriously the cross-section of photographs that act as or within catalogues in a place like a university library.[10] "Paying attention" means studying not only how photographs are deployed within catalogues as authoritative and objective, but also how they can be redeployed or reorganized as a collection of photohistorical importance.[11] There are hints of these administrative practices in the way in which photographs are described and displayed for access to the public via the digital catalogue (because roughly 90 percent of the access to the St Andrews collection comes via its digital catalogue).[12] The photographic objects/documents of objects, for they are always both things at once, listed here give a surprisingly good overview of the many ways in which photography contributed as a "micromaterial culture of knowledge" within broader practices of rewriting history (or indeed a special collections catalogue) in images.[13] If in fact the many recent analyses of photographic archives signify an

increasingly knowing approach to photographs as archival sources, there has been a corresponding organizational movement at the institutional level in the recognition of masses of archival photographs as discrete "photographic" collections with interesting properties of their own. This essay is about both of these aspects. The first, that each example from the list is catalyst for a story about a particular method of photographic documenting with a history and practice all its own. The second aspect is the gathering up of these items into a photographic catalogue that attempts to incorporate all these meanings into a single metanarrative corresponding to a particularly "photographic" collection that is administered by a photographic catalogue.

Photographs of Things

A picture of a set of golf clubs is not an altogether surprising photograph to find in St Andrews, home to one of the most prestigious golf courses in the world, as well as several prolific firms in the golf industry. Hickory handled clubs like the six depicted in figure 9.1 were a new generation of modern golf clubs driven by the innovation of making golf balls out of gutta percha instead of the usual feather and leather. The image belongs to a collection of negatives depicting the products, machinery, and personalities of the Forgan Golf Club Works (later Spalding). Like many photographers, John and James Fairweather of Fife produced industrial and advertising photographs, now often referred to under the general title of "applied photography." Like the 1.5 million streamlined product photographs of toasters, light bulbs, refrigerators, lamps, motors, and other manufactured items held in the General Electric collection (Schenectady Museum, Schenectady, NY), product photographs' uncluttered backgrounds and often graphic formal qualities like dramatic lines and distinctive lighting encouraged the appreciation of the functional purpose of objects, a "simple thingness" that was celebrated in the *Film und Foto* (Fifo) exhibition of 1929.[14] In this exhibition of contemporary international photography in Stuttgart, advertising photography inhabited a devoted space. Neue Sachlichkeit, the modernist movement associated with the Fifo exhibition and in particular with Albert Renger-Patzsch, has become known in English as New Objectivity. But "thingness"—the celebration of the pure materiality of natural and manufactured things—perhaps described it better. Incorporating both a utopian optimism about the everyday and an endorsement of the moral good of innovation—in this case on the part of both photographers and manufacturers—New Objectivity turned the celebration of objects into a new way of seeing the world.[15] It is, however, extremely unlikely that George Cowie, who donated the glass plate negative of golf clubs to

FIGURE 9.1. Photograph of the item GMC-F205, a half-plate glass negative, in its paper housing. Courtesy of St Andrews University Special Collections. Digital photograph made by the author.

St Andrews, collected it for its Bauhaus narrative. Rather, he was most likely interested in its social biography as part of the golfing history of the town of St Andrews. George Middlemass Cowie, a local press photographer, and his studio photographer wife Beatrice Govan gave this image, along with more than 60,000 other photographs—theirs and those they had collected—to the St Andrews University Library in 1981.[16] Cowie and Goven amassed a particularly fine collection of golf-related imagery in addition to his local and topographical views. St Andrews' identity as the "home of golf" is here implied not only in the image content but in the collection history, and hence in the resulting photographic catalogue.

These two descriptions reflect two ways of reading, or indeed cataloguing, a particular photograph of objects. The first, from a photohistorical point of view, assumes the natural connections of form, function, and photographic practice in a continuous and linear visual cultural history.[17] The second takes its reading from the relationship of the collection (the *fonds* in Schwartz's article) of George Cowie and in the identity of St Andrews, both the town and the University Library Special Collections. It is a pattern of double meaning that repeats itself throughout the collection in St Andrews, arising from the various impulses to identify a geographical and cultural area by means of industrial and natural objects on the one hand and collections of images on the other. While these two sorts of interpretations imply a contemporary user with particular disciplinary affiliation, some of the photographs, in particular ALB2-244 and its variations, reflect the many strands of narrative that could influence a user toward one or the other of these readings.

Four or five versions of figure 9.2 exist in the St Andrews collection. They are represented as five photographic prints, in five different albums, and one lantern slide. Although the compositions are similar and in one case the same, and the photographs show archaeological finds from the same location, on the same date, they vary in framing and the number of depicted items. Not only is the "find" a critical concept in archaeology, it is also something that, by the very nature of archaeological excavation, is destroyed and recontextualized at the moment of its becoming a find.[18] Visualization provides a way of conserving or fixing the finds in a historical context,[19] and it makes them into "detached, mobile and meaningful objects."[20] In 1859, when these urns were found and photographed, the usefulness of photography for the sciences remained unproven. Although authors like Talbot and Herschel had written enthusiastically about its possibilities, the reputation of photography was still a matter for debate.[21] St Andrews has a number of archaeological sites, several of which date back as far as the Bronze Age. It was an exciting find of eighteen to twenty cinerary urns and bronze implements, so exciting it was published in the *Proceedings for the Society of Antiquaries of Scotland*.[22] That Thomas Rodger so quickly documented the urns so close to their discovery shows the rapidity with which photography was taken up within at least two practices of documentation: the documenting of archaeological finds, and the visual cataloguing of museum objects.

Although this photograph could easily be an example of either of these traditions, in this case a close look at ALB2-244 and the others in the series ALB24-95-1, ALB10-57, ALB49-51-1, and ALB55 reveals another documenting practice, one charting the early use of photography in science and the historiography of

FIGURE 9.2. ALB2-244, urns found at Law Park. Albumen print from wet plate collodion negative, attributed to Thomas Rodger junior or senior. ca. 1859. In the original album, a typewritten text reads, "From a wet plate by Thomas Rodger." These urns were discovered near Law Park, when a field was being plowed. Mr. Charles Howie, who kept a nursery garden in the neighbourhood, made a thorough investigation and discovered about twenty urns. He says: "They were all filled with fragments of calcined human bones, many of them apparently as fresh as if newly deposited. Two pieces of bronze were also found among the bones." The bronze blades are shown in the illustration. The place was evidently the site of a cremation cemetery of the Bronze Age. Howie had previously found near the same spot the foundations of a rude circular building, and later the fragments of a jet necklace were discovered. For full particulars, see *Proceedings of the Society of Antiquaries of Scotland* 42 (1901): 401ff. Courtesy of St Andrews University Special Collections.

photographic history in St Andrews. One clue to this reading is the attribution of photographer as Thomas Rodger. Rodger was a member of a community of St Andrews photographers who made the city an important location for early photographic history.[23] He was also a member of the St Andrews Literary and Philosophical Society, and opened one of the earliest Scottish photography studios in ca. 1849. Dr. John Adamson, physician and friend of Sir David Brewster, taught Rodger the calotype at a very early stage in his career, although Rodger soon turned to wet plate collodion in the 1850s.[24]

Adamson, author of the sun fish specimen of figure 9.3, founded and curated the collections of the St Andrews Literary and Philosophical Society until his death in 1870. Several boxes and some albums from the Literary and Philosophical Society collection can be found in the St Andrews University Special Collections. Rodger and Adamson were friends of Sir David Brewster, who first exhibited specimens of Talbot's photogenic drawing in February 1839 to audiences in St Andrews. Ever interested in the practical applications

of photography to science, Brewster asked Talbot as early as February 1839 whether he had yet made a "map of the solar lines" with his photogenic drawing.[25] Figures 9.2 and 9.3 exhibit more than just the close relationship of these early photographic experiments to experimental science. Both images are part of albums collecting specimens, both in the pictorial sense (the sun fish, the urns) and the photographic history sense (the wet plate, the albumen print). In their album contexts, they accumulate meaning, in the words of Stephen Bann, to become "much more than the sum of their parts."[26] In this case they become a narrative propagated by the editor or compiler of the album as a "collection" of a certain sort. Photographic albums were (and still are) integral to the encapsulation of survey projects, personal events like weddings, lives of artists, international exhibitions, and much more. In each of these uses, the "natural" qualities of each image belonging as a part of a whole tames the polysemy of a single photograph, harnessing it for a particular narrative. Although the St Andrews catalogue does not clarify what sort of

FIGURE 9.3. ALB8-91-2. Specimen of a sun fish. Albumen print by John Adamson, ca. 1865. Courtesy of St Andrews University Special Collections.

photographic artifacts we might find in these albums, which will be a discussion point later, we can reconstruct at least some of the companion images. Figure 9.2, located as it is in General Album 2, accompanies several photograms of botanical specimens (ALB2-245;246) with their descriptions; Figure 9.3, in General Album 8, accompanies a color absorption spectrum (ALB8-89) and a selection of animal skeletons (ALB8-91-1) from the Literary and Philosophical Society collection. As albums, General Albums 2 and 8 are a sampling of the many uses of photography for the sciences. The other photographs of urns can be found in General Album 10 and General Album 24. In General Album 10, the urn image accompanies human and animal portraits, mostly unknown, and copies of engravings and other artwork, firmly situating photography within the arts. General Album 24 is titled "Calotypes taken at Calton Stairs, Edinburgh in 1843, 1844 and 1845." The inscription signals the photohistorical importance of the album, as Calton Stairs was the address of Rock House, where David Octavius Hill and Robert Adamson, brother of John Adamson, operated their famous photographic studio from 1843 until Adamson's death in 1848. Rock House remained the site of photographic studios for nearly a century afterward. In among the many famous portraits by Hill and Adamson of the founders of the Free Church of Scotland, and some of the earliest documentary photographs of the fishing community of Newhaven, is the page with the urns, and the accompanying image of the photographic result of an optical experiment.[27] There are many layers of documenting at work around this series of images of urns. The original photographs begin as documents of archaeological finds that were then incorporated by the editors of the albums into the three narratives of art history, photographic history, and science. They come together via collection by the St Andrews University Special Collections to document St Andrews as the locus for inventive and pioneering photography.

These narratives are further intertwined by the presence of a lone lantern slide copy of one version of the photograph of urns. John Hardie Wilson, a St Andrews native and lecturer in agriculture and rural economy, made figure 9.4 around 1900 apparently from a print made in 1859 (an example might be ALB49-51-1) and it was subsequently collected by George Cowie, which means it arrived into the collection along with the glass plate negative of golf clubs shown in figure 9.1.[28] Connected as they are by practices of documenting visual documents—a lantern slide of a photographic print of an archaeological find—and through practices of collection—a print collected into an album acquired by the special collections—the urn images are, via this one lantern slide, also connected to the broader educational component of the St Andrews Special Collections, housed mainly in the muniments collection.

FIGURE 9.4. Lantern slide of Urns print. Courtesy of St Andrews University Special Collections.

The muniments are "the archives of the institution itself" and include title deeds, minutes, accounts, lists of students, matriculation and graduation records, plans, maps, correspondence, and photographs.[29] Part of the mission of the library special collections is to acquire papers and teaching materials of individuals important to St Andrews University.[30] In these teaching materials, lantern slides, like the one of the urns in figure 9.4, are plentiful.

Lantern slides, like stereographs, make up a huge proportion of photographic material in archives and collections around the world, but are often among the most neglected items and are frequently the first to suffer material damage or de-accessioning, if they were ever accessioned in the first place. They account for a large percentage of the photographic material in circulation around the turn of the twentieth century in part due to their use in education. Between 1870 and 1915 the Royal Photographic Society Exhibition showed 3119 entries relating to lantern slides. The number of individual slides was much higher, since many entries were actually groups of lantern slides, like Newton and Company's forty-eight lantern slides of India, Japan and the South Sea Islands, or Alfred Watkins' twenty lantern slides on bee-keeping.[31] Even more of the entries were complete lectures, on subjects ranging from "Manchester Past and Present" by S. L. Coulthurst to Henry Sandland's "A Visit to the Zoo." Many of the subjects, like Wilson's slides of Bronze Age and Celtic finds in St Andrews, entered the muniments collection as part of the

papers of former university lecturers. In this case, Wilson, who was born only a year before Rodger photographed the urns, helped to found the University Botanical Garden in 1889, and returned as a lecturer in agriculture and rural economy from 1900–1920. The slide of the urns was made in his first year of teaching.

Very often, lecturers would not make their own lantern slides, but would buy them ready-prepared from commercial studios. D'Arcy Wentworth Thompson quite likely bought his set of fifty lantern slides from the local Dundee firm Valentine and Co. entitled *Greenland's Icy Mountains*. Thompson, the author of the influential monograph *On Growth and Form*, wrote of the intersection of looking and knowing, a sentiment that was fully fledged by the time he published in 1917.[32] Photography had since its inception been acting as a "surrogate for travel," whisking viewers effortlessly from their armchairs to the far reaches of the world.[33] Photography's role in constructing "imaginative geographies" has not gone unnoticed by the scholarly community.[34] Often these studies are based on photographic prints, sometimes by well-known photographers like Frith, Alinari, and Fenton, and sometimes by lesser known amateurs, like English survey photographers F. J. Allen or George Scamell.[35] Only rarely has attention been paid to the considerable trade in lantern slides and lantern lectures that contributed very materially to notions, many of them limited and one-dimensional, about peoples and places.[36] Thompson, a zoologist and founder of the Dundee Museum of Zoology, was a great collector in the natural history tradition, amassing a museum's worth of specimens for research and teaching, the foundation for the D'Arcy Thompson Zoology Museum, Dundee. Valentine's lantern slides were part of this collecting impulse, and can be historically situated as part of a larger educational movement in which "the whole world was laid tribute that the children in the schools might have at hand the best material obtainable," and lantern slide companies advertised all-encompassing documentation of the world. Keystone, for instance, advertised stereographs and stereo lantern slides used in education in the United States representing each continent of the world and each state of the U.S., harmonizing the images with geography textbooks of the day.[37] The sheer number of lantern slides in circulation around 1900 was enormous. The Yorkshire Photographic Union's advertised list of lantern lectures for 1902 runs to thirty-six men and women undertaking lectures with 12–60 slides each, some professional subjects, some photographic and some travelogues.[38] In 1912, Underwood and Underwood of New York were advertising 250,000 negatives fit for making into lantern slides.[39] Deeply inscribed in these images were the discourses of Western colonialism, as well as a nations'-eye view of the imagined geographies of different

countries and cultures. Joan Schwartz writes, "Like travel writers, photographers dramatized distance and difference," posing subjects like the child in figure 9.5 as if they were specimens.[40] The blank background and the placement of the child on an overturned barrel that acts as a pedestal invites the viewer to look at this child, not as the subject of a portrait, but as a "type" to be closely observed. Lantern slides of this sort encouraged students to adopt the appropriately distanced, objective but active looking prized by science, even if ideologically suspect. Like the archaeological images discussed in Klamm's essay (chapter 8), these images are all about training the visual perception of students. Active training as an aspect of visual education was critical to forming cultures of visual perception and merits further study. The very active nature of "training the eye" with still photographs was occasionally set against what was seen as "passive" ingestion of moving images. Charles Eliot, former president of Harvard, promoted Keystone images by insisting on differences between photography and film where students were concerned. Photographs could be studied, returned to and memorized, where films engendered passive looking over time, mere "transitory entertainment."[41] While hundreds of photographic lantern lectures and sermons took place in local village halls and churches, even more were given in schools and universities, and while it would be difficult to find any university department without some glass or film slides for projecting, it was in departments of art history that the slide library and its companion the photographic print library became truly incorporated in the teaching methods and scholarship.

In spite of their ubiquity, there is a distinct "pattern of absence" of these sorts of teaching tools in special collections.[42] Although they form a large proportion of institutional photography, and have inscribed in them many layers of institutional knowledge, they are seldom collected and deposited as objects of study. Either they are still in active use within departmental collections, although this is becoming more rare, or they are simply thrown away. In art history, nineteenth-century photographic prints and lantern slides were largely replaced by color transparencies in the 1950s and '60s, and then by Powerpoint in the 1990s. Replacement of photographic study libraries usually follows a pattern exemplified by the photograph study collection of the Metropolitan Museum of Art. Consultation diminishes in the face of newer technology (panchromatic films, 35 mm color transparencies, digitization), the collection becomes "an impediment," and like the Met's collection, is moved to dead storage and eventually deaccessioned.[43] The Metropolitan Museum of Art had collected 14,000 photographs by 1907, "responding to the museum's encyclopedic aim to cover the entire history of painting, sculpture, architecture and the decorative arts throughout the world."[44] It was roughly

FIGURE 9.5. DWT-158. Valentine & Company, "A Small Arctic Specimen" from the series of fifty lantern slides, *Greenland's Icy Mountains*. Published ca. 1890. Courtesy of St Andrews University Special Collections.

800,000 images by the time it was deaccessioned. Ironically, the Metropolitan Museum's Photograph Study Collection now serves to train the eyes of photographic historians and conservators at the Image Permanence Institute in Rochester, NY. This example bears out Costanza Caraffa's assertion that "the accumulation and sedimentation of photographs [has] continued to characterize art-historical practices far into the twentieth century."[45] Where they used to represent a "core component of operational infrastructure," they now are artefacts in the current "archaeology of art history."[46] Photographic details that might have been seen as excessive at the initial point of documentation become in this process the subject of intense ethnographic scrutiny. It is easy to see, by comparing the albumen print of a Hans Memling to a modern digital interpretation of the painting, that the unknown photographer used film that was not panchromatic, that is, it was not equally sensitive to all colors of the spectrum (the date supports it) (figure 9.6). The greens of the landscape depicted out the window behind the Virgin Mary's shoulder have been registered black, and the landscape is almost undifferentiated from the sky above it. But the photograph does more than that. It is a document of a museum piece at a particular time and in a particular place. In this case, the panel is not shown with its other half, a portrait of Maarten van Nieuwenhove at the age of twenty-three, who commissioned the painting. This is but one of the documentary layers in which this photographic reproduction of a Hans Memling painting operates, but likely not the one by which it came into the special collections at St Andrews. Since these study collections have been largely undervalued and little collected, it may be that the reason that the albumen print has become part of the St Andrews Special Collections is because it is specifically *not* a part of the usual narrative of a photographic study collection.

The ca. 1892 print, quite likely an albumen print from a dry collodion or gelatin glass plate negative is part of the collection that came from James Donaldson, classicist and theologian and principal of United College of St Andrews (1885–1915). It is part of General Album 31, along with several other images of Memling's work, from the museum of the hospital of St. John in Bruges. This album contains a large number of albumen prints, from Brussels, Antwerp, Ghent, Cologne, Caen, Mont St. Michel, Pisa, Rome and so on.[47] The content of the photographs includes church and classical architecture and artworks from the "canon" of art history: Rubens, Van der Weyden, Masseys, Steen, Rembrandt, and Vermeer among others. Some of the photographs were taken by known photographic studios like Alinari and Brogi, and one entry in the album is an advertisement for Carl Lange, an unknown German

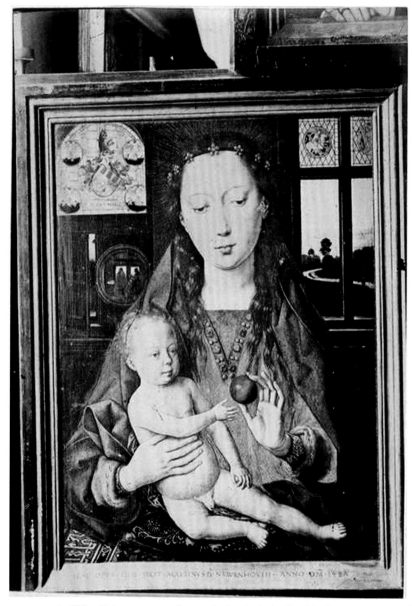

FIGURE 9.6. ALB31-6B. An anonymous photograph of a painting by Hans Memling 1485. Courtesy of St Andrews University Special Collections.

photographer offering photographs of art (ALB31-63[B]). The album represents not only one man's private study collection and memorial of European travel, but the large commercial trade that went on in photographs of artifacts for tourist consumption and the largely unknown business agreements between photographers and museums. Photographs of museum objects were the outward face of museums to their visiting public, and as Anthony Hamber has written about the London Department of Science and Art and the Arundel Society, the photographs produced by museums in collaboration with presses "led to a substantial number of photographic publications and general sales of photographs which were rightly seen by commercial photographers as a subsidised threat to their livelihood."[48] Seen in this way, photographs like the one in figure 9.7 were generated as a commercial venture and as a public face of the museum. Some museums, like the National Archaeological Museum in Naples reproduced whole displays for visitors, like Donaldson, to take away in photographic form. Not only do these photographs document the interests and travels of one person, but they show how museums used photography to actively engage with their public and disseminate their collections. Not much has changed in the intervening years, or in the shift from analogue to digital.

FIGURE 9.7. ms29951-10-50. An albumen print bearing the Giorgio Sommer blind stamp showing a display of surgical instruments from the National Archaeological Museum in Naples. Courtesy of St Andrews University Special Collections.

The photographic catalogue of St Andrews is also outward-facing, serving to engage most of its public. And at its heart, connection to the public revolves around the notion of access.

The Fantasy of the Photographic Catalogue

Elizabeth Edwards asked in a recent publication "what happens if . . . we stop thinking of photographs and their archives simply as passive 'resources' with no identity of their own, but as actively 'resourceful'?"[49] Catalogues of archives, as social and institutional constructs, deserve the same close attention. They not only shape both the retrieval and understanding of stored information, as Schwartz and Cook have written, but they actively engage potential users.[50] Each item in the St Andrews Library Photographic Archive catalogue is mediated by the archivists who care for them, who construct catalogues, and who make administrative decisions about the information that will accompany the item in the catalogue. In the last four decades the photographic objects in the St Andrews collection have been caught up in a project of consolidation and recognition as a "photographic" collection. Where photographs have formed integral parts of nearly all sections of the special collections (the muniments, the Literary and Philosophical Society archives, the image collections), digitization has brought them together in the catalogue, allowing them to form a discreet "photographic" collection even while they remain physically embedded in their original locations. While it may appear that the adjective "photographic" describes a collection distinguished by its materiality, I argue that it is really defined by the imaginary of what a photographic archive does or is for, not what it is made of, and this in turn is deeply influenced by the notion of access. In order to follow this argument, I will address first the notion of access, then the distinct lack of particularly photographic materiality in the catalogue. Then I will turn to the implications of the fantasy of the photographic archive.

The restructure of the photographic holdings of the St Andrews Special Collections is occurring largely by way of the electronic catalogue. While the reorganization is not a physical one—the archival objects will largely remain with their original collections—it constitutes a significant conceptual change, since it causes the users to encounter a top layer of digital imagery before proceeding to the archival objects.[51] The authority of these digital images is significant, since they form a seamless part of the electronic catalogue. Photograph and text share a materiality. Archivists in general, those at St Andrews included, are well aware of the material force of their collections. Every day they struggle with difficult or even impossible choices of collection,

storage, and organization, all mitigated by institutional politics and dwindling resources. The archivists' job, however, is not only reactive—they too have agency—but is always outward facing, serving a public of one kind or another.

"Access," linked sometimes with "preservation," sometimes with "outreach" is now a byword in archives and museum management. For better or for worse it has led to countless cataloguing and digitization projects. Access has always been one of the distinctive characteristics of the St Andrews Library Special Collections. "People can [go] in and look at a copy of the *Pencil of Nature* if they like, and not a facsimile."[52] In spite of this open access policy, only a small percentage of research is conducted in person—less than 10 percent at a rough estimate.[53] Until the 1990s, the St Andrews University Special Collections was organized by a series of analogue ledgers.[54] The text-based ledger directed interested researchers or staff to an object in the collection. As collections grew, ledgers abounded. Sometimes three or four entries in different ledgers were necessary to catalogue an object appropriately. The digitization project was intended to be a direct response to the need for enhanced access, but it was also intended in part to address the unwieldy (and eventually untenable) analogue system. As the digital catalogue relies heavily on images where the preceding ledger system was text based, the digitization project had several immediate effects. First, it tipped the balance of the catalogue from a text base to an image base. Secondly, the digital catalogue served a dual purpose as an access point first and foremost and then as a way of forming the notion of a collection, in this case, a "photographic" archive. In some ways the notion of "access" can work against the creation of a digital catalogue that is also a catalogue about the objects in the collection. When the digitization project began, it was not instigated as a method for collections management, but as a method for enhancing access.[55] However, not all institutions divide these roles as cleanly as St Andrews. Databases in St Andrews are used in the day-to-day management of the collection, acting as a support system to the largely public-facing online catalogue. For the St Andrews collection the digitization process has heightened the perception of the collection being photographic, and aided its rebranding as special collections with significant photographic holdings.[56] It is true that this is a response to the identification of individuals within St Andrews Special Collections with the growing professionalization of photographic history. But it is not only reactive to this trend, as it also bolsters the notion of the collection as photographic by presenting itself outwardly as a photographic archive in name and in content. Interestingly, "photographic" does not mean that the collection is defined by its analogue photographic materiality, which has largely disappeared in the digitization process.

FIGURE 9.8. Screen shot of GMC-F205 taken on 10 December 2011, showing the information page and the image in positive, and the description of the object as a negative.

If we return to the golf clubs of figure 9.1 (GMC-F205) via the online catalogue it is unclear what sort of photographic object we would see were we to call it up. Figure 9.8 clearly shows a positive digital image, but is described in the "image type" field as a half-plate negative.[57] The object in the collection is, as figure 9.1 shows, clearly a negative, and it has no corresponding analogue print. What exactly is, then, the function of the positive digital image within the catalogue, and how does it relate to the photographic object to which it refers? Is this catalogue image a document? If yes, what it is documenting? The first consequence of the digital shift from negative to positive is the clear differentiation of the access-oriented catalogue from the collection object. The reader who comes to this object via the online catalogue alone is encouraged to look only at the image content, not at the material of the glass plate negative. To a reader attuned to the contradiction of positive image and "glass plate negative," a moment of confusion ensues. As the realization dawned on me, curiously it was the image I believed, thinking "is there a mistake in the text entry?" Upon reflection it is clear that the same impulse that informed the original photograph of six golf clubs rules the positive digital catalogue image. Photography has an outward-facing, in modern parlance an "accessibility" characteristic. It presents objects for study to the broadest

possible audience. While it most definitely is "material evidence of a human decision" it is not only concerned with exact preservation of "the appearance of a person, an object, a document, a building, or an event judged to have abiding value."[58] A digital photograph showing the glass negative of golf clubs would fall into this category of preserving an object, but negatives are for the dwindling numbers of analogue photographic professionals. Positive images invite access beyond that limited audience, projecting an accessible record into the digital future, where knowledge of analogue photography wanes to near extinction.

This deconstruction of the digital catalogue might appear to merely uncover a slightly awkward phase of the meeting of old analogue cataloguing methods with newer digital methods that have yet to be perfected. In fact it signals much more. It shows that at the root of collecting together all the photographs into a photographic archive, there is an assumption of the naturalness with which these items accrue as "photographic" that belies their complicated material histories. Just as the collection of modern archives by *fonds* was promoted as a way of collecting documents that had naturally accumulated, the photographs are brought together merely because they are presumed to adhere to that adjective "photographic." "Thus," Schwartz writes, "the 'natural' relationship between archives and administration, as well as the 'natural' relationship between present and past which is preserved through archives, like the 'natural' relationship between photographic image and photographic subject, [is] presumed to be organic and unmediated."[59] This sort of presumed homogeneity by material is at the very core of the fantasy of photography—that it will exert control or discipline unruly, dispersed, large, or impermanent objects into taxonomic submission. The problem is that the objects this digital catalogue is trying to discipline are photographs themselves, with all of the inherent problems of their polysemous existence.

Returning to the origins of this fantasy in the nineteenth century, in 1852 James Glaisher, scientist and photographer, publicly lamented the dearth of photographs at the Crystal Palace Exhibition that showed the power "of condensing in volume for preservation in Museums*, &c., the enormous mass of documentary matter which will one day become matter of history." The note indicated by * states that "a catalogue of the National Library of Paris, in which the photographic fac-simile of the title-page of each work, in miniature, is registered, is actually in progress."[60] Microfilms and Google books are merely the most recent iterations of the same impulse, the impulse to catalogue the contents of a library, an archive, material objects or even the world, in photographs. The only constant here is the promise that the object will not change no matter how many transformations of materiality it might undergo and this

is perhaps the most important assumption to pinpoint when considering photographic catalogues. They rely on the rather fantastic assumption that one materiality can be equally and naturally exchanged for another without adding sedimentary layers of photographic practice. This essay has shown how those layers are in fact of critical importance in influencing how photographs function as documents in the archive, and in its outward-facing catalogue.

Acknowledgments

I would like to thank Marc Boulay, former photographic archivist in the special collections of the St Andrews University Library. Not only did he open my eyes to the tremendous possibilities of this archive as a point of study, but he also spent many hours explaining cataloguing structures, discussing changes in photographic catalogues in general, and reading and commenting on this essay. I would also like to thank Rachel Hart, muniments archivist, for giving her time so generously during my visit and for explaining some of the important structures of the collections.

Notes

1. Norman Bryson, *Looking at the Overlooked: Four Essays on Still Life Painting* (London: Reaktion, 1990). Elizabeth Edwards used this concept too, when she drew the comparison of photographs of museum objects with this category of still life in *Raw Histories: Photographs, Anthropology, and Museums* (Oxford: Berg, 2001), 51.

2. Joan Schwartz, "'Records of Simple Truth and Precision': Photography, Archives, and the Illusion of Control," *Archivaria* 50 (2002): 4–5.

3. Like Swinney, I argue that these working tools require a closer and more critical look. Geoffrey Swinney, "What Do We Know about What We Know? The Museum 'Register' as Museum Object," in *The Thing about Museums: Objects and Experience, Representation and Contestation*, ed. Sandra Dudley et al. (London: Routledge, 2012), 31–46.

4. See Estelle Blaschke's essay in this volume (chapter 10) for an excellent example of this phenomenon.

5. The literature on bureaucratic prose is summarized nicely by the introduction to Peter Becker and William Clark, eds., *Little Tools of Knowledge: Historical Essays on Academic and Bureaucratic Practices* (Ann Arbor: University of Michigan Press, 2001), 1–34, but images are only just beginning to benefit from the same treatment, for instance in the work of Joan Schwartz and Sandra Dudley, and in Elizabeth Edwards and Sigrid Lein, eds., *Uncertain Images: Museums and the Work of Photographs* (Farnham, UK: Ashgate Press, 2014).

6. This is well documented in chapter 3 of Edwards, *Raw Histories*, 51–79, and Swinney, "What Do We Know?"

7. Mitman and Wilder, chapter 1, this volume.

8. Geoffrey Batchen, *Burning with Desire* (Cambridge: MIT Press, 1997); Tiziana Serena, "The Words of the Photo Archive," in *Photo Archives and the Photographic Memory of Art History*, ed. Costanza Caraffa (Berlin: Deutscher Kunstverlag, 2011), 57–71.

9. Peter Geimer (chapter 3, this volume) points out that indexicality is not necessarily a dead end, but can lead to a consideration of the more material and affective components of photography, as for instance they do in color film.

10. André Malraux, "Le musée imaginaire," in *La Psychologie de l'art* (Geneva: A. Skira, 1947–50), 32. There are many authors who also see this shift toward privileging the ocular as a part of the rise of objectivity and observation (e.g., Walter Ong, Jonathan Crary, Lorraine Daston) and it has been well discussed in W. J. T. Mitchell's *What Do Pictures Want* (2005) and Barbara Stafford's *Artful Science* (1994).

11. For an excellent article on the epistemological implications of this shift within art history see Costanza Caraffa, "From 'Photo Libraries' to 'Photo Archives': On the Epistemological Potential of Art-Historical Photo Collections," in *Photo Archives and the Photographic Memory of Art History*, ed. Costanza Caraffa (Berlin: Deutscher Kunstverlag, 2011), 11–44.

12. Private communication with Marc Boulay.

13. Becker and Clark, *Little Tools of Knowledge*, 25.

14. Gustav Stotz, "Werkbund—Ausstellung 'Film und Foto' Stuttgart, 1929," *Das Kunstblatt* 13 (May 1929): 154.

15. Victor Margolin, *The Struggle for Utopia: Rodchenko, Lissitzky, Moholy-Nagy 1917–1946* (Chicago: University of Chicago Press, 1997), 157–58. It might easily be argued that the Hamann photographs (Klamm, chapter 8, this volume) caused the seeing of materiality differently long before the Bauhaus came along.

16. These are the details given in the St Andrews University Library Catalogue about this and other objects in the same series.

17. Here "natural" is a substitute for a very particular sort of disciplinary eye.

18. Stefanie Klamm, "Bilder des Vergangenen: Strategian archäologischer Visualisierung im 19. Jahrhundert," doctoral dissertation, Humboldt University, Berlin, 2012, 50.

19. Klamm, "Bilder des Vergangenen," 50.

20. Mirjam Brusius, "Preserving the Forgotten: William Henry Fox Talbot, Photography and the Antique," doctoral dissertation, University of Cambridge, Cambridge, 2011, 8.

21. See Jennifer Tucker, *Nature Exposed: Photography as Eyewitness in Victorian Science* (Baltimore: Johns Hopkins University Press, 2005).

22. D. Hay Fleming, "Notice of the Recent Discovery of a Cist, with Fragments of Urns and a Jet Necklace, at Law Park, near St Andrews; with a Note of the Discovery, near the same place, of a Cremation Cemetery of the Bronze Age, with many Cinerary Urns, in 1859," *Proceedings of the Society of Antiquaries of Scotland* 41 (1906–7): 401–14.

23. Sir David Brewster, professor of natural philosophy at St Andrews, was a close friend and correspondent of W. H. F. Talbot. Talbot wrote to Brewster before 8 February 1839 for advice about what he should do in the priority debate, and Brewster showed members of the St Andrews Literary and Philosophical Society some examples of Talbot's photogenic drawings in February or March of 1839. Talbot to Peter Mark Roget, 8 February 1839, and Brewster to Talbot, 14 March 1839 in Larry J. Schaaf, *The Correspondence of William Henry Fox Talbot*, www.foxtalbot.dmu.ac.uk.

24. Dr. John Adamson was one of the pioneers of calotype photography in Scotland. He was attempting to make calotypes as early as July 1841, months after William Henry Fox Talbot had announced the new process. See Brewster to Talbot, 26 July 1841 and other dates, Talbot Correspondence Project 4315, Collection of the National Media Museum, Bradford.

25. Letter from Sir David Brewster to William Henry Fox Talbot, 12 February 1839, Talbot Correspondence Project 3804. Accessed 12 December 2011.

26. Stephen Bann, "The Photographic Album as a Cultural Accumulator," in *Art and the Early Photographic Album*, in *Art and the Early Photographic Album*, ed. Stephen Bann (New Haven: Yale University Press, 2011), 9.

27. The portraits contributed to the painting of the Disruption by D. O. Hill, *The First General Assembly of the Free Church of Scotland; signing the Act of Separation and Deed of Demission—18th May 1843*, which was completed in 1867 and hangs in the headquarters of the Free Church of Scotland in Edinburgh. The mismatch of the title of the album and the image of the urns, which was decidedly not taken at Calton Stairs, and not by Hill or Adamson, is the subject of another paper, but brings up the misleading textual information that cuts across these visual interpretations.

28. See St Andrews Library Photographic Archive catalogue for entry JHW-4.

29. St Andrews University web page http://www.st-andrews.ac.uk/library (accessed 12 December 2011). In the time it has taken to publish this chapter, the web pages have been re-launched, and present quite a different public face of the collection.

30. Kelley Wilder, interview with Rachel Hart.

31. Roger Taylor et al., *Exhibitions of the Royal Photographic Society 1870–1915* (Leicester: De Montfort University, 2008). Accessed 15 December 2009.

32. D'Arcy Wentworth Thompson, *On Growth and Form* (Cambridge: Cambridge University Press, 1917).

33. Joan Schwartz, "'The Geography Lesson': Photographs and the Construction of Imaginative Geographies," *Journal of Historical Geography* 22, no. 1 (1996): 33–35.

34. James Ryan, *Picturing Empire: Photography and the Visualization of the British Empire* (Chicago: University of Chicago Press, 1997); Schwartz, "The Geography Lesson," 18; Schwartz and Ryan, *Picturing Place: Photography and the Geographical Imagination* (London: Tauris & Co., 2003); Christopher Morton and Elizabeth Edwards, eds., *Photography, Anthropology, and History* (Farnham, UK: Ashgate, 2009); Elizabeth Edwards, *The Camera as Historian* (Durham: Duke University Press, 2012).

35. Edwards, *Camera as Historian*, chapter 3.

36. Schwartz, "The Geography Lesson," 34.

37. Charles Eliot et al., *Visual Education through Stereographs and Lantern Slides* (Meadville, PA: Keystone View Company, 1906), iii–iv. Recently the Keystone manual has been reprinted as *Visual Education through Stereographs and Lantern Slides: Knowledge Visualized and Vitalized: Travel Studies, 50 Cross Reference Classifications* (Ulan Press, 2012).

38. Anonymous, "The Yorkshire Photographic Union," *British Journal of Photography* 49, no. 2197 (13 June 1902): 471–73.

39. Underwood & Underwood advertising flyer "Stereopticons," collection of the author.

40. Schwartz, "The Geography Lesson," 29.

41. See the introduction of Eliot, *Visual Education through Stereographs and Lantern Slides*.

42. Elizabeth Edwards, "Photographs: Material Form and the Dynamic Archive," in *Photo Archives and the Photographic Memory of Art History*, ed. Costanza Caraffa (Berlin: Deutscher Kunstverlag, 2011), 49.

43. Valentina Branchini, "The Photograph Study Collection of the Metropolitan Museum of Art: A Change of Reference," in *Photo Archives and the Photographic Memory of Art History*, ed. Costanza Caraffa (Berlin: Deutscher Kunstverlag, 2011), 389.

44. Branchini, "Photograph Study Collection," 390.

45. Caraffa, "From 'Photo Libraries' to 'Photo Archives,'" 21.

46. Anthony Hamber, "Observations on the Classification and Use of Photographs at the South Kensington Museum: 1852–1880," in *Photo Archives and the Photographic Memory of Art History*, ed. Costanza Caraffa (Berlin: Deutscher Kunstverlag, 2011), 266.

47. For more on images from the Grand Tour and the photographers who contributed see Italo Zannier, *Le Grand Tour* (Venice: Canal and Stamperia, 1997).

48. Anthony J. Hamber, *"A Higher Branch of the Art": Photographing the Fine Arts in England, 1839–1880* (Amsterdam: Overseas Publishers Association, 1996), 395.

49. Edwards, "Photographs: Material Form and the Dynamic Archive," 47.

50. Joan M. Schwartz and Terry Cook, "Archives, Records, and Power: The Making of Modern Memory," *Archival Science* 2, no. 1–2 (2002): 3.

51. When this piece was originally written, the special collections were in the process of change. Now the changes have been instituted, and a new interface created. Access to the photographic items now differs from access in 2011, when the original research was conducted, but the process at St Andrews is also being repeated even now at other museums. Even the process of doing the research and writing this piece has caused internal changes that are now reflected in the catalogue users confront today.

52. Kelley Wilder, interview with Marc Boulay (St Andrews University Special Collections, 2010).

53. Interview with Boulay.

54. Interview with Boulay.

55. Interview with Boulay.

56. Wilder, interview with Rachel Hart.

57. One curious feature of most scanning software is the inbuilt function that turns material scanned as a "negative" into a positive image file. Sadly, there is no space in this paper to discuss the implications of this elision of photographic materiality in scanning software.

58. Schwartz, "Records," 19.

59. Schwartz, "Records," 35.

60. James Glaisher, "Report to Class X: Philosophical Instruments and Processes Depending upon Their Use," in *Reports by the Juries* (London: For the Royal Commission, 1852), 275. I am thankful to Roger Taylor for pointing out this quote to me.

The Excess of the Archive

ESTELLE BLASCHKE

The invention of digital imaging reanimated the fantasy that had infused photography from its early days: the fantasy of "scooping up the world"[1] or "collecting everything." Oliver Wendell Holmes had already expressed such hopes in the nineteenth century with the advent of the stereoscope, which he imagined would provide access to "enormous collections of forms, classified and arranged in vast libraries, as books are now."[2] To facilitate the development of such collections, Holmes suggested the formation of a "comprehensive system of exchanges, so that there may grow up something like a universal currency of these bank-notes."[3] Like Holmes, Paul Valéry applauded the economic potential of photography and its siteless and timeless reproducibility when stating in his 1928 essay *The Conquest of Ubiquity*: "Like science, it [the reproduced work of art] becomes an international need and commodity."[4] Understood in relation to the development of an increasingly democratic process, Valéry explicitly related the gains of mechanical reproduction to the empowerment of the individual. Liberated from the location of an artwork's performance and its temporal continuum, the mechanically reproduced form would enable the individual not only to access and participate in the experience of art, but also to choose when and where to do so. Thus, as Valéry envisioned, various types of reproductions would soon spread into the private space, easily available without much effort and individually programmed, to "satisfy our needs in response to a minimal effort . . . at a simple movement of the hand, hardly more than a sign," and as simple as "water, gas, and electricity are coming to our houses from far off."[5] The comparison of the reproduced work of art, and, by extension, photography, with utilities reaffirms its character as a product of mass consumption of twentieth-century consumer society, but also its notional status as a vital, ubiquitous element of modern life, of

FIGURE 10.1. The Information Revolution: 500 Monitors, 2003 © Louie Psihoyos/Corbis.

the modern (bourgeois) individual in particular, whose home is equipped with standard amenities such as running water, gas, and electricity and who listens to radio, takes photographs, leafs through illustrated magazines, plays a record, and attends movies.

It is precisely this juxtaposition between the liberation of experience on the one hand and its privatization and individualization on the other hand that is illustrated in the digital painting by Louie Psihoyos, *The Information Revolution: 500 Monitors* (2003) (figure 10.1). Situated in the very center of a panoptic structure, we see the dark silhouette of a person in front of a white, glaring light, comfortably leaning back in a chair. Conveying an atmosphere of leisure, the person is surrounded by a grid of colorful, brightly illuminated screens. While the image suggests a maximized visual experience, the boundaries between entertainment and control, monitors and monitoring, the observer and the observed are blurred. Thus, it may be interpreted as corresponding perfectly to the Zeitgeist increasingly present since the early 1990s: the idea of the ultimate transformation of everyday life facilitated by the progress of communications technology and its electronic apparatuses.[6] Yet, it embodies, intentionally or not, the very critique of such a concept.[7]

But rather than discussing the dichotomy between the enhanced accessibility provided by digital imaging on the one hand, and on the other hand the loss of information in the process of digitization, this chapter focuses on the

intrinsic relation between the fantasy of "collecting everything" and the idea of earning money from it. It thus aims at drawing attention to the economic potential of both archiving and reproducing photography. This idea of commodification seems to appear with every major technical development of the photographic method as a medium of storage and dissemination, creating new standards, new markets, and new networks. In this context, I will discuss the enhanced mobility and mobilization of images through their reproduction as well as the recurring imaginary of immateriality. Building on recent scholarship, however, that has been critically investigating the multiple material manifestations of photography,[8] this chapter aims at contraposing and exploring the idea of materiality with regard to the digital form of photography and the way digital materiality shapes and is shaped by the archive. This relation, and the implications of the economical paradigm for managing and archiving vast photographic collections, will be examined through the history of the visual content provider[9] Corbis, a company founded by Bill Gates in 1989 under the name Interactive Home Systems (IHS).

Immateriality made the digital form of photography so appealing to anyone involved in the archiving and the management of collections, facing space, time, and monetary constraints. The digital image was understood as an image without physical substance, reduced to a binary code, an image "produced without the intermediaries of film, paper or chemicals."[10] The economic potential of digital imaging, as well as other forms of photography, relied precisely on this: the idea of immateriality and enhanced mobility. As Holmes had suggested in 1859 in his plea for the sales potential of stereoscopic views, "Form is henceforth divorced from matter."[11] The anticipated potential of analogue photography lay in substituting an object for an image, replacing the "immobile and expensive" form of an object depicted in the photograph. The same reasoning was applied to digital imaging. While the digital reproduction of images was not considered the equivalent of the original photograph, its quality was adequate and could therefore be rendered marketable. And since the picture market, in contrast to the art market of photographs, does not deal with the photographic object but with the intangible rights for reproducing, using, and publishing the images, the shift from the analogue to the digital was interpreted as a mere continuation of existing practices. Digital imaging promised to be a further step in the continuous search for higher efficiency in the reproduction technique, management, and exploitation of images. Thus, it was assumed that the digital reproduction, compared to analogue matter, was mobile and inexpensive and as such, would inevitably replace its analogue predecessor. And just as photography had superseded previous reproduction techniques, above all lithography and engrav-

ing and their related professions and businesses during the early nineteenth century, a new market with new rules would emerge and eventually replace existing businesses.

The idea of immateriality and enhanced mobility was so powerful that it "captured the imagination of the cultural heritage community and private companies alike."[12] Numerous institutions and private companies involved in the archiving of collections sensed the opportunity not only to reduce the volume of their collection by preserving the digital surrogates, but also to earn income from their digitized holdings. Accompanied by a widespread debate on the impacts on knowledge production and the dissolution of "the archive" as an authoritative body,[13] digital imaging led to major financial investments and emergence of new business ventures. While most of the players in the traditional picture market, embodied by photography agencies and commercial image banks, were hesitant or simply did not have the financial means and the technological know-how to invest in digital technology, the possibilities of digital imaging were considered so promising that it attracted investors and speculators alien to the picture market, notably Corbis and its major competitor, Getty Images.

When the company IHS (Corbis) was formed in 1989, Gates envisioned the creation of a distribution service for digital images, a "delivery service for sensory reality,"[14] simulating and satisfying the alleged needs of twenty-first-century society and the modern individual. In his book *The Road Ahead* (1995),[15] Gates unfolds his vision of an information society and his motivation for creating IHS. The chapter "Cyber-Home" presents in particular the construction plan for Gates' own private home, which was planned to be equipped with "news coverage and entertainment at the touch of a button."[16] An individual choice of images, recordings, films, and TV programs would be displayed on several synchronized wall monitors. Gates specifically mentions photography: as the first private user of a "databank of a million pictures" comprising photographs and photographic reproductions of art, he imagined a "unique and comprehensive archive of images of all kinds."[17] With the help of wide-ranging data registers, these images were intended to be easily retrievable. At last, the illusion of ubiquity for profit-making purposes appeared a reality with the establishment of IHS. In contrast to most photographic agencies and commercial image banks, which primarily target the press, publishing, and advertising industry, the IHS business model was designed for an additional and highly potent group of customers: the individual consumer.

The business model of the IHS distribution service was based on two assumptions. First, it relied on the assumption that the "information highway," whose infrastructure in the early 1990s was still rudimentary, would soon

allow for the transmission and reception of large amounts of data, including images. This technological development would automatically stimulate the demand and create a desire for digital images and subsequently generate new marketing opportunities. IHS would benefit from this infrastructure by installing, as many feared, "a tollgate on the information super highway."[18] The fear of an image monopoly was not unjustified, given the dominance imposed by Microsoft Corporation on the world's personal computers through the supply of operating systems.[19] And indeed, by heavily investing in technology for the digitization, storing, and dissemination of images, IHS aimed at controlling the anticipated stream of digital images as such. Second, Gates believed that "just as software had replaced hardware as technology's most valuable product, so too would content eventually replace instruction sets as a basis of digital value."[20] Digital content, be it visual, aural, or textual information, would become the capital of information technology. And this capital needed to be amassed.

For Corbis and Getty Images the accumulation of as much visual material as quickly as possible to amass a comprehensive collection of images, or as Corbis projected, a "digital Alexandria" or an "Encyclopaedia Britannica without body text" was imperative.[21] The company's aim was to be "*the* place for pictures on the Internet,"[22] assuming that there was a clearly defined amount of images worth owning. The development of a particular thematic grid, or "gridded territory"[23] determined what images were needed to build this place, a place composed of potentially profitable images, and, in view of the prospective clients, a territory dominated by American and Western visual regimes and visual histories. To distinguish itself from existing photographic agencies and image banks, the Corbis collection would allow the client to find everything in one place. However, as the history of Corbis shows, the accumulation of "virtually anything imaginable"[24] proved to be more difficult than anticipated.

Banking on Images

In the early 1990s, Corbis negotiated nonexclusive licensing rights with photographers and a number of museums and libraries to market their collections, such as the Smithsonian Institute, the Barnes Foundation, the Academy of Natural Sciences in Philadelphia, the Minnesota Historical Society, the Seattle Art Museum, the Carnegie Institute, the archive of the Massachusetts Institute of Technolgy's School of Architecture and Planning, and also non-American institutions including the British National Gallery and the State Hermitage in St. Petersburg, Russia. Corbis, as its former director Steve Davis

explains, was "interested in different types of works from around the world," and thus approached a number of museums "based on the nature of the collections, or because of their interest in working in digital technology."[25]

The nonexclusive rights agreement would allow the company to create digital reproductions and distribute them to private consumers as well as publishing and advertising professionals. Museum collections seemed particularly appealing as they represented a preselection of acclaimed artworks certified by the authority of the cultural institution and thus promised to be valuable and profitable. In turn, many museums, especially smaller ones, were seeking collaborations with private or institutional partners, conscious of the need to digitize their holdings for promotion and editing purposes, as well as for registrarial and record-keeping needs.[26] The museums were to benefit not only financially from the arrangement, since part of the generated profit was to be shared by Corbis, but also through the indirect promotion of their collections.[27] However, many museums balked, or gave their consent for a very limited period of time, as they feared a loss of control over the use of their holdings especially given that copyright legislation had yet to be adjusted to reflect the rapidly changing technology. The primary concern of photographers and institutions was that Corbis initially claimed a *separate* copyright protection, arguing that the digital reproduction of an artwork or photograph could be considered as fundamentally distinct from its original. Through the potential adjustment of color, brightness, and contrast, the digital reproduction could be interpreted as a unique work of art. In addition, the museums feared that Corbis would take possession of and commercialize a wide range of artworks, which were regarded as common property. The company countered these allegations by stating that the copyright protection applied only to the digital image, the visual surrogates of the primary materials produced by Corbis, and argued that it was not preventing anyone from reproducing and subsequently disseminating the same original work of art.[28] The company undoubtedly capitalized on the general confusion about "who owns what version of what,"[29] part of a broader debate in the early 1990s on the authenticity and validity of the digital record. At that time, though, the marketing opportunities for digital images were virtually nonexistent. The desire for digital images and marketing opportunities both had to be created. The initial products, made up largely of digital reproductions of artworks, were first directed at private individuals rather than professionals. It was only later that the company would target the established customers of the picture market, namely advertisers, editors, and designers.

Technological challenges and lack of demand ended the IHS idea of delivering digital reproductions to private homes. Corbis turned to another

marketing tool: virtual multimedia exhibitions packaged on CD-ROMs, such as *A Passion for Art: Renoir, Cezanne, Matisse and Dr. Barnes*, *Volvanos: Life on the Edge*, and *Leonardo da Vinci*. Apart from the novelty of viewing (relatively) high-quality images on computer screens for the first time,[30] Corbis hoped to entice consumers through interactive features linked to the still image. In addition, through the licensing of a selection of images, "students, teachers and surfers" were encouraged to "create their own documentaries by doing moulded searches."[31] This description suggests that Corbis had only a vague idea of the potential users and uses of digital images in the beginning.

The revenue generated by the sales of CD-ROMs paled in comparison to the considerable financial investments in the digitization and the development of a comprehensive databank system. Copyright issues plagued the project. And, even in the digital age, Holmes' fantasy of a "divorce from matter"[32] seemed insurmountable. The amassing of visual content by means of cooperation with museums and photographers proved too complicated and too time-consuming. The original IHS model was soon abandoned.

Beginning in 1995, the year that Corbis adopted its name,[33] the company was forced to reconfigure its business model to counter the rights issue and to gain a leading position in the picture market. What followed was the acquisition of a myriad of photographic collections and the takeover of a wide range of photographic agencies and commercial picture archives. The policy of acquisition and merger of collections is a common practice in the history of photographic agencies and commercial archives: holding as many pictures as possible is the principle and the catalyst of the picture market. Yet, with the emergence of digital images and the creation of a new industry, the picture market was radically transformed. Owing to their substantial investments, Corbis and Getty Images absorbed a diversity of collections and companies replicating the predigital market environment.[34] As a consequence, photographic collections of unparalleled scale emerged.

Corbis' aim was to cover a wide variety of subject areas, including fine arts; political, social, and cultural history; entertainment; science and technology. In 1995, Corbis purchased the Bettmann Archive, which had previously merged with United Press International (UPI), itself an amalgam of various collections such as ACME and Pacific & Atlantic. In 1996 the holdings of the agency Sygma, with a corpus of approximately 40 million images, were added, as well as those of various smaller collections. Aside from the accumulation of material stock, such as the Bettmann Archive, UPI, and Sygma, which alleviated problems of copyright, Corbis established several commission contracts for mining predigitized private and institutional collections, among them parts of the prints and photographs collection of the Library

of Congress, the publishing house Condé Nast, the Alinari collection, the Ansel Adams estate, and the Andy Warhol Foundation. Acting as a flagship brand, Corbis also increasingly invested in stock and celebrity photography and founded GreenLight, a company focusing on image rights services, including rights clearance, tracking, and administration.

Interestingly, both Corbis and Getty Images consciously sought out and purchased historic collections of nineteenth- and early twentieth-century photography in an attempt to recycle visual history and exploit the vague notion of collective memory. Enriched through time, these photographs were considered highly valuable. They deepened the collection and provided the company with credibility. And with the digitization, these historical photographs gained an added market value—the digital form, and the ability to be used and reused in new and different ways, the "reuse value"[35] of images. It is indeed through the digitization that these photographs were integrated into a new economic cycle. Moreover, in order to flesh out the thematic grid, several photographers hired by Corbis set out to systematically capture potentially profitable objects, themes, and sites that were yet missing from the collection. Of particularly promising subjects, various views and constellations were photographed: the Eiffel Tower during all seasons; by day and by night; as closeup, panoramic, or aerial view; with one person, two or more, crowded; in black and white and color; etc. These contemporary photographs added to the purchased photographs of the Eiffel Tower in construction, portraits of its engineer, the Eiffel Tower during various decades, drawn or painted. The company's bulimic appetite for images was whetted by photographic reproducibility, the imaginary of the immateriality, and the capitalist principle of continuous growth. As Elizabeth Swan, the chief librarian at the Academy of Natural Sciences in Philadelphia recalls, "Initially Corbis wanted only selected images from selected classics. The more they saw, however, the more they wanted. Then they wanted all the images from the selected classic."[36]

As scholars have argued, the digitization and the digital image displayed on the screen reemphasize the illusion of transparency, privileging, once more, the perception of the image content rather than its context.[37] Digital imaging accentuates an aspect of photography that is indeed an important characteristic of the medium (and the basis for a business model built on the licensing of images), but one that may have prevented us from understanding the multiple functions of the medium that is, its quality as a depictive device and as a means of creating multiple reproductions. The seemingly effortless reproducibility of digital images, and the ease with which digital information is copied, altered, and combined, has prompted the comparison of digital imaging with the idea of reproductive cloning.[38] It is a concept that may well be

FIGURE 10.2. Corbis website, "The possibilities are endless," 10 November 2002.

invoked by the opening page of the Corbis website of 2002, ultimately point-
ing to the company's understanding of the medium. The microphotography
of spermatozoa buzzing in various directions and accompanied by the head-
ing "The possibilities are endless" construes the notion of digital imaging as a
quasi-inexhaustible natural resource, endlessly reproducible, endlessly com-
binable (figure 10.2).

The ultimate aim of Corbis' world-documenting project was to become a
shopping mall for images and a company that would be difficult to avoid. Or,
as Corbis put it, "The range of the company's visual content attempts to en-
compass the breadth of civilization, containing everything from reproductions
of cave drawings to contemporary celebrity photographs."[39] Its motivation was
purely commercially driven, yet it was dressed in a vocabulary that had ac-
companied photography since its beginnings. Photography, as contemporaries
marveled, was capable of bringing to us, right away, "hieroglyphs from Thebes,
Memphis and Karnak,"[40] alongside artworks from the Louvre, water from the
river Seine, the pavement, and the sky,[41] "all things big and small," permitting
"the collection of all riches and treasures."[42] Photography suspended time and
space; it drew miscellaneous representations, like cave drawings and celebrity
portraits, into one all-encompassing narrative.

According to Corbis' corporate information, the company today represents the work of more than 30,000 photographers and has a stock that totals over 100 million images, distributed through the company's website with the help of sales offices in numerous countries worldwide.[43] Operating at that time with the largest concentration of high-quality scanners, such as the Heidelberg Topaz and Creo Scitex, costing approximately $500,000 (US) each, Corbis engaged in digitizing vast numbers of photographs. In 1996 the digitization of the purchased collections operated at full stretch. Soon, about 1,000,000 scans were at Corbis' disposal; with 40,000 images added each month, the company was scanning around the clock. In a further iteration of the initial impulse to document the world with photography and film, Corbis sought to reproduce digitally and license anything it could get hold of.

The Revenge of Materiality

While digital technology certainly accelerated the mobility of images and changed the way images were produced, stored, distributed, and viewed, digital imaging was far from being inexpensive and immaterial. Corbis, like many others invested in the digitization, development, and recycling of historical collections, encountered a myriad of problems, mainly originating in the materiality of photography. These problems related not only to the materiality of the analogue holdings that Corbis had purchased, but also to the frequently neglected aspect of the materiality of the digital images. Only in recent years has the immateriality of digital imaging, and digital holdings in general, come into question. The materiality of digital imaging and its undeniable dependency on the analogue holdings becomes readily apparent in describing the practices that sustain Corbis' virtual image bank.

The initial objective of reproducing 40,000 photographs per month and eventually all of the collections purchased was soon curtailed. Not only were the costs for digitization, including the handling, the indexing, and postproduction soaring, but further complications arose from bringing together the different collections and their individual classification systems. Except for the Bettmann Archive, the historical collections acquired by Corbis were not created with their reuse and long-term preservation in mind, which undoubtedly contributed to the difficulties Corbis encountered with the development of its products. Information was missing or erroneous, files were lost, and the copyright could not be traced or existed under different rights regimes. Corbis, like many others, had misjudged the difficulties in migrating the existing, often very heterogeneous metadata into a new visual database, and underestimated the very importance of both a well-functioning database and

the development of an effective search engine. By primarily concentrating on the accumulation of image content and by conceiving the photograph and the digital image merely as two-dimensional, or no-dimensional, resources, the company had underestimated the time and labor needed for turning digital data into a valuable product. Yet the economic value of a photograph does not rely solely on the image content. It is primarily constituted through the information attributed to and the services associated with the image. In other words: in the picture market, the value of a photograph or a digital image is composed of the image content *and* the way it is formed, interpreted, distributed, etc., thus, the context it appears in.[44] Both are intertwined and cannot be separated. The "materialization" of the digital image product, however, is not some kind of automated process, but needs to be carried out for each individual image and relies on the evaluation and interpretation of individuals. The materialization of the digital image is, therefore, not only a precondition for the commercial exploitation, it is critical to its very existence.

Corbis' heavy investment in content in its early years gave way to a much greater investment in the development of context, achieved through comprehensive editing of the analogue and digital material. It is an ongoing process. The conversion of the holdings into digital form and their development into digital products entails multiple steps. First, the analogue material is thoroughly examined, with duplicates identified. Information related to the photograph (i.e., caption, photographer, copyright) is researched, verified and eventually corrected in order to render the image exploitable. Similar to most private or institutional digitization projects, the digitization of the analogue prompted a major reassessment and revaluation of the material, eliciting questions such as: In what condition is the negative or print? Is the negative the original one, or a copy? Does the collection contain vintage prints? Who owns the image? What exactly does the photograph document? Is the material interesting to today's viewers? Is it historically valuable? Will it generate profit? In the case of Corbis, this evaluation process also involved the attribution of the photographer's name that was hitherto irrelevant for the marketing of the image. As a result, an image such as *Massive Crowd on Beach at Coney Island* by the American news photographer Weegee (Arthur H. Fellig) was not simply the illustration of a massive crowd on a beach, but promoted as a masterpiece by the acclaimed photographer Weegee. Arguing with Douglas Crimp, who had described the process of reclassification at the New York Public Library some thirty years earlier, a new category was added to the set of accompanying information: the "artist," who made the photograph. While this a posteriori attribution of the photographer's name contributes to the further alienation of the photograph from its original production

and agency context and to the construction of what John Szarkowski called "photography itself,"[45] it also enhanced the commercial value of an image and added the notion of quality and art historical value to the whole collection.

In a second step, the Corbis editors select photographs for the digital reproduction according to their relevance, their reuse and sales potential, and the physical condition of the analogue negatives and prints. The photographs are digitized as high-quality scans of approximately 60 MB, serving as the raw, uncropped version. This master file is considered the original digital file. The actual visual products are modified and resized versions of the raw scan. Formatted in different dimensions, they are available as low-resolution images for "Web & Mobile," as small, medium, or large images. The image resolution thus infuses the intended end product and their potential uses. One digital image is several products, each of them priced differently. Consequently, the commercial value of a digital image product is defined not only by the scope of its distribution, such as the number of print runs or regional, national, or international coverage, but also by its resolution and format. What is important to note here is that the analogue carrier is not discarded, but remains in the collection and is marked with a barcode, through which the complete set of original and added metadata becomes machine-readable. The analogue negative or print serves as a guarantee in a double sense: on the one hand it is considered the source, which can be rescanned if data is damaged or if future quality standards require it. On the other hand, the analogue photograph functions, in most cases, as the essential rights certificate, stamped or marked on the reverse side of the print or envelope.

Following the digitization and the formatting, all available text information is then incorporated into the electronic file, including the caption, the provenance, and the available sizes as well as the copyright. The attribution of categories and the detailed indexing of the image are carried out by the editor and the indexing department. Thus, reflecting the methods of the traditional picture market, the creation of a digital image product is embedded in a detailed production process built upon the idea of economic efficiency and the division of labor. Finally, the digital images products are displayed on the virtual picture store and gigantic shop window, the Corbis website (figure 10.3).

The relation between the image content and the way it is formed, interpreted, and distributed becomes apparent when looking at the display of an individual image on the Corbis website, such as the aforementioned *Massive Crowd on Beach at Coney Island* (figure 10.4). The digitized photograph takes up approximately half of the screen surface and appears in combination with all sorts of information listed as "image details." It is accompanied by the indication of the image category (archival), the historical collection the

FIGURE 10.3. Corbis website, French edition, *24/7 365*, 2011.

FIGURE 10.4. Weegee, *Massive Crowd on Beach at Coney Island*, display on Corbis website, 2010.

image belongs to (Bettmann), a condensed and more detailed original cap-
tion, and the digital archive number. The location (Brooklyn, New York,
New York, USA) and the photographer (Weegee) are hyperlinked, referring
to the image classification and the searchable keywords. Special emphasis is
put on the indication of the copyright, be it in the form of the digital water-
mark inserted into the image or information concerning the model and prop-
erty release. The image, placed on the right-hand side, is framed by a dark
gray background, evoking, though inversed, the viewing mode of a light ta-
ble supported by the luminosity of the computer screen. The configuration
of the screen design, combining both image and text, is reminiscent of the
design of accession cards used in library or museum collections. The various
information accompanying the image and its prominent display points to an
essential, yet strangely ignored aspect: one does not search for an image, but
for the text associated with the image. Reflecting the archival structure, image
query tools have always been, and still are, largely based on text. Hence, the
image *Massive Crowd on Beach at Coney Island* is visualized and materializes
through the textual information associated with it. The image echoes the in-
formation attributed to the image, deduced from the analogue object, and its
interpretation.

Furthermore, as with digital holdings in general, the materiality of digital
images is articulated through the supporting structures required for the ar-
chiving, the display, and the distribution of the products. As Manoff and oth-
ers have argued, "We access electronic texts and data with machines made of
metal, plastic, and polymer. Networks composed of fiber optic cables, wires,
switches, routers, and hubs enable us to acquire and make available our elec-
tronic collections."[46] It is especially the acute energy consumption for the
maintenance of the servers, hosting large digital image collections, that has
not only become a growing cost factor, but is also one of growing ecological
concern.

Public Access, Private Library

On a more abstract level, the rhetoric employed by Corbis for advertising
its products and services may also be seen as indirectly contributing to their
materialization, infusing them with value. Interestingly, this rhetoric oscil-
lated for many years between two concepts: the appreciation of the photo-
graph as an object with a particular genealogy on the one hand, and the
two-dimensional endlessly reproducible and "ahistorical" image on the other,
and also between singularity, rarity, authenticity and multiplicity, ubiquity,
equivalence.[47] In its search for a functioning business model and business

philosophy, Corbis deliberately positioned itself between philanthropy and business, as evidenced by the visual and verbal rhetoric used by the company.

In *The Road Ahead* Gates argues against the concerns of museums regarding the uncontrolled proliferation of digital images by claiming that the "exposure to the reproductions is likely to increase rather than diminish reverence for real art and encourage more people to get out to the museums and galleries."[48] This argument recalls André Malraux's idea of the Musée Imaginaire (Museum without Walls) and the potential of photography as a medium for studying and popularizing art.[49] Yet, as Doug Rowan, the former CEO of Corbis, stresses in a 1996 interview, "This is not a 'not-for-profit' organization."[50] And Bill Gates is no altruist. Tellingly, the allusion to the concept of the library appears repeatedly. The coined reference to the Library of Alexandria, for instance was eagerly picked up by the media during the mid-1990s, picturing that "[Corbis] may swell into the world's most comprehensive digital reserve of the imagery of mankind." For the magazine *Wired*, "Corbis is more than the ultimate digital stock image house. It may be the first online, for-profit library." In turn, Corbis viewed itself as "the prototype of an all-content-on-demand, public access, private library,"[51] further blurring the line between public and private ambition.

Corbis used the idea of the library as an institution dedicated to the public by turning it into a tool for its own self-promotion and as a catalyst for digitization. However, the functioning of the company, and in particular the organization of its holdings, clearly contradicts this idea. First, it benefits stakeholders and not the general public. Second, the Corbis digital archive is not structured according to the metonymic principle of the library, the *Nebeneinander* (juxtaposition) of elements, but operates with a hierarchical system. Compared to the library, where each book, apart from rare ones, is valued and handled in the same way, attributing to it a certain place on the bookshelf, next to all other books, Corbis highlighted certain images and certain collections, a point I will explore later in this essay.

Yet Corbis does not use this cultural vocabulary for mere marketing purposes. In references to the Library at Alexandria and the idea of the Museum without Walls, and particularly the liberation and promotion of the work of art through digital reproduction, the company seeks to legitimize its business model. The digitization as a technological invention, one strongly supported and developed by Corbis as well as Getty Images, is framed within a wider cultural history of technological innovation. These efforts of legitimization emerged at a time in the mid-1990s when the commercial benefit of digital reproduction, namely its sales potential, was still purely hypothetical, and at a time of considerable unease with regard to the new technology.

PHOTOGRAPHY

Picture This

A company called Corbis wants nothing less than to
capture the history of human existence—and sell it

FIGURE 10.5. Douglas Rowan, Corbis CEO, in Kate Hafner, "Picture This," *Newsweek*, 26 June 1996,
photograph © Jayne Wexler.

This dichotomy becomes evident with the illustration for a *Newsweek* article,
showing a color positive photograph of then Corbis CEO Douglas Rowan
operating a view camera directed towards us, the spectator (figure 10.5). With
this representation Corbis explicitly seeks to position its efforts not only in
relation to a history of photographic techniques. It also creates a clearly de-
lineated, rather plain, but reassuring visual narrative of human and political

achievement, arts, and entertainment, deeply entrenched in Western visual history. Corbis mobilizes cultural history as a marketing strategy to legitimize its policy, thereby alleviating anxieties about the consequences of a new technology. It also mobilizes cultural history to counter the widespread criticism of the appropriation and control exerted by Corbis, and private companies, in general, over visual cultural heritage.

As the example of Corbis shows, the materiality of digital imaging manifests itself in the visible and invisible metadata attributed to the images, the copyright, as well as the software and the hardware required for their archiving and distribution. The characterization of photography as a multilayered laminated object, as suggested by Joanna Sassoon and others, could therefore also be applied to digital imaging.[52] It is especially in the merging of collections and the development of digital imaging products that the various layers of photographic materiality surface. And although digital imaging may be perceived or considered as flat or ephemeral, it produces matter that is indeed material when considering the substantial investments needed for the development of digital imaging products, the maintenance of the collection as well as the efforts put into the conservation of the digital data. What also becomes evident is that a digital image does not have a value in itself, but needs to be "materialized" to become valuable. Yet, this "exchange value"[53] and the conversion of an image into a "visual currency"[54] depend on the development of demand and of market structures. Developing these structures, however, proved to be arduous, complicated, and time-consuming.

In addition to the soaring costs for the development of viable products and their archiving, Corbis experienced additional problems with the market for digital images itself. As mentioned earlier, the demand for digital images developed rather slowly. The transition from a business model that relied on direct contact between client and the agency editor to a model based on virtual searches and electronic delivery faced considerable resistance, especially among professionals. The shift threatened to, and indeed did, significantly reduce the number of picture editors, thus virtually eliminating an established profession.

The Corbis example also reveals—and this is also valid for other archives and collections, be it in the commercial or the institutional context—that digitization does not replace analogue holdings. Instead, it creates parallel archives. The digital archive is not a replica, but rather a "trace" of the archive. It establishes its own archival paradigm by distinguishing between a digital master file and various compressed versions, between the original and the copy. Thus, Corbis preserves the analogue holdings (such as the Bettmann Archive, UPI, and Sygma) *and* maintains a digital archive. In the case of Corbis, the

FIGURE 10.6. Iron Mountain. Corbis Film Preservation Facility, 2010 © Estelle Blaschke.

digitization has resulted in the geographic divide between the conservation and archiving of photographs, and the circulation and distribution of their digital surrogates.[55] To alleviate the deterioration process of cellulose nitrate and acetate negatives, color photographs, and prints, Corbis transferred its analogue holdings to Iron Mountain in 2001, a specialized high-security and subzero preservation facility located in a former limestone mine in a secluded area in

western Pennsylvania (figure 10.6). The facility is owned and managed by the information protection and storage company Iron Mountain, which also gave the mine its name. Iron Mountain holds the documents and data of approximately 2,300 clients, including government departments, private companies, libraries, museums, and media corporations.[56] This includes highly sensitive documents and data from the US Patent and Trademark Office, the Census Bureau, and the Social Security Administration, bank details and insurance papers, as well as the complete collection of film and music recordings from Universal Pictures Company. The storage in a humidity-controlled and high-security venue aims at the long-term protection of documents and data from manmade or natural disasters, it is "protecting the world's information."[57]

Thus, the artifact does not become obsolete with the digitization. Quite the contrary. The information related to the photographic object, in particular the copyright indication, and its initial context and use are crucial for their very existence in digital form and a precondition for building a product from digital data. As Kenneth Johnston, the director of the historical collections at Corbis, notes, "digitization is not preservation, but rather a safety backup."[58]

Finding Pictures

From a total of 100 million photographs owned or managed by Corbis, "only" four million are displayed on the website today, which drastically reduces the number of visible and circulating images belonging to the Corbis collections.

The question of accessibility is indeed pivotal. On the one hand, this question relates, of course, to the control and "authority" of the archive. On the other hand, the archival systems providing access and allowing the fast retrieval of the holdings are an essential part of the economic potential of archiving. In the commercial context, an image is worthless if it cannot be found quickly. And an image is nonexistent if it cannot be found at all. Thus, the economic potential of archiving relies not only on the accumulation and long-term storage of holdings, but is also reflected in and dependent upon the various tools and methods for managing and accessing a collection. The history of image query tools is particularly illuminating with regard to photographic agencies and commercial image archives, as their business is largely based on the pertinence and fast retrieval of their holdings.

In the past, the service of image providers consisted of searching for and filtering a selection of pictures according to the client's needs. Essential to this was the specific knowledge of the archivists and editors derived from dealing with a collection on an everyday basis. In the case of digital archives, however, it is the client who performs this task with the help of electronic search

FIGURE 10.7. First Corbis website, 5 April 1997.

engines. Consequently, the primary concern, and the very problem for commercial image suppliers, lies in rendering their products as accessible as possible and navigating the client through the plethora of digital images. The challenge for Corbis, with its 100 million digital holdings, as with most digital archives, is displaying the abundance of the collection and the variety of images the company has to offer, while creating a search engine that can find *the* image.

The development of editing and managing tools for these massive picture collections, namely the development of electronic databases and efficient, user-friendly search engines is not a straightforward story of success. It is one of continuous experimentation and slow progress. The changing interfaces and search mechanisms of the Corbis website bear witness to this process. The search field for entering keywords, for instance, was integrated rather late, in 1999, two years after the launch of the first Corbis website, which mainly functioned as a billboard for the company's URL address (figure 10.7). The advanced search options appear more prominently on the portal in the design of 2002 and developed into a multioption search field, as shown on the current website, combining the search by keywords with search options related to the location, date, photographer, collection, availability, copyright, and formats, among others (figure 10.8). To respond to different search scenarios, the client is given several options to access and search the collection. With its menu of unfolding fields and boxes, the present interface reminds one of a control board, if not a mixing console. Corbis' quest for an ever more

FIGURE 10.8. Corbis website, display of advanced search options, May 2010.

efficient search engine not only points to the difficulties in finding images, especially with regard to the radical increase in digital image production; it also demonstrates that image research tools are becoming more important than ever in the accessing and use of digital image archives.

Yet, regardless of the ongoing improvement in search options and meta-data, the Corbis database and the search engine are far from flawless. The search results often generate too broad a selection that lacks pertinence and includes repetition. From the perspective of a photographic historian the search results for "weegee, coney, crowd" may be valuable as they reveal the existence of several versions of an iconic photograph (figure 10.9). From the perspective of a commercial image provider, the display of eight still im-ages of more or less the same scene is archival noise. While this arises from the sheer quantity of images corresponding to the image query, it also results from the fact that each image is conceived and treated individually within the digital archive. All knowledge that it formerly belonged to a series of photo-graphs of one object, topic, or event is lost. Moreover, the photographic image has, paradoxically, proven to be quite resistant to its indexing and retrieval, although it has widely shaped archival practices as an efficient medium of information storage. The polysemic nature of photographs, and visual rep-resentations in general, often hinders unambiguous classification, especially with regard to large collections and even more so with historical photographs.

In recent years, Corbis and other companies involved in digital informa-
tion and image management have therefore developed additional tools and
methods for structuring the data overload. While continuous efforts to de-
velop a mechanism capable of recognizing the image content by means of
color and form are still in progress, Corbis is structuring its vast visual corpus
through the rating of images. The rating is hidden to the user accessing the
digital archive. The images are assessed with regard to their sales potential
and accumulated revenue, and their present-day relevance and artistic qual-
ity. Besides the labeling with a basic category—among others fine arts, archi-
val, or entertainment[59]—the editor ranks an image according to one of the
five levels: the highest rating carries the abbreviation SS for "Super Show-
case."[60] The rating of the images has become a crucial tool for structuring the
masses of images, as it determines the order in which the search results are
displayed on the website.

With the creation of a rating system and other marketing tools to high-
light certain collections, the digital archive functions according to a hierar-
chical system. This system replaces the metonymic system, the principle of
the library, which characterizes the analogue photographic archive. However,
in an attempt to counterbalance the effects of this hierarchization (i.e., the
reduction of the visible digital holdings), and in order to underline the depth

FIGURE 10.9. Corbis website, search results for "weegee, coney, crowd," May 2010.

and variety of the Corbis collections, the search engine mixes different picture categories, be it documentary, archival, current events, entertainment, etc., and includes lower-rated images along with "picture gems."

Reflecting the industry's current development, Corbis also works on the widespread profiling of its customers and the analysis of search behaviors. In accessing the Corbis website and search query, and in particular through the registration, the researcher or client leaves numerous traces behind, also referred to as the "digital footprint." These traces are analyzed in order to keep track of the client, but more importantly to automatically anticipate his potential request, his taste, and his consumer attitude. While one may argue that the profiling enhances the navigation, it also seriously challenges the paradigm of the archive. Instead of providing more or less unbiased and universally valid search results, the results are shaped according to the individual client. The results seen are thus the sum of one's previous inquiries and search behaviors. This also means that, to some extent, the client is mirroring himself in each image or piece of information requested. As part of this individualization of the results of an archival request, the displayed selection is furthermore molded according to the client's specific location, i.e., accessing the Corbis website from the United Kingdom instead of France, for instance, influences the search and its results. Consequently, electronic databases and search engines are in the process of developing from a simple text-based documentation to a multilayered mechanism of visible and invisible information and metadata, and of predetermined choices and decisions. Thus, the gains of the machine, which led to an unprecedented virtual availability in form of cross-referenced, standardized, and watermarked screen pictures, evaporate with the individualization and customization of search results. To be sure, the archive has always been built on predetermined choices and decisions. But the absolute lack of transparency regarding how an image is shaped and displayed through metadata and algorithms creates a divide between what a photographic archive was in the past, how its content was read and reactivated, and the ways we will interact and make use of images in the future.

Corbis, like any commercial archive in the digital age, exerts control over its collection in two ways. First, it controls the access to its analogue collection by deciding what should be digitized and what should remain only in an analogue form. In this respect, the digitization may be regarded "as an insidiously repressing technology, enabling institutional control over what is made accessible."[61] With this in mind, it was especially the transfer of the analogue holdings to the remote preservation facility Iron Mountain that was widely condemned in the media and in the writings and works of artists as an imperious cultural act.[62]

Given the geographical location, this transfer theoretically limited access to the analogue holdings and reduced the "visible" pictures to those selected for digitization. An idiosyncratic search, vital to any scientific examination of the collection, is thus considerably limited. Moreover, the disproportion between the digitized and nondigitized holdings is rather unlikely to improve, since Corbis has shifted, like many others, from systematic digitization to more careful and selected projects, such as the digitization of card catalogues and reverse sides of photographs as well as digitization on demand. Second, the control is wielded through the search engine. The current development shows that the control over a collection is exercised not only by controlling the digital technology, but also the technology to render a collection accessible through the programming of a search engine—"a power that has equal potential to be democratizing and passive, or repressive and active."[63] Thus, the question about the "ownership of the printing press" that determined "the politics of the use and the access to the images"[64] has shifted towards the technology used for finding and searching for images.

Today, the references to a "digital Alexandria" have been dropped from the Corbis business rhetoric. One reason for this may be that the visual content providers face tough competition from a new generation of digital image archives, such as Flickr, Google Images, Facebook, and YouTube. In less than five years, the picture sharing website Flickr, for instance, has accumulated more than four billion digital images provided by and exchanged among their users.[65] Many professional photographers and public institutions use Flickr for promoting their collections, and since 2008 Flickr has been in cooperation with Getty Images in the area of image licensing. But as the example of Flickr shows, lacking the archival authority (in the form of consistent classification and indexing), the problem of finding a specific image has become even more complex.

The In/Discipline of the Archive

In conclusion, this short history of Corbis exemplifies what scholarship has characterized as the in/discipline of the archive.[66] The assignment of an archival number, keywords, categories, and groups and the attribution of a specific storage place—be it in a folder, box, or shelf for the analogue material or a programmed databank for digital images—conveys the idea of the archive as a fixed, disciplined structure, an orderly place. And it certainly is. Otherwise, it would be useless. However, what becomes evident from the history of Corbis (similar to most archives or collections) is also the *fragile* character of the archive, and the indiscipline. This fragility varies in degree and tends to be

covered by and contradicts the concept of an archive as a robust, authoritative body.

This fragility reveals itself first in the materiality of the analogue and the digital form and on the dependency of the photograph to its performance within the archive. Information gets lost, photographs and digital data deteriorate, images cannot be found, or exist in several quasi-identical copies, etc. The Corbis collection, for example, contains a considerable amount of "orphaned" works. These are historical photographs that cannot be exploited commercially, either because the copyright remains unresolved or unknown, or because it is just impossible to tell what the photograph depicts, and where, when or why it was taken. Thus, regardless of its form, the photographic archive contains considerable amounts of static, noncirculating images, which is particularly counterproductive in the case of commercial enterprises as it becomes visual waste.

Second, it is the aforementioned polysemic nature and the different temporal layers of photography that yield the fragile character of photography as an archival object. As generally acknowledged, the translation of a photograph (or an image) into text is by definition impossible given the different nature of visual and textual information, of image and text. The description of an image through keywords and the caption is thus limited by its "aboutness."

Third, an archival system is and will always be predicated on the manual efforts of the archivists and editors, and by extension, their know-how and rigor. In the case of Corbis, however, the geographic divide between Iron Mountain, headquarters, and sales offices, and the disembodiment of the archive, inevitably impairs the skills that stem from the daily interaction and responsibility connected with the handling of a photographic collection. If, for example, the indexing of a digitized photograph is not done by the editor who selected the image, but by a separate indexing department, inaccuracy and the loss of information may result.

The in/discipline, also revealed in the discrepancy between the notion of a quasi-automated, ideal (and idealized) archive and the actual practice of the archive, is undoubtedly amplified by the digitization and the accumulation of vast and excessive amounts of images. As masses of pictures are added to the collection, and other collections are integrated into it, the archival system becomes susceptible to errors and heterogeneity. Being an eclectic compilation of collections and lacking institutional authority, the Corbis digital archive has no epistemic value per se. Through the abundance of styles, themes, and categories and the increasing individualization of search results (figure 10.10), it becomes a serendipitous juxtaposition of images, an archive of "everything" that is potentially marketable and that has been sold in the past, reflecting

FIGURE 10.10. Corbis website, search results for "archival collection," 2009.

and nourishing the notion of taste in consumer culture. The sheer impossibility of setting boundaries and creating a narrative in such an archive runs against the grain of an archive's essential function and purpose, that of "making sense."

Notes

1. See Mitman and Wilder, chapter 1, this volume.

2. Oliver Wendell Holmes, "The Stereoscope and the Stereograph," *Atlantic Monthly* 3 (June 1859), reprinted in Trachtenberg, *Classic Essays on Photography* (New Haven: Leete's Island Books, 1980), 71–82, here 81.

3. Holmes, "Stereoscope and the Stereograph," 82.

4. Jackson Mathews, ed., *The Collected Works of Paul Valéry*, trans. Stuart Gilbert (Princeton: Princeton University Press, 1970), 227. French original version: Paul Valéry, "La Conquête de l'ubiquité," in *De la musique avant toute chose* (Paris: Éditions du Tambourinaire, 1928). [Original: "Telle que la science, elle devient besoin et denrée internationaux."]

5. Mathews, *The Collected Works of Paul Valéry*, 226. [Original: "Elles ne seront plus que des sortes de sources ou des origines, et leurs bienfaits se trouveront ou se retrouveront entiers où l'on voudra. Comme l'eau, comme le gaz, comme le courant électrique viennent de loin dans nos demeures répondre à nos besoins moyennant un effort quasi nul, ainsi serons-nous alimentés d'images visuelles ou auditives, naissant et s'évanouissant au moindre geste, presque à un signe."]

6. The implications of the emergence of digital media on 1990s culture and society have been discussed most prominently by Nicolas Negroponte, *Being Digital* (New York: Vintage Books, 1996); Lev Manovich, *The Language of New Media* (Cambridge: MIT Press, 2001); Carl Shapiro and Hal R. Varian, *Information Rules: A Strategic Guide to the Network Economy* (Cambridge: Harvard Business School Press, 1998).

7. The critique of Valéry's idea of ubiquity of the aural or visual experience reflected in *The Information Revolution: 500 Monitors* further resonates with Walter Benjamin's writings. In his 1928 text "This Space Is for Rent" as part of the essay collection "One-Way Street," Benjamin claims that the "insistent, jerky nearness" and "special ubiquity of things," and Benjamin refers to advertising and film here, "make criticism impossible," as "criticism is a matter of distancing." It [criticism] was at home in a world where perspectives and prospects counted and where it was still possible to take a standpoint. See Walter Benjamin, "This Space Is for Rent," in *Reflections: Essays, Aphorisms, Autobiographical Writings*, ed. Peter Demenz, trans. Edmund Jephott (New York: Schocken, 2007), 85–86.

8. The material turn in photography history and theory has been introduced and developed by Elizabeth Edwards and Janice Hart, *Photographs Objects Histories: On the Materiality of Images* (London: Routledge, 2004). See also Geoffrey Batchen, *Burning with Desire: The Conception of Photography* (Cambridge: MIT Press, 1997).

9. The term predominantly appears in the self-portrayals of Corbis and Getty Images and points to the fact that both companies not only distribute still images but also film. This chapter, however, concentrates on photography and digital imaging.

10. Joanna Sassoon, "Photographic Materiality in the Age of Digital Reproduction," in *Photographs Objects Histories: On the Materiality of Images*, ed. Elizabeth Edwards and Janice Hart (London: Routledge, 2004), 186.

11. Holmes, "Stereoscope and the Stereograph," 80.

12. Jennifer Trant, "The Getty AHIP Imaging Initiative: A Status Report," *Archives and Museums Informatics* 9, no. 3 (1995): 262.

13. Jacques Derrida, *Mal d'archive: Une impression freudienne* (Paris: Édition Galilée, 1995).

14. This description refers again to Paul Valéry; see note 3. ["I do not know, whether a philosopher has ever dreamed of a company engaged in the home delivery of Sensory Reality."]

15. Bill Gates, Nathan Myrvold, and Peter Rinearson, *The Road Ahead* (New York: Penguin, 1995).

16. Gates, Myrvold, and Rinearson, *The Road Ahead*, 257.

17. Gates, Myrvold, and Rinearson, *The Road Ahead*, 257.

18. Jane Lusaka, Susannah Cassedy O'Donnell, and John Strand, "Whose 800lb Gorilla Is It? Corbis Corporation Pursues Museums," *Museum News*, May/June 1996, 37.

19. Microsoft's policy culminated in the highly mediatized 1998 trial *United States v. Microsoft*, in which the US government investigated Microsoft's monopoly power. The trial undoubtedly contributed to the negative image of Corbis.

20. Richard Rapaport, "In His Image," *Wired Magazine* 2, no. 11 (1996).

21. Rapaport, "In His Image," 72.

22. See portal of Corbis website of November 1999. Available from https://web.archive.org/web/19991105133839/http://www.corbis.com/ (accessed 9 May 2015).

23. Gillian Rose, "Practising Photography: An Archive, a Study, Some Photographs, and a Researcher," *Journal of Historical Geography* 26, no. 4 (2000): 564.

24. David Bearman, "The Challenge of the Acquisition of the Bettmann Archive by Corbis," *Archives and Museum Informatics* 9, no. 3 (1995): 261.

25. Lusaka, O'Donnell, and Strand, "Corbis Corporation Pursues Museums," 35.

26. Lusaka, O'Donnell, and Strand, "Corbis Corporation Pursues Museums," 78.

27. Patricia Failing, "Brave New World or Just More Profitable?" *Artnews* 9 (October 1996): 114–18.

28. Barbara Hoffmann, ed., *Exploiting Images and Image Collections: Goldmine or Legal Minefield?* (London: Kluwer Law International, 1999).

29. Lusaka, O'Donnell, and Strand, "Corbis Corporation Pursues Museums," 77.

30. For an analysis on the display methods and aesthetics of the computer screen, see Anne Friedberg, *The Virtual Window: From Alberti to Microsoft* (Cambridge: MIT Press, 2006).

31. Rapaport, "In His Image," 73.

32. Holmes, "Stereoscope and the Stereograph," 80.

33. The company name Corbis refers to the Latin word *corbis*, meaning basket. The choice of this name can be interpreted as a reference to the shopping cart, which will later become the icon of electronic commerce. Prior to the choice of the new name in 1995, IHS was renamed Continuum Corporation in 1994.

34. In the early 1990s the picture market was composed of a variety of smaller agencies, specialized on specific themes, photojournalistic news agencies as well as stock photography agencies, such as Comstock and the Image Bank, a subcontractor of Eastman Kodak. Anticipating the radical transformation in the field of communications, Corbis and Getty Images quickly become major competitors on the picture market, as most traditional agencies had underestimated the impact of digitization.

35. Jenny Tobias, "Re-Use Value," *Cabinet* 22 (2006): 44.

36. Lusaka, O'Donnell, and Strand, "Corbis Corporation Pursues Museums," 76.

37. Marlene Manoff, "The Materiality of Digital Collections: Theoretical and Historical Perspectives," *Libraries and the Academy* 6, no. 3 (2006): 311–25.

38. Geoffrey Batchen, "Photogenics/Fotogenik," *Camera Austria* 62–63 (1998): 5–16.

39. Tina Gant, ed., *International Directory of Company Histories* (London: St. James Press, 2000). Available from http://www.fundinguniverse.com/company-histories/c.html (accessed 14 November 2015).

40. François Arago, *Rapport de M. Arago sur le daguerréotype: lu à la séance de la Chambre des députés le 3 Juillet 1839, et à l'Académie des sciences, séance du 19 août* (Paris: Bachelier, 1839).

41. Jules Janin, "'Le Daguerotype [*sic*],' *L'Artiste*, 1838–1839," in *La Photographie en France*, ed. André Rouillé (Paris: Macula, 1989), 48.

42. Auguste Belloc, *Compendium des quatre branches de la photographie: traité complet théorique et pratique des procédés de Daguerre, Talbot, Niepce de Saint-Victor et Archer* (Paris: chez l'auteur, 1858), 14.

43. See Corbis corporate fact sheet, updated November 2012. Available from http://corporate.corbis.com/company-fact-sheet (accessed 14 November 2015).

44. See especially Jennifer Tucker, chapter 2, this volume.

45. Douglas Crimp, "The Museum's Old/the Library's New Subject," in *The Contest of Meaning: Critical Histories of Photography*, ed. Richard Bolton (Cambridge: MIT Press, 1989), 3–12. Crimp describes the implication of the reclassification of photographs in books through the example of the New York Public Library, which ultimately led to the formation of the library's Photographic Collections Documentation Project in the early 1980s.

46. Manoff, "Materiality of Digital Collections," 312.

47. Christopher Phillips, "The Judgment Seat of Photography," *October* 22 (Autumn 1982): 28. Contrary to Phillips, who describes the passage from the concept of multiplicity, ubiquity, and equivalence to its recognition of photography as art and the reconstitution as an art object, I use these concepts in opposition here.

48. Gates, Myrvold, and Rinearson, *The Road Ahead*, 259.

49. André Malraux, *Le Musée Imaginaire* (Paris: Gallimard, 1965), 123. [Original: "La reproduction ne rivalise pas avec le chef-d'oeuvre présent: elle l'évoque ou le suggère."]

50. Rapaport, "In His Image."

51. Rapaport, "In His Image."

52. Sassoon, "Photographic Materiality," 186.

53. Edwards and Hart, *Photographs Objects Histories*, 5.

54. John Tagg, *The Burden of Representation: Essays on Photographies and Histories* (London: Macmillan, 1988).

55. Corbis solicited a group of photography conservators, among them specialists from George Eastman House, to develop a preservation plan to stop the deterioration process of large numbers of negatives. In keeping with this plan, in 2002 Corbis transferred the Bettmann Archive and UPI files to Iron Mountain. Temperature and humidity controls ensure the long-term preservation of the analogue materials. For a selection of approximately 28,000 "icons of photography"—a set of vintage negatives of bestselling and best-known pictures—the preservation plan foresees storage at −4 degrees Fahrenheit, thereby freezing the negatives. The preservation plan for the Bettmann Archive and UPI was also the model for the long-term preservation project, Sygma Initiative. The analogue archive of the former picture news agency is preserved in Garnay, in Paris, since April 2009. In the case of the Corbis historical collection, or the Universal film archive, the preservation of photographs and film in high-security, subzero storage creates a quite interesting tautology: photography freezes the moment and is frozen in time.

56. See website of Iron Mountain Corporation, http://http://www.ironmountain.com /company. Already before the company Iron Mountain purchased the mine, it served as a long-trem storage facility since the early 1950s run by the private company National Underground Storage Incorporated. See "Photo Archives Heads Underground," *New York Times*, 15 April 2001, accessible through the website of Wilhelm Imaging Research, http://www.wilhelm-research .com/corbis_subzero.html.

57. Advertising slogan of Iron Mountain Incorporated, 2010. The company is active in more than forty countries. However, the site in Pennsylvania is the only high-security preservation facility.

58. Interview conducted by the author with Kenneth Johnston on 25 March 2009 at the Corbis New York office.

59. Corbis distinguishes between two major categories, that is "creative" and "editorial." There exist two subcategories for "creative" pictures, namely Rights Managed and Royalty Free and five subcategories of "editorial": documentary, fine arts, archival, current events and entertainment. See also Paul Frosh, *The Image Factory: Consumer Culture, Photography, and the Visual Content Industry* (Oxford: Berg, 2003) and Matthias Bruhn, *Bildwirtschaft: Verwaltungen und Verwertungen von Sichtbarkeit* (Weimar: WDG Verlag, 2003).

60. The different levels are marked SS (Super-Showcase), S (Showcase), B, C, D; most pictures belong to the first three categories.

61. Sassoon, "Photographic Materiality," 187.

62. See, for example, Hal Foster, "The Archive without Museums," *October* 77 (Summer 1996): 97–119; Allan Sekula, "Between the Net and the Deep Blue Sea (Rethinking the Traffic of Photographs)," *October* 102 (Fall 2002): 3–34; See also Alfredo Jaar's *Lament of the Images* (2002), an installation displayed at Documenta XI, Kassel, 2002. The ramification of Corbis' policy becomes particularly evident when comparing Iron Mountain, a private endeavor "protecting the world's information," with the high-security, long-term storage facility and former silver mine

in Oberried, Germany, also known as the Barbarastollen (Barbara tunnel). Conceived as a time capsule for preserving the nation's cultural heritage, the German government has been storing a variety of defining manuscripts, documents, artifacts, and artworks on microfilm there since 1975. Arguing with Aleida Assmann, the business model of Iron Mountain is far more than mere information management; it is an immortalization industry (*Verweigungsindustrie*). Aleida Assmann, *Erinnerungsräume: Formen und Wandlungen des kulturellen Gedächtnisses* (Munich: C. H. Beck, 2006).

63. Sassoon, "Photographic Materiality," 187.
64. Sassoon, "Photographic Materiality," 187.
65. See Flickr website, http://www.flickr.com.
66. Rose, "Practising Photography," 567.

Acknowledgments

This book started with an act of matchmaking. Lorraine Daston has a knack for bringing people together of different intellectual backgrounds and persuasions, confident that in a maelstrom of ideas, an intriguing project will surface. Raine orchestrated our meeting. It was a meeting that sparked a simple question. Why, we asked, was the divide between scholars of the moving image and those of the still image so firm, when we often worked on such similar questions? In the intervening years this simple question has grown to span disciplines, continents, and centuries and accrued many debts of gratitude. The largest of these is to Raine and Department II of the Max Planck Institute for the History of Science (MPIWG) in Berlin, which provided not just the space and resources, but also a model for collaborative, interdisciplinary working groups developed through face-to-face meetings and exchanging of manuscripts. It is a model of working that requires time and generosity of spirit by all contributors, and the editors would like to thank the authors in this volume for their frank discussions and their commitment throughout the lengthy duration of this project.

In 2008, we held a conference called The Educated Eye: Photographic Evidence and Scientific Observation, which was supposed to be about evidence, observation, photography, and film. It turned out to be mostly about the archive. The contributors to that conference, Faye Ginsburg, Anna Grimshaw, Tal Golan, Sarah de Rijcke, Tania Munz, Scott Curtis, Robin Kelsey, Jordan Baer, Jimena Canales, Fatimah Tobing Rony, Elizabeth Edwards, Stefani Klamm, Janet Vertesi, and Peter Geimer, were integral to the formation of the Documenting the World working group. In 2010 the working group met for the first time, and the authors of this volume struggled with the concept of the document

or record, with archives and their meaning making, and with the central concepts of circulation and recirculation. Throughout this process, Raine has been unstinting in her support of this project, giving us her time, her insights, and space at the MPIWG, without which the project would have never come to fruition. At the University of Wisconsin-Madison, the Nelson Institute's Center for Culture, History, and Environment; the Holtz Center for Science & Technology Studies; the Department of Medical History and Bioethics; and the Department of History of Science have offered a supportive environment for interdisciplinary thinking. Thanks also to the UW-Madison's Arts Institute, which has helped to support an environmental filmmaker-in-residence program connected with the Tales from Planet Earth film festival, which has helped to bring into focus questions related to the materiality and impact of film. The Department of Medical History and Bioethics and the Vilas Trust of the University of Wisconsin both generously provided the funds for a subvention grant to reproduce the images in this volume, while a grant from the National Science Foundation (SES-1331078) has been critical to putting into practice the repatriation of an expeditionary film and photographic record, giving these historic images a second life in Liberia. At De Montfort University, the support for photographic history teaching and research through the founding of both the MA Photographic History (2008) and the Photographic History Research Centre (2010) provided a crucible in which materiality, archives and photography's role in history could be seriously considered.

In a book devoted to the richness of photographic and film archives the world over, we are deeply indebted not only for this volume but for all our research to the critical interventions made by those who work at the coal face, so to speak, pinched between the ever increasing deluge of image material and the steadily decreasing funds with which to archive them. Our heartfelt thanks go to: Marc Boulay, Rachel Hart, and Rachel Nordstrom at the St Andrews University Library Special Collections; Chris Morton at the Pitt Rivers Museum; Sarah Walpole at the Royal Anthropological Institute; Mandy Wise from the University College London Special Collections; Sarah Farley at the Hampshire Record Office; colleagues at the National Archives (Kew); Cambridge University Museum of Archaeology and Anthropology; Nikolaus Dietrich, Stephan Schmid, and Antonia Weiße at the Winckelmann-Institut of the Humboldt University, Berlin; Harvard University Library; Randal Whitman, Verlon Stone, and the Indiana University Liberian Collections; and Bloh Sayeh at the Center for National Documents and Records Agency in Monrovia, Liberia. Thanks to Jayne Wexler and Louie Psihoyos for permission to use their photographs. For photographs of the Spiegelgrund burial

in Vienna, Austria, we would like to thank Milli Segal and photographer David Reinhard.

In the process of writing the book together we have benefitted from the excellent criticism, insights and opinions of many scholars: Paula Amad, Daniela Bleichmar, Lorraine Daston, Peter Galison, Bettina Gockel, Jean-Baptiste Gouyon, Kris Juncker, Rick Prelinger, Vanessa Schwartz, and the blind referees of the manuscript. Karen Merikangas Darling has been unstinting in support of this volume in spite of the many delays, and Evan White and the rest of the Chicago publication team have ironed out many of the final details.

Bibliography

Adamson, Jeremy. "Kodachrome: The New Age of Color." In *Bound for Glory: America in Color 1939–43*, edited by Paul Hendrickson. New York: Harry Abrams, 2002.

Albertz, Jörg, and Albert Wiedemann, eds. *Architekturphotogrammetrie gestern-heute-morgen: wissenschaftliches Kolloquium zum 75. Todestag des Begründers der Architekturphotogrammetrie Albrecht Meydenbauer, in der Technischen Universität*. Berlin: Technische Universität, 1997.

Allen, Glover M., ed. *Harvard Traveler's Club Handbook of Travel*. Cambridge: Harvard University Press, 1917.

Alvarez Roldán, Arturo. "Looking at Anthropology from a Biological Point of View: A. C. Haddon's Metaphors on Anthropology." *History of the Human Sciences* 5, no. 4 (1992): 21–32.

Amad, Paula. "Cinema's 'Sanctuary': From Pre-Documentary to Documentary Film in Albert Kahn's 'Archives de la Planète' (1908–1931)." *Film History* 13 (2001): 138–59.

———. *Counter-Archive: Film, the Everyday, and Albert Kahn's Archives de la Planète*. New York: Columbia University Press, 2010.

Amann, Klaus, and Karen Knorr-Cetina. "The Fixation of (Visual) Evidence." In *Representation in Scientific Practice*, edited by Michael Lynch and Steve Woolgar, 85–122. Cambridge: MIT Press, 1990.

Anonymous. "The Yorkshire Photographic Union." *British Journal of Photography* 49, no. 2197 (13 June 1902): 471–73.

Arago, François. *Rapport de M. Arago sur le daguerréotype: lu à la séance de la Chambre des députés le 3 Juillet 1839, et à l'Académie des sciences, séance du 19 août*. Paris: Bachelier, 1839.

Armstrong, Robert P. *The Affecting Presence: An Essay in Humanistic Anthropology*. Urbana: University of Illinois Press, 1971.

Arnheim, Rudolph. *Film as Art*. Berkeley: University of California Press, 1957.

———. "On the Nature of Photography." In *New Essays on the Psychology of Art*, 102–14. Berkeley: University of California Press, 1986.

Assmann, Aleida. *Erinnerungsräume: Formen und Wandlungen des kulturellen Gedächtnisses*. Munich: C. H. Beck, 2006.

"Auto Film Shows World on Wheels." *New York Times*, 26 January 1928.

"Auto's Varied Uses Shown." *New York Times*, 27 January 1928.

Azoulay, Ariella. *The Civil Contract of Photography*. New York: Zone, 2008.

Bader, Lena, Martin Gaier, and Falk Wolf, eds. *Vergleichendes Sehen*. Paderborn: Fink, 2010.

Baird, Thomas. "Films and the Public Services in Great Britain." *Public Opinion Quarterly* 2 (1938): 98.

Banks, Marcus, and J. Ruby. "Introduction: Made to Be Seen." In *Made to Be Seen: Historical Perspectives in Visual Anthropology*, edited by M. Banks and J. Ruby, 1–18. Chicago: University of Chicago Press, 2011.

Bann, Stephen. "The Photographic Album as a Cultural Accumulator." In *Art and the Early Photographic Album*, edited by Stephen Bann, 7–30. New Haven: Yale University Press, 2011.

Barthes, Roland. *Camera Lucida: Reflections on Photography*. Translated by Richard Howard. New York: Hill and Wang, 1981.

Batchen, Geoffrey. *Burning with Desire: The Conception of Photography*. Cambridge: MIT Press, 1997.

———. *Forget Me Not: Photography and Remembrance*. Princeton: Princeton Architectural Press, 2004.

———. "Photogenics/Fotogenik." *Camera Austria* 62–63 (1998): 5–16.

Bazin, André, and Hugh Gray. "The Ontology of the Photographic Image." *Film Quarterly* 13, no. 4 (Summer 1960): 4–9.

Bearman, David. "The Challenge of the Acquisition of the Bettmann Archive by Corbis." *Archives and Museum Informatics* 9, no. 3 (1995): 261.

Beaulieu, Anne. "Images Are Not the (Only) Truth: Brain Mapping, Visual Knowledge, and Iconoclasm," *Science, Technology & Human Values* 27 (2002): 53–86.

Becker, Peter, and William Clark, eds. *Little Tools of Knowledge: Historical Essays on Academic and Bureaucratic Practices*. Ann Arbor: University of Michigan Press, 2001.

Beckmann, Angelika, and Bodo von Dewitz, eds. *Dom, Tempel, Skulptur: Architekturphotographien von Walter Hege*. Cologne: Wienand, 1993.

Bell, James F. et al. "Mars Exploration Rover Athena Panoramic Camera (Pancam) Investigation." *Journal of Geophysical Research*, 108, E1 (2003). doi 10.1029/2003JE002070

Belloc, Auguste. *Compendium des quatre branches de la photographie: traité complet théorique et pratique des procédés de Daguerre, Talbot, Niepce de Saint-Victor et Archer*. Paris: chez l'auteur, 1858.

Benjamin, Walter. "Theses on the Philosophy of History." In *Illuminations: Essays and Reflections*, edited by Hannah Arendt, translated by Harry Zohn, 253–64. New York: Schocken Books, 1968.

———. "This Space Is for Rent." In *Reflections: Essays, Aphorisms, Autobiographical Writings*, edited by Peter Demenz, translated by Edmund Jephott, 85–86. New York: Schocken, 2007.

Bergson, Henri. *Creative Evolution*. Translated by Arthur Mitchell. New York: H. Holt and Co., 1911.

Berlinger, Joe, director. *Gray Matter* (television documentary). Third Eye Motion Picture Company, 2004. Distributed by New Video Group.

Blair, Mary Ellen. *A Life Well Led: The Biography of Barbara Freire-Marrecco Aitkin, British Anthropologist*. Santa Fe, NM: Sunstone Press, 2008.

Bloom, Peter J. *French Colonial Documentary: Mythologies of Humanitarianism*. Minneapolis: University of Minnesota Press, 2008.

Bol, Peter Cornelius, and Herbert Beck, eds. *Olympia: Eine archäologische Grabung*. Frankfurt am Main: Leibighaus, 1977.

Borbein, Adolf Heinrich. "Klassische Archäologie in Berlin vom 18. zum 20. Jahrhundert." In *Berlin*

und die Antike: Architektur, Kunstgewerbe, Malerei, Skulptur, Theater und Wissenschaft vom 16. Jahrhundert bis heute: Aufsätze: Ergänzungsband zum Katalog der Ausstellung "Berlin und die Antike," edited by Willmuth Arenhövel and Christa Schreiber, 118–23. Berlin: Wasmuth, 1979.

Branchini, Valentina. "The Photograph Study Collection of the Metropolitan Museum of Art: A Change of Reference." In *Photo Archives and the Photographic Memory of Art History*, edited by Costanza Caraffa, 389–94. Berlin: Deutscher Kunstverlag, 2011.

Brand, Stewart, et al. "Digital Retouching: The End of Photography as Evidence of Anything." *Whole Earth Review* 47 (July 1998): 42–49.

Braun, Adolphe. *Photographies de fleurs, à l'usage des fabriques de toiles peintes, papiers peints, soieries, porcelaines, etc.* Paris: Mulhouse, 1855.

British Association for the Advancement of Science. *Notes and Queries on Anthropology.* 5th ed. London: Royal Anthropological Institute, 1929.

Brown, Elspeth H., and Thy Phu. *Feeling Photography.* Durham: Duke University Press, 2014.

Bruhn, Matthias. *Bildwirtschaft: Verwaltung und Verwertung von Sichtbarkeit.* Weimar: WDG Verlag, 2003.

Brusius, Mirjam. "Preserving the Forgotten: William Henry Fox Talbot, Photography, and the Antique." Ph.D. diss., Darwin College, University of Cambridge, 2011.

Bryson, Norman. *Looking at the Overlooked: Four Essays on Still Life Painting.* London: Reaktion, 1990.

Buell, Raymond Leslie. *The Native Problem in Africa.* 2nd ed. London: Frank Cass & Co., Ltd., 1928.

Burnett, D. Graham. *Masters of All They Surveyed: Exploration, Geography, and a British El Dorado.* Chicago: University of Chicago Press, 2000.

Caraffa, Costanza. "From 'Photo Libraries' to 'Photo Archives': On the Epistemological Potential of Art-Historical Photo Collections." In *Photo Archives and the Photographic Memory of Art History*, edited by Costanza Caraffa, 11–44. Berlin: Deutscher Kunstverlag, 2011.

———, ed. *Photo Archives and the Photographic Memory of Art History.* Berlin: Deutscher Kunstverlag, 2011.

Cartwright, Lisa. *Screening the Body: Tracing Medicine's Visual Culture.* Minneapolis: University of Minnesota Press, 1995.

Cavell, Stanley. *The World Viewed: Reflections on the Ontology of Film.* Cambridge: Harvard University Press, 1979.

Certeau, Michel de. "L'Espace de l'Archive ou la Perversion du Temps." *Traverses* 36 (1986): 4–6.

Christy, Cuthbert, Charles S. Johnson, and Arthur Barclay. *Report of the International Commission of Inquiry into the Existence of Slavery and Forced Labor in the Republic of Liberia.* Washington, DC: U.S. Government Printing Office, 1931.

Clifford, James. *The Predicament of Culture.* Berkeley: University of California Press, 1988.

Coe, Brian. *Colour Photography: The First Hundred Years 1840–1940.* London: Ash and Grant, 1978.

Collins, Harry. *Changing Order: Replication and Induction in Scientific Practice.* London: Sage Publications, 1985.

Connerton, Paul. *How Societies Remember.* Cambridge: Cambridge University Press, 1989.

Coulter, Jeff, and E. D. Parsons, E. D. "The Praxiology of Perception: Visual Orientations and Practical Action." *Inquiry* 3 (1990): 251–72.

Cox, Amy. "Purifying Bodies, Translating Race: The Lantern Slides of Sir Everard im Thurn." *History of Photography* 31, no. 4 (2007): 348–64.

Crane, Susan. "Choosing Not to Look: Representation, Repatriation, and Holocaust Atrocity Photography." *History and Theory* 47, no. 3 (2008): 309–30.

Creager, Angela, Elizabeth Lunbeck, and Norton Wise. *Science without Laws: Model Systems, Cases, Exemplary Narratives*. Durham: Duke University Press, 2007.

Crenshaw, Kimberlé Williams. "Mapping the Margins: Intersectionality, Identity Politics, and Violence against Women of Color." In *Critical Race Theory: The Key Writings That Formed the Movement*, edited by Kimberlé Crenshaw et al. New York: New Press, 1995.

Crimp, Douglas. "The Museum's Old/the Library's New Subject." In *The Contest of Meaning: Critical Histories of Photography*, edited by Richard Bolton, 3–12. Cambridge: MIT Press, 1989.

Daston, Lorraine, ed. *Biographies of Scientific Objects*. Chicago: University of Chicago Press, 2000.

———. "The Coming into Being of Scientific Objects." In *Biographies of Scientific Objects*, edited by Lorraine Daston, 1–14. Chicago: University of Chicago Press, 2000.

———. "Life, Chance, and Life Chances." *Daedalus* 137, no. 1 (2008): 5–14.

———. "The Moral Economy of Science." *Osiris* 10 (1995): 3–24.

Daston, Lorraine, and Peter Galison. "Images of Objectivity." *Representations* 40 (Fall 1992): 81–128.

———. *Objectivity*. New York: Zone Books, 2007.

Daston, Lorraine, and Elizabeth Lunbeck, eds. *Histories of Observation*. Chicago: University of Chicago Press, 2011.

Daston, Lorraine, and Katherine Park. *Wonders and the Order of Nature, 1150–1750*. New York: Zone Books, 1998.

Daziell, R. "Everard im Thurn in British Guiana and the Western Pacific." In *Writing, Travel, and Empire*, edited by P. Hulme and R. McDougall, 97–118. London: I. B. Tauris, 2007.

de Klerk, Nico. "Home Away from Home: Private Films from the Dutch East Indies." In *Mining the Home Movie*, edited by Karen Ishizuka and Patricia Zimmerman, 148–61. Berkeley: University of California Press, 2008.

de Mondenard, Anne. *La Mission Héliographique: cinq photographes parcourent la France en 1851*. Paris: Monum, Éd. du Patrimoine, 2002.

del Barbarò, Falzone, and Monica Maffioli, eds. *Das Italien der Alinari: italienische Kunst und Kultur in den Aufnahmen der Fratelli Alinari, Firenz, 1852–1920*. Florence: Alinari, 1988.

Derenthal, Ludger, and Christine Kühn, eds. *Ein neuer Blick: Architekturfotografie aus den Staatlichen Museen zu Berlin*. Tübingen: Wasmuth, 2010.

Derrida, Jacques. *Archive Fever: A Freudian Impression*. Translated by Eric Prenowitz. Chicago: University of Chicago Press, 1996.

———. *Mal d'archive: Une impression freudienne*. Paris: Édition Galilée, 1995.

di Giulio, Katherine. *Natural Variations: Photographs by Colonel Stuart-Wortley*. San Marino, CA: Huntington Library Press, 1994.

Dias, Nélia. "Photographier et mesurer: les portraits anthropologiques." *Romantisme* 84 (1994): 37–49.

Dikovitskaya, Margaret. *Visual Culture: The Study of the Visual after the Cultural Turn*. Cambridge: MIT Press, 2005.

Dilly, Heinrich. "Lichtbildprojektion—Prothese der Kunstbetrachtung." In *Kunstwissenschaft und Kunstvermittlung*, ed. Irene Below, 153–72. Gießen: Anabas-Verlag 1975.

Doane, Mary Ann. *The Emergence of Cinematic Time: Modernity, Contingency, the Archive*. Cambridge: Harvard University Press, 2002.

———. "Indexicality and the Concept of Medium Specificity." In *The Meaning of Photography*, edited by Robin Kelsey and Blake Stimson, 3–14. New Haven: Yale University Press, 2008.

Domosh, Mona. *American Commodities in an Age of Empire*. New York: Routledge, 2006.

———. "Geoeconomic Imaginations and Economic Geography in the Early 20th Century." *Annals of the Association of American Geographers* 103 (2013): 944–66.

Duncan, Barbara. "Liebe Perla: A Complex Friendship and Lost Disability History Captured on Film." *Disability World: A Bi-Monthly Webzine of International Disability News and Views*, 9 (July–August 2001), http://www.disabilityworld.org/07-08_01/arts/perla.shtml (accessed 20 July 2009).

Eaton, Mike, ed. *Anthropology-Reality-Cinema: The Films of Jean Rouch*. London: British Film Institute, 1979.

Edney, Mathew H. *Mapping an Empire: The Geographical Construction of British India, 1765–1834*. Chicago: University of Chicago Press, 1997.

Edwards, Elizabeth. *The Camera as Historian*. Durham: Duke University Press, 2012.

———. "Performing Science: Still Photography and the Torres Strait Expedition." In *Cambridge and the Torres Strait*, edited by A. Herle and S. Rouse, 106–35. Cambridge: Cambridge University Press, 1998.

———. "'Photographic Types': The Pursuit of Method." *Visual Anthropology* 3, no. 2–3 (1990): 239–58.

———. "Photographs: Material Form and the Dynamic Archive." In *Photo Archives and the Photographic Memory of Art History*, edited by Costanza Caraffa, 47–56. Berlin: Deutscher Kunstverlag, 2011.

———. "Photography and the Material Performance of the Past." *History and Theory* 48 (2009): 130–50.

———. *Raw Histories: Photographs, Anthropology, and Museums*. Oxford: Berg, 2001.

———. "Tracing Photography." In *Made to Be Seen: Perspectives on the History of Visual Anthropology*, edited by J. Ruby and M. Banks, 159–89. Chicago: University of Chicago Press, 2011.

———. "Unblushing Realism and the Threat of the Pictorial: Photographic Survey and the Production of Evidence 1885–1918." *History of Photography* 33, no. 1 (February 2009): 3–17.

———. "Visualising Science." In *Anthropology and Photography 1860–1920*, edited by E. Edwards. 108–21. New Haven: Yale University Press, 1992.

Edwards, Elizabeth, and Janice Hart. "Introduction: Photographs as Objects." In *Photographs Objects Histories: On the Materiality of Images*, edited by Elizabeth Edwards and Janice Hart, 1–15. London: Routledge, 2004.

———. "Mixed Box: The Cultural Biography of a Box of 'Ethnographic' Photographs." In *Photographs Objects Histories: On the Materiality of Images*, edited by Elizabeth Edwards and Janice Hart, 47–61. London: Routledge, 2004.

———, eds. *Photographs Objects Histories: On the Materiality of Images*. London: Routledge, 2004.

Edwards, Elizabeth, and Sigrid Lein, eds. *Uncertain Images: Museums and the Work of Photographs*. Farnham, Surrey, UK: Ashgate Press, 2014.

Eigen, Sara. "Liebe Perla, Memento Mori: On Filming Disability and Holocaust History." *Women in German Yearbook: Feminist Studies in German Literature and Culture* 22 (2006): 1–20.

Eliot, Charles, et al. *Visual Education through Stereographs and Lantern Slides*. Meadville, PA: Keystone View Company, 1906.

Elkins, James, ed. *Photography Theory*. The Art Seminar. New York: Routledge, 2006.

———. *Six Stories from the End of Representation: Images in Painting, Photography, Astronomy, Microscopy, Particle Physics, and Quantum Mechanics, 1980–2000*. Stanford: Stanford University Press, 2008.

Engelke, Matthew. "The Objects of Evidence." *Journal of the Royal Anthropological Institute*, n.s. 14, supplement S1 (2008): S1–S21.

Erlanger, Steve. "Vienna Buries Child Victims of the Nazis." *New York Times*, 29 April 2002.

Ernst, Wolfgang. *Im Namen von Geschichte: Sammeln—Speichern—Er/Zählen: Infrastrukturelle Konfigurationen des Destschen Gedächtnisses*. Munich: Fink, 2003.

Failing, Patricia. "Brave New World or Just More Profitable?" *Artnews* 9 (October 1996): 114–18.

Fellmann, Berthold, ed. *100 Jahre deutsche Ausgrabung in Olympia*. Munich: Prestel, 1972.

Ferro, Marc. *Cinéma et Histoire*. Paris: Folio, 1993.

Firestone, Harvey S. *Men and Rubber: The Story of Business*. Garden City, NY: Doubleday, Page & Co, 1926.

"Firestone Rubber on the Screen." *New York Times*, 10 March 1927, 40.

Fleming, D. Hay. "Notice of the Recent Discovery of a Cist, with Fragments of Urns and a Jet Necklace, at Law Park, near St Andrews; with a Note of the Discovery, near the same place, of a Cremation Cemetery of the Bronze Age, with many Cinerary Urns, in 1859." *Proceedings of the Society of Antiquaries of Scotland* 41 (1906–7): 401–14.

Flusser, Vilém. *Towards a Philosophy of Photography*. London: Reaktion, 2000.

Foster, Hal. "The Archive without Museums." *October* 77 (Summer 1996): 97–119.

Foucault, Michel. "Technologies of the Self." In *Technologies of the Self*, edited by L. H. Martin, H. Gutman, and P. H. Hutton, 16–49. Amherst: University of Massachusetts Press, 1988.

Friedberg, Anne. *The Virtual Window: From Alberti to Microsoft*. Cambridge: MIT Press, 2006.

Frosh, Paul. *The Image Factory: Consumer Culture, Photography, and the Visual Content Industry*. Oxford: Berg, 2003.

Galison, Peter. "Contexts and Constraints." In *Scientific Practice: Theories and Stories of Doing Physics*, edited by J. Z. Buchwald, 13–41. Chicago: University of Chicago Press, 1995.

———. *Image and Logic: A Material Culture of Microphysics*. Chicago: University of Chicago Press, 1997.

———. "Judgment against Objectivity." In *Picturing Science Producing Art*, edited by Caroline Jones and Peter Galison, 327–59. New York: Routledge, 1998.

Gant, Tina, ed. *International Directory of Company Histories*. London: St. James Press, 2000.

Garland-Thomson, Rosemarie. "The Politics of Staring: Visual Rhetorics of Disability in Popular Photography." In *Disability Studies: Enabling the Humanities*, edited by Sharon L. Snyder, Brenda Jo Brueggemann, and Rosemarie Garland-Thomson, 56–75. New York: Modern Language Association of America, 2002.

———. *Staring: How We Look*. New York: Oxford University Press, 2009.

Gates, Bill, Nathan Myrvold, and Peter Rinearson. *The Road Ahead*. New York: Penguin, 1995.

Geimer, Peter. "Bild und Maß: Zur Typologie fotografischer Bilder." In *Einführung in die Kunstwissenschaft*, edited by Thomas Hensel and Andreas Köstler, 157–77. Berlin: Reimer, 2005.

Geismar, Haidy. "The Photograph and the Malanggan: Rethinking Images on Malakula, Vanuatu." *Australian Journal of Anthropology* 20, no. 1 (2009): 48–73.

Gell, Alfred. *Art and Agency*. Oxford: Oxford University Press, 1998.

Gilman, Sander L. "The New Genetics and the Old Eugenics: The Ghost in the Machine." *Patterns of Prejudice* 36, no. 1 (2002): 3–4.

Ginsburg, Faye. "Screen Memories: Resignifying the Traditional in Indigenous Media." In *Media Worlds: Anthropology on New Terrain*, edited by Faye Ginsburg, B. Larkin, and L. Abu Lughod, 3–4. Los Angeles: University of California Press, 2002.

Ginsburg, Faye, B. Larkin, and L. Abu Lughod, eds. *Media Worlds: Anthropology on New Terrain*. Berkeley: University of California Press, 2002.

Ginzburg, Carlo. *Clues, Myths, and the Historical Method.* Baltimore: Johns Hopkins University Press, 1992.

Glaisher, James. "Report to Class X: Philosophical Instruments and Processes Depending Upon Their Use." In *Reports by the Juries,* 275. London: For the Royal Commission, 1852.

Golan, Tal. "History of Scientific Expert Testimony in the English Courtroom." *Science in Context* 12 (1999): 5–34.

———. *Laws of Man and Laws of Nature: A History of Scientific Expert Testimony.* Cambridge: Harvard University Press, 2004.

Goldberg, Carey. "Filmmakers Study a Man Who Studied Apes." *New York Times,* 23 March 1999.

Goodwin, Charles. "Professional Vision." *American Anthropologist* 96, no. 3. (1994): 606–33.

Gower, H. D., et al. *The Camera as Historian: A Handbook to Photographic Record Work for Those Who Use a Camera and for Survey or Record Societies.* London, 1916.

Green, David. "Constructing the Real: Staged Photography and Documentary Tradition." In *Theatres of the Real,* edited by J. Lowry and D. Green, 103–10. Brighton: Photoworks, 2009.

Greene, Graham. *Journey without Maps.* New York: Penguin Classics edition, 2007.

Grierson, John. *Grierson on Documentary.* Edited and compiled by Forsyth Hardy. London: Faber and Faber, 1966.

Griffiths, Alison. *Wondrous Difference: Cinema, Anthropology, and Turn-of-the-Century Visual Culture.* New York: Columbia University Press, 2002.

Grimshaw, Anna. *The Ethnographer's Eye.* Cambridge: Cambridge University Press, 2001.

Guha, Sudeshna. "The Visual in Archaeology: Photographic Representation of Archaeological Practice in British India." *Antiquity* 76 (2002): 93–100.

Gunning, Tom. "Before Documentary: Early Non-Fiction Film and the View Aesthetic." In *Uncharted Territory: Essays on Early Non-Fiction Film,* edited by Daan Hertogs and Nico de Klerk, 9–24. Amsterdam: Nederlands Filmmuseum, 1997.

Hacking, Ian. *Representing and Intervening: Introductory Topics in the Philosophy of Natural Science.* Cambridge: Cambridge University Press, 1983.

Haddon, Alfred C. *History of Anthropology.* London: Watts & Co, 1910.

———. "Photography." *Notes and Queries on Anthropology,* 3rd ed. London: BAAS, 1899.

———. "Photography." *Notes and Queries on Anthropology,* 4th ed. London: BAAS, 1912.

———. "The Saving of Vanishing Knowledge." *Nature* 55 (1897): 305–6.

Hackin, Joseph. "In Persia and Afghanistan with the Citroën Trans-Asiatic Expedition." *The Geographical Journal* 83 (1934): 353–61.

Hamber, Anthony J. *"A Higher Branch of the Art": Photographing the Fine Arts in England, 1839–1880.* Amsterdam: Overseas Publishers Association, 1996.

———. "Observations on the Classification and Use of Photographs at the South Kensington Museum: 1852–1880." In *Photo Archives and the Photographic Memory of Art History,* edited by Costanza Caraffa, 265–77. Berlin: Deutscher Kunstverlag, 2011.

Hannavy, John, ed. *Encyclopedia of Nineteenth-Century Photography.* 2 vols. London: Routledge, 2008.

Haraway, Donna. "The Persistence of Vision." In *The Visual Culture Reader,* edited by Nicholas Mirzoeff, 191–98. London: Routledge, 2001.

Harder, Matthias. *Walter Hege und Herbert List: griechische Tempelarchitektur in photographischer Inszenierung.* Berlin: Reimer, 2003.

———, ed. *"Wanderer, kommst Du nach Hellas": deutsche Photographen sehen Griechenland in der ersten Hällfte des 20. Jahrhunderts.* Thessaloniki: Museum für Photographie, 1997.

Harris, Neal. *Humbug: The Art of P. T. Barnum.* New York: Little Brown and Company, 1973.

Hastrup, Kirsten. "Getting It Right: Knowledge and Evidence in Anthropology." *Anthropological Theory* 4, no. 4 (2004): 455–72.

Hediber, Vinzenz, and Patrick Voncerau, eds. *Films That Work: Industrial Film and the Productivity of Media.* Amsterdam: Amsterdam University Press, 2009.

Heffernan, Virginia. "'Gray Matter': A Driven Filmmaker and His Grim Subject." *New York Times*, 23 April 2005.

Heidegger, Martin. *The Question Concerning Technology, and Other Essays.* New York: Harper Perennial, 1982.

Helmreich, Stefan. *Alien Ocean.* Berkeley: University of California Press, 2009.

Hendrickson, Paul. "The Color of Memory." In *Bound for Glory: America in Color 1939–43*, 7–19. New York: Harry Abrams, 2002.

Hersonski, Yael. *Study Guide to a Film Unfinished* (2010). http://www.afilmunfinished.com/film.html.

Hertogs, Daan, and Nico de Klerk, eds. *Uncharted Territory: Essays on Early Non-Fiction Film.* Amsterdam: Nederlands Filmmuseum, 1997.

Hevey, David. *The Creatures Time Forgot: Photography and Disability Imagery.* London: Taylor & Francis, 1992.

Hevia, James. "The Photography Complex, Exposing Boxer Era China (1900–1901), Making Civilization." In *Photographies East: The Camera and Its Histories in East and Southeast Asia*, edited by Rosalind C. Morris, 79–119. Durham: Duke University Press, 2009.

Hirsch, Marianne. *Family Frames: Photography, Narrative, Performance.* Cambridge: Harvard University Press, 1997.

Hoffmann, Barbara, ed. *Exploiting Images and Image Collections: Goldmine or Legal Minefield?* London: Kluwer Law International, 1999.

Holmes, Oliver Wendell. "The Stereoscope and the Stereograph." *Atlantic Monthly* 3 (June 1859): 738–49.

Howell, S. *Handbook of CCD Astronomy.* 2nd ed. Cambridge Observing Handbooks for Research Astronomers series. Cambridge: Cambridge University Press, 2006.

Hübner, Gerhild. "Walter Heges Blick auf die griechische Antike." In *Dom, Tempel, Skulptur: Architekturphotographien von Walter Hege*, edited by Angelika Beckmann and Bodo von Dewitz, 41–52. Cologne: Wienand, 1993.

im Thurn, Everard. "Anthropological Uses of the Camera." *Journal of the Anthropological Institute* 22 (1896): 184–203.

Ingold, Tim. *The Perception of the Environment: Essays on Livelihood, Dwelling, and Skill.* London: Routledge, 2000.

Ireland, Richard. "The Felon and the Angel Copier: Criminal Identity and the Promise of Photography in Victorian England and Wales." In *Policing and War in Europe, Criminal Justice History*, edited by Louis A. Knafla, ed., 53–86. Westport, CT: Greenwood Press, 2002.

Ishizuka, Karen, and Patricia Zimmerman, eds. *Mining the Home Movie: Excavations in Histories and Memories.* Los Angeles: University of California Press, 2008.

Ivahkiv, Adrian J. *Ecologies of the Moving Image: Cinema, Affect, Nature.* Waterloo: Wilfred Laurier University Press, 2013.

Janin, Jules. "'Le Daguerotype [sic]', L'Artiste, 1838–1839." In *La Photographie en France*, edited by André Rouillé, 46–51. Paris: Macula, 1989.

Jay, Martin. "Photo-unrealism: The Contribution of the Camera to the Crisis of Occularcentrism." In *Vision and Textuality*, edited by S. Melville and B. Readings, 344–60. London: Macmillan, 1995.

Jones, Caroline, and Galison, Peter. *Picturing Science, Producing Art.* New York: Routledge, 1998.

Kestel, Friedrich. "Walter Hege (1893–1955): 'Race Art Photographer' and/or 'Master of Photography'?" In *Art History through the Camera's Lens*, edited by Helene E. Roberts, 283–316. New York: Gordon and Breach, 1995.

Kirby, David. *Lab Coats in Hollywood: Science, Scientists, and Cinema.* Cambridge: MIT Press, 2011.

Klamm, Stefanie. "Bilder des Vergangenen: Strategian archäologischer Visualisierung im 19. Jahrhundert." Doctoral dissertation, Humboldt University, Berlin, 2012.

Koch, Gertrud. "Nachstellungen—Film und historisches Moment." In *Die Gegenwart der Vergangenheit: Dokumentarfilm, Fernsehen und Geschichte*, edited by Eva Hohenberger and Judith Keilbach, 216–29. Berlin: Verlag Vorwerk, 2003.

Koenig, Robert. "Max Planck Offers Historic Apology." *Science* 292, no. 5524 (15 June 2001): 1979–82.

Kohler, Robert. *Landscapes and Labscapes.* Chicago: University of Chicago Press, 2002.

Kopf, Barbara. "Skulptur im Bild: Visuelle Dokumentation und deren Beitrag zur Entwicklung der archäologischen Wissenschaft." In *Verwandte Bilder: Die Fragen der Bildwissenschaft*, edited by Ingeborg Reichle, 149–68. Berlin: Kadmos, 2007.

Koppe, Reiner. *Griechenland: 1891/1892 und 1910 in Messbildern.* Ruhpolding: Verlag Franz Philipp Rutzen, 2008.

———. "Zur Geschichte und zum gegenwärtigen Stand des Meßbildarchivs." In *Architekturphotogrammetrie gestern—heute—morgen: wissenschaftliches Kolloquium zum 75. Todestag des Begründers der Architekturphotogrammetrie Albrecht Meydenbauer, in der Technischen Universität Berlin am 15. November 1996*, edited by Jörg Albertz and Albert Wiedemann, 41–58. Berlin: Technische Universität, 1997.

Koren, Yehuda, and Eilat Negev. *In Our Hearts We Were Giants: The Remarkable Story of the Lilliput Troupe.* New York: Da Capo Press, 2005.

Kracauer, Siegfried. "Zur Ästhetik des Farbenfilms." In *Kino*, edited by Siegfried Kracauer, 48–53. Frankfurt am Main: Suhrkamp, 1974.

Krauss, Rosalind E. "Notes on the Index: Part I." In *The Originality of the Avant-Garde and Other Modernist Myths*, 196–209. Cambridge: MIT Press, 1985.

———. "Notes on the Index: Seventies Art in America." Part 1: *October* 3 (Spring 1977): 68–81; part 2: *October* 4 (Autumn 1977): 58–67.

Krumme, Michael. "Der Beginn der archäologischen Fotografie am DAI Athen." In *Diethnes Synedrio aphieromeno ston Wilhelm Dörpfeld: ypo tin aigida tou Ypourgeiou Politismou*, Lefkada 6–11 Augoustou 2006, edited by Chara Papadatou-Giannopoulou, 61–78. Patra: Peri Technon, 2008.

Kuhn, Annette, and Emiko McAllister. "Locating Memory: Photographic Acts—An Introduction." In *Locating Memory: Photographic Acts*, edited by Annette Kuhn and Emiko McAllister, 1–17. New York: Berghahn Books, 2006.

Kuklick, Henrietta. "The British Tradition." In *A New History of Anthropology*, edited by H. Kuklick, 52–78. Oxford: Blackwell, 2009.

———. *The Savage Within: The Social History of British Social Anthropology 1885–1945.* Cambridge: Cambridge University Press, 1991.

Kyrieleis, Helmut, ed. *Olympia 1875–2000: 125 Jahre Deutsche Ausgrabungen.* Internationales Symposium, Berlin 9.–11. November 2000. Mainz: Von Zabern, 2002.

Lamprey, J. "On a Method of Measuring the Human Form." *Journal of the Ethnological Society*, n.s. 1 (1869): 84–85.

Landecker, Hannah. "Cellular Features: Microcinematography and Film Theory." *Critical Inquiry* 31 (2005): 903–37.

———. "Microcinematography and the History of Science and Film." *Isis* 97 (2006): 121–32.

Lane, Maria. "Geographers of Mars: Cartographic Inscription and Exploration Narrative in Late Victorian Representations of the Red Planet." *Isis* 96 (2005): 477–506.

Latour, Bruno. "Drawing Things Together." In *Representation in Scientific Practice*, edited by Michael Lynch and Steve Woolgar, 19–68. Cambridge: MIT Press, 1990.

———. "The 'Pedofil' of Boa Vista: A Photo-Philosophical Montage," *Common Knowledge* 4.1 (1995): 145–87.

———. "Visualization and Cognition: Thinking with Eyes and Hands." *Knowledge and Society* 6 (1986): 1–40.

———. *We Have Never Been Modern*. Translated by Catherine Porter. New York and London: Harvester Wheatsheaf, 1993.

Latour, Bruno, and Steve Woolgar. *Laboratory Life: The Social Construction of Scientific Facts*. Princeton: Princeton University Press, 1979.

Lemy, Jérôme. *La carte du ciel*. Paris: EDP Sciences, 2008.

Lifton, Robert Jay. *The Nazi Doctors: Medical Killing and the Psychology of Genocide*. New York: Basic Books, 2000.

Lippard, Lucy, ed. *Partial Recall: With Essays on Photographs of Native North Americans*. New York: New Press, 1992.

Lusaka, Jane, Susannah Cassedy O'Donnell, and John Strand, eds. "Whose 800lb Gorilla Is It? Corbis Corporation Pursues Museums." *Museum News*, May/June 1996, 34–37; 76–79.

Lydon, Jane. *Eye Contact: Photographing Indigenous Australians*. Durham: Duke University Press, 2005.

Lydon, Jane, and Tracy Ireland, eds. *Object Lessons: Archaeology and Heritage in Australia*. Melbourne: Australian Scholarly Publishing, 2005.

Lynch, Michael. "Archives in Formation: Privileged Spaces, Popular Archives and Paper Trails." *History of the Human Sciences* 12, no. 2 (May 1999): 65–86.

———. "Discipline and the Material Form of Images: An Analysis of Scientific Visibility." *Social Studies of Science* 15 (1985): 37–66.

———. "The Externalized Retina: Selection and Mathematization in the Visual Documentation of Objects in the Life Sciences." In *Representation in Scientific Practice*, edited by Michael Lynch and Steve Woolgar, 153–86. Cambridge: MIT Press, 1990.

———. "Laboratory Space and the Technological Complex: An Investigation of Topical Contextures." *Science in Context* 4.1 (1991): 81–109.

———. "Science in the Age of Mechanical Reproduction: Moral and Epistemic Relations between Diagrams and Photographs." *Biology and Philosophy* 6 (1991): 205–26.

Lynch, Michael, and Samuel Edgerton. "Abstract Painting and Astronomical Image Processing." In *The Elusive Synthesis: Aesthetics and Science*, edited by A. I. Tauber, 103–24. Dordrecht: Kluwer Academic Publishers, 1996.

———. "Aesthetics and Digital Image Processing: Representational Craft in Contemporary Astronomy." In *Picturing Power: Visual Depiction and Social Relations*, edited by Gordon Fyfe and John Law, 184–220. London: Routledge and Kegan Paul, 1988.

Lynch, Michael, and Steve Woolgar, eds. *Representation in Scientific Practice*. Cambridge: MIT Press, 1990.

Malinowski, Bronislaw. *Coral Gardens and Their Magic*. Vol. 2. London: Routledge and Kegan Paul, 1932.

Mallwitz, Alfred. "Ein Jahrhundert deutsche Ausgrabungen in Olympia." *Mitteilungen des Deutschen Archaologischen Instituts, Athenische Abteilung* 92 (1977): 1–31.

Malraux, André. *Le musée imaginaire.* Vol. 1 of *La Psychologie de l'art.* Geneva: A. Skira, 1947–50.

———. *Le Musée Imaginaire.* Paris: Gallimard, 1965.

Manoff, Marlene. "The Materiality of Digital Collections: Theoretical and Historical Perspectives." *Libraries and the Academy* 6, no. 3 (2006): 311–25.

Manovich, Lev. *The Language of New Media.* Cambridge: MIT Press, 2001.

Marchand, Suzanne L. *Down from Olympus: Archaeology and Philhellenism in Germany, 1750–1970.* Princeton: Princeton University Press, 1996.

———. "The Excavations at Olympia, 1868–1881: An Episode in Greco-German Cultural Relations." In *Greek Society in the Making, 1863–1913,* edited by Philip Carabott, 73–85. Aldershot: Ashgate, 1997.

Margolin, Victor. *The Struggle for Utopia: Rodchenko, Lissitzky, Moholy-Nagy 1917–1946.* Chicago: University of Chicago Press, 1997.

Mathews, Jackson, ed. *The Collected Works of Paul Valéry.* Translated by Stuart Gilbert. Princeton: Princeton University Press, 1970.

Mathews, William S. *Admeasurement of Photographs, as Applied to the Case of Sir Roger TIchborne. Identity Verified by Geometry.* London, 1873.

Matless, David. "Regional Surveys and Local Knowledges: The Geographical Imagination in Britain 1918–1939." *Transactions of the Institute of British Geographers,* n.s. 17, no. 4 (1992): 464–80.

Matyssek, Angela. "Kein Singular: Fotografie und Übersicht." In *Wege zur Moderne: Richard Hamann als Sammler,* edited by Agnes Tieze, 190–215. Munich: Edition Minerva, 2009.

———. *Kunstgeschichte als fotografische Praxis: Richard Hamann und Foto Marburg.* Berlin: Mann, 2009.

McLuhan, Marshall. *Understanding Media: The Extensions of Man.* New York: McGraw-Hill, 1964.

McDannell, Colleen. *Material Christianity: Religion and Popular Culture in America.* New Haven: Yale University Press, 1997.

McIntyre, Martha, and Maureen MacKenzie. "Focal Length as an Analogue of Cultural Distance." In *Anthropology and Photography 1860–1920,* edited by E. Edwards, 158–63. New Haven: Yale University Press, 1992.

McMaster, Gerald. "Colonial Alchemy: Reading the Boarding School Experience." In *Partial Recall: With Essays on Photographs of Native North Americans,* edited by Lucy Lippard, 77–87. New York: New Press, 1992.

McWilliam, Rohan. *The Tichborne Claimant: A Victorian Sensation.* London: Hambledon Continuum, 2007.

Messeri, Lisa, "Placing Outer Space: An Earthly Ethnography of Other Worlds." Ph.D. dissertation, MIT Program in History, Anthropology and Science, Technology and Society, 2011.

Meydenbauer, Albrecht. *Handbuch der Meßbildkunst in Anwendung auf Baudenkmäler- und Reise-Aufnahmen.* Halle: Knapp, 1912.

Miller, Toby. *The Well-Tempered Self: Citizenship, Culture, and the Postmodern Subject.* Baltimore: Johns Hopkins University Press, 1993.

Mitchell, W. J. T. *What Do Pictures Want? The Loves and Lives of Images.* Chicago: University of Chicago Press, 2005.

Mitman, Gregg. *Reel Nature: America's Romance with Wildlife on Film.* 2nd ed. Seattle: University of Washington Press, 2009.

Mnookin, Jennifer. "The Image of Truth: Photographic Evidence and the Power of Analogy." *Yale Journal of Law and the Humanities* 10 (Winter 1998): 1–74.

Mondenard, Anne de. *La Mission Héliographique: cina photographes parcourent la France en 1851.* Paris: Monum, 2002.

Morton, Christopher. "The Initiation of Kamanga: Visuality and Textuality in Evans-Pritchard's Zande Ethnography." In *Photography, Anthropology, and History*, edited by C. Morton and E. Edwards, 19–42. Farnham: Ashgate, 2009.

———. "Indigenous Agency and Fieldwork Photography." Unpublished workshop paper delivered at The Image Relation: Towards an Anthropology of Photography, Oxford, November 2009.

Morton, Christopher, and Elizabeth Edwards, eds. *Photography, Anthropology, and History.* Farnham, UK: Ashgate, 2009.

Nead, Lynda. *The Haunted Gallery: Painting, Photography, and Film, c. 1900.* New Haven: Yale University Press, 2007.

Negroponte, Nicolas. *Being Digital.* New York: Vintage Books, 1996.

Nesbit, Molly. *Atget's Seven Albums.* New Haven: Yale University Press, 1992.

Neumayer, Georg. *Anleitung zu wissenschaftlichen Beobachtungen auf Reisen.* Berlin: Robert Oppenheim Verlag, 1875.

Nickel, Douglas R. "History of Photography: The State of Research." *Art Bulletin* 83, no. 3 (September 2001): 548–58.

———. "Talbot's Natural Magic." *History of Photography* 26, no. 2 (Summer 2002): 32–140.

O'Brian, Maureen C., and Mary Bergstein. *Image and Enterprise: The Photographs of Adolphe Braun.* London: Thames and Hudson, 2000.

Oreskes, Naomi. "From Scaling to Simulation: Changing Meanings and Ambitions of Models in Geology." In *Science Without Laws: Model Systems, Cases, Exemplary Narratives*, edited by Angela Creager, Elizabeth Lunbeck, and Norton Wise, 93–124. Durham: Duke University Press, 2007.

Ostherr, Kirsten. *Medical Visions: Producing the Patient through Film, Television, and Imaging Technologies.* New York: Oxford University Press, 2013.

Pauly, Philip. "The World and All That Is in It: The National Geographic Society, 1888–1918." *American Quarterly* 31 (1979): 517–32.

Peirce, Charles Sanders. *Collected Papers of Charles Sanders Peirce.* Edited by Charles Hartshorne and Paul Weiss. Cambridge: Harvard University Press, 1931–58.

Phillips, Christopher. "The Judgment Seat of Photography." *October* 22 (Autumn 1982): 27–83.

Philp, Jude. " 'Embryonic Science': The 1888 Torres Strait Photographic Collection of A. C. Haddon." In *Woven Histories, Dancing Lives: Torres Strait Islander Identity, Culture, and History*, edited by R. Davies, 90–106. Canberra: Aboriginal Studies Press for the Australian Institute of Aboriginal and Torres Strait Islander Studies, 2004.

"Photo Archives Heads Underground." *New York Times*, 15 April 2001.

"Photography in the Tichborne Case." *Photographic News*, 17 November 1871, 542.

Pickering, Andrew. *The Mangle of Practice: Time, Agency, and Science.* Chicago: University of Chicago Press, 1995.

Pinney, Christopher. *Camera Indica.* London: Reaktion, 1997.

———. *The Coming of Photography in India.* Chicago: University of Chicago Press, 2010.

———. Introduction. In *Photography's Other Histories*, edited by C. Pinney and N. Peterson, 1–14. Durham: Duke University Press, 2003.

————. "The Parallel Histories of Anthropology and Photography." In *Anthropology and Photography 1860–1920*, edited by Elizabeth Edwards, 74–95. New Haven: Yale University Press, 1992.

————. *Photography and Anthropology*. London: Reaktion, 2011.

————. "What Is It to Do with Photography?" In *Photography's Orientalism: New Essays on Colonial Representation*, edited by Ali Behdad and Luke Gartlan. Los Angeles: Getty Research Institute, 2013.

Pinney, Chris, and Nicolas Peterson, eds. *Photography's Other Histories*. Durham: Duke University Press, 2003.

"Plenyono Gbe Wolo." *Harvard Class of 1917: 25th Anniversary Report*, 1018–20. Cambridge: Harvard University Press, 1942.

Poignant, Roslyn. "Surveying the Field of View: The Making of the RAI Photographic Collection." In *Anthropology and Photography 1860–1920*, edited by E. Edwards, 42–73. New Haven: Yale University Press, 1992.

Poole, Deborah. "An Excess of Description: Ethnography, Race, and Visual Technologies." *Annual Review of Anthropology* 34 (2005): 159–79.

————. *Vision, Race, and Modernity: A Visual Economy of the Andean Image World*. Princeton: Princeton University Press, 1997.

Poovey, Mary. *A History of the Modern Fact: Problems of Knowledge in the Sciences of Wealth and Society*. Chicago: University of Chicago Press. 1998.

Portman, M. V. "Photography for Anthropologists." *Journal of the Anthropological Institute* 1 (1896): 75–87.

Prelinger, Rick. *The Field Guide to Sponsored Films*. San Francisco: National Film Preservation Foundation, 2006.

Quintavalle, Arturo Carlo, and Monica Maffioli, eds. *Fratelli Alinari: fotografi in Firenze, 150 anni che illustrarono il mondo 1852–2002*. Florence: Alinari, 2003.

Rapaport, Richard. "In His Image." *Wired Magazine* 2, no. 1 (1996).

Rapp, Rayna. "Communicating About Chromosomes: Patients, Providers, and Cultural Assumptions." *Journal of the American Medical Women's Association* 52 (1997): 28–30.

————. *Testing Women, Testing the Fetus*. New York: Routledge, 1999.

Rapp, Rayna, and Faye Ginsburg. "Enabling Disability: Rewriting Kinship, Reimagining Citizenship." *Public Culture* 13, no. 3 (2001): 533–56.

Read, C. H. "Preface." *Notes and Queries on Anthropology*. 4th ed. London: Royal Anthropological Institute, 1912.

Rheinberger, Hans-Jörg. "Cytoplasmic Particles: The Trajectory of a Scientific Object." In *Biographies of Scientific Objects*, edited by Lorraine Daston, 270–94. Chicago: University of Chicago Press, 2000.

Riles, Annelise. "Introduction." In *Documents: Artifacts of Modern Knowledge*, 1–40. Ann Arbor: University of Michigan Press, 2006.

Roberts, Pamela. *A Century of Colour Photography from the Autochrome to the Digital Age*. London: Andre Deutsch, 2007.

Rodenwaldt, Gerhart, and Walter Hege. *Olympia*. Berlin: Deutscher Kunstverlag, 1936.

Roe, Michael. *Kenealy and the Tichborne Cause: A Study in Mid-Victorian Populism*. Melbourne: Melbourne University Press, 1974.

Rony, Fatimah Tobing. *The Third Eye: Race, Cinema, and Ethnographic Spectacle*. Durham: Duke University Press, 1996.

Rose, Gillian. "Practising Photography: An Archive, a Study, Some Photographs, and a Researcher." *Journal of Historical Geography* 26, no. 4 (2000): 555–71.

Rosenberg, Emily. *Financial Missionaries to the World: The Politics and Culture of Dollar Diplomacy, 1900–1930.* Durham: Duke University Press, 2003.

Rothenberg, Tamar Y. *Presenting America's World: Strategies of Innocence in National Geographic Magazine, 1888–1945.* London: Ashgate, 2007.

Ryan, James. *Picturing Empire: Photography and the Visualization of the British Empire.* Chicago: University of Chicago Press, 1997.

Samuel, Raphael. "The Eye of History." In *Theatres of Memory: Past and Present in Contemporary Culture*, vol. 1., edited by Raphael Samuel, 315–36. London: Verso, 1996.

Sassoon, Joanna. "Photographic Materiality in the Age of Digital Reproduction." In *Photographs Objects Histories: On the Materiality of Images*, edited by Elizabeth Edwards and Janice Hart, 186–202. London: Routledge, 2004.

Schaaf, Larry L., ed. *The Correspondence of William Henry Fox Talbot.* http://www.foxtalbot.dmu.ac.uk.

———. *Records of the Dawn of Photography: Talbot's Notebooks P&Q.* Cambridge: Cambridge University Press, 1996.

Schaffer, Simon, Lissa Roberts, Kapil Raj, and James Delbourgo, eds. *The Brokered World: Go-Betweens and Global Intelligence, 1770–1820.* Sagamore Beach, MA: Science History Publications, 2009.

Schneider, Alexandra, ed. *Virtual Voyages: Cinema and Travel.* Durham: Duke University Press, 2006.

Schwartz, Joan. "'The Geography Lesson': Photographs and the Construction of Imaginative Geographies." *Journal of Historical Geography* 22, no. 1 (1996): 16–45.

———. "'Records of Simple Truth and Precision': Photography, Archives, and the Illusion of Control." *Archivaria* 50 (2002): 1–40. Reprinted in *Archives, Documentation and Institutions of Social Memory: Essays from the Sawyer Seminar*, edited by Francis X. Blouin Jr. and William G. Rosenberg, 61–83. Ann Arbor: University of Michigan Press, 2006.

———. "'We Make Our Tools and Our Tools Make Us': Lessons from Photographs from the Practice, Politics, and Poetics of Diplomatics." *Archivaria* 40 (1995): 40–74.

Schwartz, Joan M., and Terry Cook. "Archives, Records, and Power: The Making of Modern Memory." *Archival Science* 2, no. 1–2 (2002): 1–19.

Schwartz, Joan M., and James R. Ryan, eds. *Picturing Place: Photography and the Geographical Imagination.* London: Tauris, 2003.

Seidelman, William E. "Science and Inhumanity: The Kaiser-Wilhelm/Max Planck Society," *If Not Now* 2 (Winter 2000), http://www.baycrest.org/journal/ifnot01w.html, revised 18 February 2001. http://www.doew.at/thema/planck/planck1.html (accessed 21 July 2009).

Sekula, Allan. "Between the Net and the Deep Blue Sea (Rethinking the Traffic of Photographs)." *October* 102 (Fall 2002): 3–34.

———. "The Body and the Archive." *October* 39 (Winter 1986): 3–64. Reprinted in *The Contest of Meaning*, edited by Richard Bolton, 343–89. Cambridge: MIT Press, 1992.

———. "Reading an Archive: Photography between Labour and Capital." In *The Photography Reader*, edited by Liz Wells, 443–52. London: Routledge, 2003.

Sen, Satadru. "Savage Bodies, Civilized Pleasures: M. V. Portman and the Andamanese." *American Ethnologist* 36 (2009): 364–79.

Sera-Shriar, Efram. *The Making of British Anthropology, 1813–1871.* London: Pickering and Chatto, 2013.

Serena, Tiziana. "The Words of the Photo Archive." In *Photo Archives and the Photographic Memory of Art History*, edited by Costanza Caraffa, 57–71. Berlin: Deutscher Kunstverlag, 2011.

Serlin, David, ed. *Imagining Illness: Public Health and Visual Culture*. Minneapolis: University of Minnesota Press, 2010.

Shapin, Steven, and Simon Schaffer. *Leviathan and the Air-Pump: Hobbes, Boyle, and the Experimental Life*. Princeton: Princeton University Press, 1985.

Shapiro, Carl, and Hal R. Varian. *Information Rules: A Strategic Guide to the Network Economy*. Cambridge: Harvard Business School Press, 1998.

Sibum, Otto. "Reworking the Mechanical Value of Heat: Instruments of Precision and Gestures of Accuracy in Early Victorian England." *Studies in History and Philosophy of Science* 26 (1995): 73–106.

"Slavery of Liberia Bared in Report." *Boston Globe*, 27 September 1930.

Smith, Neil. *American Empire: Roosevelt's Geographer and the Prelude to Globalization*. Berkeley: University of California Press, 2003.

Smith, Pamela. "Art, Science, and Visual Culture in Early Modern Europe." *Isis* 97 (2006): 83–100.

———. *The Body of the Artisan: Art and Experience in the Scientific Revolution*. Chicago: University of Chicago Press, 2006.

Snyder, Joel, and Neil Walsh Allen. "Photography, Vision, and Representation." *Critical Inquiry* 2, no. 1 (Autumn 1975): 143–69.

Sontag, Susan. "The Image-World." In *On Photography*, 153–80. New York: Doubleday, 1990.

Spirn, Anne Whiston. *Daring to Look: Dorothea Lange's Photographs and Reports from the Field*. Chicago: University of Chicago Press, 2008.

Stafford, Barbara Maria. *Artful Science: Enlightenment, Entertainment, and the Eclipse of Visual Education*. Cambridge: MIT Press, 1994.

Steedman, Carolyn. *Dust: The Archive and Cultural History*. New Brunswick, NJ: Rutgers University Press, 2002.

Stepan, Nancy. *Picturing Tropical Nature*. Ithaca, NY: Cornell University Press, 2001.

Stewart, Phillip W. *Henry Ford's Moving Picture Show: An Investigator's Guide to the Films Produced by the Ford Motor Company, Volume One: 1914–1920*. Crestview, FL: PMS Press, 2011.

Stocking, George. *After Tylor: British Social Anthropology 1888–1951*. London: Athlone Press, 1995.

———. *The Ethnographer's Magic*. Madison: University of Wisconsin Press, 1983.

———. "What's in a Name? The Origins of the Royal Anthropological Institute." *Man*, n.s. 6, no. 3 (1971): 369–90.

Stoler, Anne Laura, ed. *Imperial Debris: On Ruins and Ruination*. Durham: Duke University Press, 2013.

Stott, William. *Documentary Expression and Thirties America*. Chicago: University of Chicago Press, 1986.

Stotz, Gustav. "Werkbund—Ausstellung 'Film und Foto' Stuttgart, 1929." *Das Kunstblatt* 13 (May 1929): 154.

Strong, Richard P., ed. *The African Republic of Liberia and the Belgian Congo, Based on the Observations Made and Material Collected During the Harvard African Expedition, 1926–1927*. Cambridge: Harvard University Press, 1930.

———. "Conditions in Liberia." *Boston Herald*, 14 January 1928.

Stuart-Wortley, Colonel. "On Photography in Connection with Art." *The Photographic Journal* no. 138 (15 October 1863): 365–68.

Stürmer, Veit. "Eduard Gerhards 'Archäologischer Lehrapparat.'" In *Dem Archäologen Eduard Gerhard 1795–1867 zu Seinem 200. Geburtstag*, edited by Henning Wrede, 43–46. Berlin: Arenhövel, 1997.

Sundiata, Ibrahim. *Black Scandal: America and the Liberian Labor Crisis, 1929–1936*. Philadelphia: Institute for the Study of Human Issues, 1980.

———. *Brothers and Strangers: Black Zion, Black Slavery, 1914–1940*. Durham: Duke University Press, 2003.

Swinney, Geoffrey. "What Do We Know about What We Know? The Museum 'Register' as Museum Object." In *The Thing about Museums: Objects and Experience, Representation and Contestation*, ed. Sandra Dudley et al., 31–46. London: Routledge, 2012.

Tagg, John. *The Burden of Representation. Essays on Photographies and Histories*. London: Macmillan, 1988. Also Minneapolis: University of Minnesota Press, 1993.

———. *The Disciplinary Frame: Photographic Truths and the Capture of Meaning*. Minneapolis: University of Minnesota Press, 2009.

———. "Neither Fish Nor Flesh." *History and Theory* 48, no. 2 (December 2009): 77–81.

Tait, David. "Rethinking the Role of the Image in Justice: Visual Evidence and Science in the Trial Process." *Law, Probability, and Risk* 6, no. 1–4 (2007): 311–18.

Talbot, William Henry Fox. *The Pencil of Nature*. London: Longman, Brown, Green & Longmans, 1844–46. Reprint with introduction by Beaumont Newhall. New York: Da Capo Press, 1968.

———. "Some Account of the Art of Photogenic Drawing." *Philosophical Magazine*, 3rd ser., 14, no. 88 (1839): 196–211. Reprinted as a pamphlet, London: R. and J. E. Taylor, 1839.

Tayler, Donald. "'Very Lovable Human Beings': The Photography of Everard im Thurn." In *Anthropology and Photography 1860–1920*, edited by E. Edwards, 187–92. New Haven: Yale University Press, 1992.

Taylor, Roger, et al. *Exhibitions of the Royal Photographic Society 1870–1915*. Leicester: De Montfort University, 2008. http://peib.dmu.ac.uk/.

"Tells Firestone Dealers about Liberian Rubber." *New York Times*, 3 April 1927, xx16.

Thompson, D'Arcy Wentworth. *On Growth and Form*. Cambridge: Cambridge University Press, 1917.

Tobias, Jenny. "Re-Use Value." *Cabinet* 22 (2006): 44–47.

Tomas, David. "Tools of the Trade: The Production of Ethnographic Observation in the Andaman Islands 1858–1922." In *Colonial Situations*, edited by George Stocking, 79–108. Madison: University of Wisconsin Press, 1991.

Trachtenberg, Alan, ed. *Classic Essays on Photography*. New Haven: Leete's Island Books, 1980.

Trant, Jennifer. "The Getty AHIP Imaging Initiative: A Status Report." *Archives and Museums Informatics* 9, no. 3 (1995): 262–78.

Tucker, Jennifer. "The Historian, the Picture, and the Archive." *Isis* 97 (2006): 111–20.

———. *Nature Exposed: Photography as Eyewitness in Victorian Science*. Baltimore: Johns Hopkins University Press, 2005.

———. "Photography as Witness, Detective, and Impostor: Visual Representation in Victorian Science." In *Victorian Science in Context*, edited by Bernard Lightman, 387–408. Chicago: University of Chicago Press, 1997.

United States Holocaust Memorial Museum. "Josef Mengele." In *Holocaust Encyclopedia*, http://www.ushmm.org/wlc/en/article.php?ModuleId=10007060.

Urry, James. "*Notes and Queries on Anthropology* and the Development of Field Methods in

British Anthropology, 1870–1920." *Proceedings of the Royal Anthropological Institute 1972* (1972): 45–57.

Vertesi, Janet. "*Drawing As*: Distinctions and Disambiguations in Digital Images of Mars." In *Representation in Scientific Practice Revisited*, edited by Catelijne Coopmans, Janet Vertesi, Michael Lynch, and Steve Woolgar, 15–35. Cambridge: MIT Press, 2014.

———. *Seeing Like a Rover: How Robots, Teams, and Images Craft Knowledge of Mars*: Chicago: University of Chicago Press, 2015.

Walkowitz, Judith. *City of Dreadful Delight: Narratives of Sexual Danger in Late-Victorian London*. Chicago: University of Chicago Press, 1992.

Whitman, Randal, and Loring Whitman. "Photography." In *The African Republic of Liberia and the Belgian Congo, Based on the Observations Made and Material Collected During the Harvard African Expedition, 1926–1927*, edited by Richard P. Strong, 1048–52. Cambridge: Harvard University Press, 1930.

Wilder, Kelley. Interview with Rachel Hart. St Andrews University Library, Special Collections, 2010.

———. "Invention of Photography." In *The Oxford Companion to the Photograph*, edited by Robin Lenman, 314–17. Oxford: Oxford University Press, 2005.

———. "Looking through Photographs: Art, Archiving, and Photography in the Photothek." In *Fotografie als Instrument und Medium der Kunstgeschichte*, edited by Costanza Caraffa, 117–28. Berlin: Deutscher Kunstverlag, 2009.

"Wives Pawned into Slavery!" *Boston Sunday Post*, 18 January 1931.

Wolf, Herta. "Das Denkmälerarchiv Fotografie." In *Paradigma Fotografie: Fotokritik am Ende des fotografischen Zeitalters*, edited by Herta Wolf, 349–75. Frankfurt am Main: Suhrkamp, 2002.

Woodruff, Douglas. *The Tichborne Claimant: A Victorian Mystery*. London: Farrar and Straus, 1957.

Wrede, Henning, ed. *Dem Archäologen Eduard Gerhard 1795–1867 zu Seinem 200. Geburtstag*. Berlin: Arenhövel, 1997.

———. "Olympia, Ernst Curtius und die kulturgeschichtliche Leistung des Philhellenismus." In *Die modernen Väter der Antike: Die Entwicklung der Altertumswissenschaften an Akademie und Universität im Berlin des 19. Jahrhunderts*, edited by Annette M. Baertschi and Colin G. King, 165–208. Berlin: De Gruyter, 2009.

Young, James C. *Liberia Rediscovered*. Garden City, NY: Doubleday, 1934.

Young, Michael. *Malinowski's Kiriwina*. Chicago: University of Chicago Press, 1998.

Zannier, Italo. *Le Grand Tour*. Venice: Canal and Stamperia, 1997.

Zevi, Filippo, ed. *Alinari: Photographers of Florence 1852–1920*. Florence: Alinari, 1978.

Zimmerman, Andrew. *Anthropology and Antihumanism in Imperial Germany*. Chicago: University of Chicago Press, 2001.

Zimmerman, Patricia R. "Geographies of Desire: Cartographies of Gender, Race, Nation, and Empire in Amateur Film." *Film History* 8 (1996): 85–98.

Contributors

Estelle Blaschke
Postdoctoral fellow
Cultural History Department
University of Lausanne

Elizabeth Edwards
Professor of Photographic History
Photographic History Research Centre
De Montfort University

Peter Geimer
Geschäftsführender Direktor
Kunsthistorisches Institut
Freie Universität, Berlin

Faye Ginsburg
Director, Center for Media, Culture and History
David B. Kriser Professor of Anthropology
Codirector, Center for Religion and Media
Codirector, Council for the Study of Disability
New York University

Stefanie Klamm
Research Fellow
Photography Collection, Art Library
Staatliche Museen zu Berlin

Gregg Mitman
Vilas Research and William Coleman Professor of History of Science,
 Medical History and Environmental Studies
University of Wisconsin-Madison

Jennifer Tucker
Associate Professor of History
Wesleyan University

Janet Vertesi
Assistant Professor
Department of Sociology
Princeton University

Kelley Wilder
Director
Photographic History Research Centre
De Montfort University

Index

Page numbers in italic refer to figures.